C0-EFL-406

COORDINATED BY

Instituto Universitario de Restauración del Patrimonio Arquitectónico (IRP)

Universitat Politècnica de València (UPV)

SCIENTIFIC COORDINATION

Francisco Juan Vidal

AUTHORS FOR TEXTS

Instituto de Restauración del Patrimonio Arquitectónico (IRP), Universitat Politècnica de València (UPV, Valencia, Spain): *María Teresa Doménech Carbó (WP project manager), Francisco Juan Vidal (WP manager assistant), Filippo Fantini, Ángeles Benlloch, Alesandra Insa, Salvador Lara Ortega, María José Viñals Blasco, Maryland Moran, Pau Alonso-Monasterio, Alicia Llorca Ponce, Laura Fernández Durán, Arturo Barba Sevillano, María Emilia Casar Furió, María Jesús Romero Aloy, Laura Osete Cortina, Stephan Kröner.*

Department of Antiquities (DOA), Ministry of Tourism and Antiquities (MOTA, Amman, Jordan): *Mohammad El Khalili, Monther Jamhawi, Marwan Asmar.*

ATHENA PROJECT RESEARCHERS

Instituto de Restauración del Patrimonio Arquitectónico (IRP), Universitat Politècnica de València (UPV, Valencia, Spain): *María Teresa Doménech Carbó (IRP-UPV project manager), Francisco Juan Vidal (IRP-UPV manager assistant), Filippo Fantini, Ángeles Benlloch, Alesandra Insa, Salvador Lara Ortega, María José Viñals Blasco, Maryland Moran, Pau Alonso-Monasterio, Alicia Llorca Ponce, Laura Fernández Durán, Arturo Barba Sevillano, Maria Emilia Casar Furió, María Jesús Romero Aloy, José Luís Alapont Ramón.*

Department of Antiquities (DOA), Ministry of Tourism and Antiquities (MOTA, Amman, Jordan): *Nizar Al Adarbeh (Project Manager), Munther Jamhawi, Mohammad Al Khalili, Marwan Asmar, Hanadi Al-Taher, Samia Khouri, Asem Asfour, Jamal Al Safi, Tawfiq Al Hunaiti, Mahmood Al Arab, Talal Akasheh, Naif Haddad, Leen Fakhoury, Huda Najjar.*

Institut Préparatoire aux Etudes Littéraires et de Sciences Humaines de Tunis (IPELSHT, Tunis, Tunisia): *Ahmed Al Marouani (IPELSHT project manager), Selima Lejri, Samir Souit, Adel Khadraoui, Hayat Hamdi Smiri, Habeeb Baklouti, Hager Ben Driss, Chebbi Noureddine, Majdi Ben Souf, Amel Ben Saidane, Sadok Abcha, Eafiak Amri Abbes Ahmed Al Marouani, Amel Mzali-Sebai, Amel Khemira Ben Saidane, Baklouti Habib, Rafika Amri Abbes.*

Labo Bati Dans l'Environnement (LBE), University of Science And Technology Houari Boumediene (USTHB, Alger, Algeria): *Fattoum Kharchi (LBE project manager), Djillali Ben Nouar, Youcef Chennaoui, Abdelwahab Zekagh, Zehira Helal.*

Dipartimento di Storia, Disegno e Restauro dell'Architettura (DSDRA), Università La Sapienza di Roma (Roma, Italy): *Carlo Bianchini (DSDRA Project Manager), Mario Docci (Coordinator of Scientific Committee), Alfonso Ippolito, Emanuela Chiavoni, Carlo Inglese, Luca J. Senatore, Francesco Borgogni, Francesco Cosentino, Chiara Capocefalo, Eliana Capiato, Francesca Porfiri, Gaia Lisa Tacchi, Alessandro Cappelletti, Federico Fallavollita.*

FRONT PAGE DESIGN

Filippo Fantini

GRAFIC DESIGN

Estudio David Cercós

Carles Rodrigo Monzó (layout)

PROOFREAD BY

Neil Larsen

© **TEXTS:** Their authors
© **PHOTOS:** Their authors
© **EDITION:** General de Ediciones de Arquitectura

PUBLISHER: General de Ediciones de Arquitectura
Avda. Reino de Valencia, 84
46005 Valencia-España
www.tccuadernos.com

© All rights reserved
ISBN: 978-84-940229-6-8
Legal Deposit: V-121-2013
Print: Tonos Impresión S.L.
Printed in Spain

PROTOTYPE OF MANAGEMENT PLAN FOR ENHANCEMENT OF NEW ACTUALITIES

ATHENA PROJECT

Ancient THeatres Enhancement for New Actualities

www.athenaproject.eu

European Commission

EUROMED HERITAGE IV

Grant Application Form

Budget line: 19.080101

European Neighbourhood and Partnership (ENP)
financial co-operation with Mediterranean countries

Reference: EuropeAid/126266/C/ACT/Multi

Deadline for submission of concept notes: 15/02/2008, 16:00 CET

PROJECT LEADER

Department of Antiquities, Ministry of Tourism and Antiquities,
The Hashemite Kingdom of Jordan

PROJECT MANAGER

Nizar Al Aderbeh

PARTNERS

Institut Préparatoire aux Etudes Littéraires et de Sciences
Humaines de Tunis (IPELSHT, Tunis, Tunisia)

Labo Bati Dans l'Environnement (LBE), University of Science
And Technology Houari Boumediene (USTHB, Alger, Algeria)

Instituto de Restauración del Patrimonio Arquitectónico (IRP),
Universitat Politècnica de València (UPV, Valencia, Spain)

Dipartimento di Storia, Disegno e Restauro dell'Architettura
(DSDRA), Università La Sapienza di Roma (Roma, Italy)

ASSOCIATES

Instituto de Arqueología - Mérida (IAM, Spain)

Centro Regionale per la Progettazione e Restauro
(CRPR, Regione di Sicilia, Italy)

Arab Towns Organization (ATO, Kuwait)

CyArk High Definition Heritage Network (Orinda, United States)

The views presented in this publication solely reflect those of its
authors and contributors

The European Commission shall not be liable for any act or use
based on the information it contains

ATHENA PROJECT
ANCIENT THEATRES ENHANCEMENT
FOR NEW ACTUALITIES

PROTOTYPE OF MANAGEMENT PLAN FOR ENHANCEMENT OF NEW ACTUALITIES

Preface .. 11

Introduction .. 13

PRELIMINARY ACTIVITIES

1. Preconceptions .. 19

 1.1. DEFINITION AND THEATRE'S PART .. 20

 KEY NOTE 1
 DESIGN AND DIMENSIONING CRITERIA FOR THE INTERPRETATION OF
 ANCIENT THEATRE DEVELOPMENT PROCESS .. 22

 ATTACHMENT 1.1. Spain theatres: Identification .. CD
 ATTACHMENT 1.2. Spain theatres: Athena evaluation ... CD
 ATTACHMENT 1.3. Spain theatres: Reference ... CD
 ATTACHMENT 1.4. Spain frame: State of the Art ... CD
 ATTACHMENT 1.5. Spain frame: Legal ... CD
 ATTACHMENT 1.6. Spain frame: Restoration .. CD
 ATTACHMENT 1.7. Spain frame: Best Practices, Segobriga theater CD

2. Basic Information .. 31

 **2.1. RESPONSIBLE AGENCY FOR THE DEVELOPMENT AND IMPLEMENTATION OF
 THE MANAGEMENT PLAN** ... 31

 KEY NOTE 2
 LEGAL FIGURES FOR THE MANAGEMENT OF THE PROPERTY: THE FOUNDATION AND
 THE CONSORTIUM ... 32

 2.2. IDENTIFICATION OF THE SITE AND CULTURAL CLUSTER 37
 2.3. IDENTIFICATION OF THE UNIVERSAL AND EURO-MEDITERRANEAN WORTH 41
 2.4. SITE CLASSIFICATION ... 43

 ATTACHMENT 2.1. Deliverables tool I: Model .. 51
 ATTACHMENT 2.2. Deliverables tool I: Example ... CD
 ATTACHMENT 2.3. Deliverables tool I: Cherchell theatre CD
 ATTACHMENT 2.4. Basic Information IRP: Spanish example CD

3. Intrinsic Actions .. 61

 3.1. Knowledge .. 61
 3.2. Conservation .. 64
 3.3. Maintenance .. 65
 3.4. Cultural Heritage's increase of worth .. 66
 3.5. Dissemination ... 67
 3.6. Economic development ... 68

 ATTACHMENT 3.1. Deliverables tool II: Model ... 71

FUNDAMENTALS

4. Guidelines for Compatible Utalitation .. 85

 4.1. CHARTS AND RECOMMENDATIONS .. 85

 4.2. IDENTIFICATION AND DEFINITION OF USES .. 86

 4.2.1 Tourism .. 87

 KEY NOTE 3
 KEY ISSUES IN THE ANCIENT THEATRES RECREATIONAL CARRYING CAPACITY
 ASSESSMENT STUDIES .. 89

 4.2.2 Staging Activities .. 97
 4.2.3 Educational Activities .. 97
 4.2.4 Formal and Ceremonial Activities .. 98
 4.2.5 Cultural Activities and local Traditions .. 99

 KEY NOTE 4
 ACOUSTIC STRATEGIES FOR IMPLEMENTING NEW PRACTICAL USES IN ANCIENT THEATRES .. 101

 4.3. RISK AND THREATS (TA) .. 107

 4.3.1. Introduction .. 107
 4.3.2. Approach & methodology .. 108
 4.3.3. Ancient theatres risk mitigation management .. 109
 4.3.4. Recommendations for ancient theatres risk planning, response and recovery .. 110
 4.3.5. Evaluation and mitigation of ancient theatres risks: towards defining and analysis of these entire risks component .. 110
 4.3.6. Main categories of risk mitigation of ancient theatres and odea .. 111
 4.3.7. Natural causes of deterioration and threats, geo and bio environmental risks .. 111

 KEY NOTE 5
 CHEMICAL ANALYSIS AS A USEFUL TOOL FOR ESTABLISHING THE STATE OF
 CONSERVATION OF ANCIENT THEATRES .. 117

 4.3.8. Reference .. 127

 4.4. SOCIO-ECONOMIC AND INTANGIBLES PARAMETERS (EA) .. 129

 4.4.1. Nature and characteristics of the activities and cultural property .. 129
 4.4.2. The concept of cultural capital: tangible and intangible heritage .. 130
 4.4.3. Stakeholders .. 132
 4.4.4. The demand for cultural assets .. 133
 4.4.5. Culture as an engine for job creation and local development .. 134
 4.4.6. The sector of culture as an engine for local development. .. 137
 4.4.7. The distribution of cultural activities in the territory. cultural cluster .. 137
 4.4.8. Sustainability and cultural activities .. 139
 4.4.9. Good practices in old theatres .. 141
 4.4.10. Reference .. 151

 KEY NOTE 6
 CULTURAL CLUSTERS AND LOCAL ECONOMIC DEVELOPMENT: THE CASE OF THE
 THEATRE OF MÉRIDA (SPAIN) AND SIRACUSA (ITALY) .. 153

4.5. LEGAL FRAME (JA) ... 163
 4.5.1. Legal ownership: copyright and easements ... 163
 4.5.2 Urban frame ... 166
 4.5.3. Cultural protection framework .. 167
 4.5.4. Additional rules (legal frame on the activities) 167

4.6. EQUIPMENTS AND REQUIREMENTS (TA) ... 168
 4.6.1. Equipments ... 168
 4.6.2. Resources ... 184
 4.6.3. Internal Services .. 188
 4.6.4. External Services ... 193

ATTACHMENT 4.1. Segesta Declaration ... CD
ATTACHMENT 4.2. Siracusa Chart .. CD
ATTACHMENT 4.3. Verona Chart ... CD
ATTACHMENT 4.4. ICOMOS International ... CD

DIAGNOSTIC

5. Ancient Theatre Usage Manual ... 201

5.1. CULTURAL CLUSTER DEVELOPMENT ... 201
 5.1.1. Socio-economic and intangible aspects .. 201
 5.1.2. The culture-based development. Cultural Cluster 202
 5.1.3. Identification of resources .. 202
 5.1.3.1. ORDINARY AND SPECIAL RESOURCES FOR THEATRE AND CC 203
 5.1.3.2. ASSOCIATIONS AND FOUNDATIONS ... 205
 5.1.3.3. STAKEHOLDERS AND INVESTORS ... 206
 5.1.4. Economy of culture ... 207
 5.1.4.1. NATIONAL AND LOCAL ECONOMY ANALYSIS 207
 5.1.4.2. ACCESSIBILITY AND INFRASTRUCTURES 212
 5.1.4.3. TRADITIONAL LOCAL ACTIVITIES .. 214

5.2. USER'S PROFILE .. 215

5.3. TIME DISTRIBUTION .. 217

5.4. CULTURAL CLUSTER INFORMATIVE SYSTEM (CCIS) 220
 5.4.1. Technical aspects ... 220
 5.4.1.1. STUDY OF THE THEATRE .. 220
 5.4.1.1.1. General graphic information 220
 5.4.1.1.2. Description of the theatre ... 222
 5.4.1.1.3. Historical Knowledge on the theatre 227
 5.4.1.1.4. History of interventions and restorations on the theatre 228
 5.4.1.1.5. Scientific and technical studies 228
 5.4.1.1.6. Physical compatibility .. 231

- 5.4.1.2. DEVICES AND SERVICES .. 235
 - 5.4.1.2.1. Equipment .. 235
 - 5.4.1.2.2. Resources .. 252
 - 5.4.1.2.3. Internal services .. 258
 - 5.4.1.2.4. External services .. 261
- 5.4.2. The tourism sector .. 267
 - 5.4.2.1. INTRODUCTION .. 267
 - 5.4.2.2. CARRYING CAPACITY .. 267
 - 5.4.2.2.1. Physical carrying capacity .. 269
 - 5.4.2.2.2. Real carrying capacity .. 269
 - 5.4.2.2.3. Effective carrying capacity .. 272
- 5.4.3. Juridical aspects .. 273
 - 5.4.3.1. PROPERTY REGIME OF THEATRE AND CC .. 273
 - 5.4.3.2. System of protections and urban planning inside the CC .. 274
 - 5.4.3.3. Safety standards for performance building at local and national level .. 274

ATTACHMENT 5.1. Deliverables tool III: Model .. 277
ATTACHMENT 5.2. Evaluation Questionnaires Results of Cherchell Theatre .. CD
ATTACHMENT 5.3. Questionnaire tool: IPELSHT-IRP
"Artists, visitants, spectator, local residents" .. CD

PROPOSALS

- 6. Action Plans .. 303
 - 6.1. TO DETECT COMPATIBILITY/INTERFERENCE .. 303
 - 6.2. ANALYSIS SWOT .. 212
 - 6.2.1. Strengths/weaknesses .. 312
 - 6.2.2. Opportunities/threats .. 312
 - 6.3. DEFINITION OF AIMS .. 314
 - 6.4. PROPOSAL .. 314
 - 6.4.1. Aspiration .. 314
 - 6.4.2. Strategy .. 316
 - 6.4.3. Actions .. 317
 - 6.5. PLANNING .. 321
 - 6.6. EVALUATION .. 322

ATTACHMENT 6.1. Questionnaire IRP "evaluation":
Artists, visitants, spectator, local residents .. 323

KEY NOTE 7
STRATEGIES TO PROMOTE THE ANCIENT THEATRE AS A CATALYST FOR
THE CULTURAL RESOURCES AND POTENTIALS .. 327

As Director of the Instituto Universitario de Restauración del Patrimonio (IRP) of the Universitat Politècnica de València I am honoured to present this book issued on the occasion of the development of the Ancient THeatres Enhancement for New Actualities (ATHENA) Project ascribed to the EUROMED HERITAGE Programme under the auspices of the European Commission.

This book takes part of the dissemination results plan established in the ATHENA project and, in particular, in the dissemination plan of work package 4 (WP4) devoted to the development of a management plan, guidelines and a usage manual for compatible utilization of ancient theatres, of which the IRP team has been leader.

Despite archaeological heritage being a limited resource, the reuse of old structures for cultural activities is a growing activity in Europe as a useful strategy for activating tourism and, in this line, the ancient theatres offer a wide range of opportunities. Nevertheless, the implementation of cultural programs can easily have irreversible consequences. Multipurpose activities such as festivals, concerts and theatre performances that are carried out in a large majority of Greek and Roman theatrical structures in the Mediterranean Basin require modern facilities that can cause a notable impact and the subsequent deterioration of sites and structures, which is difficult to manage and control. The use of these monuments also causes environmental and urban management problems, so that an optimal balance between sustainable use and preservation must be achieved.

The ATHENA project has been proposed for developing management plans that enable managers to minimize the possible impact of cultural and socio-economic development on the ancient theatres through the application of appropriate overall strategies for preserving tangible and intangible aspects of heritage. This book includes not only the management plan, as the main result of work package 4, but also the methodological and operational guidelines applied in developing the document. We hope this book will be a useful tool for researchers as well as for costumers, stakeholders, and institutions responsible for the safeguard of ancient theatres.

Finally, I would like to thank all the members of the entire team of the ATHENA project for the fruitful cooperative task carried out during the four years of working together. In particular, the current Coordinator of the ATHENA project Dr. Nizar Adarbeh and the prior coordinators Dr. Ziad Al Saad and Dr. Fawwaz Khraysheh of the Ministry of Tourism & Antiquities of Jordan. Special thanks are also given to Dr. Christiane Dabdoub Nasser (team leader) and Dr. Georges Zouain from the Regional Monitoring and Support Unit Team of the EUROMED HERITAGE programme of the EC for their support and useful comments and suggestions. We would also like to give thanks to Dr. Roberto Albergoni, Secretary General of HERIMED, Association for the documentation, preservation and enhancement of the Euro-Mediterranean Cultural Heritage, who was actively involved in the preparation of the application report of this project.

MARÍA TERESA DOMÉNECH CARBÓ
Director of the IRP. Project Manager of the IRP Team

A Good Omen

"Athena" was the ancient goddess of wisdom, crafts and justice.

It is also the effective acronym for this project (Ancient THeatres Enhancement for New Actualities), part of a general EU policy regarding the European Neighbourhood and Partnership (ENP), with the aim of funding cooperation among Mediterranean countries. The goal of ATHENA is the development of a common strategy in the Mediterranean region for the management of these ancient places for performing arts that can be considered as the starting point for the achievement of social, cultural and economic development.

The classical theatre is one of the most studied typologies from the ancient age; moreover their contemporary usage for dramatic performances makes them extraordinary examples capable of highlighting a common legacy for all the Mediterranean peoples.

Over the last ten years, the theme of Cultural Heritage management has become a priority for all those institutions involved in the process of conservation, research and planning of activities related to sites inscribed on the WHL (World Heritage List). The need for coordination and harmonization of every bureaucratic and cultural aspect related to UNESCO sites and their territories was established during the 24th session of the WORLD HERITAGE COMMITTEE held at Cairns in Australia (27 November – 2 December 2000). UNESCO resisted the establishment of a rigid procedure to follow when drawing up the Management Plan; it was simply intended that all the members of the World Heritage Committee be made aware of the need to avoid, by means of this new "tool", the lack of bureaucratic coordination between the overlapping policies of different institutions operating in the same territory.

In general terms, the Management Plan should not be considered as a report about a site or a new regulation to follow, but rather a flexible "manual" aimed at starting an integrated process involving not just a WHL site and its buffer zone in this process of guardianship and improvement, but a whole territory. The strengthening of the link between a population, its Cultural Heritage (both material and immaterial) and its territory is the key to understanding the task of WP4 within the ATHENA project. As a matter of fact, this EU action includes five nations of the Mediterranean Basin (Jordan, Tunisia, Algeria, Spain and Italy), each one characterized by means of a different task. The IRP Team has to develop a Prototype Management Plan for one of the chosen theatres: Jarash South (Jordan) and its related cultural cluster (territory with its traditions and culture). The desired goal is to define a sustainable strategy that fits in with the different socio-economic conditions present in the sites, so that the most advanced practices can be shared in order to achieve better and more mindful use of the ancient theatres.

The ATHENA IRP team (AIT) gathered information about the problem of archaeological site management. In this regard, two complementary lines of investigation have been started: one references UNESCO sites in general, the other the use of ancient places of performance.

To the first category belong a great number of recent studies, most of them developed over the last ten years. Italy in particular was one of the most responsive nations in the implementation of UNESCO directives about the "Management Plan tool"; the reason can be considered the great number of Italian sites inscribed on the WHL and the need for coordination among different institutions that, in many cases, have overlapping competences on the same sites. A large amount of information is provided by PhD theses, conferences proceedings and web sites that demonstrates the interest of different institutions in disseminating the new integrated approach promoted by UNESCO after the Cairns conference and The Budapest Declaration adopted by the World Heritage Committee in 2002 during its 26th Session.

In compliance with UNESCO's requests concerning management plans, the Italian Ministry responsible for cultural heritage, the MiBAC (*Ministero per i Beni e le Attività Culturali*), founded a special office in 2004 for the implementation of the Convention for the Protection of the World Cultural and Natural Heritage; after one year of research the *"Progetto di definizione di un modello per la realizzazione dei Piani di Gestione dei siti UNESCO"* was published, a vast manual supplied with lots of examples developed by means of the collaboration of many Italian institutions and Ernst & Young Financial-Business Advisor S.p.A., one of the most important global professional services firm.

On the other hand, AIT developed a study on the theme of use and conservation of ancient theatres. The "Siracusa Charter for the conservation, fruition and management of the ancient theatrical architectures" is one of the most updated documents on the theme of theatres. It was promoted by the Sicilian Regional Councilor's office for Environment, Cultural Heritage and Education and the Regional Centre for Planning and Restoration as the final result of an international conference held at Syracuse between the 13th and 17th of October 2004 called *"La materia e i segni della storia"*.

The objective of the international meeting was to illustrate and develop planning practices, sustainable use and conservation of the ancient theatrical buildings of the Mediterranean Basin. Another aim of the conference was the sharing of the first results of a wider national project called *"Carta del Rischio"*. The "pilot project" presented at the conference was carried out by the Regional Centre for Planning and Restoration on the ancient theatrical system in Sicily, and in particular on the Greek-Roman Theatre in Taormina. Among the former related documents and studies about the use of theatres and, more generally, places of performance, can be listed the "Segesta Declaration" and the "Verona Charter".

The "Segesta Declaration" was subscribed at the end of a colloquium organized by the Council of Europe in September 1995, and concerns the protection and proper use of ancient places of performance, including theaters, amphitheaters, stadia, hippodromes, and arenas with origins in the Greek and Roman ages.

The "Verona Charter on the Use of Ancient Places of Performance", was adopted at the International Colloquy on New Technologies and Enhancement of Ancient Places of Performance, held in Verona during August 1997 and is the result of co-operation between the Council of Europe, the European Union and UNESCO. The charter is the product of experts who met within the framework of the MINOTEC Project, launched with the support of the European Union in association with various institutions from France, Greece, Italy and Spain.

The ATHENA project deals with a complex "scenario" formed of various categories of opportunities and problems that have to be organized and solved with the aim of creating a sustainable Management Plan

developed for those sites belonging to the project partnership: archaeological investigation, restoration, legal framework of the managerial practices, dissemination, cultural and economic development.

Within this project, the task of WP4 is the development of a managerial tool aimed at improving the general condition of a site in accordance with the concepts established by the most recent prescription by UNESCO, the Verona and Syracuse Charters and the Segesta Declaration. Each one of these last three documents underlines the need for integration between different countries by means of a theatre network in order for every archaeological site to be able to share common regulations about usage and conservation policies. In this regard, one of the final goals is more general in nature and relates to international neighbourhood policies because, through the activities needed for the development of a "Management Plan for Enhancement of New Actualities", it will be possible to deepen cultural relations and encourage political and economic reforms. This managerial structure is not meant to be a static document; instead, it is a flexible "manual" aimed at starting an integrated process within the cultural cluster of the theatre. The most updated concept of a Management Plan deals with putting into practice a self-sustaining process, one that is the product of the collaboration of various actors (local population, stakeholders, local institutions, etc.).

Theatre has always represented a symbol, a good omen, in the process of integration of cultures by means of art. This spirit inspired the ATHENA project, perhaps illuminated by the muse "Athena". We hope that it will also inspire those responsible for the management of ancient theaters in the Mediterranean Basin and help them in their efforts to enhance and adapt these theatres to new actualities.

FRANCISCO JUAN VIDAL
Assistant Manager of the IRP Team

ATHENA PROJECT
ANCIENT THEATRES ENHANCEMENT FOR NEW ACTUALITIES

PRELIMINARY ACTIVITIES

1. Preconceptions

The Management Plan ("MP") is intended as an "open" and "flexible" document that improves and strengthens the strong points of a WHL (World Heritage List) site. It has to be made in agreement with every segment of the population involved in the economic and cultural development (local and general authorities, stakeholders, institutions, etc.) with the aim of preserving the distinctive features of the cultural heritage. The MP also has to be made in such a way that the authorities can easily modify it in response to the feedback generated from the site after its implementation.

The MP improves and increases the data gathered for the conservation of a site and its surroundings: historical studies, urban planning, former restorations, property regime and so on.

The Athena Project focuses the actions of the MP on the development of ancient theatres by means of compatible usage criteria: ancient places for spectacles have a central role in the improvement of local economies inside the so called Cultural Cluster ("CC"), which is an area where conservation policies have to be coordinated in order to magnify the effectiveness of managerial practices.

The Athena Project has "vertical" and "horizontal" aims. The vertical ones concern single theatres that are supposed to adopt sustainable usage and conservation policies. The horizontal aims relate not just to the CC of every theatre, but are more challenging and general aims, as Management Plans have to be coordinated at the Euro-Mediterranean level. Athena MPs will promote the adoption of shared standards between the net of ancient theatres of the Mediterranean basin in order to develop common procedures, both for cultural-economic development as well as the safeguarding of these ancient structures.

In order to achieve the goals of this project, a Prototype Management Plan for the compatible use of ancient theatres has been developed. It does not deal with a Management Plan for theatres, because it is focused on a more specific topic: the management and coordination of all the uses to which ancient theatres are put, independently from the so-called intrinsic uses. The activities that form part of the ancient theatre uses are the following: "tourism, staging activities, educational activities, formal and ceremonial activities, cultural activities and local traditions."

The management plan of all the uses is split into three main parts. The first lays out a series of preliminary activities aimed at deepening the state of knowledge of the theatres. The second sets out the general fundamentals that should be followed for their sustainable usage. The third is split into two parts, one aimed at diagnostics, the other at proposals. This last part identifies a series of suggestions for the compatible use and conservation of each specific theatre.

In carrying out the first part, it is necessary to gather much information with the objective of understanding the theatre from many points of view. Furthermore, a chapter is included where Intrinsic Actions are defined: these essential actions should always form part of a classic Management Plan of an archaeological area, but not in the case of this Prototype because they do not directly affect the management of uses of either the theatre or the relative Cultural Cluster. The intrinsic actions deal with general topics such as knowledge, conservation, maintenance, the increase in value of the cultural heritage, dissemination and economic development.

The document that defines the fundamental aspects is called "GUIDELINES FOR COMPATIBLE UTILIZATION". The drafters of these recommendations used, as a reference, the international scientific literature on the themes of usage, tourism and conservation, which are clearly summarized in international charters and declarations. In particular, the Syracuse Charter, for the conservation, fruition and management of the ancient theatrical architectures; the Segesta Declaration, drawn up at the end of the conference *"Salvaguardia e uso dei teatri antichi"*, Segesta (Trapani, Palermo, 17-20 September 1995), and the Verona Charter on the Use of Ancient Places of Performance adopted at the International Colloquy held in Verona, August 1997. In addition, international standard have been included, being commonly accepted in relation to the management of the uses of such heritage (manuals, treatises, etc.). As well, the basic requirements for staging activities have been contemplated (stages, dressing rooms, ticket offices, parking, etc.).

Within the guidelines can also be found general suggestions and recommendations related to socio-economic development, the definition of the legal framework, and the identification of local traditions inside the Cultural Cluster, aspects that should be taken into account when formulating the action strategies of the Management Plan.

In the third part of the Prototype, there is a diagnostic tool for each specific theatre drawn from the case studies of the ATHENA project,

together with a proposal for how to act in each specific context. Considering the present state of the Project, the development of just one case study is foreseen, that of the Jerash theatre.

The basic document aimed at diagnosis is the ANCIENT THEATRE USAGE MANUAL. In carrying out the diagnosis, a series of data split into three sections is needed. The User's Profile defines the distinguishing characteristics of tourists, spectators, and every other category of party that makes use of the theatre. The Time Distribution, a detailed description of the timing of usage of the theatre for each activity, is aimed at detecting compatibilities and interferences among the contemporaneous uses. The Cultural Cluster Informative System gathers a detailed and exhaustive description of all the information concerning the theatre from the technical, economic, intangible and juridical points of view.

As mentioned before, the last part deals with different proposals aimed at obtaining compatibility between activities: these proposals are the Action Plans. Once the compatibilities and interferences among uses have been detected, a SWOT analysis is carried out to identify strengths/weaknesses and opportunities/threats. Finally, the objectives to be achieved are defined in order to make a final proposal for planning and evaluation.

1.1. DEFINITION AND ROLE OF THEATRE

Roman theatre was a real mass spectacle, dynamic, expressive and full of passions; all things considered, it was quite far removed from its Greek ancestor. Theatre formed part of a complex and widely spread iconography that still survives today, with all its creativity, within mosaics, frescos and potteries that once adorned villas, houses and public buildings of the Ancient Age, bearing testament to the social relevance of the *ludi scaenici*. Theatrical activities began, according to philological tradition, during the *ludi romani* of 240 BC, one of the main official festivals in Rome in honour of *Jupiter Optimus Maximus*. On that occasion, Livio Andronico translated an original Greek tragedy for Roman spectators. After him, many Latin authors, such as Tito Maccio Plauto and Publio Terenzio Afro, gained great success with their comedies, a genre that Romans enjoyed more than tragedy. But at the same time other authors, such as Seneca, Quinto Ennio and Marco Pacuvio, were also developing this literary genre in Rome with great success. Within the Latin cultural framework, other kinds of spectacles were also developed, converting theatres into multipurpose buildings where the staging of activities was not just limited to comedy and tragedy, since in Rome and many of the western provinces mime and pantomime enjoyed great success with the public. Over the centuries, and depending on the predilection of local populations, theatre as performing art and theatre as a building for spectacles developed in order to host *munera* (gladiatorial games) and *venationes* (hunting) or, for example, during the Severan dynasty, the popularity of *thetymine* (a kind of aquatic ballet) led to the necessity of reshaping the lower part of the bleachers.

Roman theatres, as with many other public buildings of that age, reflected the importance of social classes in their architectural features: for example, the *cavea*, the part of the theatre dedicated to the public, was horizontally divided into three sectors, and the *ima cavea*, the part closest to the stage or *pulpitum*, was reserved for the aristocratic equestrian order by law (the Lex Roscia Theatralis enacted in 87 BC assigned the first fourteen rows of seats in theatres to the equites). For this reason the first horizontal sector of the bleachers, the *maenianum imum*, generally has fourteen rows of seats. The physical and conceptual "core" of the theatre is a circular area used by the Greeks to host a group of performers called *khoros*; during the Hellenistic and Roman Age this area was progressively reduced because of the decreasing importance of the *khoros* in the performances. In Roman theatres this part is generally semi-circular and hosts seats of honour for the main authorities, the *proedria*.

The etymology of the word theatre comes from the Greek "theatron", which means "watching place", but later this term came to identify the whole building. As previously mentioned, Roman and Greek theatres played fundamental roles in the social and religious lives of ancient towns, but with different characteristics, both formal and cultural. One of the main differences of these places designed for "watching" was the stage building, the Hellenic *skené* or the Latin *Scaena*. This aspect developed from a simple veil supported by an ephemeral wooden structure to become a very complex building made of masonry walls and columns. In the case of Greek theatre, the *skené* never got as big as those of the Roman buildings where the aim of the architects was to close and isolate the building inside a single volume; on the contrary, in Greece and Asia theatre was more integrated with the territory, and the three parts forming the building (*cavea*, *scaena*, and orchestra) always kept their independence because the two lateral accesses to the orchestra, called *parodoi*, were open spaces in the majority of cases. The Roman *scaena* is "welded" to the rest of the building thanks to passages covered with barrel vaults (*cornificationes*) that led to the *aditus maximi*, the two lateral portals to the orchestra. FIGURA_PA_1.1_01

The *scaena* of the Roman theatre was a huge building formed by many parts that enclosed the stage, called the *pulpitum*: the *frons pulpiti* (or *proscaenium*) was the short facade toward the orchestra, while the *frons scaenae* with the *columnatio* was the idealized representation of an urban scenario (a road or a palace) with three doors (*valva regia* and the two lateral *hospitalia*) from

Main parts:
- Cavea (*Koilon-Theatron*)
- Orchestra
- Scaena (*Skenè*)

which actors entered onto the stage through the *versurae*. Other lateral rooms were the *paraskenia* and the *basilicae*, while the upper part of the stage was covered by a roof made of wood whose structure was wedged between the wall of the *frons scaenae* and the wall of the *postscaenium*.

Acoustic quality was one of the strong points of classical theatres, and in particular Roman ones, thanks to their high and closed stages that achieved, by means of architecture, a true "resonating chamber" whose sounds could freely propagate within the *cavea*. The Latin author Vitruvius gives detailed information about the design of the cavea in order to improve the sound propagation in accordance with the most updated physical knowledge of his age. In particular, he commented on a diagram from Aristoxenus of Tarentum that has not reached the modern age.

Vitruvius gave great importance to the theatre in his treatise, dedicating a great part of the fifth book to this typology. Only the temple was so thoroughly described in all its parts, while other important buildings for spectacles such as amphitheatres and circuses are not systematically mentioned. A possible explanation can be found by analysing the historical and cultural framework that characterized this time period, in other words, the birth of the Empire: among the various goals of Augustus' policy, theatre played a fundamental role because it was a distinctive feature of the *urbanitas* and a tool aiding the process of Romanisation.

At the end of the first century BC, Augustus promoted the construction of the greatest part of the theatrical buildings that now can be seen within the regions of the Mediterranean Basin, from Lusitania in the west to the Hellenistic towns at the eastern side of the empire - the Decapolis.

Over the centuries, Roman theatres underwent many restorations, enlargements and conversions, and in many cases the original Greek theatres were converted into Latin ones, while in some other cases, such as in Asia Minor, the two typologies coexisted until the Late Empire.

Ancient theatres represent a legacy for the whole Mediterranean Basin and Europe because they bear witness to how the creativity of ancient populations interpreted and modified the characteristics of a particular type of building, adapting it to their specific cultural and artistic needs.

DESIGN AND DIMENSIONING CRITERIA FOR THE INTERPRETATION OF THE ANCIENT THEATRE DEVELOPMENT PROCESS

Salvador Lara Ortega
Filippo Fantini
Instituto Universitario de Restauración del Patrimonio,
Universitat Politècnica de València
slara@cpa.upv.es
filippofantini@quipo.it

1) ABSTRACT

The Greek theatre was one of the most successful typology of the ancient age. Its Roman variation was exported in the whole Mediterranean Basin during the Republic and the Empire and then it was used as a constant reference for the architects of the Renaissance until the contemporary age. The evolution process of this type started in the sixth century BC until ending in the third century AD and was carried out in order to comply with a complex and heterogeneous cultural scenario: theatres were converted, enlarged and in many cases changed their shape with the aim of extending their usage to different kinds of spectacles.

In De Architectura, Vitruvius provided reading keys for the interpretation of the main aspects that characterized the design process of Latin theatre, but due to the intentionally theoretical nature of his treatise, he gave little information about practical aspects, focusing his text on more conceptual issues about the relation between acoustic and geometrical patterns. Measures and standards to adopt for calculating the capacity of the cavea are just briefly mentioned although they were the starting condition for launching the "algorithm" that led to the definition of the frons scaenae.

It is very difficult to apply these rules to the remains of ancient building with the aim of confirming Vitruvius' theories, but thanks to the synergy between architectural design techniques and ancient mathematical formulas, it is possible to glimpse the cause-effect relation that led architects to carry out variations and enlargements of theatres local propensity towards different kinds of spectacles and, last but not least, with laws and tastes of the Roman hegemonic class.

Circuses, the Roman development of Greek hippodromes, theatres, odeons, amphitheatres and stadiums all shared several aspects- functional, technological, constructive, and also cultural, as they played a fundamental role in religious festivals and civil ceremonies.

Ancient Typologies for spectacles (from Humphrey, 1986).

As theatres are spread all over the Mediterranean Basin, it was chosen as a representative urban sign of the Romanisation process, but other typologies developed from Greek prototypes, for example those related to sport, such as the stadium, did not achieved the same popularity and can be considered a more localized phenomenon (Greece, Asia Minor, and Microasia).

Amphitheatres are widely spread inside western provinces, but it is quite difficult to find them to the east of Greece because those countries never considered munera (gladiatorial games) and venationes (hunting) essential spectacles if compared to tragedy, comedy and athletic games.

Chariot races were a kind of entertainment that also had more fortune in eastern provinces and in many cases circuses were used as multipurpose buildings thanks to provisional arrangements, in many cases made of wood.

2) GREEK AND ROMAN TYPOLOGIES FOR SPECTACLE

The social significance of these buildings made theatres living architectures, constantly used and redesigned for the most heterogeneous reasons, pushing the flexibility of the original Greek prototype to the limit, as underlined by Gros (2001, p. 325-331).

This evolutionary process involved not just the theatre, but also other ancient buildings for spectacles that shared many common features with those original and homologous Greek typologies. Different factors caused morphological and dimensional variations on those architectures: in many cases they had to do with the presence of former buildings whose structures could be reused, but they also dealt with

The distinctive feature of Roman buildings in comparison to Greek prototypes is the conversion of open compositions (opened to the town, to the environment) into closed volumes. This tendency is attested to in many examples in Italy and provinces, but the theatre erected by Pompey in 55 BC in Rome, due to its significance, can be selected as the main witness of the Latin prototype (Moracchiello, Fontana 2009, p. 154).

Although based on Hellenistic examples, probably Mytilene and Alabanda, though similar features can be identified in the theatre of Teano, this building was the product of the originality of Roman architects: the cavea (the space reserved for the seats) is semicircular and directly "welded" to the scaena (the stage building) by means of vaulted spaces aimed at linking two lateral volumes of the frons scaenae, the basilicae. So the aditus maximi, the two accesses to the orchestra in the Latin theatre, become covered spaces unlike the parodoi of Greek typology. Moreover, Roman architects decided to exploit these parts by turning them into boxes of honour reserved for authorities.

3) VERIFICATION OF THE PATTERNS OF VITRUVIUS

The classic theatre is one of the most studied typologies of the ancient age. Amongst the reasons for this scientific interest, there is the detailed description made by Vitruvius in the fifth book of his treatise on the geometrical rules that lead to its planimetric definition.

The graphic pattern originated by an ordered sequence of passages based on circles and triangles, establishes a relation that mutually links orchestra and scaena (two of the three main parts of a theatre), but it is generally recognized that this graphic "algorithm" does not perfectly fit the majority of theatres that have undergone this kind of check.

This problem can be considered one of the main brainteasers for many architects and artists who, from the second half of the 15th century, wanted to illustrate Vitruvius's treatise[1], not just by means of drawings but with the surveys of what still remained of ancient theatres, in particular in Rome.

During the Renaissance, a new interest in theatrical buildings emerged due to the reuse project of the Theatre of Marcello in Rome, promoted by the Savelli Family, who commissioned Baldassarre Peruzzi to convert the ancient mediaeval fortress built on a part of the ancient theatre into a new palace, as reported by Sebastiano Serlio (Salvatore, 2007, p. 64).

Peruzzi used the occasion for testing whether or not the ancient ruins fit with Vitruvius' prescriptions, but the best results he achieved only regarded the modular structure of architectural orders, because the general planimetric composition gave unsatisfying results.

[1] *No drawings of the ancient architect's treatise reached the modern age, consequently generating confusion, and thus misunderstandings mark the work of many scholars until now, as perceptively highlighted by Salvatore (2007).*

The problem of architectural design of ancient theatres as explained by Vitruvius presents two basic ambiguities when trying to make theory (treatise) fit into practice (surveys): the first concerns the natural and constant development of theatrical Roman architectures from the II century BC to the III century AD in a complex and heterogeneous stage as the Roman Empire was; the second concerns the misinterpretation of the Latin author's text because, in many cases, it would have been necessary or advisable to have at their disposal the original graphic schemes mentioned in his work.

The final design achieved by Roman theatres cannot be explained merely as the product of a single design solution, but rather as the development of a sequence of successive designs aimed at managing the changes, adaptations, and extensions of theatrical structures carried out with the purpose of providing growing populations with more comfortable spaces.

The strict observance of Vitruvius' pattern produced no more than confusion and complexity until evidence was given that Roman architects never ceased to follow the directions of the Latin author. What happened was that architects began to use the original pattern more freely at the moment that they began to apply the geometric model not just to the design of new theatres, but also to their enlargements. What had seemed incomprehensible was a different use of the pattern that was concentric in comparison with the first design (Lara, 1992, p. 151-179).

Successive Vitruvius paths for enlargements of the Roman theatres. (Lara, 1992)

To arrange or extend theaters, the Romans used the same centre as used for the first implantation, but each time they wanted to increase the building capacity they chose larger diameters of the orchestra which, consequently, generated larger semicircular rings.

By means of this smart and practical solution, they achieved a concentric enlargement of the three parts of the cavea, and they

developed for each constructive phase a new semicircular outer ring while the core theatre underwent a reformation. Meanwhile, they pushed away the scenic building, extending it outward through the projection of the equilateral triangles inscribed in the circle of the Orchestra and absorbing former walls in the new frons scaenae which, arrangement after arrangement, achieved a more complex shape, built of different planes of walls which gave the architecture more depth, while the construction of new semicircular valvae decorated these vertical planes.

In this way, the Romans were able to increase the spectator capacity and, by extending concentrically the cavea, they moved the frons scaenae position and renewed it in order to modernize the decoration in order to adjust it to the tastes of the time. By doing this, they also reused all former theatrical structures. This has been shown in the theaters of Hispania, with special transparency in the one of Saguntum (Lara, 1991, p. 266-270).

Ostia Theatre: the analemmata walls can provide useful information in order to detect different phases of construction.

Vitruvius paths applied in successive reforms and enlargements of the Roman Theatre of Sagunto (Lara, 1991)

To give an example of how to detect the trails of these extensions, let's take into consideration the Ostia theatre. A clear reading of the development process can be carried out looking at the analemmata, the lateral walls of the cavea that led to the orchestra. Though heavily restored, they present a first constructive phase (first century BC) underlined by the use of opus reticulatum, while the main enlargement (end of second century AD) is made of opus latericium. Details like these can also be noticed in other buildings such as the analemmata of Sagunto theatre; in this case the construction technique is different and homogeneous (opus quadratum) for the first and second phases, but a vertical cut breaks the continuity of the wall bearing testament to the presence of additions.

Detail of the left analemmata of the theatre of Ostia: even though heavily restored during the 1830s, traces of the two different techniques are still visible and correspond to different phases of construction.

4) CDESIGN AND CAPACITY OF THE CAVEA

Even though chapters three to nine of the V book of De Architectura supply lots of information, and also considering the deep study carried out by scholars and researchers from the Renaissance to the contemporary age[2], there still seems to be missing a final word aimed at providing an exhaustive solution to the theatrical building as a whole.

In any case, casting a glance beyond Vitruvius' graphic pattern made of triangles inscribed inside a lower circle (perimetros imi), some interesting suggestions may come from another author, active at the end of the first century AD, Heron of Alexandria. During antiquity, his skill in the fields of applied mathematics, geometry and mechanics converted him into one of the most popular science communicators of the ancient word.

Heron is representative of a practical kind of knowledge, aimed at supplying numerical examples in place of theoretical demonstrations (as, for instance, in the works of Apollonius of Perga on Conics or Euclid's Elements): amongst his works, more manuals than treatises can be mentioned: Pneumatica, Automata, Mechanica, Metrica.

In the first fourteen years of the XIX century, the publishing house Teubner gathered inside five volumes of the series Bibliotheca Scriptorum Graecorum et Romanorum Teubneriana, the Heronis Alexandrini opera quae supersunt omnia[3] which contained all the texts from the Alexandrian scientist that reached our age.

Within the framework of this wide and heterogeneous set of writings on mathematical applications, two of them concern architectural construction: De mensuris and Stereometrica[4].

Theatre, amphitheatre and hippodrome are the three typologies that Heron briefly treated from the point of view of numerical calculation, for instance De mensuris 24, entitled "Measurement of theatres":

"We can measure a theatre in this way: if the larger perimeter of a theatre is equal to 100 feet and the smaller is 40 feet, we can know how many people fit into it. Calculate in the following way: the larger perimeter plus the smaller perimeter is equal to 100+40=140 feet, 1/2x140=70 feet. Count the rows (steps) of the theatre and we find

[2] Amnng the great quantity of researchers whose work can be considered very useful for clarifying the design process of ancient theatres, see: D. B. Small (1983, p. 55), F.B. Sear (1990, p. 376-382), S. Lara (1992, p.151-179).

[3] The copy consulted for this paper is the one belonging to the *Biblioteca del Dipartimento di Matematica* of the Università degli Studi di Ferrara. In particular the anastatic facsimile of the fifth volume of the original book edited in 1914: Heiberg, J. L., 1976, *Heronis Alexandrini, Opera quae supersunt omnia*, volumen V. , B. G. Taubner, Stuttgart.

[4] The authors of this article would like to record its gratitude to Paloma Musté Ferrero for collaborating in the translation of Heronis Alexandrini texts from German into Spanish

Graphic interpretation of the "Measurement of theatres" contained in De mensuris by Heron.

out they are 100; 100x70=7000 feet; this is the number of people that fit, 7000."

The paragraphs from 40 to 43 of the Stereometrica provide interesting examples related to the computation of theatre capacity; also the title of the chapter is indicative: "Different ways for calculating basins". The first example at paragraph 42 is quite similar to Metrica 24:

"A theatre whose external circumference is equal to 420 feet and the internal is 180 feet is provided with 280 rows of seats; if we want to determine the capacity of spectators it should be done like this: the external circumference plus the internal circumference is equal to 420+180=600 feet; 600/2=300; the number 300 multiplied by the number of rows, that is 280, leads to 300x280=84000 spectators; because each foot corresponds to a person. In the case we had on the whole 600 feet, we divide them in two, in order to obtain the average. 1/2x600=300. If we have 50 rows: 50x300=15000 feet. This is the number of people that fit because the space for a person is equal to the width of a foot."

Graphic interpretation of the "Different way for calculating basins" contained in Stereometrica by Heron.

Paragraph 43 supplies another two examples about the capacity of theatres:

"In another theatre, with 250 steps, the first row contains 40 people and the last row of bleachers 120 people. To calculate the total number of people you must do the following: make the sum of the first step and the last, which is 160 people, and divide by two: 160/2=80; 80x250=20000 people. This is the capacity of the theatre".

Graphic interpretation of another example from Stereometrica: Heron provided many similar examples of calculation, but he did not give any formulas, his work being a manual more than a theoretical treatise.

There is also an example of an arithmetic progression, as underlined by Heiberg (1976, p.161) aimed at calculating the number of spectators at a certain height of the cavea:

"If you want to know how many people the last step of a theatre contains in which we know that starting from the first step we have a steady increase equal to 5 spectators, the first step contains 40 people and the theatre is made up of a total of 250 steps, then do the following: 250 steps minus 1 is equal to 249 steps, 249x5 = 1245+40 of the first step. 1285 is the number of people that the last step contains."

A great part of the examples from Stereometrica are based on simple circle squaring algorithms aimed at calculating the capacity of the building, but there are also other formulas on capacity that allow the architect to calculate the number of spectators at a certain row of seats.

As a first general statement on these relevant formulas for the design of caveas, we can say that Heron basically applies the same methodology in the two books: he explains by means of numerical examples the special cases of the squaring of circles.

The measures, in particular the depth of the seats, are totally out of reality as they range from 5.6 cm to few millimetres; it is evident that Heron's purpose is another; rather than providing standards he supplies examples of cavea physical dimensioning in relation to the capacity, i.e. to the number of spectators. The same statement regards the width of the seats of the locus, which he gives as equal to a foot: 29.56 cm. This measure seems to be used inside these formulas just in order to simplify the computation.

Like Vitruvius, he does not talk of an orchestra's circle but just talks about the two semi perimeters that bound a sector of the cavea (or the whole cavea), but he puts in evidence the importance of how to subdivide the analemmata; basically the semi-annular ring is converted into a linear surface whose sides are the analemmata and the average between the two half-circle, even though the density of the seats seems to be the scalar quantity that Heron uses in his formulas, because

the length of the analemmata never appears as a physical measure. When drawing the examples, it is possible to notice the presence of a common module, a greatest common divisor of the cavea that starts from the perimetros imi (or the orchestra boundary) and arrives at the upper praecintio.

De Mensuris and Stereometrica provide relevant information, not contained in De Architectura, that allows for the investigation of theatre design from the point of view of ancient requirements and, moreover, the two technical manuals provide the reading key for other investigations: amongst them can be mentioned a marble model of a rare shaped amphitheatre found at the Villa Adriana during the restorations carried out between 1964 and 1972 (Fantini, 2009).

The model represents a building characterized by three main parts: the arena, the bleachers and a rectangular room whose function was not clearly identified. The building presents a module repeated in the whole composition; moreover the same slab of Carraca's marble used for the model is the scale representation of a standard measure used by Romans for partition and assignment of territories, the jugerum.

These two elements, the module and the identification of a standard measure for areas, led to a possible scale of the model: 1:40. Once this relevant data was obtained, it was possible to compare the areas of the rows of seats (the two linear ones and the curved one) in the hypothetical to the real construction and the result was that each area was equal to the standard measure called clima, the fourth part of the actus.

Schematic map with modular structure of the marble model of a building for performances found at Hadrian's Villa.

The Roman standard areas were used for the partition and assignment of territories, but they can also be detected within the maps of ancient buildings, for example in the cavea. In this model it is quite clear that the lesson from Heron is present both for the modular structure and for the squaring of the circle that clearly appears in the linear part followed by the curved one.

BIBLIOGRAPHY

Azara, P. (editor), "Las casas del alma, maquetas arquitectónicas de la Antigüedad (5500 a.C./300 d.C.)", Institut d'Editions de la Diputació de Barcellona y Centre de la Cultura Contemporània de Barcelona,1997.

Bartoli, M.T., "Le ragioni geometriche del segno architettonico", Alinea, Firenze, 1997.

Bartoli, M.T., "Ichnographia, orthographia, Scaenographia". Studi e documenti di Architettura, n°8, Edizione della Cattedra di Composizione Architettonica I A, Firenze, 1978.

Boyer, C. B., "Storia della Matematica", Mondadori, Milano, 1980.

Colini, A. M., "Stadium Domitani", Ristampa anastatica con aggiornamenti", Ed. Quasar, Roma, 1998.

Docci, M., "La forma del Colosseo: dieci anni di ricerche. Il dialogo con i gromatici romani". Disegnare idée immagini, n.18/19, Gangemi, Roma, 1998.

Fantini, F., Ph.D thesis "Il modello di stadio da Villa Adriana, indagine su un progetto incompiuto", 2008.

Gros, P., "L'architettura Romana, dagli inizi del III secolo a.C. alla fine dell'Alto Impero", Longanesi, Milano, 2001.

Heiberg, J. L., "Heronis Alexandrini, Opera quae supersunt omnia, volumen V", B. G. Taubner, Stuttgart. 1976.

Humphrey, H., J., "Roman circuses, arenas for chariot Racing", University Press of California, Berkeley/Los Angeles, 1986.

Lara Ortega, S., "El Trazado Vitruviano como mecanismo abierto de implantación y ampliación de los Teatros Romanos", Archivo Español de Arqueología n° 165-166 CSIC, Madrid, 1992.

Lara Ortega, S., "El Teatro Romano de Sagunto: Génesis y Construcción" Universidad Politécnica. Valencia, 1991.

Salvatore, M., "Le geometrie del Teatro Latino di Vitruvio, Interpretazioni e sviluppi nella trattatistica rinascimentale", In Mandelli, Emma (editor), "Dalla didattica alla ricerca, esperienze di studio nell'ambito del dottorato, Alinea, Firenze, 2007.

Silvia, "I loca del Colosseo", in La Regina, Adriano (editor), "Sangue e Arena", Electa, Milano. p. 89-103, 2001.

Vitruvio M. P., "De Architectura", Einaudi, Torino, 1997.

ATTACHMENTS 1

A.1.1	Spain theatres: Identification (Digital version)	
A.1.2	Spain theatres: Athena evaluation (Digital version)	
A.1.3	Spain theatres: Reference (Digital version)	
A.1.4	Spain frame: State of the Art (Digital version)	
A.1.5	Spain frame: Legal (Digital version)	
A.1.6	Spain frame: Restoration (Digital version)	
A.1.7	Spain frame: Best Practices, Segobriga theater (Digital version)	

2. Basic Information

2.1 RESPONSIBLE AGENCY FOR DEVELOPMENT AND IMPLEMENTATION OF MP

The first step is to draw up a document in which will be described and individuated the institution responsible for the creation and implementation of the MP. In this legal paper must be identified: the legal form (company limited by guarantee with a share capital, public agency, consortium, foundation, local special agency, convention between local agencies, etc.) the statute, regulations, organization conditions (organization chart, responsibilities, managing functions, involved staff, etc.) further possible available tools

The tools to be used in this phase are interviews and meetings between the involved companies (local and general institutional level responsible for guardianship of cultural heritage, landscape, museums, and private public companies for the managing of the sites).

The table below could be a possible example to gather the necessary documentation in this chapter. It is completed with Jarash information.

Case of Jarash

The table below could be a possible example to gather the necessary documentation in this chapter. It is completed with Jarash information.

TERRITORIAL UNIT	RESPONSIBLE INSTITUTION	RESPONSIBLE MANAGER	DESCRIPTION OF THE INSTITUTION	CONTACT
Jarash Territory	Ministry of Tourism and Antiquities – Jarash Tourism Office	Mr. Khaled Shboul	MOTA is responsible for the development and promotion of publicly owned tourism sites. It also oversees regulation of the tourism sector, encouraging tourism-related investment, preparing studies and research for tourism development and growth, and enhancing the country's tourism workforce. The director of tourism for Jarash governorate, a MOTA employee, has an office at the visitor centre on the site of Jarash. This individual coordinates MOTA's responsibilities with respect to tourism at the site, including concessions, tour guides, the visitor centre, parking, and health and safety issues. Moreover, MOTA has been instrumental in the development of the tourism services infrastructure at Jarash, such as parking for vehicles and the handicraft centre.	+962 2 6351053
Jarash Territory	Ministry of Tourism and Antiquities – Jarash Antiquities Office	Mr. Ahmad Alshami	The DoA office at Jarash is charged with enforcing the Law of Antiquities at the site as well as in the rest of the governorate. It also enforces the DoA's "Instructions for Holding Activities at Archaeological Sites." Generally, any activities undertaken within the DoA-owned site should be carried out with permission of the DoA. DoA staff at Jarash are involved in raising public awareness through outreach to schools and through the site museum.	+962 2 6351014

Jarash data.

LEGAL FIGURES FOR THE MANAGEMENT OF THE PROPERTY: THE FOUNDATION AND THE CONSORTIUM

María Emilia Casar Furio
María Jesus Romero Aloy
Professor University School. Town Planning Department,
Universitat Politècnica de València.
macafu@urb.upv.es
maroal1@urb.upv.es

SUMMARY:

I. INTRODUCTION. II. LEGAL FRAMEWORK FOR MANAGEMENT OF PROPERTY ASSETS. II.-1. THE CONSORTIUM. II.-2. FOUNDATION. III.- STRENGTHS AND WEAKNESSES OF FIGURES PROPOSALS. III. - 1. POSSIBLE ADVANTAGES. III. - 2. NEGATIVES. IV. - CONCLUSIONS.

ABSTRACT:

Legal recommendations aimed at the economic, technical and administrative between local, state administrations and the private sector. Trust and foundations as figures suggested. Usefulness of these figures to coordinate the interests and criteria of different administrations in heritage management.

I. INTRODUCTION

Today, the concept of heritage goes beyond being considered as a set of protected items of artistic, historical and cultural significance, to being understood as a substantial holder of dynamism that can aid in the development of cities and regions.

This article explains the most appropriate legal forms for asset management of heritage properties, thus understood, committed to their protection and to enhancing their economic and social development, thereby redefining or recreating the image of the city and setting it as the hallmark of same.

Most cultural heritage is managed by the government directly or indirectly. Increasingly, decentralization has been occurring for foundations, public joint ventures, trusts and partnerships. In this way, a greater elasticity in the management policy is obtained.

Consequently, at this time, many local authorities play a fundamental role in the interrelations with other administrations, civil society organizations, private companies, partnerships, etc. in order to obtain funding for the conservation and use of heritage, making it turn a profit that is based on tourism. Thus, these new management initiatives are overseen by government through the legal concepts of the foundation and the consortium as specific models of heritage management for those towns with a rich urban heritage.

Our goal is to demonstrate the usefulness of the legal concepts that are proposed to coordinate the interests and criteria of different administrations in heritage management. They obtain an organization that allows for heritage conservation and enhancement, on one hand, while also making use of its value for other social and economic purposes, through protection and management models that are more flexible than those established by the legal framework governing the formally declared cultural property. New links between cultural heritage and economy by creating alternative frameworks and reference study measured through various indicators, the relationship between them.

Promote cooperation among multiple agents that shaped the various actions taken around cultural property, establishing linkages with the private sector and giving it a fundamental role in managing them.

Encourage citizen participation, social cohesion and the integration of most disadvantaged groups in the processes of interpretation and implementation heritage value.

Identify new heritage resources and take full advantage of the diversity of heritage through programs and plans involving both effective protection as its economic and cultural.

Enter in the dissemination and management of cultural heritage and new consumer trends in society, which is based largely on the use of tools, such as new technologies.

II. LEGAL FRAMEWORK FOR PROPERTY MANAGEMENT HERITAGE

The Athens Charter of 1931[1] states that the best guarantee for the preservation of monuments and works of art is the appreciation and respect of the people, and the knowledge and understanding of the significance of this heritage by society.

So, you will depart regardless of intended use, it is necessary to strike a balance that must be sought between maintaining this important legacy and your enjoyment of culture.

Moreover, currently cited as a quality sustainability inevitably associated economic and social development in those processes compatible with memory utilization and the cultural values. And yes you can say that every monument or archaeological remains that can receive current use will, with better security, preservation and guaranteed, which is sometimes more difficult, their maintenance and care.

1 Point X of the Charter of Athens 1931.

The economic, technical and administrative management of heritage between the various administrations[2], both in local services and in matters of common interest, will be developed on a voluntary basis, in the forms and in the manner provided for in the laws, can take place, in any case, through consortia or sign administrative agreements, taking place this legal in the topic at hand.

Consequently, it is considered necessary by local management to determine, through the established legal concepts that purpose, the guidelines encourage the development and balance of heritage in its territory, improving retention, preservation and possible uses.

Together with local authorities and other public authorities with powers conferred on heritage, would also be advisable to participate in this task from the private sector, too, through foundations, in order to begin the road to a correct exploitation of historical and artistic heritage through new forms of management and use of the same.

THE CONSORTIUM

Understood as corporations instrumental consortia formed by local entities with other public authorities for purposes of common interest, or private non-profit organizations that pursue public interest concurrent with the Public Administration. They are endowed with legal personality and full legal capacity and cost, created under local law or special act.

Consequently, the consortium may become as follows:

a) public administrative Consortia: conceived as a public institution owned by the Government Administration and other government composed. The difference with other public administrations is associative to its formula includes various government aimed governance of their common interests.

In our case, it would be a partnership between the administrations of various kinds with competence in the field of heritage protection in order to unite common interests between them by way of inter-administrative cooperation.

b) private administrative Consortia: formed by private non-profit public interest purposes concurrent with the public administration.

As the law of trusts, in general, is governed by its own statutes, which are ultimately the very law of the consortium. In order to properly define its characteristics, is required reading for each of the statutes established, since under the same formula consortium are distinct legal entitlements. The charter is the document that will identify the purposes and the particularities of the organic system, functional and financial consortium[3].

The government depends on its consortia General Meeting and / or its Board of Governors, whose members represent the various associated entities, in accordance with ratios set forth in its charter, which generally represent the degree of asset contribution of its members and delimiting the respective powers or any other peculiarity derived from the specificity of public service that is managed.

It is considered as the first proposal for this study, the possible creation of a Consortium entity treated as public law and legal personality for the management of all assets. The consortium would consist of different departments or areas that assume different functions for the proper management of the heritage and environment such as administration, research, documentation and library, conservation and restoration, and dissemination.

All these features make up a common program with the primary objective of creating a management model aimed at the protection of heritage and environment, supported both by the administration and by the participation, by contributions from companies and groups through patronage, etc. .

In line with the foregoing, disclosed several noteworthy examples for good results. Can not ignore the Consortium of Toledo and his Royal Trust to manage the assets. Following the Special Plan of Toledo Historical gives this city a sufficient administrative and technical tool to perform the tasks necessary urgent conservation and rehabilitation[4].

To strengthen and enhance their chances of cultural and tourism development, should form a Royal Patronage to facilitate the promotion

2. More specifically in Spain, local government is the set of territorial government of managing municipalities and provinces. The Spanish Constitution of 1978 established a State Title VIII organized territorially autonomous regions, provinces and municipalities. Each of these entities has autonomy in the management of their respective interests.

3. Minimum content of the Statute:
 1. General provisions (type and name of the consortium, constitution, purpose, applicable regulations, powers and prerogatives, home)
 2. Organic Regime (administrative, full, commission president, vice president, Special Accounts Committee, manager, responsibilities of each organ).
 3. Regime functional (performance, voting agreements and arrangements).
 4. financial System
 5. Personal service consortium
 6. other provisions

4. Also arise as legal supplements, the Special Plan Ordinance historic center of Toledo of September 17, 1998, and the Municipal Ordinance regulating aid to rehabilitation of buildings and homes running special plan of historic Toledo July 24, 2001. The Consortium of the City of Toledo is governed by Act 7 of 1985, dated April 2, regulating the Bases of Local Government, by Act 30 of 1992, dated November 26, amended by Act 4 of 1999, January 13th, on the Legal and Public Administrations and the Common Administrative Procedure, by the provisions of its statutes, internal regulations issued by developing them and, additionally, in the specific legislation applicable to him.

and coordination of activities involving state agencies, regional and local authorities directly linked.

And, as the purposes and powers of Royal Board has established the following that could form the basis for establishing the proposed consortium:

- Promote the implementation of works, services and facilities in general, and the construction and development of transport and communications.
- Promote the coordination of investments are planned by the government.
- To promote cultural initiatives and projects aimed at the conservation of historical heritage and the enhancement of the city as a meeting place.

Meanwhile, another example would be the reference of the Alhambra, an independent body responsible for the management of the monuments of the Alhambra and the Generalife of Granada. It has legal personality and is attached to the Ministry of Culture of the Junta de Andalucía.

The powers of the Board of the Alhambra are the conservation, distribution and custody of the monumental, the visitor access management, project development and research[5].

Continuing with the legal concept of the Consortium, point out the case of Segóbriga Archaeological Park[6], but not before indicating that it is a consortium with majority of the Castilla-La Mancha, although recently, in 2011[7], is chosen by public-private management[8].

c) The Foundation: In the field of historic preservation, whose security and protection is entrusted to public authorities, private participation should be done through close coordination with relevant cultural administration, under the principle of subsidiarity and its supervision.

The legal concept of the proposed Foundation, together with the previously studied the Consortium, as a management model of the assets based on a partnership between government and private owners in order to contribute to the conservation, management and promotion of heritage artistic and archaeological.

A foundation is an organization formed nonprofit, which has affected a lasting heritage for the realization of general interest. In Spain, the figure of the foundation, not only has a basic law to regulate it, but along with other state law[9] coexist regional character as the territorial scope of the foundation is exclusively regional, in which case The applicable law is only the autonomous community itself[10].

For the establishment of a foundation must be from a low initial endowment adequate foundation for the fulfillment of the foundational that will see increased over the life of the foundation.

Usually, by the time establishing a foundation, in addition to the constitution made before a notary, to proceed to registration in the Register of Foundations for your own legal personality, as well as requesting recognition Directors for approval, provided certifying that the ends are going to pursue the public interest. Since then, the Administration held control of the activity of the foundation through a body called the Protectorate, which you must file annual accounts, report possible disposal of assets of the foundation, amendments to their statutes, etc.

The Board is the only body representing government and a foundation, whose members are called patrons. The minimum composition is three employers who, in turn, can be natural or legal persons, public

5 The Council of the Alhambra and the Generalife, as the institution responsible, provides the search for new ideas and ways of conservation and restoration in its diverse range of assets, in order to establish the theoretical and operational should guide for commissioning conservation practice professionalized, coordinated and effective. "The restoration program develops its interventions with preventive conservation strategy and executive. Meanwhile, in the Archaeology program develops important research work which has remarkable fruit in recent years. Finally the protection, management and sustainable landscape management and conservation of ecosystems and natural habitats is provided by programs Forests, gardens and orchards and Biodiversity Programme "Conservation Area. http://www.alhambra-patronato.es/index.php/Area-de-Conservacion/7/0/ (accessed 10/05/2012).

6 Segóbriga Saelices locality (Cuenca), represents one of the most significant archaeological sites in the Iberian Peninsula. It was the control center for mining marketing. We must emphasize the importance of its geographical location as a place of passage of several roads, which united with Complutum Carthage and its connection with Toletum and Segontia. It reached its peak between the ages I and III d. C., becoming a communications hub city, agricultural and mining center and administrative capital of a vast territory until its gradual abandonment after the Islamic conquest. www.patrimoniohistoricoclm.es/parque-arqueologico-de-segobriga/el-yacimiento/ (accessed 10/06/2012).

7 Decree 99/2002, of July 9, established as a way of managing the Consortium constituted entities that pursue common interest, but for reasons quite economic and Decree 239/2010 provides for the dissolution before 18/03/2011, from the archaeological park to be managed by the Culture and Sport Foundation Castilla-La Mancha.

8 Formal review final report of the accounts of the consortia participated mainly by the Regional Government of Castilla-La Mancha, 2010. Posted in DOCM No. 33 of 04.26.2012. Section 4 Conclusions, Report on the Archaeological Park Segóbriga.

9 Law 50/2002 of 26 December on Foundations.

10 The Autonomous Communities of Andalusia, Canary Islands, Castile and Leon, Catalonia, Galicia, La Rioja, Madrid, Navarre, the Basque Country and Valencia have their own laws on the matter.

and private. His appointment is made in the deed of foundation by the founder or founders of it.

In this sense, it is a magnificent example of the Heritage Foundation of Castilla and Leon[11], cooperation between government and the private sector, whose statutes basic aim of its activity's contribution to the restoration of the goods under the Cultural Heritage community in question, and to facilitate and disseminate knowledge, being the direct beneficiary society[12].

The functions of the Board meet the foundational and diligently manage the assets and rights that comprise the assets of the foundation. To complement this, depending on the functions undertaken by the foundation, it is recommended the appointment of an address and a technical and administrative team to manage the daily work always managed to recover and revalue property protected.

The foundation, in addition to equity, if available, can make possible effective patronage of entities that support and seek the involvement through agreements with other companies, groups, foundations and government, to add resources for conservation, restoration and dissemination of heritage. All aimed to achieve a primary objective which is the efficient allocation of resources, managing them efficiently to generate the highest possible return. Thus, the Foundation must assume the primary role of protected heritage recovery and its environment in all its aspects and, likewise, make it known to come to a sense of attachment to the citizens regarding it as a necessary element for right direction.

In the Spanish context also deserves special mention for the purpose, the Foundation of Light of the Images. The Valencian Community Foundation Light of the Images, created in 1999 at the initiative of the Government, aims recovery, intervention and dissemination of historical and artistic heritage of Valencia[13].

The Valencian Community Foundation, The Light of the Images, is a non-profit organization that is funded mostly by the Generalitat Valenciana. Foundation fulfills three requirements is legal to be well considered, that is, is legally separate (own foundation), is designed to meet the needs of a general nature and not industrial or commercial and finally, is funded mostly by the government. However, the contracts concluded by the Foundation are considered private contracts[14], and the preparation and award of contracts that celebrates the Foundation are governed by the Consolidated Law on public sector contracts, and its implementing instructions internal hiring, apply in a supplementary remaining administrative law, or where applicable, the rules of private law. In terms of its effects and extinction, these contracts are governed by private law.

III.-STRENGTHS AND WEAKNESSES OF FIGURES PROPOSALS

In the following lines synthesize the advantages and disadvantages that were noted in the study of the different figures studied and exposed under which they could carry out asset management of the property.

III. - 1. Possible advantages

In general and with respect to the legal concept of the consortium intends to manage real object, start from the consideration of it as an agreement between several participants whose main objective is to develop an economic activity that will result in returns for every one.

The consortium operates with a joint program with the primary objective of creating a management model aimed at the protection of heritage and environment, therefore, it is management involved in various public and / or private companies that pool their aims to achieve the same end. Therefore, it is understood the advantage of coordination between them based on a single legal concept, as is the consortium, avoiding uncoordinated intervention by several administrations in the same.

Consortia pose advantages as enhance and supplement companies offer individual, costs and expenses are shared and thus more affordable. Imply easier when obtaining financial resources, in short, this legal form of management:

a) It would mean a way to supplement and increase the supply of individual firms

11 Recognized and registered as non-profit Foundation in the Register of Cultural and Educational Foundation of the Ministry of Education and Culture (04/01/1997). Founded by the President of the Junta de Castilla y León and six savings banks in the Community, also represented by their presidents, and with two governing bodies: the board of trustees and the executive committee, to be added on the advisory board, as a body of scientific expertise of the board and of the executive committee on heritage restoration proposals submitted to the Foundation (statutory modification 28.04.2005, 06.25.2005 to appoint board members, respectively). ALVAREZ VEGA, Ramon. Heritage Magazine. Management. Experiences. "Heritage Foundation of Castile and Leon. 11 years of hard work. "e-rph December 2008. Biannual Journal. Pp. 1-10.

12 The Foundation created the Board of Friends of Heritage, and currently has 3,000 members and over 200 associates. However, the Foundation does not only effective patronage of institutions which support it, but also looks for other implications of companies, groups, foundations, or government, implying an increase in resources for the conservation, restoration and dissemination of Community cultural approach. VEGA ALVAREZ, R. Op. Pp. 5-6.

13 The exhibitions held, in which the goods have shown restored, have been visited by more than 3.500.000personas (accessed on 10.08.2012)

14 Article 20.1 of the Consolidated Law on Public Sector Contracts.

b) also reported that costs and expenses are shared, which means greater affordability

c) Similarly, it is easier to achieve financial

d) The consortium is an auxiliary body only defends the interests of members

e) It would lead to significant support from both state government and autonomous.

On the other hand, the main advantages of a foundation of public utility are fiscal, since it can be placed under more favorable tax provisions of the Law of taxation of non-profit entities and tax incentives patronage, this eminently incentive for a purpose of the collaboration particularly in achieving the objectives of general interest pursued by the foundation in care and increasing recognition of the presence of the private sector in the task of protecting and promoting actions characterized by absence of profit, whose sole purpose is general in nature and public.

Foundations also improve the public image of the "brand" created, which can allow them to receive income as donations and grants and carry out activities in accordance with its purposes without paying taxes, rent to own properties exempt income, etc..

It remains to add that the companies have signed cooperation agreements with the beneficiary institutions of patronage, assuming costs of activities directly or collaborating on events of public interest, shall provide the benefits of tax incentives, to be entitled to tax deductions in the corresponding.

III.-2. – Negative aspects

As regards the consortium:

a) Feeling of loss of control, real or subjective, about the processes running in a cooperative manner.

b) Delays in some work schedules of activities together

c) Difficulty in harmonizing the different rhythms of work and service levels

d) To address the requirements of good communication, so extreme increase in a cooperative work environment.

In relation to the Foundation or Patronage:

As for the disadvantages, it is clear that the benefit of these tax concessions has a number of obligations that are not required, or only in certain circumstances, to other associations. Accordingly, institutions declared of public utility are obliged to account annually. They come obliged to provide reports that will require public authorities in relation to the purposes and activities of charitable organizations.

IV. – CONCLUSIONS

In addition, the consortium allows inter-administrative coordination, management generally in places with heritage value lies with the council and have authority financing the state in its various national, regional, provincial and municipal.

Political bodies and technical bodies are coexisting in the figure of the consortium or foundation, that through multi-annual plans are responsible for managing the site. Being civil associations have articles of incorporation and are governed by a regulation as well there is an agreement for the creation of the Foundation Consortium or where the parties undertake explaining the economic base that supports the structure[15].

Consortia must serve the basic purpose of administrative support and a heritage site management, coordinating administrative skills for decision-making. Now, the consortium is an executive body of greater flexibility and choice while a foundation is advisory, advising on specific issues.

Consortia must also ensure proper maintenance and management of facilities, equipment and services in the heritage area.

While in both cases as is the Spanish examples are shown in this proposal, are successful wealth management models worthy of being taken into account by the different administrations managing heritage sites rated. Local authorities, communities and stakeholders should be involved as much as possible to maximize, in a shared agreement on the principles and actions.

BIBLIOGRAPHY

Abad Liceras, J. Mª.: "Local and Heritage". Ed Montecorvo, Inc. Madrid, 2003.

Alvarez Vega, Ramon. Heritage Magazine. Management. Experiences. "Heritage Foundation of Castile and Leon. 11 years of hard work." e-rph December 2008. Biannual Journal. Pp. 1-10.

Martin Mateo, R. "The local consortia. An institution on the rise". Public Administration Review, n. # 129, 1992, p. 7 to 18.

Nieto Garrido, E. "The Consortium as an instrument of administrative cooperation." Journal for the Study of Local Government and Regional n. # 270, 1996, p. 327-361.

Rebollo Puig, M. "Creating and legal system of the consortia, (procedure, statutes and constitution)", in VV.AA. Study Session on local consortia, Ed CEMCI-AS, 1995, p. 151 to 194.

Vilte, Silvia. Gomez Borja, M., López Sanz, G. Research methods and analysis of tourism. "The models in World Heritage cities: a comparative study between Spain and northern Argentina." University of Castilla La Mancha, 2010. Pp. 173-184.

15 Vilte, Silvia. Borja Gómez, M., López Sanz, Gregory. Research methods and analysis of tourism. "The models in World Heritage cities: a comparative study between Spain and northern Argentina." University of Castilla La Mancha, 2010. Pp. 173-184.

2.2. IDENTIFICATION OF THE SITE AND CC.

For "Site" we identify the perimeter of the archaeological area that contains the theatre, while for "Reference Area" we identify the perimeter of the CC; therefore the CC can overlap with the perimeter of the Site or not; it depends on the location of the archaeological area context: urban location, country, isolated, still under excavation, etc.

Here then are the criteria that should be considered when defining the physical definition of the Site and Reference Area:

Cultural Criteria:

One must know the quantity, the quality and, in particular, the capability of integration of every single cultural heritage located in the area to manage and its surrounding territory. The aim is to define territorial unities that can be inserted in the Reference Area that must be intended as a net: every node has a specific heritage (material, immaterial) and a specific link strength. The stronger the links are, the more the Reference Area perimeter will be correctly drawn on the territory.

Urban Criteria:

When talking about urban criteria, we mean the features related to the historical development as well as the functional and morphological evolution of the town and territory where the ancient theatre is located. The perimeter of the CC will be the product of deep analysis, done with the aim of keeping together, while drawing that area, many aspects related to the structure of the town such as road axis, squares, distinguishing monuments and archaeological finds, and special buildings such as museums and cultural centres, etc. The CC will be "articulated" and "drawn" by means of organic criteria because we do not just have to take into consideration administrative and jurisdictional perimeters.

Geographic and Physical Criteria:

Morphology, extension of the visual field, accessibility, receptiveness, infrastructure facility, structures for the culture and the leisure time, can unite different territorial unities inside the Reference Area.

Administrative Criteria:

Different territorial unities involved in the management plan could be part of different administrative institutions (local, regional, state level); moreover, these unities can be involved, at a superior level, in projects of development. In such cases the boundaries of the Reference Area is given by the sum of all these administrative boundaries related to various institutions.

Social Criteria:

It is possible that the definition of the Reference Area should take in consideration the presence of a peculiar social and cultural condition that a community could have in common. So, the boundaries of the management plan should be stretched out to a larger territory to which those communities belong in order to save those "immaterial capitals".

Economic Criteria:

The economic aspects, the productive structures, the location and spreading of firms and stakeholders, the professionalisms and the available competences, the presence of industrial districts, can create a net among different territorial unities, defining new and more extended boundaries of the Reference Area.

Graphic documentation aimed at defining the site and the CC:

For the definition of the archaeological ensemble and Cultural Cluster, multi-scale information has been provided about the "organic area" the Management Plan is interested in, from the regional level to the architectural drawings of the main archaeologies.

Case of Jarash

GRAPHIC DOCUMENTATION NEEDED FOR THE DEFINITION OF THE SITE AND CC

The Ancient city of Jarash

Jarash is one of the major cities of northern Jordan. It is located about 40km north of the capital, Amman. Jarash has been inhabited since the Neolithic Period, but the city's prosperity was mainly achieved during the Roman Period.

In fact, the year 63 BC was a time of change in the history of Jarash. It was annexed to the Roman provinces of Syria by the Roman general Pompeii and began to attain its importance and recognition. In AD 90 Jarash became part of the Roman province of Arabia. In AD 106 the emperor Trajan annexed Petra, the city of the Nabataeans in the south of Jordan and roads were built from north to south and from east to west. Most of the cities within the vicinity of the trade routes flourished.

During the visit of Hadrian in AD 129-130 the city became the focal point of the Roman "Provincia of Arabia" and in this era many of the city's building were constructed. After that, Jarash was abandoned after the violent earthquake in AD 749 that destroyed most of the city. The city was later occupied in 1879 by a group of people who migrated from north Caucasian called the Circassians. These people marked the beginning of the advent of the new city of Jarash.

The geographical features and the geological formations in Jarash are evident factors in the inspirational aspect of land use and modification to produce the built environment of Jarash. In addition, the most dynamic component - the river Chrysorhoas - gave the Romans at that time the thread to visualize the land resources in a different scope, oriented towards integrity between nature and the human made additions, guided by their own ideology and concepts of urbanism.

Of importance amongst the geographical factors is that the river Chrysorhoas existed as a spinal dynamic physical component bisecting the land into two distinctive areas of different topographical features, east and west.

The Romans finest example in the manifestation and application of the concepts of landscape architecture and urban planning can be observed in the complex of the Forum, the temple of Zeus and the south theatre. They are thought to date from the 2nd century AD, when Jarash was at the height of its wealth and splendour.

The Romans wanted to apply their principles of urban design while exploiting the land potentialities in creating a divine complex of landscape and architecture.

The South Theatre of Jarash (General Description):

The south theatre today is one of the most impressive of Jarash's public buildings, in part because of its extensive restoration and its good condition. The theatre was constructed and completed in the early 2nd century AD. It was started during the reign of Domitian, but there is evidence of an earlier theatre beneath the present structure. On its completion in the early second century, it was one of the most splendid civic monuments in the developing city and certainly the finest of its type in the whole province. Part of the cost was defrayed by generous donations from wealthy citizens such as Titrus Flavius, son of Dionysus, who is recorded as having given a block of seats. This was the period when Trajan created his new Province of Arabia (AD 106), bringing Jarash into the vortex of Provincial affairs so that the city's grandees willingly felt beholden to ensure that their city was as magnificent and celebrated as possible.

The south theatre is oriented in such a manner that the sun shines into a spectator's eyes for only a brief period in the late afternoon. The cavea of the auditorium was divided into two sections, with a wide terrace (diazoma) describing the full half circle between them, running the full length of the cevea. The lower half was built into the side of the hill while the top half was built up above it.

The lower half of the cevea is divided by stairs into four sections of fourteen rows each, with numbers inscribed underneath each seat in two outer sections. The number is most clearly visible in the lowest seats along the western side or the auditorium. The upper cevea was similarly divided into eight sections with fifteen rows.

Visitors today enter the theatre from the front through two arched passageways, or parodoi, that lead into the semi-circular Orchestra. Three sets of stairs lead from the orchestra to the lower seats. The upper seats of the theatre were reached through four-arched vomitoria that help support the upper half of the auditorium.

The lower section, which was built into the hillside, was divided by steep flights of steps (scalarias) into four cunei, or blocks, each of which had fourteen rows of seats. The upper section was similarly divided into eight cunei with approximately fifteen rows. Although the auditorium has survived remarkably well, the top rows of seats are missing, and one cannot be sure of the exact original number. Even so, Kareling was able to estimate that the theatre could have seated well over three thousands spectators. Each seat was numbered, starting with the lowest rows working from right to leave. This lettering is very interesting and can be seen in the western cuneus. The lowest row of seats was on the top of a podium, which had a wide, strongly moulded base and cornice with regularly spaced circular blind recesses in the wall. This podium was terminated at both ends by a pedestal on which a statue stood. Inscriptions in the theatre have enabled one to identify the statues and their donors. The statues are now in the Palestine Archaeological Museum in Jerusalem. The podium stood on two wide steps, on the upper of which the chairs of important dignitaries would have been set, looking out across the beautifully paved orchestra.

As was usual with most Roman theatres, the means of access to the seats was highly organized. Spectators having seats in the lower section were admitted into the orchestra through the high arched vomitoria on either side of the front of the stage. Those with seats in the flanking cuneus then mounted steps behind the statues at the ends of the podium, whilst those with seats in the middle crossed the orchestra and went up a steep set of steps, which broke through the central point of the podium.

Those with seats in the upper section had to pass from the upper terrace of the Sanctuary of Zeus, round the back of the theatre, hard under the city wall, until they reached their appropriate vomitoria which admitted them onto the half-way terrace of the cavea. The upper section was also retained by a podium wall through which the vomitoria broke. On either side of these entrances, narrow flights divided up a break in the upper podium, giving access to the stairways, which divided the upper cunei. The upper vomitoria are worth inspecting not only for the engineering skill they display. The steep slope of the auditorium above is supported on a series of stepped arches of finely calculated masonry. This is the same arrangement as was used beneath the seats of the Hippodrome. They are massively strong and afford exciting views back through the low doorways onto the almost fantasy architecture of the scaenae frons.

Graphic documentation used for the definition of the site and CC

List of sent pictures

NAME	DESCRIPTION	FORMAT	ID CODE
Orthophoto of the Jarash Cultural Cluster	Aerial view of the city of Jarash in which the two sides of the river, shown by a dashed line, identified the ancient city.	.jpg	
Main building of the Cultural Cluster	This photo identifies the main buildings of the Cultural Cluster.	.jpg	
Map of the Jarash archaeological site and contemporary town	In this map you can distinguish the old city, where archaeological sites are identified, and the modern city across the river.	.jpg	
Aerial view of the archaeological site	Aerial view of the theatre of Jarash.	.jpg	

Jarash data.

Font: http://www.getty.edu/conservation/publications_resources/pdf_publications/jarash_case_study.pd

Font: http://www.getty.edu/conservation/publications_resources/pdf_publications/jarash_case_study.pdf

Font: APPAME: Aerial Photographic Archive for Archaeology in the Middle East
http://www.apaame.org/

Font: http://www.sacred-destinations.com/jordan/jerash-pictures/satellite-labeled-3305ft.jpg

2.3. IDENTIFICATION OF THE UNIVERSAL AND EURO-MEDITERRANEAN VALUE

The main priority in creating a Management Plan for a UNESCO site occurs through universal recognition, which recognizes the site's unique and outstanding global value. In other words, the motivation may lie in getting the site entered onto the World Heritage list (WHL). The cultural excellence of a territory is something inherited through generations. This accumulation makes it alive and capable of producing new culture today. This is the reason why the UNESCO list expresses, in static mode, naturalistic, historical and aesthetic values of a natural heritage. The Management Plan considers the evolution of heritage and its local enrichment, which is expressed through the historical statement as well as the material culture, traditions, creative spirit and skills transmitted from generation to generation.

Case of Jarash

The text below provides an example of a report about the universal value of Jarash delivered to UNESCO to be introduced onto the World Heritage list.

REPORT ABOUT THE UNIVERSAL VALUE

The Jarash archaeological city has been listed by UNESCO on the Tentative List sites with number 3 since 2004. Due to its criteria, Jarash was nominated based on the criteria (iii) and (iv). Jarash is one of the major cities northern Jordan located about 40km north of the capital, Amman. Jarash has been inhabited since the Neolithic Period, but the city's prosperity was mainly achieved during the Roman Period.

The history and archaeology of the ancient city of Gerasa have been relatively well documented, given the extent to which the site has been studied and excavated. The earliest evidence of human settlement at Jarash goes back to the Neolithic Age (8500–4000 BCE). Archaeological evidence dated to the Bronze and Iron ages was also found within the city walls, indicating a continuity of habitation for several millennia.

Jarash as a formal city had its roots in the fourth century BCE. In 332 BCE, Alexander the Great conquered the region known as Syria, which included the northern part of Jordan, and began establishing colonies throughout the region, signalling the Hellenistic era in Jordan. The Greeks knew Jarash as "Antioch on the Chrysorhoas." It and other cities in the region founded by the Greeks became known as the Decapolis (the "ten cities" in Greek), each modelled after the Greek polis. The Decapolis probably was an association of cities grouped together because of their common culture, language, and proximity.

In 106 CE, the emperor Trajan annexed the wealthy Nabataean Kingdom and formed the province of Arabia. This brought even greater commercial wealth to Jarash, which enjoyed a burst of construction activity. During its Roman period, the city was altered through the creation of an urban grid with colonnaded and paved streets and significant monuments, including immense temples, theatres, and public spaces, the most prominent being the Oval Plaza, adjacent to the Temple of Zeus. The area of the ancient city to the west of the Chrysorhoas River, which is the area preserved today, was the administrative, civic, commercial, and cultural centre of this community, while the majority of its citizens lived on the east side of the river. To honour the visit of the emperor Hadrian in 129 CE, the citizens raised a monumental triumphal arch at the southern end of the city.

After Constantine established Christianity as the official religion of the Roman Empire and transferred the capital of the empire from Rome to Constantinople (Byzantium), the Christian religion spread within the Levant region. By the middle of the fifth century, the safety and stability of the religion allowed it to flourish. This is reflected in the many churches built during this period at Jarash; remains of fifteen Christian sanctuaries have been discovered to date. Many churches were built of stones taken from pre-Christian temples.

Jarash was hit further by the Persian invasion of 614 CE. In 636 CE, Muslim armies defeated the forces of the Byzantine Empire at the battle of Yarmouk in the area of the Yarmouk River, near the modern border between Jordan and Syria, signalling the beginning of the Islamic period in the region. Evidence shows that Jarash conceded to Islamic leaders without damage being inflicted on the city. Social and economic life continued unabated.

During the Umayyad period, a large mosque was built in the centre of the city, and a significant domestic quarter was created to the north of the South Decumanos.

A series of massive earthquakes that struck the city over the years until 1927 damaged many of the monuments of Jarash beyond repair; others were completely destroyed. The most significant of these earthquakes was that of 749 CE, which coincided with the end of the Umayyad period and the beginning of the Abbasid.

The text below provides an example of contextualization of the theatre of Jarash brings in a network of ancient theatres of the Mediterranean studied at the website of *"Engramma la tradizione clasica nella memoria occidentale"*

http://www.engramma.it/eOS/index.php?id_articolo=441 .

REPORT ABOUT THE UNIVERSAL AND EURO-MEDITERRANEAN VALUE OF THE THEATRE

The rediscovery of Jarash came about in 1806 when Ulrich Jasper Seetzen, a German traveller, came across and recognized a small section of the ruins buried in sand, which accounts for its remarkable state of preservation. The city has been gradually revealed through a series of excavations that commenced in 1925. Extensive programs of conservation and restoration continue to this day.

This theatre is considered as one of the most significant and large theatres in the region and is still in a good state and condition. This potentiality makes it easy to be presented for site visitors as one of the well standing monuments in the site, in addition to its adoption for modern uses. This theatre plays an important role in enhancing art performance and other cultural activities presented in the yearly festival that takes place there. Such activities can enhance and promote the innovations of the people of Jordan and Jarash as well.

Font http://www.engramma.it/eOS/image/77/077_elenco_giordania.gif

CONSERVATION	TOPONYM	TYPOLOGY	DATING	DIMENSIONS	NOTE
● (orange)	Amman [*Philadelphia*]	Roman theatre	II cen. AD	small	Today in archaeological site
● (black)	Amman [*Philadelphia*]	Roman theatre	II cen. AD	small	Today in archaeological site
● (orange)	Jarash [*Gerasa*]	Theatre (?)			Hypothetical identification and location
● (orange)	Jarash [*Gerasa*]	Roman theatre	Beginning II cen. AD	medium	Today in archaeological site
● (orange)	Jarash [*Gerasa*]	Roman theatre	46-43 BC	large	Today in archaeological site
● (orange)	Petra [*Petra*]	Roman theatre	I-IV cen. BC		Today in archaeological site
○ (orange)	Petra [*Petra*]	Roman theatre	I cen. BC	medium	Today in archaeological site
○ (black)	Tabaqat Fahl [*Pella*]	Roman theatre	5 BC - 1 AD	large	Today in archaeological site
○ (orange)	Tell Abil [*Abila*]	Roman theatre	Second half of I cen. AD	medium	Today in archaeological site
○ (orange)	Umm Qeis [*Gadara*]	Roman theatre	II cen. AD	medium	Hypothetical identification based on epigraphical/archaeological evidence
○ (orange)	Umm Qeis [*Gadara*]	Roman theatre	I cen. AD	large	Today lying under modern buildings
○ (orange)	Petra, Wadi es Sabra [*Petra*]	Roman theatre	I cen. AD	large	Today in archaeological site

http://www.engramma.it/eOS/index.php?id_articolo=385

2.4. SITE CLASSIFICATION

The aim of this chapter is to classify sites of a territory according to some instruments that allow us to value assets depending on certain criteria. The evaluation is based on the following criteria:

- State of conservation.
- Current use.
- Management plan.
- Urban context.

STATE OF CONSERVATION

0 = The archaeological site is still not excavated.

1 = The site is used as an archaeological park.

2 = The site has been restored and consolidated.

3 = The site has been restored and has a high degree of conservation.

CURRENT USE

0 = The site is not in use.

1 = The site is used occasionally without a specific planning.

2 = Planned use of the theatre.

MANAGEMENT PLAN

0 = The site has no Management Plan.

1 = The site has no specific kind of plan.

2 = The site is under a master plan, but has no Management Plan.

3 = Has a Management Plan.

URBAN CONTEXT

0 = High impact of neighbouring constructions.

1 = Low impact of neighbouring constructions.

2 = Without impact.

Case of Jarash

An exemplification of this section with the ancient theatres of Jordan has been included. Once the information about Jordan´s theatres has been gathered, their capacity to sustain dramatic performances, visits and other kinds of activities related to the use of ancient structures can be evaluated.

The table below indicates the meaning of each score:

EVALUATION CRITERIA	0	1	2	3
STATE OF CONSERVATION	The archaeological site is still not excavated	The site is used as an archaeological park	The site has been restored and consolidated	The site has been restored and has a high degree of conservation
CURRENT USE	Site not in use	Site used occasionally without a specific plan	Planned use of the theatre	
MANAGEMENT PLAN	The site has no Management Plan	There is no specific site plan	The site is under a master plan, but has no Management Plan	Has a Management Plan
URBAN CONTEXT	High impact of neighbouring constructions	Low impact of neighbouring constructions	Without impact	

Jordan data.

JARASH SOUTH THEATRE

JARASH NORTH THEATRE

EVALUATION CRITERIA (SCORE)	0	1	2	3
STATE OF CONSERVATION			The site has been restored and consolidated	
CURRENT USE			Planned use of the theatre	
MANAGEMENT PLAN			The site is under a master plan, but has no Management Plan	
URBAN CONTEXT			Without impact on the urban context	

Jordan data.

EVALUATION CRITERIA (SCORE)	0	1	2	3
STATE OF CONSERVATION			The site has been restored and consolidated	
CURRENT USE			Planned use of the theatre	
MANAGEMENT PLAN			The site is under a master plan, but has no Management Plan	
URBAN CONTEXT			Without impact on the urban context	

Jordan data.

PRELIMINARY ACTIVITIES 45

AMMAN ROMAN THEATRE

AMMAN ODEUN THEATRE

EVALUATION CRITERIA (SCORE)	0	1	2	3
STATE OF CONSERVATION			The site has been restored and consolidated	
CURRENT USE		Site used occasionally without a specific plan		
MANAGEMENT PLAN			The site is under a master plan, but has no a Management Plan	
URBAN CONTEXT		Low impact of neighbouring constructions		

Jordan data.

EVALUATION CRITERIA (SCORE)	0	1	2	3
STATE OF CONSERVATION			The site has been restored and consolidated	
CURRENT USE		Site used occasionally without a specific plan		
MANAGEMENT PLAN			The site is under a master plan, but has no Management Plan	
URBAN CONTEXT		Low impact of neighbouring constructions		

Jordan data.

PETRA THEATRE

UMM QAIS THEATRE

EVALUATION CRITERIA (SCORE)	0	1	2	3
STATE OF CONSERVATION		The site is used as an archaeological park		
CURRENT USE	Site not in use			
MANAGEMENT PLAN				Has a Management Plan
URBAN CONTEXT			Without impact	

Jordan data.

EVALUATION CRITERIA (SCORE)	0	1	2	3
STATE OF CONSERVATION		The site is used as an archaeological park		
CURRENT USE		Site used occasionally without a specific plan		
MANAGEMENT PLAN			The site is under a master plan, but has no Management Plan	
URBAN CONTEXT			Without impact	

Jordan data.

EVALUATION RESULTS OF THE JORDAN'S THEATERS

	STATE OF CONSERVATION	CURRENT USE	MANAGEMENT PLAN	URBAN CONTEXT	TOTAL
JARASH SOUTH THEATRE	2	2	2	2	8
JARASH NORTH THEATRE	2	2	2	2	8
AMMAN ROMAN THEATRE	2	1	2	1	6
AMMAN ODEUN THEATRE	2	1	2	1	6
PETRA THEATRE	1	0	3	1	5
UMM QAIS THEATRE	1	1	2	2	6

Jordan data.

State of conservation

The theatre currently is in relatively good physical condition compared with the other Roman theatres in Jordan. However, there are still some small missing parts that need to be reconstructed to get the theatre into complete shape. These are: the two end edges of the upper cavea (see the photos) and the skaena frons. Many fallen seat stones are still there and need to be restored back into their original places (see the photos below). The upper part of the skaena frons which ties both the missing two edges of the upper cavea of the seats is missing and needs to be reconstructed using the fallen stones distributed around the theatre.

Current use

Within this national context, Jarash is currently the second most visited cultural heritage site in Jordan and plays an important part in the country's National Tourism Strategy. The site is a significant draw for foreign tourists generally and for visitors from Jordan and the Middle East, particularly during the Jarash Festival of Culture and Arts in July and August. During the summer months, the relatively moderate climate of the Jarash area and the attractive natural setting of the area, such as at the nearby forested Dibeen nature reserve, attract tourists from warmer parts of Jordan as well as from other parts of the Middle East, particularly the Persian Gulf region.

However, tourism in Jordan and to Jarash has been subject to significant fluctuations due to ongoing political conflicts and instability in the region. During the past decade, the continuing Arab-Israeli conflict, which intensified with the beginning of the Second Intifada in September 2000; the terror attacks in the United States of 2001; the subsequent attacks in Spain and England; the Iraq War, which has continued since March 2003; and other conflicts in the Middle East have had significant negative impacts on tourism to the region.

Annual visitation to the archaeological site shown in the figure below reveals large fluctuations reflecting the events of regional unrest and international terrorism. Visitation peaked at nearly 300,000 visitors in 2000. By 2003 the number of visitors to Jarash had dropped to under 106,600. In 2005 the total number of visitors was 214,550, consisting of 181,000 foreigners and 33,550 Jordanians. In 2006 the total number of visitors dipped to around 170,000.

Most tourists to Jarash come as part of organized half-day tours, some including lunch at the Rest House. The current procedure for tours is to disembark in a parking lot at the southern end of the site, walk through a recently built adjacent handicraft centre, and purchase tickets at a booth at the far end of this centre. Admission to the site, which includes the archaeological museum, costs JD8 for all foreign visitors (one-half dinar for Jordanian residents).

Local tour guides are available for an additional fee. Tours are available in Arabic, English, French, German, Italian, and Spanish. From the ticket booth, visitors proceed north through or past Hadrian's Arch and past the partially restored Hippodrome. The Hippodrome hosts the Roman Army and Chariot Experience (RACE). RACE produces a historic reenactment of Roman Legion tactics, chariot races, and mock gladiator battles, presented in a one-and-a-half-hour show daily (except Tuesdays), and twice per day on Saturdays and Sundays. There is a separate admission for RACE: JD15 for foreign adults, JD5 for Jordanian adults, and JD2 for children.

After passing the Hippodrome, visitors continue north to the visitor centre. This complex houses interpretive panels about the site's history and significance, an interpretive model of the site showing major monuments, and informational brochures in a number of languages. Restroom facilities are located to the rear of the visitor centre complex. Also near the visitor centre is the Jarash Rest House, the only restaurant on site that serves visitors.

Beyond the visitor centre is the official entrance to the site, where visitors must produce their tickets in order to enter. Once they have entered, visitors can walk north up and back along the main colonnaded street, walking up to see the primary monuments, or they can follow a dirt path to the west from either the North or South Theatre, thereby seeing several key sites not accessible from the main path, including several churches, one with exposed mosaics. The South Theatre is the site of performances by a band of local musicians, all former members of the Jordanian army band. The band members, who play bagpipes and drums, perform when tourists enter the theatre in exchange for tips. The Jarash Archaeological Museum, the main site museum, is located on a hill midway through the site, away from the monuments. It displays objects from the site representing periods ranging from the Stone Age through the Mamluke period. A second museum is located in the vault below the Temple of Zeus and interprets the Hellenistic period temple.

Management plan

Legal Framework and Governing Authorities: The Jordanian Law of Antiquities is the nation's primary law governing archaeological heritage. This statute identifies the Department of Antiquities (DoA) as the national authority responsible for the protection, excavation, restoration, conservation, presentation, and management of antiquities in Jordan. It also gives the DoA the responsibility to promote awareness of archaeology, including through educational

activities. In addition, it provides for a national register of all archaeological sites, and that the ownership of immovable antiquities is solely vested in the national government.

The principal policy objective of the DoA is the protection of antiquities, preferring conservation measures that do not require physical intervention to the remains as the first choice where possible. The secondary policy objective is for the presentation of antiquities, including research, survey, excavation, and site management. The DoA's protection-related responsibilities include enforcing national laws prohibiting illicit excavations and the trading, exporting, and importing of antiquities. The department employs a large number of site guards across the country to protect sites, including at Jarash. In the area of presentation, the DoA is responsible for preparing and placing interpretive signs at sites for visitors, as well as curating and exhibiting antiquities objects through its museums. The DoA also oversees all archaeological research missions in Jordan

Urban context

Locally, the site is situated within Jarash municipality, which is under the leadership of the head of the municipality and a city council, who are all locally elected and oversee various municipal departments. Like the physical separation of the archaeological site from the modern city, the two are also clearly separated in terms of administrative authority. The DoA and MOTA oversee the archaeological site and associated tourist facilities, respectively, while the municipality has authority over the modern city, which surrounds the site on all sides. The municipal government plays an important role in regulating and approving land use within the municipality.

Both the governor and municipal leaders have an interest in seeing increased tourism to the site and a better connection between the site and the city to produce more local economic benefits. They also believe that more effectively connecting the site with the city will bring cultural benefits that will allow international visitors to learn of the friendly and hospitable nature of Jordanians, and the local people to learn about and from the cultures of the visitors, including learning foreign languages. In addition, they believe that local interaction with foreign tourists can moderate tourist perspectives about Arabs as well as temper local views of foreigners.

Location within the city

The location of theatres was affected by the general planning of the city. In general, the location of theatres in the city is directly related with the main elements forming the urban fabric, such as the Roman theatres Cardo and Documanus, the Forum of the city, and Temples. The Greek theatre is part of the natural landscape, but the Roman structure is imposed on nature. Unlike the Greeks, the Romans typically built their theatres on flat sites, combining the acting areas and the seating areas into a single structure.

The strong relationship between theatre and temple decreased in this period. Choosing a location for the theatre followed several considerations, the most important of which was the implication of the theatre on the planning of the city where it was connected with general basic elements in the city, such as with the forum in the Theatre of Amman, and the main paved street in the city, like that of the North Theatre in Um-Qais, and Al-Souqe in the West Theatre of Um-Qais. If we study the relationship between theatres and temples in Jordan, we can see that the theatres of Jarash were located close to temples abiding by the Hellenistic tradition of the west. A small shrine was located at the top of the theatre of Amman, (an example of the western Roman tradition), while the theatre of Umm Qais was dedicated to the Goddess of Tyche.

The north theatre at Jarash offers the best example of the theatre's successful integration into the city's network of streets. Its orientation and the way in which the plaza behind the stage building is integrated with the northern decumanus and the municipal plaza to the north, confirm that much thought and careful planning were invested in the site. Since most of them were built on hillsides, theatres inevitably provided obvious urban focus.

The second point emphasizes the role that city planning plays on the location of the theatre, not the opposite. An example is found in the location that was chosen to construct the Northern Theatre in Um-Qais, where its structure is on an utterly rocky slope. Although, the curve of this slope was appropriate, it seems that there was some difficulty in dealing with it, because it did not allow for the laying of stone foundations to assist in supporting the upper parts of the theatre, and also help in providing enough room.

However, in viewing the importance of location when planning the city, and abiding with it, they seem to have found a solution to this problem by digging these foundations into the rocky slope, where they came without any constructive function. (The hill provided extra support and was easier to build on). It is a unique phenomenon in the existing theatres in Jordan. Had it not been for abiding with the location of this theatre, they would have changed its location to another. Also, there are other considerations such as the orientation.

ATTACHMENTS 2

A.2.1	Deliverables tool I: Model. (Printed and Digital version).	
A.2.2	Deliverables tool I: Example. (Digital version)	
A.2.3	Deliverables tool I: Cherchell theatre. (Digital version)	
A.2.4	Basic Information IRP: Spanish example. (Digital version)	

Attachment 2.1.
DELIVERABLES TOOL I: MODEL.
WORK PACKAGE 4

TASK 4.1 – SETTING UP THE MANAGEMENT PLAN (MP) – BASIC INFORMATION

Specification and Plan of Actions

WP Leader: *Instituto de Restauración del Patrimonio (IRP) - Universidad Politécnica de Valencia*

Plan of Action

TASK	ACTIVITY	PARTNER IN CHARGE	DEADLINE
4.1.1	Responsible agency for the development and implementation of the Management Plan	All	16th of September 2011
4.1.2	Identification of the Site and Cultural Cluster	All	15th of October 2011
4.1.3	Identification of the Universal and Euro-Mediterranean value	All with the support of IRP	30th of September 2011
4.1.4	Site classification	All with the support of IRP	30th of September 2011

General structure of the Management Plan

Task 4.1. Information for the development of MP BASIC INFORMATION
Task 4.2. Information needed for the development of MP INTRINSIC ACTIONS
Task 4.3. Information needed for the development of CC INFORMATIVE SYSTEM
Task 4.4. ACTION PLANS

Content of this document

General Description
Tasks Description
Deliverables
Plan of Action

Note

The activity written in blue is the objective of this document. Questionnaires to be filled out in the coming months will be delivered to the partners in the following weeks in accordance with the general structure of the Management Plan.

General Description

Basic information: the objective of this task is the development of integration and dialogue between all the institutions (at every institutional level) involved in the management process of the site and related

Cultural Cluster (CC). A formal relationship (as a draft agreement) should be established between the institutions aimed at identifying and describing their relative roles: once the Management Plan has been implemented it will be possible to specify and regulate the legal relationships between institutions.

Another aim is the gathering of graphic information at the regional/provincial level, which will be necessary for every partner, for the definition of two perimeters: a smaller one for the *Reference Area* of the archaeological site in which the theatre is located, and a larger one for the *Cultural Cluster*, which is the area characterized by qualitative/quantitative aspects related to tourism, cultural/economic development, etc. During WP2 – Knowledge, this information was planned to be collected in order to share between the partners drawings related to the theatre and its environment, that are now essential for carrying out this part of the preliminary activities.

In accordance with the *General Issues* of WP 1 - Setting up the common scientific and cultural framework - it is now needed the *Evaluation about the number of ancient theatres in the country, the Sites listed by UNESCO in the country, and a Brief description of every theatre* as in the examples attached to this document (state of conservation, toponym, typology, dating, dimensions, notes).

Once every theatre has been indexed, every partner should evaluate their capability to sustain dramatic performances, visits and other kind of activities related to the usage of ancient structures. Also in this case, the attached document with examples will be useful for a correct completion of this last task of WP 4.1.

EXPECTED RESULTS	TARGET GROUP / BENEFICIARIES	MAIN OUTCOMES
• Identification of suitable institutions for implementation of MP. • Identification of the physical boundaries of every Athena site and CC. • Identification of every ancient theatre in the country • Evaluation of every theatre in terms of conservation and vocation to contemporary usage	*Local institutions responsible for managerial process* *General scientific community* *Companies/institutions involved in conservation* *Event organizers*	- Fulfilment of the *Preliminary Activities*: the first step needed for the development of the Management Plan. - Improvement of the general knowledge concerning the relationship between the theatre and its environment in juridical terms (property, protections, laws, urban planning, etc.). - A *Letter of Intent* in which will be clarified the role of every institution involved in the implementation of the MP by means of the creation of common aims. - Census of every theatre in each country of the ATHENA consortium. - Evaluation in terms of management and usage of every theatre belonging to the ATHENA consortium.

Tasks Description

TASK 4.1.1 – Responsible Agency for development and implementation of MP

Every partner has to collect relevant juridical information on the chosen theatre of its country (property regime of the theatre and Reference Area, Urban Planning, Cadastral units). Then it is necessary to draw up a document, as a *draft agreement*, between the local and national institutions already involved in managerial activities related to the theatre with the purpose of sharing information and coordinating every protection on the theatre and CC by means of the forthcoming Management Plan.

In this phase it is expected that every partner produce a table like the one in the example below (table 1) with a list of every institution at the local and general level involved in conservation, cultural and economic development of the theatre and CC.

TASK 4.1.2 - Identification of the Site and Cultural Cluster

For each one of the chosen theatres, every partner has to define the physical boundaries of the *Reference Area* of the Theatre (in some cases it can overlap with the archaeological site, or maybe not) and of the related Cultural Cluster. In this case graphic documentation is needed:
- for the CC: 1:250000, 1:50000, 1:5000
- for the Site and Reference Area: 1: 5000, 1:500
- Orthophotos and aerial views of the Site and Reference Area

It is advisable to deliver editable .dwg format files: if it is not possible to get vector graphic drawing, it is considered acceptable to get graphic information from scanned drawings. It is very important to indicate the source, the author, the original scale and the date of making of each drawing. In the case of scanned drawings, a resolution between 300 and 600 dpi is needed, better if saved in .tiff file format.

It is very important that the regional/provincial maps can provide information like those listed below:

Land registry
Regional/Federal boundaries
Local/provincial boundaries
Municipal boundaries

Town planning
Built area

Cartography
Contour lines / Hydrograph / Airports / Railways / Motorways / Urban roads / Local road / Ports
Some examples are provided in the attached document.

TASK 4.1.3 - Identification of the Universal and Euro-Mediterranean Value

Every partner should collect for the chosen theatre and related Reference Area of its country (in the case it is listed on the World Heritage List, WHL) the Report about the Universal Value by UNESCO. In case the archaeological site does not belong to this WHL, in place of the Report by UNESCO, every partner should write a brief text (max 1000 words) about the Euro-Mediterranean value of the site with special regards to the dramatic activities held in the theatre. The text has to answer the following questions:
- What was the importance of the particular theatre during the Greek-Roman age?
- What ancient festivals were held in that theatre?
- What was the relation between the particular theatre and the town in ancient times?
- What was the relation between the particular theatre and the surrounding territory?

Some layout examples of how to produce the deliverables are provided in the attached document (example from the Merida Archaeological Ensemble).

The Euro-Mediterranean Value of the Theatre has to do with the implementation of a theatre network inside the Mediterranean Basin. Each partner should provide the census in accordance with the former WP1 - *Setting up the common scientific and cultural framework* - and a map of the ancient regions with the location of the known theatre. Every theatre should be alphabetically indexed in turn on the base of the actual toponym, side by side with the Latin name. For every monument, the typology should be indicated:

Greek theatre, Roman theatre, Greek odeon, Roman odeon; a question mark points out the impossibility of defining exactly the nature of the building type because of the lack of information data (ancient sources as epigraph or critical bibliography). The dating is based on the following criteria: the known chronological data on the building and the lapse of time in which notable restorations, modifications or integrations have been done. The notes related to dimensions, where known, are summed up in three categories:

- small (up to 500-700 places)
- medium (700-1500 places)
- large (over 1500 places)

A graphic symbol specifying the preservation status of the building:

- ● Indicates a good preservation status of the building structures, both in the case that it is still in use or is included in archaeological areas.

- ○ Indicates a mediocre preservation status or generally not good. To this category belong partially buried sites or those where only ruins are preserved.

- ○ Identify the known sites that cannot be used or are not clearly visible because they are still buried (included in the foundations of modern buildings or destroyed)

- ● Indicates the huge number of cases in which the identification is just hypothetical because it was based on the following criteria: indirect sources, epigraphic or literary, documentary or archaeological evidences, hypothesized on the topographical analysis of the ground; this category is suitable also in case of doubtful identification, or where it is not possible to gather the conservation status.

Some layout examples of how to produce the deliverables are provided in the attached files.

TASK 4.1.4 - Site Classification

Once the information on Roman theatres of each region of the ATHENA Consortium (Census of the ancient theatres of Jordan, Algeria, Spain, Tunisia, Italy) has been gathered, each partner should evaluate their capability to sustain dramatic performances, visits and other kinds of activities related to usage of ancient structures.

The evaluation is based on the following criteria:
- state of conservation
- current use
- management plan
- urban context.

The evaluation of each theatre's score has to be done using the following table:

EVALUATION CRITERIA (SCORE)	0	1	2	3
STATE OF CONSERVATION	The archaeological site is still not excavated	The site is used as an archaeological park	The site has been restored and consolidated	The site has been restored and has a high degree of conservation
CURRENT USE	Site not in use	Site used occasionally without a specific planning	Planned use of the theatre	
MANAGEMENT PLAN	The site has no Management Plan	There is no specific site plan	The site is under a master plan, but has no Management Plan	Has a Management Plan
URBAN CONTEXT	High impact of neighbouring constructions	Low impact of neighbouring constructions	Without impact	

Practical examples are attached to this document.

Deliverables

A list of possible agencies in each country that could be responsible for the implementation of the MP
Graphic information for the definition of the Reference Area of the theatre and related Cultural Cluster
Report about the Universal and Euro-Mediterranean Value of each theatre and Cultural Cluster.
The Census of every theatre in each country of the ATHENA consortium.
The classification of every ATHENA theatre with aims of the Management Plan (sustain dramatic performances, visits, cultural/economic development, etc.).

Index
General Description

TASKS 4.1. **INFORMATION FOR THE DEVELOPMENT OF MP BASIC INFORMATION**

 4.1.1. *AGENCY RESPONSIBLE FOR DEVELOPMENT AND IMPLEMENTATION OF MP*

 4.1.2. *IDENTIFICATION OF THE SITE AND CC*
 Graphic documentation needed for the definition
 of the site and cc

 4.1.3. *IDENTIFICATION OF THE UNIVERSAL AND EURO-MEDITERRANEAN VALUE*
 Report about the Universal Value
 Report about and Euro-Mediterranean Value of the Theatre

 4.1.4. *SITE CLASSIFICATION*

 4.1.5 *TIME DISTRIBUTION*

TASKS 4.2. **INFORMATION NEEDED FOR THE DEVELOPMENT OF MP INTRINSIC ACTIONS**

 4.2.1. **HARMONIZING THE EXISTING PLANNING**

 4.2.1. **KNOWLEDGE.**

 4.2.3. **ECONOMIC/CULTURAL DEVELOPMENT**
 Rationalization of the resources
 Development of events and cultural activities
 Economic growth by means of tourism
 Development of theatre network

 4.2.4. **CONSERVATION**

TASKS 4.3. **INFORMATION NEEDED FOR THE DEVELOPMENT OF CC INFORMATIVE SYSTEM**
 GENERAL GRAPHIC INFORMATION

 4.3.1. **TECHNICAL ASPECTS**
 Historical knowledge on the theatre
 History of interventions and restorations on the theatre
 State of conservation of the theatre and CC
 Scientific and technical studies
 Risk and threats

 4.3.2. **ECONOMIC/CULTURAL ASPECTS**
 Associations and foundations
 Ordinary and special resources for theatre and CC
 Services suppliers for theatre and CC
 Stakeholders, investors and sponsors of the CC
 Local Economy of the CC
 Accessibility and infrastructure

 4.3.3. **INTANGIBLE ASPECTS**

 4.3.4. **JURIDICAL ASPECTS**
 Property Regime of theatre and CC
 System of protections and urban planning inside the CC
 Safety standards for performance building at local and national level

Note

The activity written in **grey** is the objective of this document. Questionnaires to be filled out in the coming months will be delivered to the partners in the following weeks in accordance with the general structure of the Management Plan.

Information priority

The alphanumeric and graphic information needed for the development of the MP are of three types, depending on the importance of these documents for the upcoming Management Plan:

LOGOS	IMPORTANCE	MOTIVATION
Nec	Necessary	Information considered of high significance for the development of the MP. Without this graphic and/or alphanumeric data, the MP will not be implemented in a proper way.
Adv	Advisable	Information supposed to be provided during the implementation of the MP, but not necessary for its start up. In any case, if an institution or a research centre has already produced these documents they have to be delivered for the production of the MP.
Acc	Accessory	To this category belongs data of marginal utility. In some special cases, due to a site-specific problem or distinctive feature, the MP may also need this information.

TASKS 4.1. INFORMATION FOR THE DEVELOPMENT OF MP BASIC INFORMATION

4.1.1 - *Agency responsible for development and implementation of MP* **N**ec

To be filled in with data

Table 1

TERRITORIAL UNIT	RESPONSIBLE INSTITUTION	RESPONSIBLE MANAGER	DESCRIPTION OF THE INSTITUTION
...

Add rows if necessary

4.1.2 - *Identification of the Site and CC* **N**ec

Graphic documentation has to be sent UPV in digital format (dwg and tiff)

GRAPHIC DOCUMENTATION NEEDED FOR THE DEFINITION OF THE SITE AND CC
Attach files

Table 2

LIST OF THE SENT DRAWINGS		
Title of the file	Content of the file	Format (tiff,...)
....		

Add rows if necessary

4.1.3 - Identification of the Universal and Euro-Mediterranean value

Nec

REPORT ABOUT THE UNIVERSAL VALUE
Attach report

REPORT ABOUT THE EURO-MEDITERRANEAN VALUE OF THE THEATRE
Attach report

4.1.4 - Site Classification

Adv

To be filled in with data

Table 3

EVALUATION CRITERIA (SCORE)	0	1	2	3
STATE OF CONSERVATION				
CURRENT USE				
MANAGEMENT PLAN				
URBAN CONTEXT				
....				

Add rows if necessary

4.1.5 Time distribution

Indicate the period of the year in which the theater season is carried out (specify days):

January	February	March	April	May	June
July	August	September	October	November	Decemher

Indicate the days of the week and schedule in which the shows are performed:

Monday	Tuesday	Wednesday	Thursday	Friday	Saturday	Sunday

Indicate the days and opening hours of the theater for visitors:

Monday	Tuesday	Wednesday	Thursday	Friday	Saturday	Sunday

Indicate the days and guided tours times of the theater:

Monday	Tuesday	Wednesday	Thursday	Friday	Saturday	Sunday

Is there a diversification of time visit in the different sites of archaeological interest?

YES ☐ NO ☐

If so please indicate for each site the schedule:

Indicate the days and the opening hours of the Theatre / archaeological site for carrying out intrinsic activities (archaeological research, maintenance, etc.):

Monday	Tuesday	Wednesday	Thursday	Friday	Saturday	Sunday

Note

Questionnaires to be filled out in the coming months will be delivered to the partners in the following weeks in accordance with the general structure of the Management Plan.

3. Intrinsic Actions

The intrinsic actions are related to a set of assumptions inspired by the Syracuse Charter, Verona Charter, Segesta Declaration and can be considered as a tool for monitoring the current situation of every site and then used to rectify each specific area with the help of the operative part of the action plans: Guidelines for Compatible Utilization and Ancient Theatre Usage Manual.

The thematic areas of the aims are:

3.1 – Knowledge
3.2 – Conservation
3.3 – Maintenance
3.4 – Cultural Heritage's increasein value
3.5 – Dissemination
3.6 – Economic development

3.1. KNOWLEDGE

Definition

The development of knowledge on the theme of theatres is a vast and multi-faceted task because it is related to many cultural and scientific fields: architecture, archaeology, dramatic art, analysis and usage of materials, conservation, acoustic, safety, etc. From this viewpoint, the development of knowledge has to be seen in accordance with the most updated scientific production (Syracuse Charter, Verona Charter, Segesta Declaration, etc.), which is an integrated process capable of managing and sharing at an international level the highest achievements obtained by each country in each one of the fields related to classical theatres. The increase in knowledge is not just a progressive deepening process in one specific field of research, but has a wider scope; as a matter of fact, there cannot be development of knowledge without the sharing of the results both at horizontal and vertical levels, i.e. within each region as well as within the Mediterranean Basin, and in a specific field of research as well as within a wider scientific and cultural context.

One of the main aims of the Management Plan is to create an updated database of all the research in progress, as well as the prior historical research done on the theatre and the Cultural Cluster. Moreover, it is important to promote flows of information and suggestions at the Euro-Mediterranean level about the existing theatre network carrying out shared projects based on correct maintenance and fruition of ancient theatrical architectures. The building up and sharing of effective tools of knowledge makes the identification of the regional cultural identities feasible. Once all the specific and general research on those topics is known, it will be possible to coordinate it. All the universities, associations, foundations, research centres, local and national authorities related to the excavation, study and dissemination of the ancient theatres and local culture (material-immaterial) must be framed within a global process of cultural development.

Methodology

Depending on the scientific field, the Management Plan has to organize the synergy of every institution involved in the knowledge development process, avoiding overlapping "jurisdiction" on the study of the archaeological site. Within the Management Plan, once the census of every institution involved in the research process on an archaeological site has been carried out, the activities' timetable must be specified by means of simple categories.

The research activities need different kinds of resources, not just economic, but also physical, human and logistic, etc. The aim of the Management Plan has to do with a sustainable development of the research in accordance with the suggestion in the example table below.

Fundraising and rational usage of economic resources have the aim of developing all kinds of economic activities related to theatre usage within an overall framework related to the economic development of the whole cultural cluster. It is advisable to avoid the exploitation of theatrical activities as the main income source, but rather other compatible activities that could provide income should also be promoted throughout the year. Moreover, the responsible institutions for the development of the Management Plan have to foster and involve sponsors and local stakeholders in the financing of activities.

Application to the theatre of Jarash

To achieve development compatible with the use of the theatre, interferences and synergies of the activities contemplated in the following tables should be taken into account. These ones are completed with Jarash information in order to provide an example of this task.

PLANNING FOR KNOWLEDGE

Activity	Personnel classification (I) Internal, (E) External	Times Planning (A) annual, (S) seasonal, (P) permanent, (C) for campaign, (O) other.
Excavations	I + E	S + O
Bibliographical/Documentary study	I + E	S + O
Survey	I + E	S + O
Scientific and technical studies	I + E	S + O
Others	I + E	S + O

Jarash data.

EXPLICATION NOTE FOR "OTHERS"

In terms of the DoA's administrative structure, the department is managed by a director-general who is directly linked to the minister of tourism and antiquities. The minister also oversees the Ministry of Tourism and Antiquities (MOTA) and the Jordan Tourism Board, an independent public–private sector partnership charged with promoting tourism to Jordan. These three bodies operate separately from one another. For example, although the DoA is under the minister of tourism and antiquities, it is not under MOTA. The minister is a key figure in decision-making concerning tourism and archaeology on a national scale, as well as specifically regarding the site of Jarash.

The DoA's headquarters are in Amman, and it has twelve major offices around the country—representing each of Jordan's twelve governorates—and eight subsidiary offices. The department's office for the governorate of Jarash is located at Jarash archaeological site, and approximately sixty-five DoA personnel are based at the site. An inspector, who is also an archaeologist, supervises all DoA personnel in the governorate, including at the site of Jarash. Other DoA staff within the governorate are currently composed of two other archaeologists, one museum curator, seven ticket sellers, six personnel who check tickets at the entrance gate, fourteen guards, ten custodial staff, and a few administrative personnel. The Jarash Project for Excavation and Restoration, based at the Jarash archaeological site, also has administrative staff, approximately fifty workers, and six vehicle drivers under the management of the project's supervisor.

The DoA owns the Jarash archaeological site. The DoA office at Jarash is charged with enforcing the Law of Antiquities at the site as well as in the rest of the governorate. It also enforces the DoA's "Instructions for Holding Activities at Archaeological Sites." Generally, any activities undertaken within the DoA-owned site should be carried out with permission of the DoA. DoA staff at Jarash are involved in raising public awareness through outreach to schools and through the site's museum. The museum curator has developed a number of educational programs for local schoolchildren grades 1 through 10, with the goal of getting their parents interested in the site. During the months of April and May, the DoA hosts two school groups per week at the site. It is currently developing new programs for families and working with the Ministry of Education to enhance school curricula on antiquities and the archaeological site of Jarash.

MOTA is responsible for the development and promotion of publicly owned tourism sites. It also oversees regulation of the tourism sector, encouraging tourism-related investment, preparing studies and research for tourism development and growth, and enhancing the country's tourism workforce. MOTA is based in Amman and has offices at most major tourism sites. The director of tourism for Jarash governorate, a MOTA employee, has an office at the visitor centre on the site of Jarash. This individual coordinates MOTA's responsibilities with respect to tourism at the site, including concessions, tour guides, visitor centre, parking, and health and safety issues. Moreover, MOTA has been instrumental in the development of the tourism services infrastructure at Jarash, such as parking for vehicles and the handicraft centre.

Jarash data.

RESOURCES FOR KNOWLEDGE	
Resources typology	Classification (I) Internal, (E) External, (N) Not present
Available Space/room	I + E
Available personnel	I + E
Facilities	I + E
	I + E

Jarash data.

ECONOMIC RESOURCES FOR KNOWLEDGE	
Economic resources typology	Financing typology (A) annual, (S) seasonal, (P) permanent, (O) occasional, (O) other.
Audience	S + O
Generic visitors	P
Complementary activities fee	O
Public Institutions	A
Stakeholders Investors	O
Foundations	O
Associations	O
Others	O

Jarash data.

3.2. CONSERVATION

Definition

In order to build up an effective tool for the safeguarding of ancient places of performance, there exists the need to prepare and carry out a conservation plan based on the knowledge and correct interpretation of the formal choices adopted with respect to the materials and building techniques used, and the transformations and actions that have occurred in accordance with the conservation conditions (from Syracuse Charter).

The protection of ancient theatrical structures, as well as their Cultural Cluster, is a very difficult task due to their continued use as places of performance. Moreover, natural disasters, pollution, and improper use have all continuously contributed to their damage. Conservation, as well as other aspects related to ancient theatres, is concerned with the planning and coordination of many activities by means of an effective policy based on prevention and mitigation of vulnerabilities and danger factors.

Methodology

It is recommended to use the tables below to prepare a generic diagnosis about the conservation status and value of the physical and economic resources that the site provides. In order to prepare a more specific evaluation, a conservation plan is required.

To detect any interferences or synergies related to the use of the theatre, the plan must take into consideration the different levels of conservation tasks. These could be a general conservation plan or a specific project in a designated part of the theatre. Unique repair works must be taken into account to avoid injury to tourists.

Application to the theatre of Jarash

Conservation work in Jarash site is not set up under a systematic action based on a well-prepared conservation plan. Although the principal policy objective of the DoA is the protection of the site, preferring conservation measures that do not require physical intervention to the remains as the first choice where possible, considering the large number of site guards across the country charged with protecting sites, including at Jarash, the department is suffering from a shortage in the annual budget oriented for conservation work.

Therefore, the only chance is to open such work to foreign expeditions, which can carry out some research and conservation work on the site.

On the other hand, very little money in the annual government budget is directed towards the random emergency work that is needed on the site.

PLANNING FOR CONSERVATION	
Conservation Plan (P) Present, (N) Not Present	Planning Typology (A) Annual, (S) Seasonal, (P) Permanent, (C) For Campaign, (O) Other.
N	C + O
Resources for Conservation	
Resources typology	Classification (I) Internal, (E) External, (N) Not present
Vocational Training centre	I + E
Economic resources	I + E

Jarash data.

ECONOMIC RESOURCES FOR CONSERVATION	
Economic resources typology	Financing typology (A) annual, (S) seasonal, (P) permanent, (O) Occasional, (O) other, (N) Not present.
Audience	Usually, the money collected goes to the government, and nothing as a percentage is returned to the site. The annual budget allocated to the site is the only source of income.
Generic visitors	N
Complementary activities fee	There is a yearly running festival on the Jarash site organized and managed by a third party (Higher National committee for Jarash Festival)
Public Institutions	A
Stakeholders Investors	N
Foundations	N
Associations	N
Others	N

Jarash data.

3.3. MAINTENANCE

Definition

Maintenance activities are considered to be all those activities related to specific actions that allow the use of the theatre with the ruins. These could include a spring-cleaning of the theatre, security staff, gardeners, or any external service that collaborates with performance facilities.

Guaranteeing efficient and safe use of ancient structures, as well as provisional ones (removable structures for performances, facilities, etc.) are the two basic aims of maintenance: to avoid the risk of staining, damaging of the walls by anchorages, and the infiltration of oxidizing substances. At the same time, technological efficiency and compatibility of ducts and systems of electricity supply should also be guaranteed, being critical elements because of their impact on ancient masonry. Also a special wariness is needed when approaching technological solutions adopted for illumination, surveillance (remote cameras, alarm system, etc.), electricity supply, etc. These apparatus should guarantee the technological efficiency and compatibility, and respect the technical standards of endurance that have emerged during the analysis of each individual theatre. They should be installed only for the duration of performances, and a constant maintenance of the materials used should also be guaranteed.

Methodology

It is recommended to review the tables below in order to prepare a generic diagnostic about the conservation status and value of the physical and economic resources that the site provides.

In order to achieve proper maintenance of the theatre, a maintenance plan should be developed that can be followed easily day by day and which contemplate all the aspects listed above.

Application to the theatre of Jarash

PLANNING FOR MAINTENANCE	
Maintenance plan (P) Present, (N) Not present	Planning typology (A) annual, (S) seasonal, (P) permanent, (C) for campaign, (O) other.
N (No Maintenance Plan is there)	C

Jarash data.

RESOURCES FOR MAINTENANCE	
Resources typology	Classification (I) Internal, (E) External, (N) Not present
Available space/room	I
Available personnel	I
Facilities	I
Economic resources	I
Is there any external maintenance team, gardener, security staff, etc?	N

Jarash data.

ECONOMIC RESOURCES FOR MAINTENANCE	
Economic resources typology	Financing typology (A) annual, (S) seasonal, (P) permanent, (O) Occasional, (O) other, (N) not present.
Audience	N
Generic visitors	N
Complementary activities fee	N
Public Institutions	A
Stakeholders / Investors	N
Foundations	N
Associations	N
Others	N
We would like to know if some of the money that is collected goes to maintenance.	No, as the maintenance is the responsibility of the local staff of the site, who are paid from the annual budget allocated.

Jarash data.

3.4. INCREASE IN VALUE OF CULTURAL HERITAGE

Definition

The achievement of higher standards related to knowledge, conservation and maintenance practices at an ancient theatre requires an integrated strategy of dissemination and valorisation of a site, i.e. the supply of a wide range of high profile services for the visitor to an archaeological area (thematic guided visits, individual guided visits, audio guides, signs etc.). The presence of interpretation centres, museums, exhibition areas, bookshops, and services creates an increase in value and makes possible the enhancement of cultural-economic conditions inside the Cultural Cluster. All of these activities have to be taken into account in order to develop a Usage Manual for Compatible Utilisation.

Methodology

In order to evaluate this concept, it is necessary to look at the different activities that have already been developed. The internal and external personnel who manage those activities and the frequency of them have to be taken into consideration for planning the increase in value of the Cultural Heritage. In addition, physical and economic resources should be evaluated in order to propose the quantity and kinds of activities that could be carried out over a period of time.

Application to the theatre of Jarash

The tables below contemplate all aspects necessary to plan a preliminary analysis. These ones are completed with Jarash information in order to exemplify this task.

PLANNING FOR INCREASE IN VALUE OF C.H.

Activity	Personnel classification (I) Internal, (E) External	Times Planning (A) annual, (S) seasonal, (P) permanent, (C) for campaign, (O) other, (N) Not present.
Museography/Exhibitions	I + E	A
Centre for interpretation of the site	I + E	A
Thematic guided visit	I + E	P
Individual guided visit	I + E	P
Domestic packaged tour (groups)	I + E	P
Signs	I	P
Others	N	N

Jarash data.

ARCHAEOLOGICAL ENSEMBLE

Activity	Classification (P) present, (N) not present	List of the monuments of the ensemble
Guided visits to the whole archaeological ensemble	P	Oval Plaza Theatres Zius and Artimes Temples The Cardo Nympheom Tetrapolions South + North City Gates City Wall Agora The Museum

Jarash data.

RESOURCES FOR INCREASE IN VALUE OF C.H.

Resources typology	Classification (I) Internal, (E) External, (N) Not present.
Available space/room	I + E
Available personnel	I + E
Facilities	I + E
Economic resources	I + E

Jarash data.

ECONOMIC RESOURCES FOR INCREASE IN VALUE OF C.H.

Economic resources typology	Financing typology (A) annual, (S) seasonal, (P) permanent, (O) Occasional, (O) other, (N) Not present.
Audience	S
Generic visitors	P
Complementary activities fee	S
Public Institutions	O
Stakeholders Investors	O
Foundations	O
Associations	O
Others	N

Jarash data.

3.5. DISSEMINATION

Definition

Among the roles played by the institutions involved in managing ancient theatres, there is one of disseminating the results of the scientific activities related to knowledge, conservation and use of the archaeological site. The dissemination has two main aims: to provide basic information for tourists and to share the most updated knowledge with the scientific community.

Methodology

The different ways of sharing information at the horizontal level are books, journals, websites and conferences, etc. At the vertical level, i.e. within the reference area and the Cultural Cluster, the dissemination task can be carried out by means of professional certified guides trained to speak various languages and provide proper and updated information.

In order to achieve dissemination of theatre information, the activities contemplated in the following tables should be taken into account. Defined activities and the frequency of them should be considered, as well as available resources.

Application to the theatre of Jarash

These tables are filled out with Jarash data in order to provide an example of this task.

RESOURCES FOR DISSEMINATION	
Resources typology	Classification (I) Internal, (E) External, (N) Not present
Available space/room	I + E
Available personnel	I + E
Facilities	I + E
Economic resources	I + E

Jarash data.

PLANNING FOR DISSEMINATION		
Activity	Classification (P) Present, (N) Not present	Times Planning (A) annual, (S) seasonal, (P) permanent, (O) other1, (N) Not present
Exhibition	P	S
Books	P	S
Journals	P	S
Websites	P	S
Conferences	P	S
Others	N	N

Jarash data.

ECONOMIC RESOURCES FOR DISSEMINATION	
Economic resources typology	Financing typology (A) annual, (S) seasonal, (P) permanent, (O) Occasional, (O) other, (N) Not present.
Audience	N
Generic visitors	N
Complementary activities fee	N
Public Institutions	N
Stakeholders / Investors	N
Foundations	N
Associations	N
Others	N

Jarash data.

3.6. ECONOMIC DEVELOPMENT

Definition

The development of integrated policies for the sustainability of performance activities, as well as for the safeguarding of the archaeological structure, is a multi-faceted task. The management plan has to promote and make the development of high quality services easier by means of involving stakeholder investors related to cultural activities and services needed for tourism. The local economy can take advantage of the use of the theatre for dramatic performances, as well as other activities related to the contemporary use of ancient places for performances. Nevertheless, economic development has to fit in with shared standards and utilisation rules, with the aim of preventing any exploitation that could put the cultural value of sites in danger. Thus, in order to achieve development compatible with the use of the theatre, synergies and interferences of the activities contemplated in the tables below should be taken into account.

Methodology

We understand that development must arise as a process of economic, social and cultural integration. In order to carry out these points, it is necessary to undertake a specific study of economic development.

The methodology to estimate a general vision of this field will be the same as in the other sections. The following tables consider activities that could collect money to be invested in the archaeological site, such as shops, restaurants, hostels etc.

Application to the theatre of Jarash

In the case of Jarash, the information provided is not enough for us to prepare a specific economic development project but, with it, we could diagnose strengths and weaknesses that the asset offers.

PLANNING FOR ECONOMIC DEVELOPMENT			
Activity	Classification (I) Internal, (C) Commercial concession (E) External, (N) Not present	Quantity	Note and comment
Annual events and festivals	E	1	Annual Festival
Bookshops	N	0	
Gift shops	N	0	
Restaurants	I	1	
Coffee shops	N	0	
Hotels2	N	0	No Hotels in Jerash
Others	N	0	

Jarash data.

RESOURCES FOR ECONOMIC DEVELOPMENT		
Resources typology	Classification (I) Internal, (E) External, (N) Not present	Quantification
Commercial concession	N	m²
Available personnel	N	number
Consortiums	N	Number of companies
Patronages	N	Number of companies

Jarash data.

ECONOMIC RESOURCES FOR ECONOMIC DEVELOPMENT	
Economic resources typology	Gains
Annual events and festivals	N
Bookshops	N
Gift shops	N
Restaurants	N
Coffee shops	N
Hotels3	N
Others	N

Jarash data.

ATTACHMENTS 3

A.3.1	Deliverables tool II: Model (Printed and Digital version).	

Attachment 3.1.
DELIVERABLES TOOL II: MODEL
WORK PACKAGE 4

TASK 4.2 SETTING UP THE MANAGEMENT PLAN (MP) - INTRINSIC ACTIONS

Specification and Plan of Actions

WP Leader: *Instituto de Restauración del Patrimonio (IRP) - Universidad Politécnica de Valencia*

Plan of Action

TASK	ACTIVITY	PARTNER IN CHARGE	DEADLINE
4.2.1	Knowledge.	All	15th of November 2011
4.2.2	Conservation.	All	15th of November 2011
4.2.3	Maintenance.	All	15th of November 2011
4.2.4	Cultural Heritage's increase in value.	All	30th of November 2011
4.2.5	Dissemination.	All	30th of November 2011
4.2.6	Economic development.	All	30th of November 2011

General structure of the Management Plan

Task 4.1. Information for the development of MP BASIC INFORMATION

Task 4.2. Information needed for the development of MP INTRINSIC ACTIONS

Task 4.3. Information needed for the development of CC INFORMATIVE SYSTEM

Task 4.4. ACTION PLANS

Content of this document

General Description
Tasks Description
Deliverables
Plan of Action

Note

The activity written in **grey** is the objective of this document. Questionnaires to be filled out in the coming months will be delivered to the partners in the following weeks in accordance with the general structure of the Management Plan.

General Description

Aims and intrinsic actions are related to a set of assumptions inspired by the Syracuse Charter, Verona Charter, Segesta Declaration and can be considered as a tool with a double purpose: on one hand, the monitoring of the current situation of every site of the ATHENA network from the point of view of the intrinsic actions of an archaeological site. On the other hand, this task seeks to highlight and determine a list of strategic aims that can properly fit with the distinctive features of each theatre and its environment.

The thematic areas of the intrinsic actions are:
– Knowledge
– Conservation
– Maintenance
– **Increase in value of the Cultural Heritage**
– Dissemination
– Economic development

Every area of the Management Plan intrinsic actions is composed of descriptive parts and tables as follows:
Definition
Strategic aims
Planning
Resources
Funding

The questionnaire attached to this document provides for every partner a series of tables focused on determining aspects related to planning, resources and funding for the theme of Knowledge, Conservation, Maintenance, etc.

EXPECTED RESULTS	TARGET GROUP / BENEFICIARIES	MAIN OUTCOMES
• Census of the planned activities related to the thematic areas. • Identification of the needed resources for every thematic area. • Evaluation and determination of the funding related to thematic areas.	*Local institutions responsible of managerial process* *General scientific community* *Companies/institutions involved in conservation* *Event organizers / Stakeholders investors*	Fulfilment of the part of the *Management Plan* called *"AIMS- intrinsic actions"*: the second step is needed for the development of GUIDELINES FOR COMPATIBLE UTILIZATION and the ANCIENT THEATRE USAGE MANUAL. Sharing of common definitions of the thematic areas of the **"AIMS- intrinsic actions"**. Determination of specific **"AIMS- intrinsic actions"** concerning each theatre.

Tasks Description

Every partner has to fill in the tables of the attached document taking into consideration the following list of thematic areas of the *"AIMS-intrinsic actions"*

TASK **4.2.1. *Knowledge***

The improvement of the general knowledge about classical theatres is a vast and multi-faceted task because it is related to many cultural and scientific fields: architecture, archaeology, dramatic art, analysis and usage of materials, conservation, acoustic, safety, etc. From this point of view, the development of knowledge, has to be seen in accordance with the most updated scientific production (Syracuse Charter, Verona Charter, Segesta Declaration, etc.) which is an integrated process capable of managing and sharing at an international level the highest achievements obtained by each country in each one of the fields related to classical theatres.

TASK **4.2.2. *Conservation***

The protection of ancient theatrical structures, as well as their Cultural Cluster, is a very difficult task due to their continued use as places of performance. Moreover, natural disasters, pollution, and improper use have all continuously contributed to their damage. Conservation, as well as other aspects related to ancient theatres, is concerned with the planning and coordination of many activities by means of an effective policy based on prevention and mitigation of vulnerabilities and danger factors.

TASK **4.2.3. *Maintenance***

Guaranteeing efficient and safe use of ancient structures, as well as provisional ones (removable structures for performances, facilities, etc.) are the two basic aims of maintenance: to avoid the risk of staining, damaging of the walls by anchorages, and the infiltration of oxidizing substances. At the same time, technological efficiency and compatibility of ducts and systems of electricity supply should also be guaranteed, being critical elements because of their impact on ancient masonry. Also a special wariness is needed when approaching technological solutions adopted for illumination, surveillance (remote cameras, alarm system, etc.), electricity supply, etc. These apparatus should guarantee the technological efficiency and compatibility, and respect the technical standards of endurance that have emerged during the analysis of each individual theatre. They should be installed only for the duration of performances, and a constant maintenance of the materials used should also be guaranteed.

TASK **4.2.4. *Increase in value of Cultural Heritage***

The achievement of higher standards related to knowledge, conservation and maintenance practices at an ancient theatre requires an integrated strategy of dissemination and valorisation of a site, i.e. the supply of a wide range of high profile services for the visitor to an archaeological area (thematic guided visits, individual guided visits, audio guides, signs etc.). The presence of interpretation centres, museums, exhibition areas, bookshops, and services creates an increase in value and makes possible the enhancement of cultural-economic conditions inside the Cultural Cluster. All of these activities have to be taken into account in order to develop a Usage Manual for Compatible Utilisation.

TASK **4.2.5. *Dissemination***

Among the roles played by the institutions involved in managing ancient theatres, there is one of disseminating the results of the scientific activities related to knowledge, conservation and use of the archaeological site. The dissemination has two main aims: to provide basic information for tourists and to share the most updated knowledge with the scientific community.

The different ways of sharing information at the horizontal level are books, journals, websites and conferences, etc. At the vertical level, i.e. within the reference area and the Cultural Cluster, the

dissemination task can be carried out by means of professional certified guides trained to speak various languages and provide proper and updated information.

TASK 4.2.6. Economic development

The development of integrated policies for the sustainability of performance activities, as well as for the safeguarding of the archaeological structure, is a multi-faceted task. The management plan has to promote and make the development of high quality services easier by means of involving stakeholder investors related to cultural activities and services needed for tourism. The local economy can take advantage of the use of the theatre for dramatic performances, as well as other activities related to the contemporary use of ancient places for performances. Nevertheless, economic development has to fit in with shared standards and utilisation rules, with the aim of preventing any exploitation that could put the cultural value of sites in danger.

Deliverables

Every partner has to deliver to the IRP team the questionnaire attached to this document, called "deliverables".

Index
General Description

TASKS 4.1. INFORMATION FOR THE DEVELOPMENT OF MP BASIC INFORMATION

 4.1.1. AGENCY RESPONSIBLE FOR DEVELOPMENT AND IMPLEMENTATION OF MP

 4.1.2. IDENTIFICATION OF THE SITE AND CC
 Graphic Documentation Needed For The Definition
 Of The Site And Cc

 4.1.3. IDENTIFICATION OF THE UNIVERSAL AND EURO-MEDITERRANEAN VALUE
 Report about the Universal Value
 Report about and Euro-Mediterranean Value of the Theatre

 4.1.4. SITE CLASSIFICATION

TASKS 4.2. IINTRINSIC ACTIONS

 4.2.1. KNOWLEDGE

 4.2.2. CONSERVATION

 4.2.3. MAINTENANCE

 4.2.4. INCREASE IN VALUE OF THE CULTURAL HERITAGE

 4.2.5. DISSEMINATION

 4.2.6. ECONOMIC DEVELOPMENT

TASKS 4.3. INFORMATION NEEDED FOR THE DEVELOPMENT OF CC INFORMATIVE SYSTEM
 General Graphic Information

 4.3.1. TECHNICAL ASPECTS
 Historical knowledge on the theatre
 History of interventions and restorations on the theatre
 State of conservation of the theatre and CC
 Scientific and technical studies
 Risk and threats

 4.3.2. ECONOMIC/CULTURAL ASPECTS
 Associations and foundations
 Ordinary and special resources for theatre and CC
 Services suppliers for theatre and CC
 Stakeholders investors and sponsors of the CC
 Local Economy of the CC
 Accessibility and infrastructure

 4.3.3. INTANGIBLE ASPECTS

 4.3.4. JURIDICAL ASPECTS
 Property Regime of theatre and CC
 System of protections and urban planning inside the CC
 Safety standards for performance building at local and national level

Note

The activity written in blue is the objective of this document. Questionnaires to be filled out in the coming months will be delivered to the partners in the following weeks in accordance with the general structure of the Management Plan.

Information priority

The alphanumeric and graphic information needed for the development of the MP are of three types, depending on the importance of these documents for the oncoming Management Plan:

LOGOS	IMPORTANCE	MOTIVATION
N$_{ec}$	Necessary	Information considered of high significance for the development of the MP. Without this graphic and/or alphanumeric data, the MP will not be implemented in a proper way.
A$_{dv}$	Advisable	Information supposed to be provided during the implementation of the MP, but not necessary for its start up. In any case, if an institution or a research centre has already produced these documents they have to be delivered for the production of the MP.
A$_{cc}$	Accessory	To this category belongs data of marginal utility. In some special cases, due to a site-specific problem or distinctive feature, the MP may also need this information.

TASKS **4.2. INFORMATION NEEDED FOR THE DEVELOPMENT OF INTRINSIC ACTIONS**

4.2.1. Knowledge

N$_{ec}$

TABLE 4

PLANNING FOR KNOWLEDGE		
ACTIVITY	PERSONNEL CLASSIFICATION (I) INTERNAL, (E) EXTERNAL	TIMES PLANNING (A) ANNUAL, (S) SEASONAL, (P) PERMANENT, (C) FOR CAMPAIGN, (O) OTHER.
Excavations		
Bibliographical/Documentary study		
Survey		
Scientific and technical studies		
Others		

To be filled in with data

EXPLICATION NOTE FOR "OTHERS"

Max 500 words for every other activity

Table 5

RESOURCES FOR KNOWLEDGE

Resources typology	Classification (I) Internal, (E) External, (N) Not present
Available Space/room	
Available personnel	
Facilities	
Economic resources	

Add rows if necessary

Table 6

ECONOMIC RESOURCES FOR KNOWLEDGE

Economic resources typology	Financing typology (A) annual, (S) seasonal, (P) permanent, (O) Occasional, (O) other.
Audience	
Generic visitors	
Complementary activities fee	
Public Institutions	
Stakeholders Investors	
Foundations	
Associations	
Others	

Add rows if necessary

EXPLANATORY NOTE FOR "OTHERS"

Max 500 words for every other activity

4.2.2 Conservation

Table 7

PLANNING FOR CONSERVATION	
Conservation plan (P) Present, (N) Not present	Planning typology (A) annual, (S) seasonal, (P) permanent, (C) for campaign, (O) other.

To be filled in with data

Table 8

RESOURCES FOR CONSERVATION	
Resources typology	Classification (I) Internal, (E) External, (N) Not present
Vocational Training centre	
Economic resources	

Add rows if necessary

Table 9

ECONOMIC RESOURCES FOR CONSERVATION	
Economic resources typology	Financing typology (A) annual, (S) seasonal, (P) permanent, (O) Occasional, (O) other.
Audience	
Generic visitors	
Complementary activities fee	
Public Institutions	
Stakeholders Investors	
Foundations	
Associations	
Others	

Add rows if necessary

EXPLANATORY NOTE FOR "OTHERS"
Max 500 words for every other activity

4.2.3 Maintenance

N_{ec}

Table 10

PLANNING FOR MAINTENANCE	
Conservation plan (P) Present, (N) Not present	Planning typology (A) annual, (S) seasonal, (P) permanent, (C) for campaign, (O) other.

To be filled in with data

Table 11

RESOURCES FOR MAINTENANCE	
Resources typology	Classification (I) Internal, (E) External, (N) Not present
Available Space/room	
Available personnel	
Facilities	
Economic resources	

Add rows if necessary

Table 12

ECONOMIC RESOURCES FOR MAINTENANCE	
Economic resources typology	Financing typology (A) annual, (S) seasonal, (P) permanent, (O) Occasional, (O) other.
Audience	
Generic visitors	
Complementary activities fee	
Public Institutions	
Stakeholders Investors	
Foundations	
Associations	
Others	

Add rows if necessary

EXPLANATORY NOTE FOR "OTHERS"
Max 500 words for every other activity

4.2.4 Cultural Heritage increase *in value*

N_{ec}

Table 13

PLANNING FOR INCREASE IN VALUE OF C.H.		
Activity	Personnel classification (I) Internal, (E) External	Times Planning (A) annual, (S) seasonal, (P) permanent, (C) for campaign, (O) other.
Museography/Exhibitions		
Centre for interpretation of the site		
Thematic guided visit		
Individual guided visit		
Domestic packaged tour (groups)		
Signal		
Others		

To be filled in with data

EXPLANITORY NOTE FOR "OTHERS"
Max 500 words for every other activity

ARCHAEOLOGICAL ENSEMBLE		
Activity	Classification (P) present, (N) not present	List of the monuments of the ensemble
Guided visits to the whole archaeological ensemble		

Table 14

RESOURCES FOR INCREASE IN VALUE OF C.H.	
Resources typology	Classification (I) Internal, (E) External, (N) Not present
Available Space/room	
Available personnel	
Facilities	
Economic resources	

Add rows if necessary

Table 15

ECONOMIC RESOURCES FOR INCREASE IN VALUE OF C.H.	
Economic resources typology	Financing typology (A) annual, (S) seasonal, (P) permanent, (O) Occasional, (O) other.
Audience	
Generic visitors	
Complementary activities fee	
Public Institutions	
Stakeholders Investors	
Foundations	
Associations	
Others	

To be filled in with data

EXPLANITORY NOTE FOR "OTHERS"
Max 500 words for every other activity

ATHENA PROJECT
ANCIENT THEATRES ENHANCEMENT FOR NEW ACTUALITIES
FUNDAMENTALS

4. Guidelines for Compatible Utalitation

4.1. CHARTERS AND RECOMANDATIONS

List of Charters

During the last forty years, a remarkable number of recommendations have been written by international institutions and scientific communities about the theme of conservation and cultural heritage in general. But over the last fifteen years in particular, they have focused their attention on more specific topics concerning the relationship between the utilization and conservation of cultural sites with special regards to the opportunities provided in other fields (economic development, enduring sustainability, etc.).

The following is a list of the main documents related to the themes of the Athena Project:

CHARTER
SIRACUSA CHARTER *For the conservation, fruition and management of the ancient theatrical architectures*
SEGESTA DECLARATION *Adopted at the conclusion of the Symposium "safeguarding and use of ancient theatres", organized in Segesta, Trapani, Palermo, 17-20 September, 1995*
VERONA CHARTER ON THE USE OF ANCIENT PLACES OF PERFORMANCE *Adopted at the International Colloquy held in Verona, August 1997*
CHARTER INTERNATIONAL FOR ARCHAEOLOGICAL HERITAGE MANAGEMENT *Adopted by ICOMOS in 1990*
PRINCIPLES FOR THE CREATION OF DOCUMENTARIES OF MONUMENTS, ARCHITECTURAL SETS, AND HISTORICAL AND ARTISTIC SITES FILES *Adopted by ICOMOS in 1996*
RECOMMENDATION (88) 5 ON THE CONTROL OF THE PHYSICAL DETERIORATION OF THE ARCHITECTURAL HERITAGE, ACCELERATED BY POLLUTION *Of the Committee of Ministers to the Member States. Adopted by the Committee of Ministers on 7 March 1988 in the 415th meeting of the delegates of Ministers*
RECOMMENDATION (86) 15 ON THE PROMOTION OF THE CRAFTS CRAFT INVOLVED IN THE CONSERVATION OF ARCHITECTURAL HERITAGE *Council of Europe Committee of Ministers to the Member States. Adopted by the Committee of Ministers meeting of the delegates of Ministers on October 16, 1986 in the 400th meeting*
RECOMMENDATION (93) 9 OF THE COMMITTEE OF MINISTERS TO MEMBER STATES ON THE PROTECTION OF THE ARCHITECTURAL HERITAGE AGAINST NATURAL DISASTERS *Adopted by the Committee of Ministers on 23 November 1993 in the 503rd meeting of the delegates of Ministers*
RECOMMENDATION NO. R (95) 10 OF THE COMMITTEE OF MINISTERS TO MEMBER STATES ON A POLICY OF SUSTAINABLE TOURISM DEVELOPMENT IN PROTECTED AREAS *Adopted by the Committee of Ministers on 11 September 1995 in the 543 meeting of Ministers.*
RECOMMENDATION (98) 4 OF THE COMMITTEE OF MINISTERS TO MEMBER STATES ON MEASURES TO PROMOTE THE CONSERVATION INTEGRATED HISTORICAL DATASETS COMPOUNDS OF REAL ESTATE AND MOVABLE PROPERTY *Adopted by the Committee of Ministers on 17 March 1998 at the 623ª meeting of the delegates of Ministers.*
RECOMMENDATION ON THE SAFEGUARDING OF TRADITIONAL AND POPULAR CULTURE *Adopted by the General Conference at its twenty-fifth session, Paris, 15 November 1989*
RECOMMENDATION THAT DEFINES THE INTERNATIONAL PRINCIPLES TO BE APPLIED TO THE ARCHAEOLOGICAL EXCAVATIONS *December 5, 1956*
RESOLUTION (66) 20 RELATIVE TO THE RESUSCITATION OF MONUMENTS *Adopted by the representatives of the Ministers on 29 March 1966*
RESOLUTION (68) 12 ACTIVE CONSERVATION OF MONUMENTS, ENSEMBLES AND SITES OF HISTORIC OR ARTISTIC INTEREST WITHIN THE CONTEXT OF THE MANAGEMENT OF THE TERRITORY *Adopted by the delegates of Ministers on 3 May 1968*
RESOLUTION (76) 28 ON THE ADAPTATION OF THE LEGISLATIVE AND REGULATORY SYSTEMS TO THE REQUIREMENTS OF THE INTEGRATED CONSERVATION OF ARCHITECTURAL HERITAGE *European council Adopted by the Committee of Ministers on 14 April 1976 in the 256ª meeting of the delegates of Ministers*
RESOLUTION (98) 4 ON THE CULTURAL ROUTES OF THE COUNCIL OF EUROPE *Adopted by the Committee of Ministers on 17 March 1998 at the 623ª meeting of the delegates of Ministers*
SUSTAINABILITY OF TOURISM THROUGH ITS NATURAL AND CULTURAL RESOURCES MANAGEMENT ORGANIZATION OF AMERICAN STATES *INTER-AMERICAN CONFERENCES OF TOURISM XVII Inter-American Congress of tourism. OEA/Ser.K.III.18.1 7-11 April 1997. Tourism-doc.11/97 San Jose, Costa Rica. January 31, 1997.*

4.2. IDENTIFICATION AND USES DEFINITIONS

Current uses of theatres create a continuous impact on theatre structures, and also the lack of awareness among the local population can sometimes play a role in aggravating the situation, whereby little or no cultural value is attached to the asset itself. Thus, a well-oriented policy based on the evaluation of risks and the setting up of proper measures for their mitigation could be an attempt to create a balance in terms of compatible uses throughout the year.

Thus, the need for a common strategy seems to arise, involving the design, testing and implementation of a management plan. This instrument would not only deal with the theatre's issues only, but would also extend its influence to the environment and landscape of which the theatre is part, so that it would affect an ensemble of cultural heritage elements.

The guidelines for a compatible utilization of the Ancient Theatres pursue:

- To facilitate the management of visitor flows in order to improve the site and minimize impacts
- To improve the image of the responsible institution managing the site
- To seek a supportive behavior from the visitors for conserving the site
- To promote the socio-economic development of the local community by providing tourists with information about local tourism services (hotels, restaurants, handicrafts, etc.)
- To mitigate risks by providing information and safety recommendations to the users.

Identification and uses definitions

Ancient Theatres, while constituting important attractions for cultural tourism purposes, are currently also used for various activities, especially those related to cultural issues. Usually, these activities take place in the same space and at the same time.

Other thing is that the current uses of theatres create a continuous impact on theatre structures originally designed for needs very different from contemporary ones. Moreover, these structures are intensively used during certain periods, while experiencing a sort of hibernation during other periods.

Thus, the first step is to identify the possible different uses that an Ancient Theatre can support. Activities can be classified in several groups: Tourist Activities, Staging Activities, Cultural Activities and Traditional Activities.

- Tourist Activities are dealing with visitation actions. These visits can fall within the scope of leisure and entertainment activities or in the field of educational and interpretative ones. This depends on the programs and services delivered by the responsible theatre authorities. The desirable situation is to implement an interpretation program with the related services and facilities because an Ancient Theatre is a valuable cultural resource that deserves this kind of presentation.

- Different types of visits can be arranged in the Ancient Theatres: extraordinary pre-arranged visits composed of special groups of experts or VIPs, and the ordinary visits (individual guided visits, individual self-guided visits, domestic or international packaged guided tour groups).

- It is important to know if the theatre is the only attraction for the visitor or if it is considered in a larger historical context.

- Staging Activities are those related to theatrical performances. Beyond the drama activities that are the most popular among the staging activities, other art performances take place in Ancient Theatres such as musical concerts (orchestras or bands), operas, dance performances (ballets, etc.), choir events, lectures, cultural shows, or historical representations among others.

- Cultural Activities are special events and include cultural shows, permanent or temporary exhibitions, museums, etc.

- Traditional Activities include any activity held by the local community as part of their cultural legacy. It is important to know about this group if there is any kind of legal regulation for the activity.

For all the developed activities it is important to know the Activity Schedule in terms of Availability (explanations if the activity is held on a daily, weekly, monthly basis, and the reason for this) and Duration (the estimated time for carrying out the activity). It must also be noted if these activities are programmed or if they are sporadic or specific.

4.2.1. TOURISM

Definition

The Athena Project has the aim of promoting responsible and sustainable tourism; people travelling and staying in one or more of the Cultural Clusters of the Athena consortium should be informed about themes related to the traditional culture of the local population and, in addition, should receive proper education on the meanings of the ancient theatres.

Travelling for recreational, leisure or business purposes should be undertaken with the aid of a general policy aimed at creating a deeper awareness about the usage of ancient structures; if people don't know about an archaeological site, they cannot truly respect it and its environment. The consciousness about every part of a cultural set should avoid anthropic danger and exploitation of

TOURISM Best Practices

Visit to the Villa Adriana (Roma)

a site. For example, it is important to control access to overcrowded areas of an archaeological site by means of regulating the numbers of visitors at planned times; these kinds of measures can produce inconvenience and irritation for tourists, but with proper education about the potential threats generated by the exploitation of a site, tourists can understand the importance of stricter rules being necessary to preserve delicate and fragile ancient buildings.

On the other hand, there is the problem of the promotion of unused or not well-known archaeological sites. In this case it is important to put into practice policies aimed at promoting and facilitating transportation to these sites and to let tourists know about the presence of relevant cultural sites in a cultural cluster.

Theatres can be considered as powerful attractors for tourists thanks to their legacy both in cultural terms and contemporary use. At the same time, the Athena Project wants to promote sustainable tourism of the theatres by means of a managerial tool capable of using all kinds of resources: economic, social and built heritage. These purposes have to match other aims that have to do with maintaining cultural integrity, ecological-environmental respect, and the ability of future generations to develop their economic-cultural level. Sustainable tourism can be seen as having regard to ecological and socio-cultural carrying capacities and includes involving the community of the destination in the planning of tourism development.

Users profile and motivations

Visitors´ profile studies must be conducted in order to know the answers to these key questions:

- Who are the tourists that visit Ancient Theatres, and why?
- What specific motivations, attitudes and behaviours make them distinct from other tourists?
- How large is the demand for Ancient Theatres and what specific activities attract tourists?
- How can tourism in Ancient Theatres be successfully developed and promoted?

Many research studies suggest that a substantial percentage of tourists (40% according the World Tourism Organization) seek cultural experiences, such as visiting cultural attractions and participating in diverse cultural activities. Based on this data, it has been argued that cultural tourists represent a new type of mass tourist who seeks meaningful travel experiences.

Planning and managing tourism in Ancient Theatres demands setting up specific instruments to guarantee both: the resources' conservation and the visitors' satisfaction.

One of the most important factors in relation to the spatial components is the Recreational Carrying Capacity. This management tool is one of the most recognized methods in order to guarantee the sustainability and conservation of the iconic attractions. It sets the limits of the established and desired site conditions according to both the proposed recreational use level and the conservation goals. In general terms, the concept of Recreational Carrying Capacity addresses the question of how many people can be permitted into an area without the risk of degrading the site and the visitors' experience on it.

Recreational Carrying Capacity represents an important conceptual framework within which to view recreation management because it provides the basis for examining the interactions between recreational supply and demand considerations, between concerns about resource conditions and perceived recreational quality, and between the quantity of recreational opportunities supplied and the quality of experiences derived from them.

For all these reasons a Recreational Carrying Capacity study for determining and managing the suitable number of visitors and spectators is suggested.

- An applied evaluation must be done to establish the Theatre Values for culture and tourism purposes. Recreational criteria must be taken into account for the evaluation of the tourism potential such as attractiveness, accessibility, fragility/vulnerability, feasibility, availability, educational values and increasing awareness values.
- Accessibility refers to how easy it is to visit the element in terms of road communications, tourism facilities and services.
- Fragility is defined as susceptibility to disturbance, usually human-caused (impacts). The importance of using this criterion lies in its relationship with the likelihood of destruction of or alteration to the element in question.
- Feasibility is used to evaluate the internal and external repercussions of the tourism and staging options and association with economic viability (assessment costs and benefits, acquisition costs, restoration costs, management and maintenance costs), social benefits and the attitude of the stakeholders.
- Availability is associated with the possibility, frequency or temporal availability of the element. In the case of the Ancient Theatres availability is permanent but some climatic conditions, managerial staff, and other causes can limit the availability.

KEY ISSUES IN THE ANCIENT THEATRES RECREATIONAL CARRYING CAPACITY ASSESSMENT STUDIES

María José Viñals
Maryland Morant
Pau Alonso-Monasterio
Universitat Politècnica de València
mvinals@cgf.upv.es
marmogon@cgf.upv.es
paualfer@doctor.upv.es

ABSTRACT

Planning and managing tourism in Ancient Theatres demands setting up specific instruments and tools to guarantee both the site conservation of this significant Greco-Roman Mediterranean heritage, and the visitors' satisfaction by providing a quality experience.

This paper focuses the interest in the Recreational Carrying Capacity Assessment by pointing to the main elements that must be addressed in these studies. Therefore, an analysis is provided of the key issues in relation to the characterization of the space where the activity takes place; the natural, cultural and the scenic resources involved in the tourism activity; the recreational activities planned making them compatible with the staging activities, as well as the analysis of visitors' profiles, behaviours and expectations.

Results point out some methodological remarks about calculations and spatial standards (performance criteria) for determining the available space for recreation activities considering the fragility of the resources, the space requirements for developing the interpretative activities, including the analysis of the facilities and safety limiting factors. Standards about the perceptual components (Visitors' Psychological Comfort) have been provided on the basis of the social limiting factors analysis (proxemic standards, group size, number of encounters with other groups, perception of crowding, etc.). Additionally a touring pattern for managing visitors in Ancient Theatres is proposed in order to avoid impacts, congestion, and to provide a good interpretation program and a quality experience to the visitors.

Key words: Recreational Carrying Capacity Assessment, Ancient Theatres, Visitor Management, Performance criteria

1. INTRODUCTION

The Ancient Theatres represent one of the most significant cultural heritage remains of the Greco-Roman Mediterranean civilizations. The diffusion of this architectural type throughout the whole Mediterranean Basin is extraordinary. They are considered physical witnesses to the past; thus reconstructing and understanding the past allows local people to reinforce their identity links and permits the general public to access that history.

Additionally, it can be stated that a large number of Ancient Theatres are still being used for various activities. They are utilized as cultural venues, especially for performances and staging activities. However, an increase in public awareness and also local socio-economic development could be stimulated by adequately enhancing Ancient Theatres as tourism attractions, contributing in this way to the enormous costs that restoration and conservation entail. Therefore, an important responsibility of modern societies is to conserve this precious legacy through the preservation of their unique scientific, cultural, artistic and historical values.

Nevertheless, it must be pointed out that the Ancient Theatres, being elements located outdoors, are fragile sites subject to physical degradation due to natural hazards and weathering conditions, but visitors and spectators can also have an impact on these heritage sites.

For these reasons, it is very important to highlight the need for tourism technical management tools to avoid the degradation of these sites.

This paper focuses its attention on tourism activities taking place in the Ancient Theatres, particularly on planning and managing tools that could help with heritage conservation and also those that could provide a satisfactory experience to the visitors as the Verona Charter[1] suggests. Among the tools, this research investigates the Recreational Carrying Capacity Assessment (RCCA) because it has

[1] The Verona Charter on the use of performance (1997) is the result of co-operation between the Council of Europe, the European Union and Unesco (Accessed 10 June 2012).

scientifically proven its value as an instrument for setting the limits of the established and desired site conditions according to both the proposed recreational use level and conservation goals. The Recreational Carrying Capacity Assessment addresses the question of how many people can be permitted into an area without the risk of degrading the site and the visitors' experience in it (Pedersen, 2002).

Traditionally, the Recreational Carrying Capacity Assessment is a long-standing issue in outdoor recreation, guiding the decision making processes in relation to these sites and becoming increasingly important since the 1960s when the first rigorous applications of carrying capacity occurred. Mathieson and Wall (1986), Kuss et al., (1990), O'Reilly (1991), Cifuentes (1992), McNeely et al., (1992), Butler (1996), Buchinger (1996), Chamberlain (1997), and Middleton and Hawkins (1998) were important authors, among others, who have mainly worked with a perspective orientated to biophysical components and impacts prevention based on the study of thresholds or tolerance levels beyond which further exploitation or use may impose strains on the natural or cultural resources. Other authors have incorporated to the analysis some social aspects of the visitors' experiences. Therefore, psychological and sociological components focused on visitors' perceptions when developing the recreational activity in direct relation with the quality of the experience have been studied by Shelby and Heberlein (1986), Harroun and Boo (1995), Tarrant and English (1996), Lindberg and McCool (1998), Viñals et a (2003), López Bonilla and López Bonilla (2007), among others. Thus, during the evaluation it is necessary to consider some visitors' personality traits or cultural features such as behaviour and habits, beliefs, etc., these components being difficult to quantify and evaluate (Morant, 2007, Morant and Viñals, 2010).

2. BACKGROUND

In relation to the study of the Ancient Theatres' management, previous projects have dealt with the Mediterranean area such as the ERATO devoted to the identification, evaluation and revival of the acoustical heritage of ancient theatres and odea[2]. Moreover, Haddad (2007) studied the framework of this project, criteria for the assessment of the modern use of ancient theatres and odea. These criteria considered several parameters related to human comfort, in addition to architecture and acoustic qualities.

However, no previous research dealing particularly with the Recreational Carrying Capacity Assessment for these sites has been found. Coccossis and Mexa (2004) broadly addressed the limits related to build-cultural environment aspects for cultural sites (ancient theatres, museums, etc.), indicating the need to establish their capacity in terms of an acceptable level of congestion or density. Rose (2005) studied aspects in relation with the spectators' comfort in Roman entertainment buildings, and Viñals et al. (2011) have presented results about the recreational carrying capacity assessment of archaeological sites and other outdoor heritage sites.

It must be noted that Recreational Carrying Capacity Assessment is not the same concept as Seating Capacity, which refers to the number of spectators that an Ancient Theatre can accommodate. This is very important data that is interesting to know in order to develop staging and performance activities.

3. APPROCH OF THE MEDITERRANEAN ANCIENT THEATRES RECREATIONAL CARRYING CAPACITY ASSESSMENT

the main goal of this paper is to analyse the usefulness of applying the Recreational Carrying Capacity Assessment in the framework of the Ancient Theatres enhancement, and to identify and characterize the key elements of this managerial instrument. Although RCCA seems to be a simplistic and easy-to-implement tool, it is quite complex and works based on a systemic approach, examining area issues from different perspectives, studying specific site conditions and limiting factors (physical-ecological, social and political-economic), and it must be considered within the framework of a huge planning process for tourism development.

The key components of the analysis are: the space where the activity takes place (size and features of the area); resources involved; proposed recreational activities planned; and visitors' profile, behaviour and expectations. Also, standards for conservation and physical and psychological comfort of visitors have been considered. Results from the different analyses have been integrated and relationships (performance criteria) among the components, standards and limiting factors have been underlined.

The process of setting up all the aforementioned components and data was drawn following the classical three consecutive level approaching: Physical Carrying Capacity (PCC), Real Carrying Capacity (RCC), and Effective Carrying Capacity (ECC).

The analysed spaces in this research are the Ancient Theatres (fig. 1), which are semi-circular outdoor opened historical monuments consisting of different spaces: the auditorium or cavea (seating area) is an area made up of several concentric belts of rows of steps, radially split into sectors by stairs converging at the orchestra pit (circular platform for musician players and dancers); and a raised narrow platform called the stage or the scene (scaena) within this circle. The scene building (scaenae frons) encloses the stage. Numerous and

[2] This research project was implemented within the Fifth Framework INCOMED Programme of the European Commission, under the thematic title 'Preserving and Using Cultural Heritage'.

FIG. 1 Different spaces constituting an Ancient Theatre. (Roman Theatre of Jarash, Jordan) Author: P. Guerin (2008)

spacious entrances exist in the Ancient Theatres in order to safely handle the number of spectators in attendance. The most important entrances are the two aditus maximum, one on either side between the orchestra and the scene.

These ancient archaeological theatre structures are 2,000 years old or more. They were solidly constructed and have stood the test of time. Raw materials are basically hard stones such as limestone or even marble rocks that are very resistant to weathering.

The resources involved in these processes are the monuments themselves; in other words, the architectural structure is both the main attraction, and also the physical support of the activities. This means that Ancient Theatres are subject to the natural damage caused by weathering and natural hazards, and also to those effects due to staging and visitation activities. Related-impacts can be multiple and represent a great threat to the conservation of this heritage.

Tourism activities have been the focus of this RCCA study, basically those related to visitation actions. These visits can fall within the field of leisure and entertainment activities or the field of educational and interpretative ones. In the case of Ancient Theatres, interpretative activities have been identified as the best ones for providing historic knowledge and awareness to the public.

Regarding the different current types of visits in Ancient Theatres, the following ones have usually been registered around the Mediterranean countries: extraordinary pre-arranged visits composed of special groups of experts or VIPs; and the ordinary visits (individual guided visits, individual self-guided visits, and domestic or international packaged guided tour groups).

An important point of the study is to determine the level of compatible utilization between these activities and the staging and performance ones because both take place on the same place and present their peak season at the same time.

The standard profile visitor who best fits in the Ancient Theatres is the "cultural tourist". Silberberg (1995) identified four types of cultural tourists, ranging from the "greatly motivated" to the "accidental" and many other authors since him have agreed on the existence of diverse categories depending on the visitors' motivations and behaviour. The "greatly motivated" by culture tourists are people who travel to a city or region specifically because of its cultural opportunities, such as museums, cultural festivals and theatres, among others, because their needs deal mainly with acquiring historical and artistic knowledge. The "accidental" cultural tourists are people travelling to the region who do not intend to go to a cultural attraction or event but find that the cultural opportunity is close to their hotel, or to their cruise ship. The aim of these visitors is to satisfy some simple outdoors leisure and entertainment needs linked to the visit of the settlements and their surroundings. This last group has grown substantially in the past decades to the extent that the World Tourism Organization talks about a new type of mass tourist.

3.1. Physical Carrying Capacity

The first stage in the analysis is to determine the Physical Carrying Capacity (PCC), which is a rough estimate of the maximum number of visitors that an Ancient Theatre is actually able to support. In the case of individual attractions, as is our case, it will be the maximum number that can fit in the site at any given time and still allow people to be able to move.

PCC basically deals with spatial considerations, and is easier to be determined in limited well-defined areas. Only space limiting factors must be taken into account, considering the existence of restricted zones, because archaeological resources are unique and fragile[3] and they must be preserved, and also because of safety reasons. Other spatial limitations could be due to the incompatibility with other staging and performance activities and also with archaeological works in operation. In the Ancient Theatres, the cavea, the orchestra pit and, on a partial and occasional way, the stage can all be considered as suitable spaces for visitation activities.

Once a zoning system is established highlighting the Available Surface Area for Recreation (Viñals et al., 2004), the PCC can be easily calculated by following Boullon's formula (1985): the area used by visitors divided by the average individual standard. In this way the peak capacity is obtained. The total number of daily visits is obtained by applying a rotation coefficient (number of daily hours available for the visit divided by average time of the visit).

The standard of individual space requirements are directly linked with the Visitors' Psychological Comfort. Proxemic studies developed by Hall (1966) stated that the need for inter-personal space in a social

[3] The Verona Charter suggests building "attractive paths that steer the public away from fragile areas. In some cases, access to sensitive or dangerous areas will have to be prohibited".

context is 120 cm higher than for calculations used for the seating capacity, estimated at 0.5 m² for every person following the Spanish National Regulation. When developing dynamic activities, the World Tourism Organization (2005) talks about 4.00 m² which is also the standard space in recreational outdoor activities deduced by some authors such as Morant (2007), and Morant and Viñals (2010) from several empirical works on outdoors spaces.

3.2. Real Carrying Capacity

The second level of the process is to evaluate the Real Carrying Capacity (RCC). This stage of the process basically deals with the study of the limiting factors, reducing the amount of visitors obtained from the PCC calculation.

This study includes the analysis of the site conditions, and the physical, ecological (if necessary) and social factors. It can be said that this stage is the most complex to address because of the many variables influencing the analysis. It is necessary to take into consideration that this study can vary according to the different settings, activities, resources or visitors' profiles considered. Thus the limiting factors are not necessarily the same for each theatre.

The identification of the physical and social limiting factors is based on the application of the performance criteria. These are the standards that define the desirable site conditions. The method to follow is firstly to carry out an Inventory of Resources. This tool records the current status quo of the elements of the Ancient Theatre, considering the minimal acceptable conditions for conserving the place but expecting to improve the site as much as possible by managing techniques and strategies. Furthermore, a direct and indirect, short-term and long-term impacts study must be carried out in order to know the different levels of archaeological resources degradation or even destruction and the preventive and contingency measures to be considered in order to prepare the site to be presented to the public.

Therefore, results of this study allow us to: refine the zoning system previously established and know the most appropriate areas for visitation (i.e. where materials, fabrics and pavements are inherently more resistant, avoiding mosaic and opus sectile floors), set the visitors' touring pattern inside the site, identify areas that need particular physical protection through ropes, fences, handrails, etc., and avoid improper uses.

In relation to tourism activities, it is necessary to undertake a detailed study of the features and actions developed in these activities. Consequently, information about activity schedules in terms of availability (explanations if the activity is held on a daily, weekly, monthly basis, and the reason for this), and duration (the estimated time required to carry out the activity) is needed. Also, it must be noted if these activities are programmed or are sporadic or specific. Additionally, a detailed study evaluating the potential damage that public access may provoke must be carried out. In relation to that, it must be noted that the most relevant impact detected concerning the nature of degradation at archaeological sites, are mechanical and occasionally voluntary degradations that exist in various forms. Viñals et al. (2011) found evidence that human passage provokes abrasion due to the rubbing of shoes on the floors. Individually, a visitor does not cause significant damage, but these many small acts of degradation are cumulative. Therefore, it may be argued that the risks for an archaeological site are to a certain extent related to the number of visitors. Another impact is the destruction of the archaeological setting (the falling of blocks and fabric degradation), which is closely related with the action of stepping on the archaeological structures. Littering is an action that often occurs and causes visual and olfactory impacts. Other voluntary damaging actions are related to plundering and looting, making graffiti and committing vandalism.

This kind of research about the site conditions and physical limiting factors usually uncovers the need to apply some reductions in the number of visitors or planned activities according to the impact level caused.

On the other hand, limiting social factors are related with the Visitors' Psychological Comfort, and also with the needs, wants and expectations of visitors. This study goes beyond the aforementioned proxemic approaches. Thus, user perceptions and opinions about what types and levels of use are appropriate are an essential element of carrying capacity prescriptions. In this kind of study, several variables must be taken into account that determine the social standards, such as: some features of the setting where the activity is developed; the thermohygrometric features that determine human climatic comfort (weather limiting factors); the visitors' motivations and behaviour; the visitors' expectations, the existing facilities (facilities limiting factor); and the safety conditions (safety limiting factor). Other social standards are usually considered, especially in highly frequented sites, such as the visitors' perception of crowding and the number of encounters with others groups at the site.

The configuration, shape and characteristics of the space where tourism activity takes place is important for designing and implementing the best touring pattern in order to avoid impacts, congestion, and to provide a good interpretation program and a quality experience to the visitors.

The Ancient Theatres configuration imposes a complicated touring pattern, because they are open-air spaces with a high visual fragility due to the existence of many viewing locations, and also many available view points (at the foreground, middle ground and background planes), and also panorama views. Nothing can be hidden there, included the

presence of visitors. This means visitors themselves constitute a visual and also acoustic intrusion that reduces the quality of the experience.

At most Ancient Theatres, the entrances to visit the site are usually arched passageways named aditus maximum or parados. Thus the flow of visitors leads directly to the orchestra. Other entrances, such as the vomitoria leading to or from the cavea, are currently not in operation. Therefore, the orchestra is the meeting point and first stop on the tour. Moreover, walking the cavea implies going up steps and stairs. For these reasons, the logical touring pattern proposed to guarantee the minimum visual impact and the most physical and psychological comfort for visitors, is a pie-shaped pathway (fig. 2), with the orchestra pit being the apex of the triangle and accessing the upper part of the cavea (summa cavea) by the side staircase. Also, an access to the large passage or corridor (diazoma) between the summa cavea and media cavea must be facilitated for the people with a lower physical fitness level. Once in the upper or medium belt of rows, some spontaneous diversions can be permitted to the media cavea and ima cavea (lower part). Nevertheless, the expected behaviour from visitors is not much climbing and descending the steps because it is exhausting. Afterwards, the pathway leads the visitors to come back down to the orchestra pit by descending the opposite side staircase. Other pathways could be implemented from the orchestra to the stage out of the staging season. In any case, it is important to highlight that the orchestra pit is the core element where groups must be organized and distributed to avoid congestion.

FIG. 2 Proposed pie-shaped touring pattern for Ancient Theatres. The orchestra pit is the apex of the triangle that leads to summa cavea by the side staircase and also to the diazoma and to the stage.

Additionally, Ancient Theatres provide a unique sensory landscape due to their particular acoustic features. For one to enjoy this experience it is necessary to be aware that a large number of visitors all talking at once can affect the acoustic performance and limit the opportunity to benefit from the uniqueness of this special soundscape. For this reason, the need for the existence of a Code of Ethics and Etiquette and controls over the number of visitors must be emphasised.

In relation to the weather limiting factors determining the physical comfort of visitors, it should be stated that the thermo-hygrometric features of the Mediterranean climate allow for the development of open-air activities throughout practically all the year; therefore the weather limiting factors are negligible. Nevertheless, summer time is the peak season for tourism and in the early afternoon the hours of higher temperature occur; therefore visitation activities must be restricted due to the risk of heat strokes and heat exhaustion.

Another key component of the RCCA analysis are visitors. The crucial data in this study is to know the number of visitors. Accordingly, the total number of visitors per year must be registered, noting the peak season and the low season. Other useful data are the maximum number of visitors recorded in one day (especially in those cities which are cruise ship destinations); the daily and monthly average of visitors; and the type of visitors in terms of socio-demographic data (nationals, internationals, age, gender, level of education, occupation, individuals and scholar groups, tourist package groups, others). Potential demand studies must be carried out when an Ancient Theatre hosts tourism activities for the first time. Although it is true that the volume of tourist flows is an important variable, McCool (1996) and also Pedersen (2005) suggest that rather than the number of users, it is the behaviour of those users that create the problem of recreational use and related-impacts, because a large number of people can be accommodated in an area if there is enough education and proper site management. Therefore, it should be stated that visitors' behaviour is related to the level of respect, appreciation and education that visitors have for this kind of heritage.

Furthermore, to achieve a satisfactory experience, it is important to guarantee psychological comfort for the visitors. Therefore, understanding the needs and expectations of the visitors and designing activities to meet them is a relatively straightforward concept. Rather than personal factors (age, gender, etc.), it is also crucial to consider the cultural background (beliefs, rituals, values, ways of thinking, etc.), and social influences (references groups, lifestyle, etc.). Visiting the Mediterranean Ancient Theatres is an increasing trend among tourists, but when they are choosing a destination to spend their holidays, they are looking for a vital experience beyond just obtaining knowledge about the heritage; thus managers not only should conserve and present accurately the site but also provoke emotions and valuable experiences. This approach was already adopted by the Verona Charter, being one of the principles strongly recommended for ensuring a satisfying and enjoyable experience for visitors.

The social limiting factors regarding the psychological comfort of users also consider other issues such as the perception of crowding, the group size, and the number of encounters with others groups. Congestion or overcrowding of the main iconic attractions produces a psychological constraint for the visitors. Congestion can occur always, periodically or seldom. Other elements related to the unsatisfactory experience include the presence of large queues in some areas. It should be highlighted that not only can the iconic attractions be affected by queues but also the toilettes, entrances and ticket offices can be affected.

In the case of interpretative and educational activities and appreciating the theatre's visual and acoustical features, the suggested number of encounters must be low. This means that few groups can visit the theatre at the same time because visitors feel uncomfortable meeting other people that do not belong to their group. Stankey and McCool (1984) note that the importance of the experience greatly influences attitudes towards encounters with others and measures of satisfaction. Field observations show that most visitors like visiting these unique places in the context of a quiet atmosphere and an acceptable solitude level; thus no more than four or five groups at the same time must meet.

On the other hand, it is reasonably to propose group sizes limited to 10 people as being appropriate in these kinds of heritage sites. This figure is justified for heritage conservation reasons, by safety measures, and also by educational and interpretative effectiveness. The American Educational Research Association (2003), the National Gallery Management authorities (UK)[4] or the Alhambra (Granada, Spain) managers[5] recommend groups of less than 30 people, and the appropriate group-size was established to be of 20 people or less.

The safety limiting factors are also strongly linked to visitors' physical and psychological comfort, and then to the quality of the experience. Safety issues deal with the risks for users during the development of the activity (places with stairs or slopes, irregular floor surface, holes, etc.) and must be taken into consideration, especially in relation with kids and elderly visitors. Emergency and evacuation measures must be planned (ways of escape, entry/exit access, etc.) for guaranteeing the perception of safety and, of course, for handling any contingency.

The facilities limiting factor is related to the existing facilities and services. Facilities are movable or permanent installations created to support the development of the activities, services and programs. The study of the facilities deals with their design and location because they can have implications in relation to negative impacts on the settlement, aesthetics, visitors, etc. Recreational facilities in Ancient Theatres provide the physical support to address different issues such as the Visitors' Welcome services, the Information and Interpretation Programs, the Awareness and Public Participation Programs, the Visitors Management Programs, the Safety Measures Programs and the Promotion of the Institutional Public Image, among others.

There are several types of recreational facilities in Ancient Theatres that can be grouped into categories: basics (restrooms, paths and trails, first aid, parking area, entry/exit access, management offices, police station, others); impaired facilities (adapted trails, disabled restrooms, handicap parking stalls, others); information facilities (reception and information points, information signage, directional signage); and interpretive facilities (interpretation centre, museum, cultural park, interpretative routes, interpretative signage).

In essence, it should be emphasized that social limiting factors, which basically deal with visitor comfort, bring reductions in the number of visitors. In any case, many types of visitors exist, and it is necessary to have a good knowledge of the target audience in order to implement the best measures to succeed in providing a quality experience. It implies that reductions in visitor number due to limiting factors could vary depending on the visitor profile, needs, motivations and expectations of the public.

3.3. Effective Carrying Capacity

Finally, the third analytical stage is the Effective Carrying Capacity (ECC) that deals with the managing capacity available of the corresponding site administration (managerial limiting factor). Managing capacity is defined as the sum of conditions that the site administration requires in order to carry out its functions and objectives (Tran Nghi et al., 2007), and it is a crucial concern in implementing Recreational Carrying Capacity.

Measuring managing capacity is not an easy task, since many variables (several of which are quite subjective) are involved, such as policy measures, legislation, infrastructure, facilities and equipment, staff, funding, and motivation for heritage conservation.

Establishing appropriate prevention and protection policies are absolutely essential in order to avoid impacts in Ancient Theatres derived from recreational activities. Planning tools, such as zoning, and management techniques, such as visitor flow management, as mentioned, can mitigate the recreation impacts.

Moreover, alternative fields of actions must be evaluated, and strategies for tourist development formulated. Additionally, the use of adequate information, interpretation, education, and the involvement of the visitor in the preservation process can help to achieve the conservation

[4] http://www.nationalgallery.org.uk/visiting/organise-a-group-visit/, (accessed 3 September 2011)

[5] http://www.alhambra.org/esp/index.asp?secc=/alhambra/visitas (accessed 3 September 2011)

goals. Then, raising visitors' awareness and their integration into the protection process do not only help site preservation but could also provide a better quality experience.

Furthermore, an effective legal framework (mandatory permits, regulations, rules, restrictions, etc.) could help to reduce/mitigate the negative impacts from recreation in order to preserve the Ancient Theatre valuable resources. Nevertheless, legislation alone is not enough to conserve the site but also the administration's managing capacity in applying these legal measures is necessary.

The facilities definitively determine the amount of visitors, independently of the available space. On this point it is important to note that an excess of facilities is equally as harmful for conservation and recreation purposes as a lack thereof. Therefore, an over-dimensioned number of facilities may provoke site damage because they disguise the Real Carrying Capacity of the resources themselves.

Regarding the staff members, it should be said firstly that it is necessary to count on a sufficient number of people in order to address managerial and monitoring conservation and tourism tasks. Moreover, staff members must have appropriate qualifications through regular training programs. The presence of wardens to take care of the site and/or interpreters capable of explaining the site and its conservation issues is a helpful tool in safeguarding these sites and preventing damage.

Financial support is always necessary to maintain heritage conservation, at least in the first stages of the enhancement process. Later, some funds can be retrieved from visitors through ticketing policies, fees, etc. and also from donors. In any event, it must be noted that funding is an important limiting factor in framing the effectiveness of the managing plan.

4. DISCUSSION AND CONCLUSIONS

The Recreational Carrying Capacity Assessment works adequately in determining the adequate number of visitors in the Mediterranean Ancient Theatres, considering the spatial and social requirements needed for having a quality experience. Nevertheless, RCCA on its own is not able to address all the issues and it cannot work independently. It must be part of an integrated management plan where all the activities (staging and performance, tourism, scientific and research, cultural, etc.) must be considered from a comprehensive and long-term approach, taking into account the intrinsic value and the iconic attraction value that these sites exercise at the local, national and international level. The desirable situation is to implement all the necessary management tools and measures because an Ancient Theatre is a valuable cultural resource that deserves this kind of presentation.

Furthermore, it is important to recall that performance criteria in relation to spatial standards and perceptual components only address adequately the peak use level of the site at a given moment. This analysis is not enough to guarantee site conservation because impacts from recreation are cumulative and it is necessary to know the weekly, monthly and yearly use level.

The limiting factors working in the RCCA analysis are multiple and they may vary depending on each theatre. In archaeological sites, such as the case of Ancient Theatres, the space and cultural resources are one of the most restrictive factors that condition all the others because of their historical value.

Regarding the consecutive level of analyses (PCC, RCC and ECC), it is recommended to implement the results obtained from the most restrictive analysis. Physical Carrying Capacity always provides the broadest approach; Real Carrying Capacity lowers the figure after applying limiting factors; and Effective Carrying Capacity in relation to visitor management usually takes the most restrictive approach.

It must also be emphasized that the number of visitors will always be lower than the number of spectators because visitation is a dynamic activity that needs free spaces for visitors to circulate and enjoy a pleasant experience.

Finally, it is important to communicate to visitors that a recreational carrying capacity policy exists in an Ancient Theatre in order to be able to book the most convenient visitation options during their stay in a destination.

FIG. 3 Visitors walking on the diazoma of the Roman Theatre of Cartagena (Spain). Author: M.J. Viñals (2010)

REFERENCES

American Educational Research Association. 2003. Class size: counting students can count. Essential Information for Education Policy. Fall 2003, v.1, issue 2, 4pp.

Boullon, R. 1985. Planificación del espacio turístico. Ed.Trillas. México.

Buchinger, M. 1996. Turismo, recreación y medio ambiente. Problemas y soluciones. Ed. Universo, Buenos Aires.

Butler, R.W. 1996. The concept of Carrying Capacity for Tourism Destinations: dead or merely buried? Progress in Tourism and Hospitality Research, vol.2, pp.283-293.

Chamberlain, K. 1997. Carrying capacity. UNEP Tourism Newsletter, 8, pp.1-8.

Cifuentes, M., 1992. Determinación de la Capacidad de Carga Turística en áreas protegidas. Ed. Turrialbe (Costa Rica), WWF-Catie, 34 pp.

Coccosis, H. and Mexa, A. (eds). 2004. The challenge of Tourism Carrying Capacity Assessment. Theory and Practice. Ed. Ashgate Publishing Limited, UK.

Hadad, N. 2007. Criteria for the Assessment of the Modern Use of Ancient Theatres and Odea. International Journal of Heritage Studies, 13 (3), pp. 265-280.

Hall, T. 1966. The Hidden Dimension. Anchor Books, New York.

Harroun, L.A. and Boo, E.A. 1995. The search for visitor carrying capacity. Draft paper, World Wildlife Fund, Washington, DC.

Kuss, F., Graefe, A. and Vaske, J. 1990. Visitor Impact Management. National Parks and Conservation Association, Washington.

Lindberg, K. and McCool, S.F. 1998. A critique of environmental carrying capacity as a means of managing the effects of tourism development. Environmental Conservation, 25 (4), pp. 291-92.

López Bonilla, J.M. and López Bonilla, L.M. 2007. La capacidad de carga psicológica del turista como indicador del turismo sostenible, Boletín de ICE, 2911, pp.25-35.

McCool, S.F. 1996. Limits of Acceptable Change: A Framework for Managing National Protected Areas: Experiences from the United States. Unpublished paper. Missoula, MT: School of Forestry, University of Montana.

Mathieson, A. and Wall, G. 1986. Turismo: Repercusiones económicas, físicas y sociales. Ed. Trillas, México

Mcneely, J.A., Thorsell, J. W. and Ceballos-Lascuráin, H. 1992. Guidelines: Development of national Parks and protected areas for tourism. OMT/UNEP-IE/PAC, Technical report, nº 13, 53 pp.

Middleton, V. and Hawkins, R. 1998. Sustainable tourism: a marketing perspective. Ed. Butterworth-Heinemann, Oxford.

Morant, M. 2007. Desarrollo de un modelo para la determinación de la capacidad de carga recreativa y su aplicación espacios naturales protegidos de la Comunidad Valenciana. Tesis Doctoral inédita. Universitat Politècnica de València, Valencia.

Morant, M. and Viñals, M.J. 2010. Modelo para evaluar la capacidad de carga recreativa en áreas de uso intensivo de espacios protegidos. Casos de estudio de la Comunidad Valenciana (España). In: López Olivares (ed.): Turismo y gestión de espacios protegidos, Ed. Tirant lo Blanch, Valencia. pp.618-636.

O'Reilly, A. M. 1991.Tourism carrying capacity. In Medlik (ed.): Managing Tourism. Ed. Butterworth-Heinemann, Oxford. pp.301-306.

Pedersen, A. 2005. Managing Tourism at World Heritage Sites: a Practical Manual for World Heritage Sites Managers. UNESCO World Heritage Centre, Paris.Severiades, A. 2000. Establishing the social tourism carrying capacity for the tourist resorts of the east coast of the Republic of Cyprus. Tourism Management, 21, pp.147-156.

Rose, P. 2005. Spectators and Spectator Comfort in Roman Entertainment Buildings: A Study in Functional Design. Papers of the British School at Rome, 73. pp. 99-130.

Shelby, B. and Heberlein, A. 1986. Social Carrying Capacity in recreation settings. Oregon State University Press, Corvallis. 164 pp.

Silberberg, T. 1995. Cultural Tourism and Business Opportunities for Museums and Heritage Sites. Tourism Management, 16 (5). pp. 361-365.

Stankey, G.H. and McCool, S.F. 1984. Carrying Capacity in recreational settings: Evolution, appraisal and application. Leisure Sciences, vol.6, no.4, pp.453-473.

Tarrant, M.A. and English, D.B.K. 1996. A Crowding-Based Model of Social Carrying Capacity: Applications for Whitewater Boating Use. Journal of Leisure Research, vol.28, no.3, pp.155-168.

Tran Nghi, Nguyen Thanh Lan, Nguyen Dinh Thai, Dang Mai, Dinh Xuan Thanh. 2007. Tourism carrying capacity assessment for Phong Nha-Ke Bang and Dong Hoi, Quang Binh Province. VNU Journal of Science, Earth Sciences, 23, pp.80-87.

Viñals, M.J.; Morant, M.; El Ayadi, M.; Teruel, L.; Herrera, S.; Flores, S.; Iroldi, O. 2003. A Methodology for determining the recreational carrying capacity of wetlands. In: Garrod and Wilson (eds.): Marine Ecotourism. Issues and experiences. Ed. Channel View Pub., Clevedon, England, pp.79-99.

Viñals, M.J.; Morant, M.; Hernández, C.; Ferrer, C.; Quintana, R. D.; Maravall, N. Cabrelles, G.; Ramis, J. y Bachiller, C. 2004. Albufera de Valencia (Spain): Measuring carrying capacity in a fragile ecosystem. In: Indicators of sustainable development for tourism destinations: A Guidebook. World Tourism Organization (WTO). pp.330-337.

Viñals, M.J.; Alonso-Monasterio, P.; Alonso-Monasterio,M. 2011. Recreational carrying Capacity of the Iberian Settlement Castellet de Bernabé and its environment (Llíria, Spain). 4th International Conference on Tourism & Environment. Cáceres, 2011.

World Tourism Organization. 2005. Indicators of sustainable development for tourism destinations. Guidebook. WTO, Madrid.

4.2.2. STAGING ACTIVITIES

Definition

The performance of theatrical works in ancient theatres is a complex theme because it affects many aspects related to archaeological remains: conservation, restoration, compatibility of uses, the need for specific equipment, the management of spectators, safety standards, etc.

In general, the Athena project has the aim of managing all these aspects, taking into consideration some basic rules derived from charters and recommendations. The design of the theatres of antiquity is the product of a different and ancient culture, with a concept of dramatic art very similar and yet, at the same time, very far from our contemporary conceptions. The stage of an ancient theatre shows evident spatial limitations if compared to the modern design of theatres and thus, in accordance with the Syracuse Charter, it is important not to distort ancient spaces with the aim of arranging contemporary representations. In other terms, the weight of the scenography is not just physical but also aesthetic and conceptual. All kinds of arrangements should take into consideration the basic concept of respecting the design of the ancient structures, from the point of view of the architecture, the acoustics and the lighting design. Set and stage design have to respect in cultural terms the ancient conception of the theatre, and, if possible, allow people to understand the way the Romans and Greeks conceived that aspect of their culture. In general, it is difficult to recreate the original physical and acoustic conditions of a Roman theatre because most of them no longer have a frons scaenae. Another aspect concerns the small depth of the stage, which in many cases does not allow for contemporary performances.

A performance in the performing arts, generally comprises an event in which a performer or group of performers behave in a particular way for another group of people, the audience. Choral music and ballet are examples. Usually the performers participate in rehearsals beforehand. Afterwards audience members often applaud.

As mentioned before, Ancient Theatres can host many cultural activities; thus it is necessary to identify the compatibility level among all of them.

Managing institutions face the challenge of making tourist visitation activities compatible with cultural activities, especially ones requiring stages. A cross-matrix method was used to examine the interaction of all of them. This assessment considers the temporal and physical (spatial and acoustic) components influencing the development of the activities. The results inform us about those activities that are totally incompatible, and also those that are partially compatible depending on the physical considerations (spatial, acoustic, etc.) or temporal ones (scheduling them over time).

STAGING ACTIVITIES
Taormina (Sicily)

4.2.3. EDUCATIONAL ACTIVITIES

Definition

Educating new generations is a very important task that has to be managed with care by means of proper actions. It could be useful to promote educational activities about the theatre at schools.

Education concerns visitors, spectators, local populations and basically anyone that for various reasons is in contact with the ancient theatre and its surroundings.

In particular, it is important to develop proper actions aimed at developing awareness of the theatre's legacy in local populations, because, in many cases due to the routine of everyday life, people don't understand the importance of ancient structures from the cultural point of view.

A theatre, an amphitheatre or any other kind of monument of an archaeological site comprises part of the history of a population. Sometimes this aspect is intentionally forgotten, but in order to conserve and properly use this delicate heritage, it is important to show and explain to local inhabitants the cultural value of these structures.

Ancient Theatres must be analysed following a descriptive and evaluative process in the framework of the development of an Inventory and an Intrinsic and Recreational Assessment of the existing resources. In order to assess both the intrinsic and recreational values, several criteria must be applied. The significance, representativeness, and singularity from the the historical, artistic and archaeological perspectives must be considered in the intrinsic scientific value analysis.

- Significance means the artistic, archaeological and/or historical potential of the theatre as a representative element of the Mediterranean Greco-Roman Theatres or type in which it has been included.

- Representativeness means the degree to which the theatre presents the characteristics or attributes typical of the group to which it belongs.

- Singularity shall be established according to the rarity of the theatre in relation to the characteristics typical of the class or type to which it belongs. This criterion shall be defined by taking into consideration the spatial scale.

- Attractiveness refers to aesthetic, emotive and perceptual parameters such as the beauty, originality, symbolism and emotions that the element gives rise to in people.

- Educational Values are regarded as those values for Education and Public Awareness.

4.2.4. FORMAL AND CEREMONIAL ACTIVITIES

Definition

A ceremonial or formal activity is an event of ritual significance, performed on a special occasion in order to celebrate an important event, for example:

- Graduation as a Honorary Degree.
- Marriage.
- Retirement.
- Death (Day of the Dead).
- Feast.
- Award of prizes.
- Opening ceremony of the academic year.
- Government ceremonies as a ceremony performed by a person with certain authority; for example, the annual opening of the activities of an institution.
- Vernal equinox, winter solstice and other annual astronomical positions.
- Inauguration of an elected office-holder.

From the point of view of the ATHENA project, it is very important to carefully select the kinds of ceremonies that match or not with the cultural essence and spirit of the ancient monument. At the same time, an incorrect evaluation could produce a sense of discomfort in the audience when attending a ceremony, in particular those concerning faith and religion, inside a building characterized by a very different and distant legacy.

EDUCATIONAL ACTIVITIES
Jerash (Jordan)

Formal and ceremonial
EUROPA NOSTRA GRAND PRIZE AWARD
Taormina, Sicily, Italy. June 5, 2009

These kinds of activities can be organized by local institutions or by private bodies that desire to rent the theatre for the celebration of a specific event (from a wedding to a company dinner, etc.) and should comply with the criteria for proper utilization: in other words, it is fundamental to avoid risk to the users and to the monument.

An interesting example of a contemporary use of a theatre is the EUROPA NOSTRA GRAND PRIZE AWARD, held at the Taormina (Sicily, Italy). Europa Nostra is a pan-European Federation for Cultural Heritage representing 250 heritage NGOs active in 45 countries across Europe. It is the voice of this vast movement of European civil society active in the field of heritage towards the international bodies concerned, in particular the European Union Institutions, the Council of Europe and UNESCO. Europa Nostra supports national and international campaigns for the preservation and rescue of Europe's heritage at risk. It encourages initiatives in favour of the conservation and enhancement of cultural heritage by recognising outstanding heritage achievements, in particular through the running of the European Union Prize for Cultural Heritage / Europa Nostra Awards, in partnership with the European Commission. The ancient theatre of Taormina was the perfect framework for hosting an international award concerning conservation and cultural heritage valorisation. These kinds of ceremonial activities can be considered a proper contemporary use of ancient structures, thanks to their capacity to receive audiences, their acoustics and, moreover, because the number of people attending and their great respect for cultural heritage constitute the best guarantee of respectful use.

4.2.5. CULTURAL ACTIVITIES AND LOCAL TRADITIONS

Definition

Culture, in its wider meaning, concerns a complex set of values of difficult definition. In some cases it is the product of human skills and creativity, as in the case of material objects; in other cases it is concerned with traditional knowledge, ideologies and habits in general that form part of the identity of a population within their geographic context. Every member of a society shares with other members of the same geographic area a system of values that is a legacy that defines his cultural identity.

Cultural activities are all actions carried out in order to disseminate and develop the culture, for example, inside clubs, associations, foundations, institutions, artistic workshop or atelier. As well as people, cultural heritage is made up of their tangible and intangible creations, reflected in their values, beliefs, music, dance, books, pictures, etc.

Cultural heritage is the product of human creation that is transferred from one generation to another. For example, the Romans left their legal brilliance, whose main output during the centuries was the Corpus Juris Civilis of Emperor Justinian, a legal legacy found in many modern civil codes. Athenian philosophy, with exponents such as Socrates, Plato and Aristotle, is a legacy, forming part of an inheritance transmitted to future generations, now widely in place.

Cultural activities, entertainment and leisure, are those that anyone can develop voluntarily to rest, relax, have fun, train, develop their creative, sports, enjoying art, museums, cinema, theatre, trips, crafts, etc.

Cultural events such as performances, openings of cultural centres, exhibitions, congresses and fairs stimulate the creation, dissemination and reproduction of culture because they facilitate the knowledge, understanding, and strengthening of the cultural identity of individuals and communities.

The traditional activities are defined as the set of cultural property from generation to generation within a community. Those values, habits and events are socially preserved because they are considered valuable and should be instilled in new generations.

Tradition, therefore, is something that is inherited and is part of identity. The characteristic art of a social group with its music, dances and stories, are all part of the tradition, like the food and other issues. Moreover, folklore and what is considered part of popular wisdom also belongs to the realm of tradition. Many times, the tradition is associated with the conservative, which means keeping certain values over time. In this sense, what is not traditional can be seen as strange or factious. Sociologists warn, however, that the tradition should be able to be renewed and updated to maintain its value and usefulness. This means that a tradition can learn new expressions without losing its essence.

Among the Spanish traditions that have been renewed, keeping at the same time the original essence, can be mentioned the *"Presentación Fallera"* that is held every year inside the Sagunto Theatre.

The most important festival held in Valencia (Spain) is called *"Fallas"*. The origin of this festival is attributed to the habit of the ancient craftsmen and carpenters of the city which, with the arrival of good weather, burned old house hold items that were no longer useful, such as clothing and disused furniture. Already in the eighteenth century, this *"costumbre fallera"* (fallera habit) formed part of the San José Festival, Patron of the Guild of Master Carpenters, held in March. In many homes during the saint's day celebrations were held: the *Pepes* (the Spanish nickname for Joses) were entertained with cakes, *buñuelos* (fried paste in general made with pumpkins) and anisette.

Over time the festival has been improved and now a woman is elected to represent these cultural events for the whole year. The choice of the Fallera is made with a formal "presentation" inside the theatre of Sagunto. This archaeological site is enriched by this kind of contemporary use, merging local traditions with its ancient past. This activity is compatible with the monument also from an historic point of view, a theatre being a multipurpose typology not bounded to the rigid limits of dramatic activities. On the contrary, theatres included a wide range of events during the whole year. During the Roman Age, the theatre and other public buildings for spectacles were the perfect locations for celebrating the Imperial Cult, to promote the career of politicians, to honour the Imperial family, and for other political-religious events.

The *Fallas* as with other examples of local traditions, generates through a commercial network, an improvement of local economy related to the production of typical handmade dresses and *papier mache* sculptures known as *Ninots*. Moreover during the *Fallas* the commerce of flowers increases (used for adorning public buildings) as does the consumption of local cuisine/gastronomy.

Methodology

Agencies and private institutions, as the main socio-cultural agents, should promote objectives, principles, and values that bolster cultural promotion policies from the starting point of the advancement of a pluralistic democracy that reaches all sectors of the population (disabled, elderly, immigrants, etc.) and the women and men belonging to these groups.

These activities should be understood as instruments for social change, communication and promotion of the democratization of culture, promoting social and ethical values that contribute to the improvement of the quality of life.

CULTURAL ACTIVITIES AND LOCAL TRADITIONS

The choice of the *Fallera*: presentation inside the theatre of Sagunto

ACOUSTIC STRATEGIES FOR IMPLEMENTING NEW PRACTICAL USES IN ANCIENT THEATRES

Arturo Barba Sevillano

Conservatory of Music of Valencia; Research Group on Virtual Acoustics UPV-UVEG Universitat Politècnica de València, Spain.

arturo@arturobarba.com

ABSTRACT:

Acoustic behaviour of ancient theatres has been always praised and applauded not only by the acoustics experts, but also by anyone interested in these buildings. However nowadays, after two millenniums of history, we find numerous ancient theatres whose shape and architectural characteristics have changed extraordinarily, in parallel to the evolution of history, society and lifestyle. These formal changes have necessarily brought changes in their acoustics. Therefore, the current archaeological trend towards the enhancement of architectural heritage by means of implementing new practical uses in these historical enclosures must take into account a previous consideration and valuation of the compatibility of those uses from the acoustic point of view. In this paper we study the original acoustic characteristics of ancient theatres and their current acoustic limitations for implementing new practical uses. Also we propose strategies of analysis and intervention to optimize their acoustics, and we provide guidelines for improving the binomial ancient theatre-new uses.

1. Introduction. Context and objectives

The acoustics of the ancient Greek and Roman theatres has always been rated as excellent by experts, without discussion. In recent years, large amount of monographs and studies have been published about classical theatres where the acoustic conditions of a particular building are studied and virtual simulations are made. In fact, nowadays, obtaining acoustics measurements in situ, developing computer simulations and carrying out virtual reconstruction and auralization are the most common acoustic research. Recently, great studies and initiatives have enhanced our knowledge about the acoustics of these theatres, such as the European Project ERATO (Evaluation and Revival of the Acoustical heritage of Ancient Theatres and Odea, 2003-2006; Rindel 2011b), the project of the Italian Ministry of University and Investigation ATLAS (Ancient Theatres Lighting and Acoustics Support), the international congress developed in Patras titled The Acoustics of Ancient Theatres (Greece, 2011) or even a part of the ATHENA Project, where this article is inscribed (Ancient Theatres Enhancement for New Actualities).

First, we will analyse the excellent acoustics of the Greco-Roman theatre designs and we will look for the factors that define their sound today, largely changed by over two millenniums of history. This approach seeks to value the acoustics of these theatres as an intangible asset to be protected. In addition, acoustics should be taken into account when assessing the possibility of introducing new practical uses and new social activities in ancient theatres to revitalize the historic architectural heritage. Our aim fits perfectly with the ambitious proposals of the ATHENA Project, considering the novelty of using acoustics as an analytical tool and as a final criterion of functional compatibility.

2. Approach to the acoustics of ancient theatres

The Greco-Roman theatrical typologies form the core from which the whole history of the western theatre buildings begins. Their study is based on an analysis of the architectural remains of many classical theatres that, with unequal fortune and condition, have survived until the present day. In addition, one must add the valuable theoretical

Floor plan of Roman Theatre (Vitruvius translation 1787, sheet XLII)

support provided by the written sources of that period, among which the treatise De Architectura, written by Vitruvius Polione between 21-11 BC deserves special mention. In chapters III to IX of book V, we can find a comprehensive description of how to draw floor plans of theatres, the criteria of their choice of location, characteristics and differences between Greek and Roman theatrical buildings, scene descriptions, acoustic behaviour, etc. (Vitruvius trans. 1787, pp. 112-28)

In Western ancient history, theatre buildings hosted primarily leisure activities (stage performances, declamation, musical activities, etc.) and political events (assemblies and all kind of propaganda activities). These uses implied finding adequate visual and acoustic conditions to allow the public to see and hear what was happening on the stage. For this reason some of the formal features of ancient theatres have been inherited by all theatre buildings throughout Western history. We detail below the formal features present in both, Greek and Roman models, alluding to their acoustical implications:[1]

1 - LONGITUDINAL AXIS OF SYMMETRY. It can be found in almost all theatre buildings throughout history. This is due to the fact that speech and music activities have an implicit directionality determined by the vertical plane of symmetry of the human body, responsible for the direction of our voice and gestures. Therefore, ancient theatres seated the audience in front of the stage in order to better see the action and hear the words and music. In contrast, ancient Roman amphitheatres were designed with two orthogonal axes of symmetry, since their action was not directional at all (gladiator fights, beasts, Naumaquias, etc.), as currently happens at the bull-fighting arenas, football stadiums or boxing rings.

2 – SLOPED CURVED CAVEA. The audience area forms a semicircular shape because this geometry minimizes acoustic loss of direct sound by allowing the seating of the maximum number of spectators close to the stage. Also, this distribution in concentric rows allows a larger audience to be accommodated than with any other possible geometric distribution, and the adequate slope makes it possible for all viewers to have a direct view of the stage. All this has great impact on the acoustic behaviour.

3 – ELEVATED STAGE above the lower plane of the audience, in order to improve the visibility and to allow the direct sound to reach all spectators.

4 - OUTDOOR OPEN BUILDINGS. The theatrical typologies began by conditioning outside spaces for scenic purposes. This was possible

Greek theatre of Epidaurus; Greece, 300 b. C. (Izenour 1996, p. 176)

Roman theatre of Aspendos; Turkey, 155 a. C. (Izenour 1996, p. 183)

due to the mildness of the Mediterranean climate prevailing in the geographical area occupied by the classical civilizations.[2]

5- STONE AS PRINCIPAL CONSTRUCTION MATERIAL. Nevertheless, we are aware of the existence in Roman times of many theatres made of wood, but none of them have come to us because of their poor durability.[3]

6 - FUNCTIONAL HIERARCHY in the floor plan design, with two opposing areas: the *AUDIENCE AREA* and the *ACTORS AREA* (i.e. the space of contemplation and the space of representation). In Roman nomenclature, these areas are called cavea and scena, and their separation is realized via an intermediate element: the orchestra.

Despite the above characteristics of both Greek and Roman theatre typologies, there are significant morphological differences between them, derived from different ways of conceiving and occupying the space. On the one hand, Greek theatres adapted an open environment for scenic performances achieving a simple and natural architectural intervention. In a metaphorical sense, we can say that they "put" a stone mantle over a natural slope (cavea), and then they raised a small scenic building. On the other hand, the Roman theatre occupied the

[1] A synthetic presentation of morphology and acoustics of the main Western theatrical typologies was presented in the communication: (Barba et al. 2011).

[2] During the Roman period, scenic and declamation uses were developed in the theatres, but music and singing performances mostly took place in the odeas, a kind of small roofed theatre. The acoustics of these building typologies was very different, almost opposite (Izenour 1992) (Rindel 2011b).

[3] Vitruvius wrote: "Somebody will perhaps say that many theatres are built every year in Rome, and that in them no attention at all is paid to these principles; but he will be in error, from the fact that all our public theatres made of wood contain a great deal of boarding, which must be resonant" (Vitruvius trad. 1787, p. 118).

space in a more emphatic way by overlapping arches and pillars. The rear stage wall achieves the same height as the gallery located over the cavea, thereby creating a semi-enclosed space that only lacks a roof to get a completely closed building. The Roman theatre shows a greater formal coherence than the Greek model, but its presence is more aggressive and less natural than that of its predecessor. All of this has big implications for the global acoustic result.

Thus, the main **acoustics features** of ancient theatre models are:

1 - LOW BACKGROUND NOISE, due to the appropriate choice of locations, away from urban centers and often protected by topography.

2 - ARRIVAL OF DIRECT SOUND TO ALL THE CAVEA, due to the height of the stage floor, the appropriate slope of the cavea and the radial distribution of rows. In contrast, this concentric radial distribution had the disadvantage of excessively prioritizing the acoustics and visual conditions of the audience located around the central axis of symmetry of the cavea, to the detriment of the audience located in the side areas.

3 - THE REFLECTIONS OF SOUND BY THE ORCHESTRA'S SURFACE. In the Greek theatrical model, the circular stone orchestra sends strong reflections to the public that reinforce the direct sound and increase the global sound level. Those powerful reflections reach the whole cavea due to the aforementioned height of the stage floor (3 meters approx.) and to its shallow slope (average of 26º), which allowed for larger dimensions and more capacity than Roman models (Declercq and Dekeyser 2007). However, the Roman typology is different; its semicircular orchestra was frequently occupied by the public, limiting its use as a reflector. In addition, the lower height of the Roman stage floor (1.5 meters approx.) and the steeper cavea (average of 32º) limited the reflection of sounds to the audience (See Figuras).

4 - REFLECTING REAR STAGE WALL (Roman Theatre). The Roman scenae frons operate as powerful acoustic reinforcing tools, projecting the sound reflections to the audience because of their height and stone construction. In addition, they provided sound diffusion due to the complex geometry of their architectural ordering and their sculptures. There was an inclined roof over the scenae frons to focus acoustic reflections towards the central and upper stands (media and summa cavea). As examples, the theatres of Aspendus (Turkey) and Orange (France) have preserved clearly visible indications of the presence of this surface. By way of contrast, the Greek theatre had a construction behind the scene with small dimensions and unimportant acoustic features.

5 - ACOUSTICS VESSELS. To the Roman case must be added, in addition, the possible sound reinforcement provided by the hypothetical presence of acoustical bronze vessels distributed among the cavea, as was referenced by Vitruvius in his treatise (Vitruvius trans., 1787, p. 117-19). Although their existence is still questioned today, the study of their possible acoustic function has been dealt with in recent publications (Rindel 2011a), (Barba et al. 2008), (Karampatzakis et al. 2011), (Polychronopoulos et al. 2011) and (Barba and Giménez 2011).

6 - THEATRICAL MASKS. The use of masks in theatre performances, particularly in the Greek case, could help to improve voice projection and intelligibility of speech (Tsilfidis et al. 2011).

3. ACOUSTIC COMPATIBILITY OF NEW USES IN ANCIENT THEATRES

Originally, the ancient theatres enjoyed an optimal acoustic performance for the activities that they hosted. These activities were the result of a certain sociological and historical moment. Since then, the course of time course has mostly destroyed these buildings, and new uses have emerged that can be hosted in the remains of classical theatres (as an example, performing arts with modern audio and video conferences). Changes in social customs have been even greater. Theatres are no longer the same as they were in the past, similar to the changes experienced by societies or the performing arts. This situation leads to a reflexion on what activities are currently acoustically viable in ancient outdoor theatres and what conditions are required to host modern uses. We will approach these questions from three different contexts: the urban and environmental, the strictly architectural, and the functional one.

3.1 Urban and Environmental context: the Background Noise

From an acoustical perspective, the main environmental change between ancient and contemporary societies is the increase in ambient noise, primarily as a result of transport and urban mobility developed since the nineteenth century. Indeed, this urban ambiental noise is the result of drastic changes in the soundscape of our cities.

Background Noise NC Curves

Background noise (objective acoustic parameter associated with the perception of environmental noise) is defined as the noise that is heard in a room when there is no activity. Its presence produces a masking effect of sounds necessary for the development of musical or speech activities. The preferred background noise level in a room depends on the uses it hosts. In this regard, there are international standards to establish maximum permissible levels expressed in decibels through titration curves that follow the sensitivity of the human ear. The most commonly used are Noise Rating curves (ISO-R-1996 and UNE 74-022) and especially the Noise Criteria curves (NC), developed by L. L. Beranek (1953, 1957, 1971).

It is recommended to comply with the NC-15 in theatres and auditoriums, although it is considered acceptable until NC-25, which implies a midrange background noise lower than 30 decibels. This requirement should not be less restrictive for performing or musical activities in ancient theatres.

Undoubtedly much of the acoustic success of ancient theatres was due to their low background noise. Special care was taken in choosing locations, preferably away from the centre of cities and often protected by the topography, which guaranteed optimal conditions of silence despite performances being presented in outdoor open buildings (Barba 2011). Currently, cities are extremely noisy and we often find large roads or train rails near the conserved classical theatres. In order to determine the possibility of providing new functions to these ancient theatrical buildings, their background noise conditions must be studied with particular attention. The ambient noise could severely limit the new activities in these open spaces, a problem that has already been shown in recent publications (Barkas and Vardaxis 2011). As a methodological approach, we propose the following diagnostic studies about the theatre to determine its acoustic compatibility with new practical uses:

1- **Background noise measurements** on the cavea and on the stage, at different times of day. Normalized measurements according to ISO3382 and with certified instrumentation.

2- **Noise Mapping of urban environment**. Diagnostic and dimensioning of the real problem of noise affecting the theatre.

3- **Study of urban noise sources**. Analysis of trends in urban mobility, potential specific problems associated with road noise, noise of rail transport, proximity to airport zones, etc.

4- **Analysis of social uses of the area**. Proximity to industrial zones, factories, shopping areas, etc., which could generate excessive noise at certain times of day. Preferably residential or tertiary uses. Analysis of population density and morphology of nearby buildings (number of floors, etc.), with special attention to those from which the theatral zone is visible.

All this will provide an accurate diagnosis of the acoustic-environmental burdens weighing on the theatre that could pose a major constraint to new activities. Once the diagnosis has been carried out, we suggest various intervention proposals to mitigate the negative effects of a hypothetical excess of background noise:

1- **Installation of noise barriers** on roads or train rails near the theatre.

2- **Detailed study of times at which environmental noise conditions are low** and thus allowing for the implementation of new uses in the theatre (especially in areas of intensive commercial or industrial uses).

3- Thinking the **acoustic character in each permanent architectural intervention in the immediate area of the theatre**, to serve as urban noise barrier.

4- **Defining a perimeter around the theatral zone as having special noise protection**, which should be proposed to municipal authorities for their legislative process in order to receive local policy support. Regarding this, urban uses surrounding the theatre should also be limited, always with common sense, avoiding excessive impositions that break with assumed social uses.

3.2 Architectural context

Context about the **conservation status of the theatre** and its architectural elements. In the best of cases, the centuries have caused partial destruction of the Greek and Roman buildings, present today with more or less incomplete morphologies. Fortunately, over the past several decades, Western societies have shown a widespread interest in preserving, improving and enhancing ancient architectonic heritage.

Nowadays, the acoustics of ancient theatres is extremely influenced by their conservation status. These buildings were designed and built with basic geometric principles (Vitruvius trans., 1787, pp. 119-128), by assembling a set of architectural pieces with a specific function. The result is a unitary whole of harmonic proportions with appropriate visual and acoustic conditions. In the present day, we find most Roman theatres without scenae frons, without its reflective and diffusion acoustic qualities, without the acoustic vessels referred to by Vitruvius, without the upper gallery crowning the cavea, without the marble coatings, without velarium, etc. In summary, it is obvious that **current acoustic conditions of classical theatres are very different from the original ones**.

In this way **from the acoustic point of view, the compatibility to host new practical activities in an ancient theatral building will be directly influenced by its conservation status**. Thus, to face an architectonic intervention in a theatre we must ask the question: what architectural elements are preserved? What acoustic deficiencies are perceived? Will there be an excessive lost of sound pressure levels with distance? Are sound reflections conveniently focused? Will it be necessary to limit the audience for acoustical reasons?

Implementing new activities in theatres will necessarily be accompanied by ephemeral or permanent intervention projects. In the case of permanent actuations, many other criteria beyond the purely acoustic one must be considered. If, as expected, the sound plays an important role in the proposed activities (concerts, lectures, theatral performances, etc.) it would be highly desirable to carry out prior acoustic measurements on the room to obtain the current values of the objective parameters of sound quality (RT, EDT, G, C80, D50, IACCE3, STI, LF, etc.), and to develop virtual acoustic models that will allow the analysis of the acoustic changes caused by each intervention proposed. Knowing the acoustic impact, we could choose the solution that optimizes the final result.

3.3 Functional context: Acoustic requirements of new practical uses

The new practical uses that our societies could implant into ancient theatres today are very different from the original, two thousand years ago. Therefore, from the acoustic point of view, all activities and uses whose acoustic requirements are not covered by the loudness of these buildings will need punctual architectural interventions in order to be successfully developed.

There are many and very different uses: symphonic music concerts, opera performances, modern amplified music, solo recitals, theatre performances, monologues, lectures, congresses, etc. To make a quick assessment of their compatibility with ancient outdoor open theatres, we resort to the most known and used acoustic quality parameter: the reverberation time, defined as the time in seconds that elapses between the stop of the emission of a sound source, until the 60 dB decay of the sound pressure level (ISO 3382). Reverberation is the result of all sound reflections that reach the listener after striking interior surfaces of an enclosure. Many theorists have developed mathematical expressions for calculating the Reverberation Time, from the initial formula of Wallace Sabine (1922) to those of Eyring (1930), Millington (1932), Kuttruff (1976) or Arau (1988). In enclosures, the proportion "volume of air / seating capacity" is indicative of the range that RT adopts (Beranek 1996, pp. 626-630).

In ancient theatres, the reverberation time is determined by the impossibility of "holding" the sound in the theatre by interior reflections, due to the absence of a roof, i.e. to its status as outdoor building. Therefore, the reverberation of these theatres is very low (less than one second) which compromises their suitability to host new practical uses. In this regard, numerous investigators have developed abacuses and empirical equations to determine optimal reverberation times required for different activities. Knudsen (1988) distinguishes three levels of reverberation depending on the use of the room: speech, film or music, specifying chamber music and sacred music. Beranek (1993) proposes optimal reverberation times depending on use and building typologies: Catholic Church (organ music); concert hall (symphonic auditorium), Protestant church or synagogue; opera or musical recording studio; conference room and theatre, and recording speech studio. The proposal by Conturie (1955) is more synthetic and summarizes three possible reverberation uses: churches, concert halls, theatres and conference rooms. Pérez Miñana (1969) is on the same line and he differences four groups: liturgical music, chamber music, song and word.

Despite differences among the researchers, these tables clearly show that optimal reverberation time depends on the activity, distinguishing fundamentally between use for the word (recitation, speeches, lectures, etc.) and musical uses, which need more reverberation. Also, each kind of music has its own sound requirements, so that the reverberation time required by the romantic symphonic music of the nineteenth century (Berlioz, Mahler, Strauss, etc.) will be different from the needs of Baroque chamber music or the operatic repertoire of Mozart.

Usually, Greco-Roman theatres present very low reverberation, which makes them suitable for oral speech; slightly dry for the presentation of opera activities and chamber music; and inadequate to accommodate the large symphonic music of the nineteenth-century, which has been composed for Western concert halls with approximately two seconds of reverberation time. This repertoire in ancient theatres will require the placement of structures to send powerful sound reflections to the public, as much as possible, in order to increase both the acoustic energy and the reverberation time.

Finally, **electronic systems of acoustic enhancement** *should be mentioned (Carrión 1998, pp. 329-333), whose implementation cancels the acoustic qualities of the enclosure, but allows for the obtention of functionally valid results. This kind of solution can increase the sound pressure, thereby improving the sound perception in the more distant places from the stage, and it can also generate an external supply of artificial reverberation to mitigate the low number of reflections in outdoor theatral areas.*

Optimum Reverberation Time at 500 Hz frequency (Knudsen y Harris 1988)

4. CONCLUSIONS

To implement new practical uses and activities in classic ancient theatres we should consider that the current acoustic conditions of these buildings differ greatly from the original ones (sound reflection, diffusion, reverberation, sound projection, clarity, speech intelligibility, sound pressure level, etc.). The thorough understanding of the acoustic role developed originally for each architectural element of the building will provide a solid approach to face interventions of acoustical and functional improvement. Virtual acoustic simulations are postulated as powerful technological tools to verify the acoustic impact before any ephemeral or permanent intervention in ancient theatres.

In any event, the compatibility study of new uses in Greco-Roman theatres must be addressed by analysing the contributing factors in the three contexts referred to in this paper (urban and environmental, architectural and functional). In this way, we will have strict criteria and contrasted tools that will allow us to develop an objective acoustic assessment, whose conclusions can be translated into adequate permanent or ephemeral interventions.

5. REFERENCES

Arau Puchades, H., 1988. An Improved Reverberation Formula. Acustica, Vol. 65, nº 4, pp. 163-180.

Barba, A., Lacatis, R., Giménez, A., Romero, J., 2008. Acoustics vases in ancient theatres: disposition, analysis from the ancient tetrachordal musical system, Proceedings of the International Congress Acoustics-08, Paris.

Barba, A., Giménez, A., Segura, J., Cibrián, R., Cerdá, S., Lacatis, R., Montell, R., 2011, Historia del edificio teatral. Evolución formal y acústica, Actas del 42º Congreso Nacional de Acústica "Tecniacústica 2011", Cáceres.

Barba, A., Giménez, A., 2011. El Teatro Principal de Valencia: vasijas acústicas y cámaras de resonancia, Actas del 42º Congreso Nacional de Acústica "Tecniacústica 2011", Cáceres.

Barba, A., 2011. Salas de Concierto: morfología y acústica. Música y Educación, Vol. 24 (1), nº 85, pp. 106-121.

Barkas, N., Vardaxis, N., 2011. Current operation of ancient greek theatres: the problem of environmental noise, Proceedings of The Acoustics of Ancient Theatres Conference, Patras (Grecia).

Beranek, L.L., 1953. Ventilation System Noise. Journal of Acoust. Soc. Amer., New York, vol. 25, pp. 313-321.

Beranek, L.L., 1957. Revised Criteria for Noise in Buildings, Noise Control, New York, nº 3, pp. 19-27. Beranek, L.L., 1971. Revision of Noise Criteria Curves, Journal of Acoust. Soc. Amer., New York, vol. 50, p. 96.

Beranek, L.L., 1993. Acoustics. Acoustical Society of America, Nueva York, pp. 425-426.

Beranek, L.L., 1996. Concert halls and opera houses. Acoustical Society of America, New York.

Canac, F., 1967. L´Acoustique des Théâtres Antiques, éditions CNRS, Paris.

Carrión, A., 1998. Diseño acústico de espacios arquitectónicos, Barcelona, Edicions UPC.

Conturie, L., 1955. L'acustique dans les bâtiments. Theorie et applications. Éditions Eyrolles, Paris. pp. 71-74.

Declercq, N. F., Dekeyser, C.S., 2007. The acoustics of the Hellenistic Theatre of Epidaurus: the important role of the seat rows, Proceedings of the 19th International Congress on Acoustics, Madrid.

Eyring C. F., 1930. Reverberation Time in "Dead" Rooms. Journal of Acoust. Soc. Amer., New York, vol. 1, pp. 217-241.

ISO 3382. Acoustics-Measurement of the reverberation time of rooms with reference to other acoustical parameters, International Organisation for Standardisation, Geneva, Switzerland, 1997 (actualizaciones UNE-EN ISO 3382 2008, 2009, 2010).

Izenour, G.C., 1992. Roofed Theaters of Classical Antiquity, Yale University Press, Massachusetts.

Izenour, G. C., 1996. Theater Design, Yale University Press.

Karampatzakis, P., Zafranas, V., Polychronopoulos, S., Karadedos, G., 2011. A study on Aristoxenus acoustic urns, Proceedings of The Acoustics of Ancient Theatres Conference, Patras (Grecia).

Knudsen, V. O., Harris, C. M., 1988. Acoustical design in architecture. (5ª Ed.), Acoustical Society of America, Nueva York, pp. 171-174 y 331-341.

Kuttruff, H., 1976. Nachhall und effektive Absorption in Räumen mit diffuser Wandreflexion, Acustica, vol. 35 (3), pp. 141-153.

Millington, G., 1932. A Modified Formula for Reverberation. Journal of Acoust. Soc. Amer., New York, vol. 4, pp. 69-82.

Pérez Miñana, J., 1969. Compendio práctico de acústica. Labor, Barcelona, pp. 319-428.

Polychronopoulos, S., Kougias, D., Polykarpou, P., Skarlatos, D., 2011. The use of resonators in Ancient Greek Theaters, Proceedings of The Acoustics of Ancient Theatres Conference, Patras (Grecia).

Rindel, J. H., 2011a. Echo problems in ancient theatres and a comment to the 'sounding vessels' described by Vitruvius, Proceedings of The Acoustics of Ancient Theatres Conference, Patras (Grecia).

Rindel, J. H., 2011b. The ERATO Project and its contribution to our understanding of the Acoustics of Ancient Theatres, Proceedings of The Acoustics of Ancient Theatres Conference, Patras (Grecia).

Sabine, W. C., 1922. Collected papers on acoustics. Harvard: Harvard University Press.

Tsilfidis, A., Vovolis, T., Georganti, E., Teubner, P., Mourjopoulos, J., 2011. Acoustic radiation properties of ancient greek theatre masks, Proceedings of The Acoustics of Ancient Theatres Conference, Patras (Grecia).

Vitruvio, M., (traducción de 1787). De Architectura, traducido y comentado por J. Ortiz y Sanz, Madrid: Imprenta Real.

4.3. RISK AND THREATS

The Athena Project is aimed at the carrying out a methodology capable of managing the contemporary activities performed inside ancient theatres of the Mediterranean Basin.

The Prototype Management Plan for ancient theatre compatible utilization is the tool that provides the general aspects of that methodology, taking inspiration from the best practices from many different countries and from the most updated scientific research on the theme of conservation in relation to proper use and valorisation of archaeological site. The ATHENA approach to those complex problems always underlines the double nature of the management: from one side we have **Intrinsic Actions** and from the other the **Contemporary Uses**. Also, within the chapter dedicated to **Risk and Threats** it is important to distinguish these two aspects that always work together, in synergy, generating different problems that can put in danger the safety of visitors and tourists, as well as the conservation of constructed heritage.

4.3.1. INTRODUCTION

The heritage of ancient theatres has become vulnerable because of the rapidity of transformation processes resulting from many factors; urbanization and the increasing population density, development pressures, pollution, modern use, providing insufficient maintenance of susceptible materials or inappropriate conservation, lack of awareness and changing perceptions which tend to consider traditional knowledge systems as weak and outdated, and often neglected.

On the other hand, many ancient theatres have suffered from serious damage and deterioration due to natural and environmental factors such as earthquakes, landslides, structural deterioration, fire, weathering, bio-deterioration, flash floods, and other such factors.

Considerable decay is evident in many of the lime based stone theatres (limestone and marble) as well as silica based types (sandstones), especially in aggressively polluted urban environments. Moreover, colour changes, patina, blackening of rock surfaces in theatres and associated phenomena have practically always been related to other environmental factors of deterioration. All these factors put the cultural heritage of the theatre at serious risk, especially in the context of developing countries. Thus all places with theatre heritage value should be assessed as to their potential risk from any natural process or event.

However, where a significant risk is determined, appropriate action to minimize the risk should be undertaken, and a risk mitigation plan should be prepared (ICOMOS NEW ZEALAND, Charter for the Conservation of Places of Cultural Heritage Value). The proposed 'ancient theatre' risk management approach (Risk Identification, Risk analysis, Risk evaluation, Risk treatment (or mitigation) and Risk communication), could inform and guide decision makers in many other fields and offers a sound methodology to incorporate the most recent knowledge into current practice. It allows for an integrated vision of all expected damage and loss to the theatre's cultural property, and for its mitigation, thus providing a useful tool for the design of more efficient conservation strategies.

The following terminology has been identified according to Stovel, Herb, in 'Risk Preparedness: A Management Manual for World Cultural Heritage', ICCROM, Rome, 1998, as follows:

Disaster: An event whose impact exceeds the normal capacity of property managers or a community to control its consequences.

Hazard: A particular threat or source of potential damage (fire, floods, earthquakes are types of threats).

Mitigation: Means to alleviate or reduce the impact of disaster.

Preparedness: Planning efforts to reduce the risk of consequences of disaster; also includes planning efforts to prepare for response and recovery.

Recovery: Measures taken to overcome physical, social, environmental and cultural losses during disaster, and minimize the likelihood of future occurrences.

Risk: Hazard versus vulnerability; i.e. the degree to which loss is likely to occur, as a function of the nature of particular threats in relation to particular physical circumstances and time.

Vulnerability: Estimation of the level of loss associated with particular hazards.

Finally, we need to define the effective methods, materials and preservation measurements for restoring and maintaining the theatres under study, which require a multi-disciplinary approach where cooperation of monument owners, archaeologists, scientists and restorers is a must.

The following terminology is identified according to ICOMOS-ISCS illustrated glossary on stone deterioration patterns. ICOMOS: International Scientific Committee for Stone (ISCS).

Alteration: modification of the material that does not necessary imply a worsening of its characteristics from the point of view of conservation, for instance, a reversible coating applied on a stone may be considered as an alteration.

Damage: human perception of the loss of value due to decay.

Decay: any chemical or physical modification of the intrinsic stone properties leading to a loss of value or to the impairment of use.

Degradation: decline in condition, quality, or functional capacity.

Deterioration; process of making or becoming worse or lower in quality, value, character, etc...or depreciation.

Weathering: any chemical or mechanical process by which stones exposed to the weather undergo changes in character and deteriorate.

4.3.2. APPROACH & METHODOLOGY

Higher priority shall be given to the evaluation of risks concerning the physical structure of sites in relation to "use". A complete survey of the theatres should be carried out by using field observation, digital photography, a close visual inspection and other appropriate testing tools for:

1. Evaluation & investigation of theatre location, structure & materials, foundations, link to surrounding landscape in relation to the two main categories and factors of risk "Natural and Anthropogenic". The evaluation & assessment of the physical and natural threats should cover risks in relation to Geo-environmental and Bioenvironmental threats.

2. Evaluation & assessment of the risks within the urban fabric & landscape as a cultural cluster.

3. Assessment of the execution of new ideas for the construction and installation of removable structures, with the aim of establishing general regulations on the use of each site with a theatre or odea, while maintaining the acoustic qualities.

4. To establish a mechanism to produce a system of regular and permanent maintenance plans, calculated to ensure the preservation and conservation of theatres and Odea.

4.3.3. ANCIENT THEATRES RISK MITIGATION MANAGEMENT

Addressing the reason(s) why a theatre building has got into such a bad condition is an essential part of a repair scheme. Typically, proper maintenance of theatre buildings is the first important step in protecting them against the devastating effects of any natural and environmental or **anthropogenic risks.**

For the Risk Mitigation Management of ancient theatres, the following is suggested:

1. Establish a database for a core of cultural assets that will contain the surveys of all chosen theatres at risk, in order to gather information about their condition and usage, cataloguing of their structural conditions, seismic vulnerability and practical measures to safeguard their extensive categories. The 'Theatre at Risk Survey' can form the basis of a proposed Theatre Buildings at Risk Register, with each entry being categorised according to *the risk* scale. This enables the monitoring, recording, and prioritisation of cases. A classification in respect of their, location, type and their construction is needed, in order to estimate, among other things their vulnerability.

2. The conservation principles adopted should be appropriate to the original building technology, partly to preserve the integrity of the original design but also for practical reasons. A flexible approach and evaluation of the acoustical significance of the existing theatre fabric are required. However, the new target for those involved in digital acoustic technology should be to infuse ancient theatres and *Odea* with their full role as places of cultural and artistic creation, shared enjoyment and emotion (Haddad, 2007, 2008). There are four recognized steps to using a risk management approach to preservation issues:

 - *Identifying all risks to ancient theatre*
 - *Assessing the magnitude of each risk*
 - *Identifying possible mitigation strategies*
 - *Evaluating the costs (where applicable) and benefits associated with each strategy*

3. Develop guidelines for the planning of the mitigation measures and implementation of theatre mitigation technologies and products; for example: the lighting systems, preparing evacuation plans, and providing for community risk-volunteer training. In addition, there should be regular monitoring of the plans of the physical fabric after conservation work and public events; this is essential, given the theatre site's vulnerability. Such monitoring should be undertaken before, during and after performances.

4. Any rational policy and long-term plan of action for protecting theatre heritage requires co-ordination at the administrative level and relevant research and education, not to mention public information and "mobilization". This is a rather difficult task; several legal, technical, social, organizational and financial aspects should be considered.

In terms of mitigating the damage to theatre heritage assets, the ATHENA project may prepare an action plan that will mandate the development of a comprehensive inventory of cultural heritage assets, conduct/propose detailed studies to determine the different kinds of theatre vulnerabilities and recommend broad technical mitigation measures, and carry out the design/construction of a long term plan for the protection of these buildings, now and in the future. For preventive conservation, theatre risk management can provide a framework for decision-making.

4.3.4. RECOMMENDATIONS FOR ANCIENT THEATRES RISK PLANNING, RESPONSE AND RECOVERY

According to *Stovel, Herb, Risk Preparedness: A Management Manual for World Cultural Heritage, ICCROM, Rome, 1998*, the internationally accepted frameworks and procedures for Environmental Assessment can be applied in assessment and risk planning for any intervention.

Eventually, the sharing of knowledge and promotion of the principles of theatre risk preparedness for cultural heritage is crucial in order to become more aware of the dangers of the permanent loss of these resources to natural and anthropogenic deterioration and risks.

Ancient theatres Risk mitigation planning should take into consideration the following:

1. Analysis of risks and assessments of theatre heritage should begin by building on national inventories which will serve as the key instrument necessary to effective planning. Such inventories should be up to date, easily accessible and spatially related by using geographic information systems (GIS) and digital documentation tools (3D laser scanning, Thermography, multispectral photography ...)

 - A strategy based on practical testing, ceaseless monitoring and preventive care should take place in order to develop a suitable methodology for each type of risk, i.e. small or large scale in-situ testing and medium (or even long) term monitoring and feedback.

 - A successful working schedule should consider and include scientific tools to prevent the harmful effects on theatre materials, based on scientific diagnosis, and by using several methods and analytical techniques according to the nature and status of the deterioration.

 - In addition, risk theatre preparedness should not be conceived only in emergency situations but interwoven into the practical management of these theatre heritage resources[1].

2. The theatre buildings must be properly maintained to adequate conservation standards. Maintenance procedures should be taken into consideration for minimizing all interventions in the future. *"Immediate or urgent interventions, necessary intervention* and *permanent interventions"*.. By maintaining theatre heritage sites -repairing, cleaning, or correcting defects- we are not only preventing deterioration of precious original materials, we are also ensuring that possible hazards are avoided.

3. Nowadays the theatrical activities are related to cultural activities. A database should be created to provide the cataloguing of ancient and contemporary activities that contribute to the worth and originality of every site.

4. Any management, intervention, or reconstruction plan should bear in mind that local communities are dependent on tourism revenues and that tourism facilities are planned with these communities in mind. Furthermore, it would be of extreme value that the economics of the plans be commensurate with the heritage value of the site.

5. Establish margins of safety, in relation to durability, against all possible actions, including natural disasters and adverse environmental conditions which may alter material and structural properties.

6. Considering the issues and challenges described above, there is an urgent need for awareness, education and training among the local community, visitors, audience and key stakeholders to address the needs of theatre heritage threatened by various categories and types of risks.

4.3.5. EVALUATION AND MITIGATION OF ANCIENT THEATRES RISKS: Towards Definition and Analysis of These Entire Risk Components

Understanding How Ancient Theatres Risks and Disasters are Assessed.

An attempt is made here to classify the type of ancient theatres risks and disaster hazards and the likelihood of their occurrence, as a means of assessing the risk for the theatre cluster. This includes disasters and major calamities due to natural phenomena whose origin and causes are beyond human control such as environment, pollution, age and decay, in addition to disasters due to human activities. However, emphasis is placed on the factors of synergies and interactions between the natural phenomena and the other causes of damage, particularly in the theatre's masonry structures.

Risks to ancient theatre heritage may stem from exposure to one or several hazards or factors. It is of importance to clarify that certain regions may be subject to greater risk due to earthquakes (which demonstrate the greatest power of massive destruction), while other dangers are more widespread (e.g. fires in urban nuclei and historical centres with theatres). We therefore need to have a holistic understanding of risks to theatre heritage from various hazard sources and from vulnerability processes while

1 As defined by the *Standards and Guidelines for the Conservation of Historic Places in Canada* (2004), Mitigation theatre procedures should be put into place to ensure that modern performances have been adapted for the new use conditions even the seismic one.

incorporating specific actions and strategies for particular hazards. Although theatre risk is assessed by a combination of condition and occupancy - an empty theatre building can be in relatively good condition but still be rated as vulnerable simply due to the theatre building's lack of a viable use. In other words neglect is an important factor in this process. Conversely, a theatre that is in poor condition but has a viable use may not necessarily be considered to be at risk, although it will normally be monitored as a vulnerable building. We therefore need to link the physical and environmental vulnerability of theatre heritage to the vulnerability that comes from anthropogenic factors associated with social and economic development. Risk preparedness for theatre heritage will therefore involve:

- Geo and bio-environmental management, including efforts to prevent the natural hazards.
- Mitigation of those risks to the theatre which are caused by proposed physical interventions, and applying a minimum intervention approach.
- Community preparedness through awareness and training.

The degree of theatre risks can be classified as follows:

1. Not at risk, and in excellent condition.
2. Not at risk, in fair condition.
3. Vulnerable to further decay and may become at risk if problems not dealt with soon.
4. At risk of further decay.
5. Severe risk of further decay.
6. Extreme risk of further decay or total loss.

4.3.6. MAIN CATEGORIES OF RISK MITIGATION OF ANCIENT THEATRES AND ODEAS

As mentioned, there is no single reason why a theatre building becomes 'at risk', as each case has different circumstances which have led to the theatre building's decay. There are complicated processes of destruction and distress that vary in the eventual decay of the theatre building's materials due to physical, environmental, anthropogenic and even political factors and forces, which lead to typical structural changes and different types of deterioration. There are three main causes of theatre material decay and deterioration patterns (cavea seats, orchestra, stage and walls) - organic, mechanical or chemical:

- Causes that are classified as an organic result from the direct impact of a living organism on the physical material of the theatre structure.

- Deterioration from mechanical causes can often be recognized by breakage or crumbling of the theatre materials. The source of the problem is either an object striking the building or of water forcing building materials apart through expansion, an especially harmful process that may occur during the winter's freeze/thaw cycle. This is limited to the presence of other effects (wind, earthquakes, landslides etc.).

- Chemical deterioration results from localized contamination of the air or moisture, or from material incompatibility.

4.3.7. NATURAL CAUSES OF DETERIORATION AND THREATS: GEO AND BIOENVIRONMENTAL RISKS

Damage and deterioration in this category is due to external factors and can result mainly from climatic and environmental factors. Generally, many of the theatre ruins and structures suffer from the *effects of natural threats* of earthquakes, rain water and inactive drainage system (flash floods), landslides, wind, sun, physical deformation such as microbiological patinas, superficial and calcareous sedimentation, scaling, efflorescence and cracking.

Natural disasters cannot be prevented, but much of the damage to the theatre heritage can be prevented by constructional, technical, educational and planning measures.

4.3.7.1 INTRINSIC CAUSES

1) Earthquake Damage

Over the years earthquakes have caused significant damage to historical structures like theatres. Much of the damage to theatre buildings could be related mainly to the manifestations of the local and the regional seismicity, and were partially damaged by the temblors and unbalanced load distribution resulting from earthquakes, creating structural problems. In a few places with theatres there is total destruction. Additional problems that may result include cleavages, wedges and detachments on the stage and portico columns as well as failures in the original materials. The cleavages, decay and disintegration can be observed in the masonry bonds, which have accelerated the process of deterioration. Earthquakes provoke destructive effects either directly or indirectly, and when combined with the theatre slope big dangers occur. The faulting, fracturing, weathering, erosion and the phenomena of karst all provoke considerable changes in the rock characteristics (*Matova, 2008*), and **have** additional importance for the increase of geological vulnerability in areas with theatres.

For instance, the lithological and the tectonic characteristics of the locality create problems for the protection of these monuments.

Theatres placed in moderately cemented limestone have the problems of weathering, erosion and karst to be considered side by side with earthquake hazards. Meanwhile, in the case of earthquakes, the stage scene and portico columns are able to withstand seismic activity due to the partially elastic and flexible movement of the drums with respect to each other. However, reinforcement with steel may be necessary to restrict the movement and lessen its impact.

Focusing on the protection of theatres from seismic hazards is essential. This could be done by consulting on risk assessment, risk mitigation, implementation of effective measures and decision making processes for the protection of theatre buildings, especially the stage and the portico.

Pre-earthquake strategy may contain a four-fold action:

1. Completion of a theoretical understanding of masonry, development of rational models, education and training of engineers and technicians.

2. Development of specifications and guide-rules for assessment and upgrading, including quality assurance and effectiveness.

3. Reconsideration of the whole framework of administrative and legislative measures.

4. Evaluation of risks to theatre heritage, which entails estimating the hazard and assessing how vulnerable each particular theatre may be to that hazard.

The criteria for earthquake hazard mitigation in relation to modern performances should be an essential undertaking. The ATHENA project should consider that it is essential that seismic mitigation for ancient theatres be an active component of theatre conservation techniques across the world, particularly in areas at risk of high earthquake activity.

Geological data is needed. Investigation of mitigation methods for ancient theatres and identification of seismic risks is crucial; examples of mitigation approaches used in several countries with earthquakes need to be investigated. The first step is gathering information of past seismic activity and the geological conditions of the theatres. A database of cultural assets including cataloguing their location, structural conditions, construction technology, and landscape in relation to seismic vulnerability is to be evaluated and analysed.

The following types of information could be taken into account:

- Seismic history (frequency of tremors and their effects on theatre structure).

- The geography of the city and geological and tectonic features, soil characteristics and its geotechnical behaviour, seismogenetic sources.

- Assessment of the vulnerability of theatre buildings/clusters and the way this varies spatially and over time; impact of earthquakes on individual theatres and clusters.

- The mapping of seismic risks in the different urban areas with theatres.

2) Risks and problems arising from the topography/slope and landscape; i.e. renewed settling of the theatre foundations

A theatre can be identified in relation to topography,[2] by three treatments of their structures. These are: 1) on a hillside slope; 2) on a purely flat site; 3) combination of the two treatments (the lower cavea on a partially sloped hill site and the upper on a flat site). However, many theatres in Roman times were built on substructures. For many ancient theatres, most settling movements have stopped long ago. However, some changes to a theatre building's surroundings can bring about more shifting. Changes are often gradual and not noticeable over a short period of time. Some of the common signs of settling and shifting foundations are misaligned doors with gaps, openings at the cavea slope and the stage, cracks in the orchestra floor, cracks in the stone and cracks in the foundation. However, there are several actions and events, natural or manmade, that may lead to a renewed settling of the foundations. These include:

- Tree roots in clay soils will extract moisture, producing voids in the soil, at a time when the foundations lack lateral support.

- Changes in the level and quantity of ground and surface water around the foundations.

- Humidification may result in an increase or decrease in the normal moisture content in foundation or structural materials leading to shifting in the theatre foundation. Often this results from cyclic contraction and expansion of materials.

In addition to:

- Excessive traffic and human motion in the immediate vicinity which cause strong or continuous vibrations to the structures.

- New construction or excavation close to the theatre building.

2 In general, we can assume that the theatre design contributed to the urban landscape, while the theatre within the city planning was determined by a combination of several factors: the location, the size, the orientation within the city's boundaries and, in particular, the joint relationship between the theatre's location and orientation.

- Significant increases in the load due to the over-loaded capacity that a theatre must carry, often due to modern uses.
- Introduction of new installation systems for modern uses requiring new loads on the theatre, which may affect the load capacity of the structure and the foundation's stability.

3) Flash floods and proper drainage systems

Theatres are often situated outside of areas prone to floods (such considerations had a bearing on the choice of a site). The dangers of floods are therefore of minor importance if there are proper drainage systems. Disaster plans for possible emergencies should be worked out. Floods should be mapped systematically in the theatre areas. Flood torrents and avalanches in danger zones have to be recorded in order to establish flood prevention measures.

4) Biodeterioration Risks and Damage

Damage due to intense vegetation, overhanging branches or climbing plants, overgrowth of surrounding vegetation, biotic coverage (plants growing inside the stone) microorganisms, animals, goats and bird droppings.

Biodeterioration is one of the serious problems. However, biodeterioration of ancient theatre material is a complicated problem that needs an interdisciplinary approach by experienced conservators and specialized biologists. Microorganisms, plants and animals cause serious decay to the theatre building stones. Decay due to animals is principally from goats and bird droppings, and their acidic metabolic products can severely damage stone.

Some of the biodeterioration results in material loss as well as undesired mechanical, chemical and aesthetic alterations, which also affects most conservation interventions. Erosion of the exposed stone surfaces due to the direct effects of botanical and microbiological actions, lead to the loss of many surface details such as carvings and reliefs resulting from the dominant microenvironment, especially accumulated pollutants.

Microorganisms develop epileptically (on stone surfaces) as coloured mats, and chasmoendolithically (within the stone in cracks, fissures, gaps and exfoliations). Microorganisms also favour the development of plants and animals. Epilithic microorganisms form thick biological mats consisting mainly of colourful lichens and bryophytes that cause 'honeycomb' and 'pitting' decay patterns (Papida et al. 2010). Comparison with old photos and images can be used to show the epilithic mats that have now been lost from most theatre surfaces, probably due to the increase of organic pollutants in the atmosphere (Diakumaku et al. 1995, pp. 295–304). Recent research results indicate that their presence is correlated with orientation and humidity: most lichen and bryophyte mats can be observed on the northern surfaces of the monuments or on ancient inorganic mortars. Mats become more intense where water retention is higher due to the inclination of a surface or because of limited exposure to the sun (Papida et al. 2010).

On the other hand, plants develop between and near building stones and degrade them by exerting mechanical pressures, excreting corrosive metabolic products or providing nutrients and niches for micro-organisms (Papida et al. 2010). Trees and gigantic bushes grown on the theatre ruins, particularly in the walls, can cause severe damage to the theatre stone structures and construction materials. For example, the ancient theatre of Thassos in northern Greece **has suffered serious damage due to the** intense vegetation in the region; 72 trees have grown in the cavea and have transferred diseases and fungus to the material of the theatre. The roots of these trees have also broken many seats.

Thus, plant and animal elimination should be considered a crucial part of an integrated biodeterioration strategy for the Athena project. The seasonal manual elimination of plants needs to become a priority as a regular part of the annual schedule for the management of a theatre site. A key issue is whether biocide application should be before or after consolidation, cleaning, joining of fragments, filling of discontinuities and sealing; microbiologists suggest that biocide application should follow conservation procedures and that biocides should not be removed after application. In contrast, the manufacturers' guidelines regarding both issues are variable. An additional concern is that biocides may gradually be converted to nutrients and enhance recolonisation (Warscheid, Braams, 2000; Papida et al. 2010).

However, cleaning before biocide application results in effective removal of epilithic mats. On the other hand, biocide application on unconsolidated surfaces inevitably causes greater material loss. Raw microbiological data up to now suggests that the action of biocides applied after the treatment was limited, since recolonisation time was shorter (Papida et al. 2010). However, failure to remove these organic remains provides microorganisms with a nutrient substrate. In practice, biocide reapplication is also affected by the general conservation principle of minimum intervention since every conservation treatment has the potential to cause damage.

Information on the direct and indirect impact and damage **due to the** intense vegetation and biotic coverage on the theatre, and to control biodeterioration caused by microorganisms and plants using biocides, needs to be assessed. The control strategy should involve careful *in vitro* and *in situ* examination of the stone substrates, (micro) flora and fauna and biocides.

This should include the identification of plants and microorganisms that adversely affect the monuments. Constraints that inevitably affect choices and the treatment potential also have to be identified and include the varying condition of the stone, coexisting and synergistic deterioration mechanisms, and the scale of the monuments and their exposure to the natural environment (Warscheid et al. 2000). A strategy based on practical testing, ceaseless monitoring and preventive care should take place in order to develop a suitable methodology for each type of substrate, and each biodeterioration pattern.

New approaches should increasingly be part of a protective strategy against both biological growth and loss of material. This strategy for biodeterioration in the **Athena project** theatres should be designed to consider the scale of the theatre, as well as the complications encountered *in situ* because of numerous environmental and logistical parameters. This biodeterioration control strategy should illustrate a mechanism for controlling biodeterioration from plants and microbes that: (a) describes the most characteristic biodeterioration patterns in stone theatres in order to investigate their control parameters, and (b) identifies the main plants and microbes with biodeterioration potential in order to select an efficient method for controlling the damage of the stone surfaces of the agreed case studies.

5) Climate: Identifying and Measuring the Influences of Climate Weathering and Erosion Risks

There is a relationship between the pollutant levels and meteorological[3] parameters especially wind speed and Relative Humidity (RH), which are usually elevated in winter, as well as the level of exposure to weather, and the air temperature. Such parameters accelerate the degradation processes dramatically, which are: erosion, pulverization and disintegration, scaling, gaps, exfoliation, separation, biological patina, and efflorescence.

The weathering morphology is clearly controlled by the texture of the rock. It is noticeable that the formation and propagation of fractures throughout the foliation occurs in the places where the gneissic foliation is more developed, producing peeling or exfoliation. Due to the weathering factor, we can clearly see the loss of the plaster layers that used to cover the rocky facades of Petra and, particularly, the Petra theatre, which led to rock flaking. Some of the weathering aspects dominating the urban environments are exfoliation and scaling, which is mostly due to the action of freezing and thawing,

together with the presence of acidic pollutants. Rock flaking is especially caused by temperature variations and sun exposure.

Weathering morphologies could be mapped by visual inspection. This is an important step, since these morphologies are considered an effect of rock alteration and weathering processes. Visual inspection should be carried out in relationship with rock foliation and the different orientations.

Rain Wetting Damage Effect: *Direct impact and indirect impact (moisture).*

Studies of the rain wetting of walls have shown that there is appreciable nonuniformity of wetting and confirm what is often noticed when buildings are wet by rain, that much more intense wetting usually occurs near the tops of walls than at lower levels. Differences in wetting are attributable to the wind-flow patterns over the wall surface, which direct the paths of the falling raindrops (Ritchie, 1976).

The degree of rain wetting, however, should be expected to depend on two factors:

(1) The amount of rainfall, which varies over the course of the year, (2) the force of the wind, which not only blows the rain onto a wall but also applies pressure to the wall surface forcing the rain into the pores and openings of the masonry.

The rain that falls on a masonry wall has three possible paths of penetration: through the body of the unit; through the body of the mortar; through openings between the unit and the mortar. The amount of water that penetrates mortar does not contribute significantly to a leakage problem. Staining and efflorescence on masonry walls reflect the patterns of the wetting and the manner in which rainwater runs over and off the wall surface. The water flow patterns may also produce stains and streaks by eroding the masonry material, the resulting differences in texture and colour giving an appearance of vertical streaks on the wall surface.

The main problem and risk at the theatre building is to keep water/snow out of the building, which is the single most damaging element to stone. Rain results in effective removal of *chasmoendolithotrophs* on biodeteriorated stone surfaces. However, in an urban setting with ancient theatres, there exist some deterioration features such as dissolution and erosion of stone surfaces because of some chemical effects resulting from acidity spots composed as a direct result of interaction with "acid rains". For example, acidic rains cause erosion to the stone and changes in its colour. This mainly appears in urban and industrial areas, and it is very clear in the upper parts of the Roman Theatre of Amman.

3 Meteorological situations: (a) fluctuations of the temperature around freezing point, (b) frequent changes from wet to dry weather, (c) frequent storms of changing directions, (d) heavy winter and spring rain on frozen ground, resulting in flooding.

From this point of view, we can say that the damage produced by acid rain on calcareous stone can clearly be seen on the carved surfaces only a few millimetres deep, which can be lost very fast depending on the pH value, rain quantity, impurities and wind direction as reported by *Charola, 1988*. This phenomenon leads to an increase in the theatre stone's porosity, and thus water will penetrate more deeply into the pores and react with internal cement materials and Calcite grains. It also increases the ratio of damage and losses to the cohesive index of the structure, and eventually the failure of the structure after the production of the so-called sugaring appearance (*Rands et al. 1986*).

Meanwhile, due to direct synergetic effects between rainwater and soiling by particles, some layers of un-noble patina and coloured surface crusts are often observed. Severe etching and loss of calcite grains on stone theatre surfaces because of dissolution processes results directly from the effects of acid rains. In addition, there can be detachment of mortar layers and some stone fragments because of the effects of the salinity of water, some external actions and vibrations. The presence is detected of some coloured hard crusts resulted from the acid rain effects, heavy metals that dominate air composition and fly ashes "ferrous oxides".

Salt Damage in Relation to Wetting and Drying Cycles accelerating deterioration

Efflorescence is caused by the absorption of water by masonry materials. The water dissolves salts in the masonry, forming solutions that subsequently move to the surface where the water evaporates, depositing the salts. The salts may have originated within the masonry units or the mortar, but the latter is a particularly important source. Efflorescence frequently reflects the direction of rain wetting of walls. Efflorescence also reflects differences in the amount of wetting received by a wall; it often appears at the top of the wall but not at the bottom. (Ritchie, 1976)

There are several aspects of salt efflorescence and sub-efflorescence covering both theatre stone surfaces and mortar layers due to the crystallization and recrystallization cycles of salts coming from acid rains especially after drying cycles, either by air temperature or by air currents. Cracking and loss of some theatre stone surface details is largely because of aggressive effects of internal pressures and micro strains resulting from the growth of some salt crystals especially inside the pore structures. As well, there is the disappearance of some parts of stone surfaces as a direct result of salt crystal growth due to alternating processes between wet and dry cycles daily, seasonally or annually. Efflorescence or sub-efflorescence processes affect ancient theatres materials and permit the movement of different materials from inside to outside, such as calcium carbonate salt.

Formations of some salty hard-crusts on theatre stone surfaces and within stone pores create some aggressive internal pressures, which finally lead to bleeding of stone aspects. The rate of chemical reaction between stone surface and acid rain depends mainly on several catalytic effective metal ions, (Penkett *et al.* and Flatt *et al.*). Finally, this salt will penetrate into stone pore spaces and will crystallize there leading to crystallization processes over years, eventually breaking the stone surfaces. This phenomenon depends essentially on the amount of salt present, its nature and the number of dry-wet cycles (Binda and Baronio).

Brick Masonry Structure and Mortars

A brick wall is only as strong as the mortar that holds it together. The functional requirements of mortar are numerous. A mortar joint acts as a sealant, a bearing pad, sticks the units together yet keeps them apart, and in this sense performs as a 'gap filling adhesive'. Mortar joints bond bricks together allowing the brickwork to act as a structural element to carry both vertical and lateral loads. Lime mortars consist of sand mixed either with non-hydraulic lime putty or bagged natural hydraulic lime. Although non-hydraulic lime is softer and more breathable, natural hydraulic limes are suitable for repointing stonework, in particular where lime work is close to ground moisture. The colour of mortar can be severely degraded by incorrect or poor brick cleaning.

Several different mechanisms are operant in the deterioration of brick masonry through the action of acid rain. The bricks are susceptible to acid rain through the selective dissolution of their glassy phase. In the places where the water evaporates, the salts will be deposited. Repeated dissolution and recrystallization of these salts leads to the mechanical disruption of the masonry structure (Charola and Lazzarini, 1986). The wetting of masonry gives rise to problems of staining and efflorescence and is an important factor in the occurrence of frost damage of masonry materials. Openings at the unit-mortar interface are major paths for rain penetration of masonry walls. Such openings result from incomplete contact or bond between unit and mortar when masonry is laid up. Some dry, powdery, white stuff at various locations on the brick exterior appears both on the brick and sometimes in the mortar, is probably efflorescence, and is evidence that moisture is transpiring through the wall. The persistent transpiration of moisture through the wall will degrade the mortar between the bricks, requiring tuck-pointing to repair it. For brick structure to function properly, the wall must resist moisture penetration and be permeable to vapour from the structure.

Since the salts will concentrate in the more porous material, either the brick or the mortar will be more seriously affected, depending on their relative porosity. Like any brick structure, a wall could be

falling apart because the mortar has degraded, because the bricks are cracked, or both. To fix a crumbling wall, we must be prepared to both re-point the mortar and to replace damaged bricks. This action not just a cosmetic effect since stone and brickwork can destabilize if left too long without pointing. The mortar is affected mainly by the reaction of its calcareous components. The soluble salts resulting from these reactions, in solution with rainwater or condensed moisture, will migrate through the porous matrix of the masonry. If the mortar has eroded more than 1/4 of an inch, it must be replaced or re-pointed.

As an example, in the ancient theatre of Taormina in Sicily, tests on the degradation phenomena of the structural materials showed that the deterioration is due to the aggressive action of the environment agents. Soluble salts, such as chlorides, sulphates and nitrates, were found in efflorescence samples. Mortars were affected by a decomposition process induced by the attack of sulphates. In the theatre of Taormina, artificial stone materials in different conservation conditions were investigated. Samples of salt efflorescence from brick walls and degraded setting mortars were taken from the open gallery in "summa cavea". The chemical, physical and structural characterization was performed by means of X-Ray Photoelectron Spectroscopy (XPS), X-Ray Diffraction (XRD) and X-Ray Fluorescence (XRF), both in situ and ex situ.

Moisture Risks and Deterioration

In winter, the air within the theatre building has higher moisture content than outside and the resulting difference in water vapour pressure causes a diffusion of vapour outward through the theatre enclosure.

The amount of water vapour able to diffuse through the wall depends on the pressure difference as well as on the permeability of the materials through which the vapour has to diffuse. At some point in the course of its passage through a material, the vapours dew point temperature may be reached and condensation takes place, thus increasing the moisture content of the material. Condensation of water vapour can also occur within masonry walls by a process that involves the outward leakage of air through openings and cracks in the walls. Condensation occurs when the air cools.

Some signs of moisture problems are stains on dry theatre stone wall, mould or mildew (especially in corners), rust and corrosion stains on metal elements paint that is peeling or blistering, rotten wall sheathing or siding, efflorescence (salt deposits) on interior or exterior surfaces of the theatre, dank, musty smells, particularly in the poorly ventilated spaces. For example, algae arise from moisture above stones; we can see it very clearly in the Roman theatre of Amman. Thus, it is important to ask:

- Are there any signs of excessive moisture such as musty smells or corrosion?
- Is there any condensation forming?
- Are there water stains or rotted stone near the orchestra or stage floor?

Wind Erosion

Practically all of the rain striking the surface of a highly porous material is absorbed, whereas much of the rain runs off the surface of other materials without being absorbed. An index of the wind-driven rain for a particular location, which takes into account the amount of rain and the wind speed (summer wind, winter wind), may be calculated by taking the product of the annual rainfall and the mean wind speed.

Temperature and Relative Humidity

We need to monitor the air temperature and building material temperature (date, time and location, also in relation to orientation). A data of average temperature for each month of the year, including the period at least from 2000 to 2010, if possible, will help to observe when the highest and the lowest average of temperatures are occurring.

Data of Average Temperatures: Maximum Temperature (oC) / Average Minimum Temperature (oC) / Average Thermal Amplitude (oC) are of importance.

Decay due to freezing is a serious consequence of the wetting of masonry. Experiments have shown that damage done to masonry materials by freezing depends in large measure on their moisture content when the materials are frozen (Ritchie, 1976). The deterioration of masonry materials because of frost action is more rapid and intensive, therefore, in those wall areas where excessive wetting of masonry occurs, for example, at the top of a wall.

High frequency and low magnitude agents (particle disaggregation, human induced moisture) are another factor to be monitored.

4.3.7.7 RISKS ARISING FROM STRUCTURAL PROBLEMS AND AGEING OF MATERIALS

The majorities of theatre buildings are constructed mainly of limestone. In some cases they are built of marble, brick masonry and sandstone. Ancient structural material, in general, has proved to be extremely versatile and durable (as compared to more modern ones, like steel or concrete), but it presents a considerably higher level of difficulty for the study of its structural response and behaviour. The combination of many structural peculiarities (such as complexity of structure and uncertainty of quality) with pronounced anisotropy (almost unknown to steel or concrete) and the other basic

characteristic, which is age/decay (in conjunction with discontinuities and damage), creates a challenging scientific and technological problem, as well as acute socio-economical consequences.

In this respect, engineering procedures for the assessment and upgrading of theatre buildings are not yet well developed and have not yet reached an adequate degree of refinement. There are various reasons for this, not to mention the needs for unconventional analytical models and for a more general and complex reliable philosophy.

In view of this, it is not surprising that previous solutions offered to specific problems may hardly be considered as satisfactory; such an unsatisfactory situation is however successfully faced in some cases by experts and specialists by means of rough but reliable rules based on available experience and repetition.

Therefore, certain measures should be taken at international level, aiming at the:

- Completion of theoretical and experimental knowledge (models on analysis and resistance of masonry).
- Development of methods on in-situ testing and monitoring.
- Development of methods on overall testing for global verification and validation.

These methods, besides their obvious usefulness for assessment procedures, should be applied both as feedback in order to correct analytical models, and as a means to face unpredictable consequences of accidents (earthquakes, floods, fires, abnormal environmental influences, etc.). Thus, rational estimations and predictions can be made regarding the safety and performance of the monuments, and a logical framework for decision-making can be secured with possible operations in mind.

Special attention should paid to two aspects:

- Assessment of the monument and of its present condition, and decision-making regarding alternative types of operations.
- Assessment of the broader sense: besides the historical, archaeological and architectural evaluation of the theatre, a complete structural evaluation of the present condition of the theatre, is needed, like the interaction between soil structure and the building, characteristics and structural typology of the building, topography of the building, and interpreting the cracks in the theatre building within particular blocks; an examination of cracks helps us to understand what has happened. We also have to know whether the cracks are dangerous or not.

Typically, masonry structures have problems and damage associated with one or more of the following:

- Foundation displacement, also known as settling, over time
- Water penetrating into structural walls
- Shoddy construction
- Poor materials
- Stresses on the masonry walls due to fluctuations in temperature
- Aging of mortar in masonry joints.

However, monitoring the movement of the theatre structure normally takes an extended period of time. Foundations should be inspected, with additional checks following any severe rainstorm, nearby construction, excavation or maximum capacity for modern use. Every partner has to evaluate the way the theatre in their study was constructed, its architectural planning and technical execution. In addition, it is necessary to gather information and to look for:

- What is the condition of the orchestra floor? Is rainwater lodging in the orchestra and around the base of the theatre building? Are the rainwater gullies draining properly?
- What is the condition of the pointing? Has earth banked up against the base of theatre walls?
- Are any serious cracks visible in the stage structure? Are columns, posts vertical and stable? Are beams, columns, posts and joints sound?
- Is there any sign of decay of theatre stonework? Is there any plant growth on or against the theatre walls? Do the walls need to be cleaned?

CHEMICAL ANALYSIS AS A USEFUL TOOL FOR ESTABLISHING THE STATE OF CONSERVATION OF ANCIENT THEATRES

*María Teresa DOMÉNECH-CARBÓ**
Stephan KRÖNER
Laura OSETE-CORTINA
Instituto de Restauración del Patrimonio, Universitat Politècnica de València
**Corresponding author: tdomenec@crbc.upv.es*

Abstract

This paper summarizes the applications that the analytical techniques have, currently, for establishing the state of conservation of an ancient theatre. A combination of conventional and advanced instrumental techniques enables the characterization of the materials used for building the monument, the recognition of the alterations and damage due to natural ageing of the monument or to its inappropriate use and, finally, the identification of the causes of the alteration and the physicochemical mechanisms involved in such undesired processes.

1. INTRODUCTION

Preservation of cultural heritage is an important and rewarding task of European society. Ancient monuments and, in particular, ancient theatres are a source of inspiration and they can be an intersection point of the common culture and history of the past and present in the countries of the Mediterranean Basin. This valuable asset is an important legacy to be passed on to the next generations.

Conservation and preservation of heritage is a complex task, which requires that conservators, curators, art historians, architects, engineers and scientists all work together. Thus, preservation and conservation of heritage is considered nowadays a pluridisciplinary activity.

Cultural heritage and, in particular, ancient theatres are comprised of a great variety of materials. Although their significance stems from the transmitted historical, cultural or figurative message, their conservation and perpetuation in time is dependant on their materials. On this basis, chemical analysis can be considered a useful tool for characterizing and establishing the state of conservation of ancient theatres, the latter being an essential part in the development of a management plan for compatible uses of ancient theatres. This paper summarizes the applications that the analytical techniques have, currently, for establishing the state of conservation of an ancient theatre. Firstly, the combination of conventional and advanced instrumental techniques enables the characterization of the materials used for building the monument. Characterization of materials comprises not only the identification of the chemical compounds and minerals present in the monument but also dating of the archaeological remains and elucidation of the techniques and technologies of production, as well as the adscription of the raw materials used in the theatre to a specific quarry or geographical region. The recognition of the alterations and damage due to natural ageing of the monument or to its inappropriate use and finally, the identification of the causes of its deterioration and the physicochemical mechanisms involved in such undesired processes.

On the other hand, the unique and irreplaceable character of the ancient theatre restricts the conditions for applying some analytical procedures that require the taking of samples. Figure 1 is a picture that reflects the series of difficult decision that the analyst must make to carry out an analysis of an archaeological object or monument concerning both the selection of the analytical method and the sampling strategy. The analytical method can consist of a single instrumental technique or can be a more robust multi-technique method that combines several instrumental techniques, which provides complementary data and information. In any case, the analytical technique selected can provide information of a specific part of the object (reductionist approach or point analysis) or the whole object can be subjected to analysis (holistic approach). Depending on the sampling requirement, the technique can be invasive or non-invasive. Finally, in the case of invasive techniques, the destruction or not of the sample during the analytical process enables the classification of them as destructive or non-destructive.

Figure 1.- Scheme of the analytical strategy applied to the study of a monument.

2. CAUSES OF ALTERATION

Figure 2 summarizes the main causes and physicochemical and biological mechanisms that result in the deterioration of the theatre. Usually they are grouped into four types according to the class of mechanism responsible for the damage and alteration induced: physical, chemical, biological and anthropogenic.

Table 1. Main causes and mechanisms of deterioration of an ancient theatre

TYPE	CAUSES AND MECHANISMS OF DETERIORATION OF AN ANCIENT THEATRE
Physical	Thermal changes: freeze and unfreeze cycles
	Crystallization of salts (efflorescence and criptoefflorescence)
	Erosion by circulation of water
	Mechanical stress
	Wind
	Vibrations (earthquake)
Chemical	Activity of water as solvent
	Activity of acids
	Reactivity of atmospheric pollutants
	Residues of use
Biological	Microorganisms
	Macroorganisms: excrement, residues
Anthropogenic	Vandalism
	Erosion and residues of use
	Inappropriate interventions

Scientific analysis of the object provides a complete picture of the type of damage exhibited by the object:

Morphological changes observed in the bulk or on the surface of the object are mainly debris, dust, superficial deposits, crusts, cracks, pores, fissures, fractures, laminations, lixiviations, spots, efflorescences, etc.

Optical properties such as colour, pleochroism, refractive index or birefringence are essential for characterizing rocks. They also provide useful information for recognizing alteration processes. Other physical properties which determine the behaviour of the solid object are those related to the porous structure of the material comprising the object, namely, saturation coefficient, water vapour conductivity coefficient, water absorption coefficient and permeability. Among the properties commonly determining the mechanical behaviour of the object are included density, Young's modulus, ultimate tensile strength, ultimate compressive strength and ultimate flexion strength.

Qualitative and quantitative chemical information can be obtained from the materials and alteration products formed from the object depending on the analytical technique used. Elemental composition provides basic data. Structural information including recognition of functional groups or the complete molecular structure or mineralogical distribution is often needed for identifying the alteration processes. Electrochemical techniques enable identification of electroactive species and make possible speciation studies of the examined materials. Calorimetric data are available from thermoanalytical techniques.

In chromatographic techniques, qualitative identification of organic binders requires quantification of species obtained from the original polymeric materials: amino acids from proteins, fatty acids from drying oils, or monosaccharides in plant gums, among others.

Occasionally, determination of properties such as pH, conductivity or concentration of ionic species is also of interest.

Biological analysis is focused on the identification of the attacking organism, generally, fungi, algae or bacterial microorganisms, but also insects or plants. Secondly, characterization of the products resulting from their metabolic activity and the alteration products resulting from their interaction with the object are also carried out.

A more detailed description of the fundamentals and applications of the most commonly used chemical methods for analysing monuments is provided in the following sections.

3. ANALYTICAL METHODS

3.1 Petrographic and mineralogical methods

In historic buildings normally three types of inorganic materials can be found: stones, bricks and mortars. These materials can be interpreted as amalgamation of minerals and pores and/or fissures. Over time, due to the physical and chemical decay phenomena, these materials exposed to the atmospheric agents suffer changes, especially porosity increases and mineralogy. The empty spaces facilitate pathways for water, intensifying alteration effects. For this reason it is of great importance to analyse both mineralogy and porosity in order to understand alteration/decay processes and to prevent, or at least minimize, damage (Esbert, Alonso & Ordaz, 2008; Miriello & Crisci, 2006).

Here, two very powerful and typically applied analytical methods in geosciences are described: the petrographic microscope and X-Ray diffraction (XRD).

Petrographic microscopes are optical microscopes used to identify mineral phases and to characterise the texture in thin sections (normally 30μm thick). A polarizer filter is added to the light path beneath the sample slide above the light source and an analyser (removable polarizer, oriented perpendicular to the first one) is placed between the objective and eyepiece. Isotropic material does not affect the light path while passing through the sample, thus all the light is blocked (black). In contrast, in anisotropic materials (refraction index is not equal in all directions throughout the crystalline lattice) the polarized light experiences double refraction (birefringence, division in a slow and fast light ray). Consequently, in petrographic thin sections, by the analysis of the different optical properties, the mineralogical composition of the sample can be ascertained (the most commonly observed optical properties are crystal habit, fractures, relief, twins, colour, pleochroism, birefringence and extinction angle). Additionally the type of porosity at microscopic scale can be characterized: primary (e.g. intergranular, intragranular, cavity or growth) and secondary (e.g. fracture, dissolutional or intercrystalline) (Tucker, 2001). This plays a key factor in the durability of building materials, e.g. made of sedimentary rocks (Molina et al., 2011).

X-Ray diffraction is an (almost) non-destructive technique used to examine the physical and chemical make-up of unknown solids, i.e. crystallographic structure and chemical composition. XRD is particularly useful for identifying fine-grained minerals and mixtures or intergrowths of minerals, which are too finely grained to be identified by the petrographic light microscopy. The powdered sample is placed in a holder, then illuminated with X-rays of a fixed wavelength, and the intensity of the reflected radiation is recorded using a goniometer. Inter-atomic spacing D (Å, 10-8 cm) is then calculated measuring the intensity at different reflection angles and the results are used to identify possible matches ("X-Ray Diffraction Table" 2012).

Hence, these two complementary analytical methods, as aforementioned, are very suitable for determining the state of conservation of stones, bricks and mortars. For all of these three materials, the mineralogy and geometric arrangement of minerals/particles, and thus the porosity and fluid interactions or physicochemical resistance, can be deduced. Apart from that, additional information can be obtained in bricks and mortars.

In geological terms, bricks could be described as artificial rocks that have experienced metamorphism, stable under the conditions of temperature and pressure at the end of the artificial firing. However, heating and cooling rates in bricks are much faster than in 'normal' metamorphic rocks. Subsequently external exposure in buildings causes the bricks to become unstable and undergo micro-structural and mineralogical changes (alteration and deterioration) due to the outdoor weathering.

The determination of the firing temperature experienced by the bricks in historic buildings, for instance theatres, is important from the archaeological viewpoint, as it provides information about technological procedures applied at that time. The maximum temperature achieved by ancient kilns can be estimated by establishing a relation between firing temperature and changes in mineralogy and microstructure like porosity, clay matrix, vitrification, etc. (Rasmussen, De La Fuente, Bond, Mathiesen, & Vera, 2012).

Examination by petrographic microscopy (polarized light) helps to describe in detail the texture and to characterize the distribution of minerals on a microscopic scale. Special interest is given to minerals that resisted to high temperatures or did not transform completely during firing. As explained above, the formation of new mineral phases (metamorphosis) in ceramics due to firing in kilns is expected. However, when referring to geologic time, the manufacture of bricks (both heating and cooling) takes very little time and thus one expects to find these newly formed phases only at the microcrystalline scale.

These mineral phases produced during processing of the material can be detected by XRD. This technique is often used to determine the mineralogical composition, both qualitatively and quantitatively, to distinguish allotropic phases (e.g. calcite ⟷ aragonite). Furthermore, XRD also helps to determine the degree of crystallinity of mineral phases (sharper peak → more crystalline).

Consequently, firing temperature can be estimated by detecting critical mineral phases. For example, the presence of a substantial amount of primary calcite suggests a temperature below 800 °C as calcite (calcium carbonate) begins to decompose above 800 °C, and the appearance of gehlenite $Ca_2Al[AlSiO_7]$ (sorosilicate) assumes a temperature higher than 800 °C, while the coexistence of gehlenite + diopside $MgCaSi_2O_6$ points to a temperature greater than 900 °C.

In historic natural stones, besides determining or detecting the main component and discriminating different clay minerals, XRD can also be used to identify the nature of cement (carbonates, silica, sulphates, phyllosilicates) in sedimentary rocks. Moreover, with the same analytical technique, the binder of mortars can be determined, and thus the manufacturing processes deduced, or possible reparation mortars may be identified in historic buildings.

Below, an example of a joint mortar, extracted from Roman baths in Llíria (Valencia, Spain), is illustrated. The analysed bonding mortar provides the structural stability to the brickwork (arcs, see Figure 2) using clay mixed with sand (quartz). In Figure 3, the diffractogram is shown and quartz, calcite, illite dolomite and kaolinite could be identified. Illite clay is a non-expansive mica and in this case impurities of kaolinite have also been detected.

Figure 2.- Caldarium of the Thermae of Mura (Alveus, hot bath, Llíria - Valencia). Within its arches a reddish bonding mortar can be appreciated (orange box indicates the architectural / geometric arrangement and the dot marks the sample extraction).

Figure 3.- Diffractogram of the Roman bonding mortar (Fig. 1). The minerals can be identified by the characteristic 2-Theta reflection angles.

3.2 Physicochemical methods

The establishment of the suitable restoration methodologies requires a prior study of the materials present in the monument with the aim of clearly defining their state of conservation. The knowledge of the materials by means of the application of the analytical techniques (such as infra-red spectroscopy, X-ray diffraction or electronic microscopy) provides information about their chemical and mineralogical characteristics. On the other hand, the determination of the hydric behaviour allows the evaluation of the structural properties of the materials studied and their susceptibility against the deterioration.

Scanning electron microscopy coupled with X-ray microanalysis (SEM/EDX) is a very useful technique based on the interaction of electrons with the sample studied (stone, ceramic materials, mortars, etc.). As a consequence of this, electron images and X-ray spectra (graphic representations of intensity of radiation in cps versus energy in KeV) are obtained from the sample by using an electron microscope, which provide morphological information of very tiny features of the samples (pores, microcracks, salts aggregates, etc.), and analytical information about the elemental composition of the materials. In comparison with conventional microscopy, SEM/EDX has a much higher magnification power and versatility.

Chemical composition of the samples can be obtained from small (spot analysis) or bigger zones (lines or areas) by the selection of the X-ray spectrum acquisition zone on the image of the sample previously acquired. Moreover, "mappings" or elemental distribution maps can be obtained, and the analytical information can also be qualitative (only the identification of the chemical elements present in the material) or quantitative (the weight percentage of each element present in the sample).

Among the most relevant applications of this analytical technique in the field of Conservation and Restoration of Cultural Heritage, it is important to mention the morphological characterization of stone, ceramic materials or mortars (the surfaces and cross-sections) for the examination of microcracks, pores and other features of these materials and of their alteration products (crusts, superficial deposits, patinas), and the chemical analysis of these materials and their neoformation products. Mapping of elements, for instance, was applied for the chemical characterization of the arid and binder of a mortar from a monument. As can be seen in Figure 4, silica (Si) is preferentially distributed in the arid grains, whereas calcium (Ca) is concentrated in the binder, indicating that the sample studied is a lime mortar with a siliceous arid.

Infrared spectroscopy is one of the most commonly used instrumental techniques for the analytical study of all kinds of materials in the field of Conservation and Restoration. It is based on the interaction between infrared radiation (the radiation with a wave number between 12,500 and 5 cm-1) and the matter. The result of this interaction is an infrared spectrum (the graphic representation of the absorption intensity versus the wave number), which is registered by an infrared spectrometer, and provides analytical information about the molecules present in the sample.

Infrared spectroscopy is used for qualitative and quantitative analysis, but the main application is the identification of both inorganic (stone, mortars or ceramic materials) and organic compounds (conservation treatments, paints, etc.), and for that reason it complements the information obtained by SEM/EDX.

The determination of the state of conservation of a material from a monument needs the knowledge of the chemical and mineralogical composition of the material and of its alterations forms. In this sense, infrared spectroscopy can be applied for the chemical characterization of alteration products. For instance, with only few milligrams of a stone material, which exhibits a superficial brownish appearance, an infrared spectrum can be obtained, in which gypsum is identified as the main compound, indicating that the material shows a sulphation crust.

In most cases, the destruction of the materials of a monument (stone, mortars, etc.), is caused by the presence of soluble salts These

Figure 4.- Elemental distribution maps of a mortar, (a) infrared spectrum of the black crust of a stone material (b) and ion chromatogram of a ceramic material.

salts crystalize in the porous system of the material, a process that involves a significant volume increase producing its destruction. The qualitative analysis of soluble salts present in stone, ceramic materials or mortars provides information about the kind of ions occurring in these materials and indicates the deterioration process and its origin and causes, and their concentration in the material reflect its degree of alteration. For this reason, it is important their identification and quantification by using analytical techniques such as ion chromatography (IC). This separation technique allows, with a small amount of sample (between 0.02-0.1 g), the identification of the ions (cations and anions) present and the determination of their concentration. In Figure 5 the ion chromatogram obtained for a ceramic material is shown in which chloride and sulfate ions are identified in a significant concentration, and nitrate ions in a moderate proportion.

The study of the materials present in the monument is complemented with the achievement of in-situ and/or laboratory tests for the determination of physical properties, particularly, the ones for defining the microstructure of the materials studied (open porosity, apparent and real density), and that ones for the characterization of properties related to the presence of water, such as water absorption by capillary and water absorption by total immersion tests. These assays should be carried out following the methodologies described in the UNE standards for building materials, although RILEM recommendations and CNR Normal Documents are more specific and appropriate in the field of Conservation and Restoration.

Physical properties condition the alteration processes and mechanisms and, at the same time, allow one to evaluate the durability of the materials. By means of these tests, the material resistance against external agents such as water is evaluated. Determination of porosity of a stone material from a monument and the comparison with the porosity of the same material from the stone pit provides information about its degree of deterioration, and the calculation of the water absorption coefficient indicates if the material is prone to undergo deterioration by the action of water, and consequently, the need for the application of a conservative treatment (water-repellent).

Analytical information obtained by using SEM/EDX, Infrared Spectroscopy and Ion Chromatography is completed, in the case of mortars, with granulometric studies which allow the mechanical separation of the different fractions of the material by sieving, with the aim of establishing the dosification (relation arid/binder) and the correspondence with its state of alteration. Moreover, the granulometric characterization of the mortars present in a monument will provide the information about their dosification, allowing the reproduction of new materials for the restoration with similar characteristics, to ensure the compatibility between them.

Figure 5.- In situ (a) and in laboratory (b) tests for the determination of the hydric behaviour of different materials.

REFERENCES

Esbert, R. M., Alonso, F. J., & Ordaz, J. (2008). La petrofísica en la interpretación del deterioro y la conservación de la piedra de edificación. Trabajos de Geología, 28, 87-95.

Miriello, D., & Crisci, G. M. (2006). Image analysis and flatbed scanners. A visual procedure in order to study the macro-porosity of the archaeological and historical mortars. Journal of Cultural Heritage, 7(3), 186-192. doi:10.1016/j.culher.2006.03.003

Molina, E., Cultrone, G., Sebastián, E., Alonso, F. J., Carrizo, L., Gisbert, J., & Buj, O. (2011). The pore system of sedimentary rocks as a key factor in the durability of building materials. Engineering Geology, 118(3-4), 110-121. doi:10.1016/j.enggeo.2011.01.008

Rasmussen, K. L., De La Fuente, G. A., Bond, A. D., Mathiesen, K. K., & Vera, S. D. (2012). Pottery firing temperatures: a new method for determining the firing temperature of ceramics and burnt clay. Journal of Archaeological Science, 39(6), 1705-1716. doi:10.1016/j.jas.2012.01.008

Tucker, M. (2001). Sedimentary Petrology (p. 272). Wiley-Blackwell. Retrieved from http://www.amazon.co.uk/Sedimentary-Petrology-Maurice-Tucker/dp/0632057351

X-Ray Diffraction Table. (2012). Retrieved from http://webmineral.com/MySQL/xray.php

4.3.7.2 CONTEMPORARY UTILIZATION

1) Climate: Identifying and measuring the Influences of Climate weathering and erosion Risks

Orientation/Sunlight

(insolation) Sun Rays: Negative impact, Positive impact (reduce the rate of moisture, shadows in some locations).

Before evaluating the theatre orientation in relation to risk mitigation, it is of importance to understand how different orientations affect the amount and the intensity of the sunshine, the sunlight and daily sun heating received at different times of day and at different times of the year. However, varying degrees of orientation may lead to different periods of theatrical events, since the theatres had seats made of stone or marble; the trapped heat would transfer to the stone, making it bearable to sit for an entire performance, meanwhile the audience could avoid direct sun-light.

It is a fact that in summer the west-southwest and the east-southeast oriented surfaces receive the major amount of the sun exposure, while west-southwest spaces suffer from the high external temperatures which predominate during the sunshine. The minimum heating received in this period are the surfaces oriented exactly south, in spite of the greater duration of their sunshine. This is because the acute and accent angle of incident sun rays reduce highly the solar energy which come into the space (loss from reflection). In winter, on the contrary, because the sun is located in a lower position, the south surface receives, under a lesser angle, the greater amount of the solar energy than the other oriented surfaces. Even an inclination of up to 30 degrees from the south does not change the situation noticeably. Thus we realise that:

1. South oriented theatres, without any hindrance of the solar radiation, have the maximum annual average sunshine value (sunshine time x radiation intensity) and have the most favourable distribution during the year.

2. For other orientations, the highest sunshine values appear in summer.

3. Theatres oriented to the east and west receive the maximum sunshine from May until July and the minimum in winter.

4. Theatres oriented to the north are exposed to the sunshine only during summer time, early in the morning and late at the evening. So, surely the northern exposure is the most desirable. It is characteristic that the hourly maximum radiation on the northwest or northeast surfaces in June is higher than the southern.

5. Theatres with a northeast orientation would be ideal for summer performances; it would provide shade for the audience and illuminate the actors from a straight on to just stage left orientation. Any theatre used for summer performances — especially in the Eastern Mediterranean — would have to be configured to provide suitable shade and lighting for a large part of the year when the most important performances were presented. A northeast orientation would be ideal, providing shade for the audience and illuminating the actors (Haddad 2004). From a recent study, the majority of Eastern Mediterranean theatres are mainly oriented towards the north to protect spectators during summer while allowing use from spring to autumn; 35 of the 41 Roman theatres (including three *Odea*) in Greater Syria have a northern orientation (Haddad, 2010). The theatres whose orientation is not towards the north are mainly small, roofed *Odea*.

6. In general, we can assume that structures that are exposed to wind provoke disintegration and pulverization of materials, while those exposed to less sun, suffer mosses and layers of lichens of whitish colour, responsible of the chromatic alteration, and decohesion by chemical dissolution of the superficial layers.

2) Fire Damage

The major potential disaster for historical buildings remains the risks of fire, but this cannot be genuinely called a "natural" disaster since the most normal causes of fires are manmade, such as the negligence of the occupants or workmen carrying out repairs etc. Hence, fire can be considered as both a natural catastrophe and a manmade disaster. The sources of fire can be due to human error, naked flames such as candles, lighting and dangers resulting from old fireplaces **near ancient theatres.**

Many historic theatres were destroyed by fire. Each theatre has its own degree of risk of a fire, and of resultant damage. The concept of fire precautions may be broken down into two distinct subsections: fire prevention (measures to prevent fires from starting or indeed from being started) and firefighting (measures to control the spread of a fire and to extinguish it).

Many fires could be prevented by technical or educational measures. A wide range of different fire detection heads are available and can be blended in with lighting systems in a variety of ways, thus ensuring a solution which is entirely satisfactory from the aesthetic point of view. On events and visiting days, the number of visitors can be very large. This gives rise to the following protection objectives:

1. It must be possible to evacuate all visitors in time and in complete safety.

2. Damage to theatre from fire and smoke must be avoided or at least limited to one area. For example, vacuum cleaning reduces the risk of dust being ignited by lightning.

3. It is necessary to consider the fire safety of the theatre as a cluster.

Such a strategy needs to meet the following criteria:

1. To ensure that the fire is discovered in time.
2. To enable the fire to be tackled quickly and in a well organized manner.

Fire policing provisions generally require a fire protection strategy to be studied and adopted on a case by case basis in such a way as to meet the protection objectives agreed in advance between owners, managers, the authorities, the insurers and fire protection experts. In order to prevent grass fires from spreading to the theatre building, all vegetation should be removed in a 1m wide zone around the building. Emphasis should be placed on the aesthetic appearance of this zone in order to retain the relationship between the theatre building and its surroundings. To reduce the risk of fire, all stores should be cleared, taking care, of course, not to discard any valuable material that might be there.

3) Anthropogenic Risks: Causes of Deterioration and Threats to Ancient Theatres and Odea

Anthropogenic causes of deterioration and threats to Ancient Theatres and Odeas pose many risks that would result in theatres losing their authentic technical, scientific information and their acoustic characteristics. In addition to these, it is also essential to note damage caused by humans (human foot-tread). The human (anthropogenic) risks can be summarised as follows:

- **Growth of uncontrolled tourism and the lack of management plans** in relation to the accessibility and protection of sites containing ancient theatres and odeas. Lack of management plans with proposed visitors' capacity and compatible criterion for reuse. Visitors may stray into uncontrolled areas. Visitors often wear inappropriate dress and shoes.
- **Economic constraints** and lack of funding that can be seen in the maintenance and public services at the sites of ancient theatres and odeas.
- **Lack of cultural heritage education and limited public awareness** about the values of ancient theatres and odeas.
- **Limited archaeological and historical research** of ancient theatres and odeas leading to inappropriate development. The thematic patterns that could emerge from the research may be useful for planners and interpreters.
- **Absence of a holistic/integrated conservation plan** including lack of maintenance, poor application of conservation principles and lack of skilled people, can cause further decay to the infrastructure of historic theatres and odeas. There is a gradual disappearance of traditional stone crafts and skills.
- **Limited scientific approach and methodology in the diagnosis and conservation of stone.**
- **Limited detailed documentation of theatres and odeas**, in addition to a lack of documentation of environmental conditions (i.e. temperature variations, air pollutant levels, salinity of soil, wind, etc.).
- **Poor legislation** and related management programs to protect the historic ancient theatres and odeas, including special technical regulations.
- **Conflict and War areas**: As an example, the United States military turned the site of ancient Babylon into Camp Alpha in 2003 and 2004, inflicting serious damage according to an exhaustive damage assessment recently released by UNESCO. Bulldozers levelled many of Babylon's artefact-laden hills. **Helicopters caused structural damage to an ancient theatre.**
- **Deterioration due to previous restorations**: This includes restoration and conservation intervention on the structure, where new materials or interventions are incompatible with the original one.

Many theatres have not been restored in any way for a very long time. However, during previous restoration attempts, different types of damage can be observed in the structure of the theatre complex resulting from the use of the wrong materials and/or the application of inappropriate techniques. Many interventions, like the reconfigurations of the sitting, have not always been respectful of technical correctness; in the theatre of Taormina, as an example, the stairs have been reconstructed in concrete, which does not fit well with the rest of the *koílon* (Ruggirello, 2007). There were many restorations that promoted reconstruction of theatres but their general valuation is rather critical: they can be catalogued as stylistic restoration and reconfiguration, which are different from intervention of *"anastylosis"*. A clear example is the theatre of Solunto, whose reconstruction has occurred through stylistic references of other theatres, without favouring the reading of the archaeological finds. Furthermore, improper introduction of materials without regard to conservation principles can cause more damage and irrevocable harm to historic theatre structures.

On the other hand, the decision, rather unpropitious, to cover the *koílon* of the theatre of Morgantina with a cover in Perspex, is considered the worst intervention of restoration in Sicily, as the successive interventions could not cancel possible damage caused by such cover.

The archaeological excavations, especially the trenches opened for the foundations of a theatre, even if refilled, may change the compactness of the soil. This could allow more water to go under the foundation. Moreover, staining and efflorescence can be observed due to the use of cement-containing mortar which was used to in-fill losses in the stone blocks. Those mortars were not compatible with the original colour and texture, thus staining the stone surfaces. Poor quality and misguided attempts at restoration have also led to certain deformations. For example, in the Theatre of Eraclea Minoa, the entity and the causes of degradations are various: in the exposed part degradations were caused from chemical and physical effect of the aeolian and meteoric action; in the covered part they were caused both by the oxidation and corrosion of the metallic structure, with the consequent fissure of the stone, and by the infesting vegetation that is favoured by the greenhouse effect. In Morgantina's theatre some trials on filling material were executed behind the right frontal *analémma*, that had serious structural failure. They have recorded an argillaceous ground water saturation, which provoked an excessive thrust on the structures of the *analémmata*. The intervention constituted in partially dismounting the wall, replacing it with barren material in the lower surface; a tube for the water-drainage has been placed at the base of the digging, and the walls have been waterproofed with reinforced geo-membrane, coupled to geo-composite in order to facilitate the water-drainage of infiltrating waters.

Additionally, the functional properties of some of the theatre spaces were disregarded during these restorations and many original traces providing information about some parts were lost. On the other hand, poor ventilation of the theatre structural parts like vaults is evident, especially where some of them are being reused nowadays for exhibitions, offices or museums such as in the case of the Roman Theatre in Amman.

Therefore, there is the need for knowledge of construction techniques and of materials, which must be at the base of the planning of conservation activities and of the management of ancient theatres. That knowledge must consider the dynamics of the degradation processes relating to the natural, ambient, anthropogenic attack, and of past operations to evaluate mistakes, but also of effective interventions that have allowed correct preservation of the resource.

- **Deterioration due to poor maintenance and related conservation programmes**

 Regular inspections will detect problems. If these are dealt with at an early stage, it will minimise the need for major and expensive repair work. As it is easy to forget to carry out routine maintenance tasks, it is useful to have a maintenance plan for the theatre building (Maintenance, a guide to the care of older buildings, text by: Jacqui Donnelly. Series editor: Jacqui Donnelly, published by the stationery office).

 Collecting information on the restoration, maintenance and repair programmes carried out on the theatre is essential. The state of conservation, consolidation works, structural reinforcement and restoration of the theatre need to be addressed. Documents, like photos and sections indicating materials and construction techniques, are needed to identify treatment adopted by the restorers and to highlight the material integration at a theatre. In addition, photographic survey and assessment of the areas under excavation are needed near to the theatre and to the main sites under study.

- **Human impact and stone wall decay and degradation**

 Much damage occurs due to the removal of structural material from its solid walls. Many theatres have taken on some damage from stone-robbers who want to have a piece of the many famous theatres auditoria (later quarrying and stone-robbing activity).

- **Air pollution:** Pollution and pollutants from traffic, like tourist buses, especially where the theatres and odeas exist in a congested urban context. Air pollution is considered one of the most aggressive factors that lead to many aspects of deterioration, especially with the presence of and in combination with other factors in the surrounding environment such as rainwater, air temperature and wind currents. In particular, due to the many sources of air pollution, many theatres have suffered and are still suffering from much deterioration and risk factors resulting from several mechanisms, either physical or chemical, such as crustation, crystallization, dirt accumulations and other forms of deterioration.

 Urban development in the buffer zone of the theatres causes visual as well as air pollution. From an environmental point of view, we can classify the different dominant sources of air pollution affecting theatres in an urban setting into two main sources:

 Stationary (industrial activities like petroleum refineries, power stations, factories, waste water stations, and quarries) and *mobile* (vehicular traffic, transportation means such as cars, buses and planes in different station and civil or military airports), all inside and around the theatre area. They play an important role in oxidation processes that lead to many deterioration effects, mechanisms "chemical and/or physical" such as discolouring of some zones on the stone surfaces essentially due to soot, dirt, impurities of polluted oxides and erosion signs, and the presence of black and dark aspects resulting directly from air pollution and its different components like soot and organic black matter.

Theatres affected by air pollution can be divided into three main categories according to their deterioration level, as follows:

- Lightly polluted surfaces physically affected
- Moderately polluted surfaces chemically affected
- Heavily polluted surfaces chemically and physically affected

Evaluation of the direct and indirect impacts of the different components and chemical characteristics of ambient air in the theatre area, according to National and International Standards, need to be carried out. Evaluation and investigation of the different deterioration factors affecting the theatre building either chemically, physically or biologically and resulting from the different effects of air pollution should use scientific techniques such as *XRD*, *Stereo microscope*, *ICP-OES* techniques and others (*Elgohary, 2008*), especially with the presence of other synergic deterioration factors such as air temperature, relative humidity and wind erosion. The following issues need to be determined:

1. Sources of air pollution in the theatre study area: One can say that the different values of air pollution in the urban development of the buffer zone of the theatres were increased as a direct result of greater development and wide use of energy which leads to the presence of negative effects on air quality.

2. Relations between air quality and rainwater in the theatre study area: In general, we can say that there have been some aggressive changes in its chemistry, particularly over the last few decades. These changes are defined as acidification of precipitation and is called quite naturally acid deposition or acid rain (Godish, T., 1991. Air quality, 4th Ed, CRC Press). Through scientific studies we have to define the relation between air pollutants and the chemical nature of precipitation. Precipitations lead to many deterioration mechanisms that affect the theatre materials and stone structures, especially carbonated rocks, with the presence of other synergetic deterioration factors such as air temperature (Environmental Protection Agency, 1999. Progress reported on the EPA acid rain program, USA).

3. In order to distinguish the different environmental parameters and quantitative description of stone's deterioration, samples should be taken and investigated to get a proper understanding of the harmful effect of air pollution.

- **Decay and Deterioration Due to Improper Modern Uses of Ancient Theatres and Odeas**

Since all ancient theatres have their own unique set of conditions, and reuse cannot be separated from the whole ancient/modern context that surrounds them, it is important to make clear that modern use is altogether different from ancient use. Their use in modern cultural performances and actualities causes much of the risks concerning the physical structure and authenticity of theatre sites. For example, the use of heavy machinery such as bulldozers, cranes, water tanks etc., lead to vibrations on the structure of the theatres (as in the case during the Jarash Festival). However, heavy machinery is also used in restoration works to transport materials and lift the stones. According to Verona Charter on the Use of Ancient Places of Performance *(Adopted at the International Colloquy held in Verona, August 1997)* proper use of the sites should reduce the risks of material damage to ancient structures by performances and prohibit non-removable staging or modifications for the public.

Today, ancient places of performance are a vulnerable resource threatened by the erosion of time and improper uses, to which they are sometimes put, in addition to natural threats (wind, orientation, temperature, rain). The human threats and risks can be summarised as follows:

1. *Risk of Overloaded Capacity in Relation to Modern Use*

 Capacity (maximum capacity) with special regards to problems related to capacity and emergency exits, especially when they are used for festivals, conferences and receptions, exhibitions/museums and tourism purposes. The other important issue of degradation at the site concerns the lack of proper sanitation facilities at these events.

 Overloaded capacity can also create human-induced changes in relative humidity rates, with direct effects by humans on small-space humidity.

 How to Calculate Capacity of the Theatre: It is found that there was a relation between the capacity of the theatre and the length of the outside diameter by which the area theatre could be determined. The net area of the Cavea and Orchestra which was used for actual sitting by spectators equals about (80%) of the whole area of the Cavea and the Orchestra, a ratio that was approximately the same in many Roman Theatres (Haddad et al. 2003). So, once the outside diameter of the theatre is known, it is easy to calculate the whole area of the cavea and orchestra, which had the shape of a complete half circle:

 Area = ((Outside Diameter ÷ 2)2 × π/2)

 Net Area = ((Outside Diameter ÷ 2) 2 × π /2) × (80 ÷ 100)

 and by dividing this net area into (0.37 m2), which is the area needed for one person, since the average depth of the seats in the theatres is (0.73 m.), and the proposed width for one person is (0.50 m.) the capacity of the theatre can be known.

 Capacity (spectators) = Net Area ÷ (0. 37)

Information on the activities and festivals held in the theatre should also propose contemporary scientific studies about the capacity and risks facing the theatre structure, calculate the capacity of the theatre, and define unsafe places with regard to the grouping of the audience.

2. *Risks to authenticity due to new additions*

Construction of new structures such as in partitions, additional seats in the orchestra for the audience, doors, shelters, footbridge etc. is practiced to accommodate new uses and services.

Recommendations for executing new ideas for the construction and installation of removable structures, with the aim of establishing general regulations for the use of each site with theatres and odeas need to be aesthetically and architectonically acceptable, while providing enhancements for acoustics.

3. *Thermal risks of lighting systems*

These risks are especially serious when they are used at night. What is important here is that the lighting system should not harm ancient materials and should adhere to environmentally safe standards. **Due to some damage caused by fitting modern theatrical equipment during the** festival events, the Turkish authorities have suspended further shows in the Aspendos Theatre. A new modern facility known as Aspendos Arena has been constructed nearby to continue the tradition of open air theatre in Aspendos. In addition to these solutions, we have to establish a set of aesthetic rules concerning the best types, distance between parallel sources of lighting, and the way the lighting should follow the architectonic details, and so on. By following these guidelines, and by employing skilled staff, it is possible to have lighting exposed in the sensitive places without affecting the general appearance of the theatre.

4. *Noise pollution risk*

Especially with modern sound equipment, affixing the equipment to the original material of the theatre structure, including the position of loudspeakers and amplifiers in mistaken positions, can harm the ancient materials of the monument and its acoustic qualities.

5. *Visual pollution risk*

This arises from some supplementary lighting and sound system buildings and signage systems in the theatre cluster. Signage and panels, related to documents and photos, are needed for exhibition/museum areas in addition to signage for services provided, the ticket office, on site signs, bookshops, etc.)

Hence, photographic surveys and visual assessments are needed in addition to the technical devices and services provided, especially during drama performances.

6. *Deterioration of the Acoustics Qualities*

In fact, the acoustic characteristics of ancient theatres and odeas are at risk. In most ancient theatres, the stages and the upper parts have been damaged. If we use ancient theatres for modern performances with modern technology, we have to ensure that no harm is done to the original acoustics of the building (Haddad, 2007). It is necessary that a system for describing and rating ancient theatre acoustics be in place before any intervention is carried out on these monuments. On the other hand, the distinguishing qualities of the theatre structure (especially the acoustical) and its environment, in their original or earlier settings, can be restored and revived. The European Commission's ERATO (identification, evaluation and revival of the acoustical heritage of ancient theatres and odeas) project makes it possible for the first time to hear these significant structures as they sounded in the past and to feel their sense of space (Haddad, 2008). In this way, many previously unanswered questions relating to the acoustics of such spaces can be answered. It was found that, restoration (including anastylosis) of the stage wall can improve the source loudness and speech intelligibility by reflecting the sound towards the audience and reinforcing the direct sound. The stage colonnade has a scattering effect, improving sound distribution, and the colonnade around the *cavea* improves the strength of sound in remote seats. Meanwhile, the portico is not only architectonic; it also has an acoustic function (as mentioned by Vitruvius), providing acceptable voice strength to the upper levels.

The conservation and restoration of acoustical characteristics, and taking advantage of the acoustical design of ancient theatres and odeas, should be considered as one of the most important aspects of the conservation process. In order to promote human comfort and make the most of the acoustical design of ancient theatres and odeas, the conservation and restoration of acoustical characteristics should be considered as a priority. Conservation and restoration of ancient theatres and odeas can enhance and preserve their authentic scientific information, since the cultural significance of many theatres and odeas is not readily apparent (*Haddad, 2007, 2008, 2010)*.

A dialogue, though, is needed between those specialized in acoustics and those involved in the process of theatre conservation in order to **discuss some new aspects concerning the approach for conservation and restoration of these monuments,** including new ideas for the construction and installation of removable structures. They should concentrate not only on the artistic and structural requirements of the building, but also on achieving high acoustic standards by means of modern

technology. It is now possible to determine if such investments are effective and can really increase and diffuse knowledge of theatre heritage while also satisfying the requirements of users (Haddad, 2007, 2008, 2010).

The main architectural and acoustical elements of a typical open-air Roman theatre. Image: Naif Haddad.

4.3.8. REFERENCE

BASSAM SALEH, NAIF HADDAD, BALQIES SADOUN (2008), *Stability Study of Historical Buildings Using a Non-destructive Method*, European Journal of Scientific Research (EJSR), 2008, Vol. 20, No 3.pp. 520-525

BINDA, L. AND G. BARRONIO, 1985. *Deterioration of porous materials due to salt crystallization under different thermo hygrometric conditions-I Brick*, 5th International congress of deterioration and conservation of stone, Lausanne, pp: 279-288.

BRAI, M.; CASALETTO, M. P.; GENNARO, G.; MARRALE, M.; SCHILLACI, T.; TRANCHINA, L. 2010, *Degradation of stone materials in the archaeological context of the Greek-Roman Theatre in Taormina (Sicily, Italy)*, Applied Physics A, Volume 100, Issue 3, pp.945-951

CHAROLA, A.E., 1988. *Chemical-Physical factors in stone deterioration, air pollution and conservation. Safeguarding our architectural heritage*, Elsevier, Amsterdam.

Charola A. E. and Lazzarini, L, Deterioration of Brick Masonry Caused by Acid Rain, In Materials Degradation Caused by Acid Rain, Editor(s): Robert Baboian, Volume 318, September 25, 1986

Diakumaku, E., Gorbushina, A.A., Krumhein, W.E., Panina, L. and Soukharjevski, S., 'Black fungi in marble and limestone — an aesthetical, chemical and physical problem for the conservation of monuments', Science of the Total Environment 167 (1995) 295–304.

Elgohary, M.A, Air Pollution and Aspects of Stone Degradation "Umayyed Liwān – Amman Citadel as a Case Study", Journal of Applied Sciences Research, 4(6): 669-682, 2008

Emilio Barroso, Luiz Silva & Helena Polivanov, Weathering and deterioration evaluation of a Brazilian cultural heritage building, *IAEG2006 Paper number 290*

Lampropoulos, V.; Sotiropoulou, Ch.; Patrikiou, F.; Karampotsos, A. Ancient theatre of Sikyon: corrosion patterns and propositions for conservation-restoration", Proceedings of the 10th international congress on deterioration and conservation of stone, Stockholm, June 27 - July 2, 2004 , ICOMOS Sweden , Stockholm , 2004 ,pp. 915-922.

Fassina, V., 1988. Environmental pollution in relation to stone decay, Air pollution and conservation. Safeguarding our architectural heritage, Elsevier, Amsterdam.

Flatt, R., F. Giradet and J. Corvisier, 1995. Modelling of Sulphur dioxide deposition on the Bern Sandstone, Preservation and restoration of cultural heritage, Montreux, pp: 401-408.

Guidoboni, E., Comastri, A. and Traina, G., Catalogue of Ancient Earthquakes in the Mediterranean area up to the 10th century, vol.1, ING-SGA, Bologna (1994).

Lampropoulos V., Karampotsos A., (2004), "Ancient Theatre of Megalopolis - Peloponnese. Corrosion Patterns and Propositions for Conservation – Restoration" 6th International Symposium on the Conservation of Monuments in the Mediterranean Basin, Lisbon, Portugal, 6 - 10 April pp: 159-165

Lewin, S.Z., 1982. The mechanism of masonry decay through crystallization, Conservation of historic stone buildings and monuments, Washington DC, pp: 120-144.

Margarita Matova, geoenvironmental problems for the world cultural heritage in northeast Bulgaria, Geoarchaeology and Archaeomineralogy (Eds. R. I. Kostov, B. Gaydarska, M. Gurova). 2008.Proceedings of the International Conference, 29-30 October 2008 Sofia, Publishing House "St. Ivan Rilski", Sofia, 362-366.

N. Haddad, T. Akasheh, Documentation of Archaeological Sites and Monuments: Ancient Theatres in Jerash, CIPA 2005, XX International Symposium, 26/9-1/10/2005, Torino, Italy, pp. 350-355.

Naif Adel Haddad and Leen Adeeb Fakhoury, Conservation and Preservation of the Cultural Heritage of Ancient Theatres and Odea in the Eastern Mediterranean, IIC Istanbul Congress, September 2010 – 'Conservation and the Eastern Mediterranean'. Edited by Christina Rozeik, Ashok Roy and David Saunder. Published by The International Institute for Conservation of Historic and Artistic Works, London, UK, pp. 18-23.

Naif Haddad (2007) Criteria for the Assessment of Modern use of Ancient Theatres and Odea, *International Journal of Heritage studies*, 2007, Vol. 13.No. 3, pp.265-280.

Naif Adel Haddad (2008), Reviving the Architectural and Acoustical Theatre Heritage: the Role of ERATO Project, The Fifth International Conference of the **Center for the Study of Architecture in the Arab Region (CSAAR 2008B): Responsibilities and Opportunities in Architectural Conservation: Theory, Education, and Practice, 3-5 November, 2008**, Amman, Jordan, pp. pp.421-434.

Naif Haddad, Assessment of the Relation between Ancient Theatres, Landscape and Society, Third International Conference on Science and Technology in Archaeology and Conservation 7-11 December 2004, Hashemite University, Jordan, actas, Fundación El Legado Andalusí, pp. 263-280.

Naif Haddad, Monther Jamhawi, Talal Akasheh, Relation between Ancient Theatres, Landscape and Society, Second International Conference on Science & Technology in Archaeology & Conservation, 7-12 December 2003, Jordan, actas, Fundación El legado andalusí, pp.243-256.

Penkett, S.A., B.M. Jones, K.A. Brice and A.E. a Eggleton, 1979. The importance of atmospheric ozone and hydrogen peroxide in oxidizing Sulphur dioxide in cloud and rainwater, Atmosphere environment, 13: 123-137.

Rands, D.G., J.A. Rosenow and J.S. Laughlin, 1986. Effects of acid rain on deterioration of coquina at Castillo de San Marcos National Monument, Material degradation caused by acid rain, ACS Symposium, 318: 301-307.

Ritchie, T. Moisture Degradation of Masonry Walls, DBR Paper No. 693

Division of Building Research Reprinted, with permission, from Proceedings, First Canadian Masonry Symposium held at the University of Calgary, Calgary, Alberta, 7 10 June 1976. p. 66 – 71

Rohit Jigyasu1, Developing the ICCROM Training Kit on "Risk Preparedness for Cultural Heritage" - Scope, Features and Challenges, *ICCROM*

Rosval, J., 1988. Air pollution and conservation. Safeguarding our architectural heritage, Elsevier, Amsterdam.

Ruggirello V.L. In Sicilian Ancient Theatres Three Interventions Of Restorations In Sicily

XXI International CIPA Symposium, 01-06 October 2007, Athens, Greece.

Sophia Papida, Dionysis Garbis, Evi Papakonstantinou and Amalia D. Karagouni, Biodeterioration control for the Athens Acropolis Monuments: Strategy and Constraints, IIC Istanbul Congress, September 2010 – 'Conservation and the Eastern Mediterranean'. Edited by Christina Rozeik, Ashok Roy and David Saunder. Published by The International Institute for Conservation of Historic and Artistic Works, London, UK.

Stovel, Herb, Risk Preparedness: A Management Manual for World Cultural Heritage, ICCROM, Rome, 1998,

Warscheid, T. and Braams, J., 'Biodeterioration of stone: a review', International Biodeterioration and Biodegradation 46 (2000) 343–368.

Wei, H. and J.L. Wang, 2005. Characteristics of acid rain in JINYUN mountain, CHONGQING,CHINA, Applied ecology and environmental research, 3: 29-37.

Charters:

ICOMOS NEW ZEALAND, Charter for the Conservation of Places of Cultural Heritage Value.

Verona Charter on the Use of Ancient Places of Performance (Adopted at the International Colloquy held in Verona, August 1997)

Glossary

ICOMOS-ISCS : Illustrated glossary on stone deterioration patterns. ICOMOS International Scientific Committee for Stone (ISCS).

Websites

http://www.pasthorizons.com/index.php/archives/05/2010/fabrika-hill#ixzz1924CdO00

Heritage Building Maintenance Manual www.manitoba.ca/heritage

The protection of the architectural heritage against natural disasters. Proceedings of the European Colloquy on Regulatory Measures concerning the Protection of the Architectural Heritage against Natural Disasters in Europe. (Ravello, Italy, 15-17 November 1989) Architectural heritage series No. 21.Council of Council of Europe Press, 1992.

Guidelines, 1988. A working model for case studies on deterioration of stone, air pollution and conservation-safeguarding our architectural heritage, Elsevier, Amsterdam.

4.4. SOCIO-ECONOMIC AND INTANGIBLE PARAMETERS

The following part reviews the theoretical foundations that guarantee measures and actions whose objective is to generate economic development in the territories through cultural activity. The objective is the increase in the value of heritage, tangible and intangible resources, concretely, the ancient theatres, and the possible synergies with other heritage and cultural resources of the territory. As we shall see, culture as activity has the ability to boost territories and generate development, with the ultimate goal of improving the quality of life of citizens. In addition, culture generates a movement of resources that have a direct impact on the population of the territory. Legacy heritage and, specifically, the ancient theatres, are resources with the possibility of increased value and the capacity to stimulate the development of other cultural and derived activities. This part exposes what the fundamental aspects of cultural development are, most notably in the area of legacy heritage and the enhancement of the ancient theatres.

4.4.1. NATURE AND CHARACTERISTICS OF THE ACTIVITIES AND CULTURAL PROPERTY

From a functional perspective we follow Throsby (2001, p.18), who framed the cultural activity as "activities undertaken by people and the products of those activities, which are related with the intellectual, moral and artistic aspects of human life". As defined in the Convention on the protection and promotion of the diversity of cultural expressions of the UNESCO (2005, p. 2-4), cultural property and activities expressed the "symbolic meaning, artistic dimension and cultural values" of individuals, groups and societies.

According to Thorsby, one can identify three characteristics of cultural property that set it apart from the ordinary set of economic goods:
1. Its production involves some form of creativity.
2. It relates to the generation and communication of symbolic significance.
3. The product represents, at least potentially, a form of intellectual property.

Throsby (2006, p.7) notes the following characteristics of cultural property goods:
- For people who consume them, it is a new and different experience. To enjoy them, it is necessary to know their attributes and conditions.
- They have properties of public goods. The characteristics of the pure public goods are non-rivalry and non-exclusion. These features cause these goods not to be traded through the market successfully, since the mechanisms of the market do not generate adequate supply.
- Creative work is located in the centre of one's process of production[4].
- They are subject to the laws of intellectual property[5].
- They give rise to forms of value that cannot be expressed completely in monetary terms and may not be disclosed, either in actual markets or through other mechanisms.

Cultural activities are very diverse; there are studies that provide identification and classification of activities. In our case, we refer to the following classification or categorization of cultural activities[6]:
- Cultural heritage.
- Music and performing arts.
- Cultural tourism.
- Architecture. Design and advertising. Design and restoration activities.
- Socio-cultural activities. Development and participation by local citizens.
- Publication and distribution of printed material and literature.
- Archives, museums and libraries.
- Visual arts, plastic arts and crafts.
- Media, audio-visual and multimedia.

We provide the most relevant activities in the first four categories since they have a greater relationship with the use and enhancement of the old theatres. Firstly, they are among the activities that have been identified in relation to the field of **cultural heritage**:
- Museum of cultural resources.
- Management of interpretation centres.
- Exhibitions and divulgation of the cultural heritage.
- Actions of physical preservation of archaeological, historical and ethnological heritage.

The category of **Music** and **Performing Arts** brings together cultural activities relating to the creation, production, marketing and training specified in fielding musical and performing arts. Among others, we can mention the following activities:
- Creation of musical works and stage.
- Management of performing arts and ancillary activities.
- Production, shows and music festivals.
- Management of performance spaces.
- Interpretation centres.
- Marketing and communication of musical and performing arts.
- Dance and theatre companies or other artistic expressions.
- Orchestras.

4 For an analysis of creativity, see UNCTAD (2008, 9-10) and KEA (2006, 41-42), cited in Palma et al (2010).

5 For an economic analysis of the law of intellectual property, in particular copyright rights, see Landes and Levine (2006), cited in Palma et al. (2010)

6 Innoves, Foundation for the Social economy. Characterization of the cultural sector to the social economy.

In the category of cultural tourism are included the following activities:
- Touristic and cultural events.
- Travel agencies of cultural agencies.
- Tourist interpretation of Cultural Heritage (guided visits, interpretation of artistic heritage, etc.).
- Development of cultural tourism programs.

Finally, in the category of **architecture, design, advertising and activities of restoration and architectural rehabilitation**, are included activities related to buildings of historical interest.

Theatre d'orange (France)

4.4.2. THE CONCEPT OF CULTURAL CAPITAL: TANGIBLE AND INTANGIBLE HERITAGE

Throsby (2001, p.58-59) introduced the concept of cultural capital, which he defined as an "asset that incorporates, stores or generates a cultural value beyond the economic value that it has". As declared by Palma et al. (2010), "the economic value of a particular property can be defined and estimated with any certainty." A historic temple, for example, can have a sale price, as a real asset, that is, and a non-commercial value represented by the willingness of people to pay for their conservation. "But the economic value is not picking up the complexity of the cultural value of the asset, such as its aesthetic quality, its spiritual significance, its symbolic or historical importance, and its influence on the development of architectural styles".

The value of the cultural property can be approximated from the following characteristics that reflect their cultural value, Throsby (2001, p.43-44):
a. *Aesthetic value*: beauty, harmony, form, and other similar characteristics.
b. *Spiritual value*: denotes the formal religious importance of the cultural property.
c. *Social value*: refers to the connection of others to the cultural good and feelings of identity with places and societies.
d. *Historical value:* the historical connections of the good conditions the era in which it was created.
e. *Symbolic value:* the cultural goods are custodians and suppliers of meaning.
f. *Value of authenticity*: the originality of the cultural property that is authentic and unique.

Following on with the value of cultural assets, Frey (2000, p.15-16) mentions some values of art and culture that are not easily reflected in the market:
a. *Value of existence:* the population benefits along with the culture, although some individuals do not participate in artistic activities.
b. *Value of prestige:* some institutions, works and sites contribute to the sense of regional or national identity.
c. *Value of option or choice*: people benefit from the possibility to attend cultural events, although they do not attend.
d. *Value of education:* art contributes to the refinement of the individuals and the development of creative thinking of a society.
E. *Value of legacy:* people benefit from the possibility of bequeathing culture to future generations, although they have not participated in any artistic act.

Show at the theatre of Amman (Jordan)

When we talk about the value of cultural heritage and cultural property in general, we must bear in mind that they have a double dimension: on the one hand, there will be an economic assessment in which one will attempt to assess the visible elements, such as flows of income and employment generation; but we must also take into account that there are features of the property and cultural heritage that may not be valued by the market, but that also provide value, and these values must be estimated by methods of research to determine how to pay for them by potential consumers or the population.

The cultural capital can appear in two ways:
a. **Tangible cultural capital**: archaeological sites, historical buildings, sculptures, paintings, etc.
b. **Intangible cultural capital**: traditions, music, festivals, literature, values and inherited beliefs that make up the culture of the group, region, religion, etc.

The cultural capital existing at a given time and in a territory is equal to the tangible and intangible capital accumulated. This capital gives rise to a flow of capital services that can produce goods and cultural services for final consumption or for the production of new cultural goods. This is the case, for example, of the theatrical tradition, folklore, or history (as intangible heritage), which can create synergies with other tangible heritage resources (archaeological areas, old theatres, etc.), so that you get to value both resources. This idea is fundamental; the possible synergies between existing economic resources must be further developed. Synergies can allow the creation of a network of activities necessary for the sustainability of the sector. This requires a set of activities that allow artists to be invested in its success and maintenance and other workers in the sector to be able to move their activities to other positions. This fact is very important because culture work usually generates many temporary jobs and the need for the artist to change employers frequently.

Synergies between heritage resources should be both tangible resources and intangible resources. In the case of the ancient theatres, it would be seeking the benefits or opportunities to connect two tangible heritage resources, for example, the programming of activities that incorporate visits, or experiences that incorporate other resources in addition to the theatre, as in the case of the museums. Of course, it would be the programming of activities that promote the cultural activity as a musical and theatrical festival, aimed at both the local and regional population for cultural tourism.

In the case of cultural tourism, synergies between heritage resources can allow the definition of a range of cultural property that is set to new cultural resources and reporting benefits to the community. The creation of cultural property based on tangible and intangible resources may give rise to more elaborate cultural property, in the sense of providing a complete and competitive offer. For example, Greece and other countries, generates synergies between the tradition of the Greek theatre and the theatre in general (as intangible resources) and the important tangible heritage in old theatres. Cyprus is also a good example of this. In both cases, and especially in Greece, the initial theatrical tradition overflows into a general tradition for the performing arts, music, etc.

The ancient theatres can increase the value of intangible cultural property, for example, historical or popular performances, music festivals, theatre, etc. or even visits to the theatre in which customs, traditions or historical facts are represented.

The following table shows a list of cultural, tangible and intangible resources. Knowing the resources of a territory is a fundamental aspect for the design of performances: programing of activities, grants, policy formation, management, etc.

Thus, we can say that cultural heritage is an important intrinsic value that contains symbolic meanings that affect social cohesion and quality of life of the citizens by its sense of value, of ritual, religious and holiday celebrations that meet human needs of an emotional and communicative nature.

TANGIBLE HERITAGE

Immovable items
Religious cultural resources.
Cathedrals
Churches
Convents
Synagogues
Temples hermitages
Monasteries
Chapels
Others

Monumental cultural resources
Ancient theatres
Castles
Palaces
Houses
Unique buildings
Aqueducts
Main square
Old bridges
Joint architectural
Joint historical
Military buildings
Walled enclosures

Other resources linked to history
Archaeological datasets
Domestic architecture
Streets with history
Historical helmets
Roman baths
Arab baths
Artistic routes
Parks

Others
Cultural landscapes, industrial sites and civil engineering

Movable items
Handwritten
Documents
Works of art and crafts
Historical artefacts
Natural scientific collections
Recordings
Movies
Pictures

INTANGIBLE HERITAGE
Oral tradition
Gastronomy Crafts
Literature
Musical expressions
Musical instruments
Traditional theatre
Festivals
Rites and customs
Lifestyles
Ethnic histories
Popular and cultural festivities
Religion
Cultural and scientific events
Instruments of work
Modes and means of transport
Technologies and building traditional skills
Regional languages and local idioms
Costumes that identify each region
Media transport
Arts and fishing vessels
Arts and farming techniques
Work instruments

To apply correct strategies for the revitalization of the cultural sector, it is necessary to determine the value of the intangible resources of the territory, because, unlike the tangible, they are resources whose value is not so evident. For the identification of the value of the intangible heritage of a territory, one can carry out a study, based on interviews with different actors involved in the sector.

Rausell et al. (2007), based on a study that determines a list of possible intangible assets, consider that an assessment of these resources can be made from the following items:

1. *Generic value*: the objective is to evaluate the subjective perception that the respondent gives to the various resources cited generically, regardless of their capabilities to generate resource benefits, whether by their use or by other means such as their tourist value, among others.

2. *Utility as a tourist resource*: the objective is to assess the potential or capacity of the resource to generate a flow of visitors to the town.

3. *Potential of entrepreneurship*: the objective is to assess the capacity of professional activities, business, and general revenue related to the symbolic element.

4. *Utility as an element of intercultural integration*: the objective is to assess the ability to articulate processes and actions that encourage or facilitate the integration between different cultures.

As Rausell et al. (2007) point out, although we may be able to streamline and find the possible origins of the value of the heritage assets, it is impossible to determine a clear scale that classifies the value of these assets. They must be the set of agents that determine the decisions (commissions, plaintiffs, etc.).

4.4.3. STAKEHOLDERS

They are all persons, institutions or companies that have some degree of direct or indirect influence in the configuration of the local cultural activity, exerting an important role on the characteristics of the supply of cultural goods and services. We identify the following agents:

Public officials and institutions

They are the agents that define cultural policy. Institutions and public entities, from cultural policy, define part of the cultural offer through their programs of action, both aimed at the consumption of culture by the population as an incentive to the production of cultural activities, such as subsidies to companies of theatre, dance, etc. Public entities and institutions involved in cultural activities tend to be more regional or local, while the importance of the various institutions differs significantly in some places to others.

Cultural agents

They are cultural agents - persons, entities or companies - that have some influence on local cultural activities and have no dependent relationship with institutions and public entities in this category, including:

- Festive associations or cultural institutions
 Private non-profit institutions related with the culture
- Centres of education
- Companies engaged in sponsoring
- Cultural patronage-related
- Individual personalities of the world of culture
- Cultural enterprises

Focusing on the last agent, based on the conceptual constraints proposed in the document *The Economy of Culture in Europe*, we can define the following categories of economic sectors and companies in the field of culture:

a. The *creative industries*. This focuses on all those economic activities whose main input is the talent and where the main source of income comes from the exploitation of intellectual property rights. This section includes activities such as:
 - Advertising
 - Architecture
 - Visual Arts

- Crafts
- Design
- Fashion
- Audio-visual sector
- Software development for entertainment, music, performing arts, radio and television activities.

Production, distribution, dissemination and education companies, as well as other related activities, are located in this area.

b. *Cultural industries*: the set of economic activities that combine the functions of design, creation and artistic production with those of larger industrial manufacturing or marketing large scale, either through material carriers or through communication, publishing and audio-visual technology activities (television, theatrical film exhibition, production of TV programs, etc.)

c. *The economy of experience*: in the countries of Northern Europe, this terminology is used to refer to all those economic activities that are perceived by consumers as an experience. In this case, from the more traditional activities one can also include recreational training, craft design, performing acts, events and sports tourism.

In terms of the position they occupy within the set of cultural events, we can distinguish the following types of industries and businesses, Rausell et al. (2007):

d. *Industries and cultural organizations in the strict sense:* those economic activities that are dedicated to the production, reproduction and distribution of cultural goods and services, for example: theatrical, musical performances or other theatrical expressions, festivals and exhibitions, among others.

Other companies in the sector:

e. *Business mediators between the creation and the production or the production and distribution*. They structure, create or develop the connection between the creator or the set of artists and the creation, production or distribution structures. These companies are looking to value the creative qualities of the artist (artistic representative, manager of a theatre company, gallerist, literary agent, etc.). These activities do not require large investments and specific training, but they require skill and specific abilities that perhaps cannot be obtained from the local know-how. We refer to intuition on artistic trends, music and management of relationships with individuals with peculiar characteristics.

f. *Business mediators between the distribution and consumption:* Dedicated agents are economic activities relating to the supply of the final product that do not have direct contact with the creator. Basically, these are commercial activities such as bookstores, craft shops (not in all cases), music stores, among others. In this section you can find guides of monumental spaces, either traditional or based on the use of new information and communication technologies, specialists in cultural marketing, or critics (theatre, film, literary, etc.)

g. *Companies and professionals dedicated to the artistic or technical training in professions related to culture.*

h. *Companies of activities related to the conservation and preservation of the heritage sector.*

4.4.4. THE DEMAND FOR CULTURAL ASSETS

As generally happen with most of the goods offered, the economic viability of the possible use of the ancient theatres will depend on the product offered and this, in turn, will depend on whether there are consumers willing to consume it. In this section we will try to determine the most relevant aspects that the research has found with respect to the behaviour in the demand for cultural goods and for its application to the design of a strategy for the use of the ancient theatres.

Participation statistics help to measure usage (demand) of the cultural assets and services available. This information usually comes from surveys applied to the population that focus on three aspects:

1. Levels of participation.
2. Socio-economic characteristics.
3. Reasons to participate.

Measurement and results that are most disseminated are those of the (attendance) passive consumption: attendance at concerts of music, classical music, opera, ballet and dance, visits to museums, art galleries and festivals. Findings are provided below derived from studies in this area:

- The studies on the demand for performing arts agree that the price is inelastic (the demand is not very sensitive to variations in the price), especially attendance at theatres and concerts of classical music (Seaman, 2005). However, for popular music, circus and cinema, the price can have a significant effect on attendance due to the increased possibility of substitutes (Throsby, 1994, p. 7-9, and Dewenter and Westermann, 2005).

- The quality of the cultural product seems to be determinant of the attendance, but also notes that it is difficult to assess or objectify the quality, Seaman (2005, pp.144-145).

- The formation of habits, learned through consumption or rational addiction, and formal education, positively affect demand, although in the case of formal education the result is not found in

the econometric analysis, Seaman (2005, pp.144-145), DiMaggio and Useem (1980).

- Family background and early socialization through art can increase the frequency of attendance at cultural events, DiMaggio and Useem (1978).
- Life styles and previous experiences in artistic activities are more important than socio-economic, such as price or revenue, Andreasen and Belk (1980).
- The participation of certain groups in certain activities, such as high culture, is a sign of social distinction, a signal that indicates and reinforces the membership of higher socio-economic status.
- In the arts, arts education is much more important than other personal apects, such as level of education, and restrictions like prices and the geographical concentration of events, Borgonovi (2004).
- Age and occupation are important factors in determining the number of visits to theatres; in the case of the ballet it is age and ethnicity, while in the opera realm it is occupation and level of education that are the most important.

To finish with the determinants of the demand for cultural goods, it is important to highlight the role of education in cultural consumption. Today, there is some consensus in considering the positive effects of arts education at an early age for cultural consumption. Artistic education as a cultural capital training encourages participation in cultural activities (museums, performing arts, and heritage), Champarnaud et al., (2008). In the same vein, Palma et al. (2010) say that "the artistic education of children has two potential attractions to long term cultural policy: it reduces direct state support of the arts and culture once incorporated into the demand functions for consumption addiction, and moves it to consumer decision support activities".

Show at the roman theatre of Mérida

4.4.5. CULTURE AS AN ENGINE FOR JOB CREATION AND LOCAL DEVELOPMENT

Once the most relevant characteristics of the culture economy are known: determination of the tangible and intangible cultural resources, the characteristics of cultural assets, as well as the participants in the process of generating cultural assets, we shall proceed to analyse the relationship between cultural activity, specifically the implementation of tangible and intangible cultural assets, and the economic development of the territory. In our case it is the enhancement of ancient theatres and other cultural activities, fostering the emergence of a cultural cluster that can serve as a model of development and generation of employment and wealth in the territory. Initially we will try to determine the fundamental aspects that characterize local economic development, and then go more deeply later into the role of cultural activity and cultural tourism as an engine of economic development of the territories.

Local economic development - conceptual delimitation

In general terms, one can say that development aims to describe the wellbeing. We understand that development must arise as a process of economic, social and cultural integration of the dimensions that fosters the creativity of people while at the same time covering basic needs. It is necessary to point out that the idea of development differs from that of growth. The latter refers only to the quantitative increase in wealth or GDP per capita, while development includes a qualitative improvement in the economy through a social division of labour, the use of improved technology and better use of natural resources and capital.

The concept of development and its relationship with other concepts
Source: Sanchis, J.R.

Local development is currently becoming one of the most important endogenous growth strategies, especially in the context of the socio-labour insertion. It is local development "from below", bottom-up, i.e. in which the role of the set of agents in the town is essential for the definition and achievement of objectives, which must include the use of available resources most efficiently.

Antuñano et al. (1993) define local development as "that integral action, undertaken in a concentrated manner by the social partners of a particular community, in order to develop the local area through the enhancement of its human and material resources, while maintaining a negotiation or dialogue with the economic, social and political decision-makers on which they depend".

The implementation of a local development plan will be different according to the geographical area in which carried out, since it is an endogenous development, based on the resources of the area. That is why we will have to consider different specificities, opportunities and challenges in different areas, and, at least here, ad-hoc strategies.

Following Orero (1993), we can identify various elements that characterize the local development:

1. *Local character*: the development is confined to a well-defined territory, often municipal, and especially regional, as in our case.
2. *Social dimension*: the main objectives in many actions are the creation of jobs together with personal development.
3. *Institutional dimension*: it is controlled by the public administration to ensure the coordination of the agents involved.
4. *Economic dimension*: the initiatives to be carried out must be profitable and efficient, as well as sustainable; such efficiency should reach a permanent and long lasting state, allowing an increase in wellbeing continuously over time.
5. *Cooperative dimension:* because given the magnitude of the process, the collaboration and involvement of multiple agencies and groups is required.
6. *Instrumental dimension*: which facilitates the resolution of problems of design and management that may arise in the process.

Over the past four decades, a significant change has occurred in the strategy of local development in the developed countries, to the extent that the top-down approach or model has been abandoned in favour of an endogenous or bottom-up approach or model, where the participation of the different local agents is crucial, both from the production and the consumer side. They must be involved in the definition of the objectives and strategies to follow. The large participation of the different groups in the definition of the strategies and actions will achieve the objective of a sustainable model.

Local development requires the implementation of a particular process that has to be comprehensive and integrated. Doing a simplification, we can structure the process of local development in the following stages: defining objectives, planning of actions necessary to implement the selected strategies, and monitoring and evaluation of such plans. Below are several components or parts of the agenda for development.

Determination of the objectives of development and stimulus measures

The main objective of local development is the transformation of the local economic and social system. This overall goal requires the establishment of short-term objectives such as the promotion of entrepreneurship and the coordination of all actions and programs that have local impacts.

For this purpose, a fundamental element is the promotion of entrepreneurship, which corresponds to local entrepreneurs in their role as facilitators of economic and social growth. In a local development process, it will be necessary to develop a process of modernisation and restructuring that will involve:

- The development of new businesses and activities through endogenous growth, the promotion of domestic investment or a combination of both. Promoting the creation of new types of businesses and organizations: cooperatives, etc.
- Creation of advice, training, heritage, funding and technology-related support services.
- Improvement of existing infrastructure through the establishment of new links of communication and efficient management in land and real estate.
- The collection of the necessary resources to carry out development activities: human resources (qualification, business attitude, willingness to cooperate, flexibility, training, and information), financial resources and material resources (raw materials, natural resources, tangible assets in infrastructure) technology resources (capacity of innovation, research and technology transfer).

Main planes or dimensions in local development
Source: Sanchis, J.R.

The audit of the environment

Knowledge of the current situation in the area is a fundamental aspect in the process of local development. The analysis of the environment will have to take into account, in general, the following aspects:

- The environment and local culture
- The local economy
- The local labour market
- Environment
- Infrastructure
- Resources in the area
- Development activities

A more or less detailed knowledge of these aspects can be very useful to have a perspective of the current situation of the framework in which the development is going to proceed.

The Local Development Plan

The sources of funds must be assessed in relation to the financial resources available. Sources can come from funding programs of the central government of the EU, development aid, or regional and local governments, depending on the case. You can also get funding, although to a lesser extent, from some independent foundations, as well as the private sector.

Sanchis writes that the actions of a local development plan can be placed into three main areas: the zone itself, local companies and the local population. The first are related to infrastructure in the broadest sense, the latter with aid for innovation, restructuring and pursuit of efficiency, and the third with training and employment promotion programs.

The action plans set out the concrete actions to be undertaken to achieve the objectives of the strategy. We can highlight, in a general sense: measures in support of companies, restructuring, diversification, improvement of the environment, promotion of the area, stimulating private investment, etc.

Actions must solve four types of problems: 1. Relating to the financing of local firms, especially by the difficulties of access to financial markets. 2. Deficiencies in the provision of support to the production and marketing services. 3. Restrictions on access to markets as a result of inadequate services and communications infrastructures. 4. Impediments to the emergence and expansion of local businesses, given the existence of an economic and social environment that does not encourages local entrepreneurship.

From these problems arise, according to Coccossis et al. (1991)[7], the following areas of local development policies:

- The hardware of local development: The set of infrastructure needed for the operation of local productive activities. These include transport and communications networks, the development of the ground, facilities of social capital such as hospitals, libraries, schools, universities, etc.

- Local development software: This is what allows you to create qualitative factors necessary for growth, such as the actions for the improvement of human resources, the level of technology and innovative entrepreneurial capacity, the accumulated information and culture of the population.

- The orgware is needed to improve the organization's capacity in the area, i.e., the type of organizational structure of the economic and social agents in the area and their ability to interact and cooperate. Local development strategies earn effectiveness if they are implemented through offices with operating autonomy and flexibility in management.

- Finware is the set of financial instruments necessary for the development of the area, both from the private and public sectors.

- Ecoware is the set of tools needed to carry out a use appropriate to the natural resources existing in the zone, protecting the environment and preserving the cultural artistic heritage.

Once the fields of action are designed, in our case centred on the sector of culture and ancient theatres, we formulate programs of local development. The process consists of three different stages.

- Firstly, the initiative of the program, consisting of making contact with the area in which you want to act and the problems existing in the same, identifying various factors such as employment, the social demand, governance, availability of resources and the consensus by the different groups and institutions that intervene.

- Secondly, the formulation of the program or definition of the various actions to be undertaken through the determination of instrumental objectives, project definition (features, participating agents...) and estimation of the demand for the project based on its usefulness and attraction of resources through institutional support.

- Thirdly, the management of the program or the drafting and adoption of management instruments needed to proceed with the implementation of the program and projects, especially through the creation of local development agencies.

7 Cited in Sanchis, J.M. and known as "the Pentagon's Coccossis model".

4.4.6. THE SECTOR OF CULTURE AS AN ENGINE FOR LOCAL DEVELOPMENT

Culture is today recognized as a development and employment-generating activity. Amendola (2001), among the main ways in which the relationship between culture, development and territory can be thought of, focuses on three:

- Culture as a catalyst for the engine of the creative development of cities.
- Culture as item for creation and consolidation of identity.
- Collective in the development project, culture as a factor establishing the quality of life.

Culture generates jobs and mobilizes resources and needed human resources both directly related to culture, as well as to others that we might consider not cultural. Following Geffre (2001), culture creates values that constitute specific sources of employment. These values are classified as:

- *Aesthetic values*. Culture creates aesthetic values through the exhibitions of works of art, book publishing, and film production. Although the analysis of the values created is very complex and the implications of these values in a territory's economy needs to be measured more, we know that these activities generate employment. As an example, employment in the major museums.
- *Activity values*. Culture generates values of activity that correspond to direct jobs. Cultural tourism, in various cases in developed countries, has led to a successful entry into territories that had enforced its production models. The activity of cultural tourism generates a series of indirect jobs related to accommodation, food, souvenirs, etc.
- *Development values*. Culture generates economic development effects beyond what would be the traditional cultural activities. Cultural activities enable the formation of skills that can be exploited in other sectors by strengthening the competitiveness of enterprises. In this case they are cultural jobs in non-cultural companies, such as designers, stylists, craftsmen, who participate in the processes of innovation by enterprises. Specifically, with respect to design, we know that it is a factor that is used to differentiate their product offerings and enhance brands, that provides competitiveness. In other words, certain capabilities that are developed in the field of cultural activities are an input for companies in many other sectors because they increase their competitiveness, whether it is by improving their design, advertising or their image, among others.
- *Effects of social integration*. We know that many cities have created social integration or cohesion programs based on the recognition of a common heritage.

The cultural activity generates various types of employment. Geffre (2001), in a first approach, distinguishes four situations that arise from classifying jobs based on two criteria: first, the intrinsically cultural nature, or not, of generated jobs and, secondly, the other types of companies in which they arise:

1. Those jobs that are cultural in nature and develop within cultural enterprises.
2. Includes non-cultural jobs, i.e. commercial, management, etc., which are developed in the field of cultural industries.
3. Includes non-cultural jobs in non-cultural industries, as in the case of transport, hospitality, medical and insurance services.
4. Cultural jobs present in non-cultural enterprises e.g. designers, stylists etc. These jobs are not usually included in the analysis of cultural employment; however, their activities are really cultural in nature.

4.4.7. THE DISTRIBUTION OF CULTURAL ACTIVITIES IN THE TERRITORY. CULTURAL CLUSTER

Beyond the recognized heritage venues that have the ability to bring together visitors, activities and cultural jobs, one finds that artists tend to huddle around the entertainment or heritage markets. It is considered that culture takes place largely in urban environments and requires a minimum dimension of activity to be "viable". Thus, at least at first, it is the larger cities that are more capable of developing these activities.

Some authors consider that cultural employment will be increasingly less limited by the characteristics of the territory, thanks to the development of new technologies and the ability of this activity to extend to non-cultural companies, more dispersed in space that the cultural activities such as museums and shows. The issue is not settled and there are arguments that run counter to this idea, as it has often been observed that cultural activities come together in space forming what is known as cultural cluster.

Artistic activity is characterized by the need to develop projects that are constantly renewed. For artists it is important that there is the possibility to move from one project to another and perform related activities with a range of contracts in order to achieve other income (income replacement) since cultural activity, in many cases, is not generally characterized by employing workers for extended periods of time. The revenue needed to keep a pool of human resources

dedicated to culture for a significant proportion of jobs in the sector, requires the existence of density and a variety of activities.

On the other hand, producers or suppliers of cultural projects should move in a competitive environment and try to locate in those areas where they are more easily the necessary inputs for the production of culture. In other words, navigate to places where activity is concentrated, and therefore workers and other inputs can reduce the transaction costs (costs of search, artistic managers, publicists, etc.) for companies and organizations dedicated to the production of culture.

These arguments support the tendency to talk about cultural districts, Santagata (2002), or in other cases - cultural clusters. Cultural districts, more than cultural clusters, can be analysed in the context of the literature concerning industrial districts.

The **industrial district concept** was introduced by Marshall (1890) in relation to the location of industrial activities. Marshall observed that, in many cases, companies of certain activities were concentrated in the territory due to the existence of certain advantages known as localization economies. These advantages may be associated with:
- the existence of skilled workforce
- the existence of suppliers
- the existence of other elements that benefit activity: institutes, specific infrastructure, etc.

Another important contribution to the advantages of the concentration of companies and activities in space is provided by Jacobs (1961), who stated that the agglomeration of people and activities facilitates the transmission of knowledge and the generation of innovation, from the emergence of new work from the built-in work. To the extent that there is a network of companies that are related (some are from other suppliers or customers), allow for jobs to flow from one enterprise to another, as well as ideas. As noted by Jacobs (1961), the connection of activities and the proximity enhance the transmission of knowledge and the appearance of innovation.

Cultural districts

The logic of the cultural district is the same as the industrial district with significant differences. As Geffre (2001) states, it is the willingness to reorder a territory, urban or rural, integrating into it the same high value activities of creativity, image and communication. On the other hand, the installation of building activities nearby each other and resources in information technology centres, will generate external economies in the form of exchanges and qualified services, allowing for the exploitation of possible interdependencies and the emergence of new projects. Cultural districts may have diverse backgrounds and some of them have emerged spontaneously from the productive base, composed of the artisans of art, editors or producers, among others. Another feature of some industrial districts, pointed out by Geffre (2001), is the existence of a designation of origin or label.

The industrial cultural district

The most illustrative example of a cultural-industrial district is Hollywood. At one time, the combination of several studies created a market of technical and artistic work facilitating the development of this market. In turn, producers find individuals and firms with capabilities or desired skills with some ease. In this vein, there are districts that bring together activities related to the production of audio-visual products (games, educational products, etc.) and software.

At the opposite end to the previously described cultural districts known worldwide, are others of a much more modest size organised on the basis of industrial handicraft art, e.g. the Sicilian district of Caltagirone, dedicated to pottery art, which brings together some 150 workshops of small size, usually relatives.

The cultural district development

The public authorities organize these cultural districts "artificially". The objective of these is to create development in territories that have seen their traditional productive base disappear or, in other words, where its most important industry has entered into crisis, generating unemployment and situations of poverty and deterioration over time.

The objective of these districts is the creation of an atmosphere that is conducive to the exchange of ideas and at the same time to the emergence of an organizational structure that allows for the appearance of a labour market. From here, created structures should favour synergies between projects and competitions. The launching of a development environment based on the cultural sector produces two outputs, on the one hand allowing an increase in employment and, in addition, unlike many other sectors, reinforcing the image of the territory, its creativity and vital environment.

The best-known examples of this type of development, or policies, are found in European cities characterized by a weakening of their industrial base and a process of decline. One of the best examples is the Cultural Industries Quarter of Sheffield (United Kingdom) that arises as a response to the constraints of urban policy and the need to find new activities. In this case, the authorities carried out an active policy of space conditioning and empowerment of the creation of companies in the field of culture, especially theatre and music, among others. Currently there are 200 companies in the cultural district. Another known case is

that of Temple Bar in Dublin, where, under a strategy of urban renewal of a deteriorated historical neighbourhood, the authorities committed to a strategy aimed at the creation of a space for the development of cultural activities, galleries, exhibitions, performances, etc.

The Museum or Heritage District

In principle these are districts in which there is, often, important heritage linked to the existence of a monument or set of outstanding monuments, or neighbourhoods with exceptional heritage qualities. Often, these districts create an environment favourable to the development of cultural activities resulting in the emergence of other activities such as art galleries, centres of training, or of spaces related to artistic production.

In this case, both the activity of companies and other agents and the organization of the buildings, the gardens of the preserved sectors, of the perimeters of renewal in the areas of management, pedestrian streets and public art are important.

This type of renovation is becoming increasingly common since these are actions that allow the resources mobilized to fall on or benefit the territory and improve the quality of life of its inhabitants; this is an important feature that is related to culture-based development approaches.

Culture and quality of life

Culture is an element that contributes to the quality of people's lives. A traditional idea is that quality of life is derived from development, i.e. something that comes after. Today we know that this relationship is not complete, although it is true that greater resources often lead to quality of life. One notes that there are few places where the low quality of life has resulted in sustainable development processes. Instead, it is more frequent that places such as Silicon Valley in the United States, or other cases in France and Spain, where the quality of life was better, enjoyed a greater acceleration in growth. The issue is the attraction of businesses and capital and human resources of high qualification, able to settle and work anywhere.

4.4.8. SUSTAINABILITY AND CULTURAL ACTIVITIES

The concept of sustainability accepted nowadays is based on what is known as the Brundtland Report, created by the World Commission on environment and development. The report, drawn up in 1987 and entitled "Our Common Future", raises the need to establish a concept of development that "meets the needs of the present without compromising the ability of future generations". Following this idea, the World Business Council for Sustainable Development based the concept of sustainable development on three pillars: economic, social and environmental.

Firstly, sustainable development must ensure citizen wellbeing and there must be an economy that is efficient, able to compete with foreign markets and generate employment for the population over the long term. Secondly, sustainable development should seek equity and cohesion and must ensure that citizens participate in the decision process. Finally, sustainability requires development that does not compromise the resources for future generations. We need to create development that is respectful of the environment.

Sustainability involves permeability between the three mainstays. For example, our development model should stimulate activities as culture in which practices are made respectful of the environment and also involve an increase in social cohesion, equity and education levels, allowing the participation of citizens and, from this, promoting its identity with the territory.

The interrelation and balance between these three areas constitute the fundamental reference point for articulating sustainable actions by government as well as businesses and organizations.

The linkages between culture and sustainability are known today. David Throsby is a reference point in the reflection on the subject. In 1955 he published his article titled "Culture Economics and Sustainability" in the Journal of Cultural Economics Magazine. It proposes a set of principles that allow one to evaluate 'sustainable management' of cultural capital. It points out the following six principles[8]:

· The recognition of the existence of individual and collective benefits of creativity and cultural production.

· Respect for intergenerational equity, for the recognition of the interests of future generations to access the inherited culture of the past.

· The preservation of intergenerational equity concerning the rights of current generations to just access to cultural resources.

· The maintenance of cultural diversity (ideas, beliefs, traditions and values).

· The principle of caution, to avoid the risk of irreversible changes in the cultural systems (a principle equally applicable to the field of biodiversity and making reference to the risk of extinction of living species).

· The maintenance of cultural systems and recognition of the interdependence between them.

In 1995 the World Commission on Environment and Development, United Nations of WCED moved the idea of the three mainstays of sustainability to the field of culture. It raised the need for a

8 Thorosby, D. "La sostenibilidad cultural", A. Towse, R. (ed) *Manual de Economía de la Cultura*. Fundación Autor-Sgae, 2005. Cited in Cubeles (2010), p.135.

commitment between culture and economic development equal to what the Brundtland Commission had done with the economy and the environment. It defines the concept of cultural sustainability as application of the concept of intergenerational efficiency applied to the field of the management of the cultural capital, understanding this as the culture that we have inherited from our ancestors and must bequeath to future generations.

The Culture and Sustainable Development International Conference organized by the World Bank and UNESCO were important approaches on how culture can help or support sustainability.

The holistic approach between culture and sustainability has won a place in the field of cultural policies. The Agenda 21 for culture was adopted in May 2004 in the framework of the IV Forum of local authorities for Social Inclusion of Porto Alegre, and the first Universal Forum of cultures held in Barcelona. The Agenda 21 for culture expresses the necessary commitment of cities and local governments with human rights, cultural diversity, sustainability, participatory democracy and the generation of conditions for peace.

The interrelationships between the concepts of culture and sustainability have evolved over time towards a broader concept of sustainability that progressively includes the cultural dimension, such that one might propose culture as the fourth pillar of sustainability. As stated by Hawkes (2001), progress towards a sustainable society occurs more effectively if you set the vitality of cultural as one of the basic requirements.

Of course, culture policy is not alien to these new approaches and the role of promoting sustainable development. In this sense, a sustainable cultural action as one that is defined or structured based on the four pillars of sustainability.

Table 2. The four pillars of sustainabiliy and cultural action

ECONOMIC	SOCIAL
Cultural action must be viable in economic terms (results) and should contribute to the growth of the economy (direct and indirect impact on production and employment).	Cultural action should be based on participation and promoting equal opportunities for citizens to access knowledge and the creation of cultural consumption.
ENVIRONMENTAL	**CULTURAL**
Cultural action should be respectful of the environment through responsible use of materials, energy and the environment.	Cultural action should encourage creativity, cultural diversity and the conservation and dissemination of the cultural heritage, with the aim of contributing to increased individual and collective wellbeing.

Source: Cubeles, X. y Baró, F. (2006)[9]

The integration of the four pillars leads to the determination of the objectives that must be pursued in a sustainable development based on culture and that should guide the design of cultural policies, Cubeles (2010):

- *Eco-efficiency:* the local economy should be able to produce assets and services on a competitive basis, reducing the waste of resources and the environmental impact.
- *Efficiency:* should maximize the degree of achievement of the objectives of cultural action through available resources.
- *Quality of service:* the assets and services produced must satisfy the expectations of the beneficiaries/users of the cultural action and open channels for their participation in its management.
- *Social responsibility and values*: there must be a commitment by the organization in the pursuit of social, cultural and environmental values.

Based on the four pillars and their interrelations, Cubeles and Baro (2006) define eight possible axes of sustainable cultural actions (see Figure 3)

Source: Cubeles (201, p.138)
Possible axes of a sustainable cultural action.

9 Cited in Cubeles, X. (2010)

4.4.9. GOOD PRACTICES IN ANCIENT THEATRES

In this section we will try to provide information about projects completed successfully as a result of the implementation of cultural management practices developed in the ancient theatres of Europe.

THE THEATRE OF ORANGE (FRANCE)

This is one of the best preserved theatres of Europe, fitting up to 8,500 people. It closed as a theatre in the year 391 and did not begin to recover as such until its restoration started in 1825 by Prosper Mérimée, director of historic monuments who commissioned restoration architect Simon-Claude Constant-Dufeux. Due to the slowness of the procedures for expropriation, the stands were not restored until the end of the 19th century. In 2006, a roof was added to the stage to protect the walls and allow for the installation of lighting. This new roof is situated in the same place as the original Roman ceiling, but uses modern materials: glass and metal (Bellet10, M-E., 2000).

USES AND ACTIVITIES OF THE THEATRE

- **FESTIVALS** - Festivals have been performed in this theatre since 1869, when it became seat of a "Roman Festival" which was called fêtes romaines (Roman festivals). At the end of the century, it took renown when all the main interpreters of the French classical stage appeared in the Orange festivals, including Sarah Bernhardt who played Phèdre in 1903. In 1902, the festival was renamed Chorégies d'Orange, planned as an annual summer festival. The name comes from a tax that the Roman imposed on the rich to pay for the theatrical productions. Until 1969 the Chorégies consisted of plays, alternating with musical works, operas and symphonies. However, after that date, Orange became only an opera festival and theatrical works were represented in Avignon.

[10] *Michel-Édouard Bellet, Orange antique, Guides archéologiques de la France, Monum, 2000. ISBN 2-85822-437-4*

- **MANAGEMENT** was transferred to a foundation specialist in cultural events. Since 2002, the city of Orange, owner of the monument, has ordered his administration to the *Culturespaces Company*.

- **OUTREACH, INFORMATION AND COMMUNICATION**:

 - Has its own website: http://www.theatre-antique.com/fr/home

 - Included on the page of the foundation that manages and included in the tourist web d'Orange http://www.culturespaces.com/fr/home

 - Relay events in the French television channels.

- **ACTIVITIES** for all ages:

 - Educational workshops:

Source:http://www.theatre-antique.com/fr/evenements/au-temps-dauguste

 - Exhibitions and competitions for children: "Les Romains à Petits Pas"

- Musical events for young people.
- Other activities: "Les jeudis d'Orange".

- **TOURISM** - Along with the Arc de Triomphe was declared a historic "Heritage of humanity" by Unesco in 1981. The theatre is included in the circuit of sightseeing together with other museums.
- **OTHER FREE OF MARKETING** - Tickets performances to children under 17 years old, affordable prices, events, hiring of renowned artists offerings (Barbara Hendrix, Placido Domingo and Montserrat Caballé, even events for children Eric Dars and Eric Teyssier), etc.

MÉRIDA'S THEATRE (SPAIN)

This theatre has a capacity of 6,000 spectators. Excavation began in 1910 and continued until 1915, with prestigious archaeologist José Ramón Mélida Alinari in charge. The reconstruction of its monumental scene was carried out between the years 1916 and 1925 under the direction of Sevillian Architect Antonio Gómez Millán. It was not until the nineteen sixties and seventies when the stage front, under the direction of the architect and archaeologist José Menéndez Pidal Álvarez, was rebuilt.

USES AND ACTIVITIES OF THE THEATRE

- **INTERNATIONAL FESTIVAL OF CLASSIC THEATRE** - Begun in 1933 with the staging of the Medea of Seneca. In 1934 it was suspended until 1953, reopening with the representation of the play Phaedra by a University Theatre Company. In 1954 it turned professional theatre to Mérida with the representation of an Oedipus by Sophocles and since then it has been held continuously welcoming representations of the largest of the Greco-Latin Classic theatre works to its stage.
- **DIRECTION AND MANAGEMENT** - Is carried by the company *Pentacion Entertainment*, www.pentacion.com. Since 2010, the stage direction of the theatre has been performed by an actress and producer of the country, Blanca Portillo.
- **FINANCING** through a sponsor consortium composed of eight institutions, three sponsors and eight partners.
- **OUTREACH, INFORMATION AND COMMUNICATION:**
 - The Publiescena Company carries out the disclosure in the press and advertising.
 - Has its own web page: http://www.festivaldemerida.es
 - Appears on official pages of tourism of the city and the Extremaduran community, as well as on the website of company management.
- **OTHER ACTIVITIES:**
 - Forum of festivals. Artistic responsible and managers of relevant festivals and institutions convened to discuss what their potential contribution to the evolution of the global cultural thinking.
 - Ceres Prices.
 - Conferences.
 - Workshops of Assembly. Each workshop is intended for the production, testing and subsequent representation of two proposals related to classical culture and the programming of the Mérida Classical Theatre Festival.
- **INTEGRATION** of the theatre with the local culture:
 - Passacaglia. *Festivitas* is a parade that was born with the objective of filling the streets of *Mérida Festival*, as many centuries ago happened in Rome itself. According to the Roman calendar, there is a tour for every month of the year, highlighting the festivities and rituals of each month.
- **ATTENTION AND INVOLVEMENT OF THE CHILDREN:**
 - Training workshops. Agusto Program in Merida will carry out workshops for children.
- **TOURISM** - Integration in promoting heritage tourism. Mérida was declared patrimony of humanity by UNESCO in 1993. It has also been, since 2007, one of Spain's 12 treasures. The Mérida classical Theatre Festival offers spectators of the representations included in its programming tools that facilitate and complement the visit to the city businessman.

SAGUNTO'S THEATRE (SPAIN)

The Sagunto Roman Theatre was built in the 1st century B.C. in the time of Emperor Tiberius. The semi-circular set, built on a hillside

of the city, is defined by two main parts: the *cavea* or bleachers and the scene (or stage wall). It has a capacity for 4,000 spectators. It was declared a national monument in 1896. In the 20th century it was the subject of a controversial restoration which has allowed its use for theatrical demonstrations.

The most significant aspect is the set of tunnels and *vomitoria* that allowed access and the evacuation of spectators.

USES AND ACTIVITIES OF THE THEATRE

- **FESTIVALS. -** During the months of July and August, the Roman Theatre of Sagunto and the streets and squares of the town are converted on the stage of the Summer Festival, "*Sagunt a Escena*". This festival presents a varied program of dance, theatre and music with proposals of interest to the public of the Valencian Community and State or international level.

- **OTHER ACTIVITIES:**
 - *Compitalia contest*. For middle teaching students to enroll in three modes:
 - "*Pausanias*" for a story on a myth or fact of classical antiquity.
 - "*Fidias*" for a comic on the same subject.
 - "*Talia*" for a brief representation of classical themes.
 - Classical culture workshops. The Association "*Prosopon Sagunt*" is responsible for the Organization of the workshops of ceramics, archaeology, Roman games, playroom mythological, mosaics, Roman cuisine and clothing.
- **DIRECTION and MANAGEMENT. -** Sagunt scene summer festival has the artistic direction and management of theatres of the *Generalitat Valenciana*, which is a public institution. For the rest of activities, it is the "*Prosopon Association*" which is responsible for the management. It does not have a professional but rather an institutional management. Events are also financed with public and private sponsors.
- **OUTREACH and COMMUNICATION. -** Associations and management institutions are responsible for disseminating the events. It does not have a unique web page of the theatre. www.prosoponteatro.com/1festivales/9sagunto/Sagunto.htm

 www.saguntum.es/sagunt-a-escena http://teatres.gva.es/festivales/festival-d-estiu
- **TOURISM. -** The theatre is included in the tour of the city and has guided tours. Also included in the tourist site of Sagunto.

TAORMINA'S THEATRE (SICILY, ITALY)

The Taormina Theatre has a capacity of nearly 19,000 spectators. It was built in Greek style taking advantage the geography of the hill. There are treads of the staircase polished directly on the rock. While the origin of the theatre is Hellenistic, modifications and upgrades were made in Roman times, concretely the structure of the scene. It was restored during the 1990s.

USES AND ACTIVITIES OF THE THEATRE

- **FESTIVALS –** The opposite of the theatres seen previously, Taormina Theatre does not have a festival for which the theatre is recognized. The venue is used for various festivals that do not always have to do with the performing arts. So since its restoration it has been witness to the following cultural events:
 - Taormina Film Fest. Festival of Taormina Film, heir of the cinematographic *Rassegna di Messina e Taormina*, who was born in 1960 and for twenty years hosted the awards *David di Donatello* with the participation of famous characters from the world of the spectacle. In the area of the Film Festival are delivered the prestigious *Nastri d'Argento* (Silver tapes) awards, assigned by film critics.

- Festivalbar. In the classical and light music with important figures of the music concerts are performed (Sting, Ligabue...)
- The Kore-Festival fashion.
- Since 2005, the Giuseppe Sinopoli Festival has been organized in October, dedicated to this orchestra leader, who died in 2001 and who for years was the artistic director of Taormina art.
- Theatrical, lyrical operas, operettas and other shows

- **MANAGEMENT and DIRECTION** - ceded to the Taormina art cultural institution.
- The events have sponsorship of different companies and the cultural institution with the Italian Government support.
- **DISSEMINATION, INFORMATION AND COMMUNICATION:**
 - Some shows and festivals represented in the theatre of Taormina are issued in Italian broadcasting media.
 - Does not have its own web page, but you can get information of the theatre and of the events in the following web pages: http://www.taorminafilmfest.it, http://www.taormina-arte.com/, and http://www.lasicilia.es/teatro_de_taormina
- **TOURISM** - Sicilia includes the theatre of Taormina as cultural heritage of tourist interest. The regional tourist service welcomes the theatre in their tour as one of the main monuments of the city.

SYRACUSE'S THEATRE (SICILY, ITALY)

The original construction dates from the 5th century BC, but in the 3rd century BC it was rebuilt by Hiero, and it has remained almost as it was in that moment. The material for its construction was taken directly from the hill supporting the theatre.

Greeks were extremely aware of the religiosity of the people, and the theatre was a venue with a temple and an altar.

This theatre has the largest *cavea* built by the ancient Greeks: it has 67 rows, divided into 9 sections with 8 corridors. There are only ruins of the scene and the orchestra. The building (still used today) was modified by the Romans, who adapted it to their style of spectacles, including also circus games.

Nowadays "OMA", an international association of architecture, urbanism and cultural analysis together with "AMO", an research studio in Rotterdam that complements the architecture including media, politics, sociology, renewable energy, technology, fashion, editing and graphic design, designed a scene featuring three temporary architectural devices that reinterpret the Syracuse theatre spaces.

USES AND ACTIVITIES OF THE THEATRE

- **FESTIVALS** - Different cultural events are held which include:
 - Cycles of Classical Representation, already announced for May-June of 2013 *XLIX Edition*. The summer cycles are composed of different works by the "*Istituto Nazionale of the Dramma Antico*". Each year the scene changes to adapt to the representations of that edition:

STAGE AND REPRESENTATION 2010-2011:

STAGE AND REPRESENTATION 2012-2013:

Images of Alberto Moncada

 - Samples, conferences, workshops and seminars, where representatives of the Italian Government, and characters recognized in the world of classical culture are invited.

- **MANAGEMENT and DIRECTION** - With Legislative Decree n° 29 from the 20th of January 1998, the National Institute for ancient Drama has been transformed from a public entity in the foundation of private law, with a President, a Board of Directors and a Board of Auditors.

The law assigns tasks to the foundation of great importance:

- The production and representation of dramatic texts in the Greek Theatre of Syracuse, in cinemas and other environments of particular cultural importance.
- The promotion and coordination of efforts in Greco-Roman theatres.
- A series of initiatives to promote the classical culture through the use and enjoyment of the Foundation's historical and cultural heritage.

The Foundation and the various events have public and private sponsors.

- **DISSEMINATION, INFORMATION AND COMMUNICATION** - *INDA ONLUS Foundation* from which it manages and directs the theatre of Syracuse has its own web page which is linked to the Office of Tourism of Sicily. http://www.indafondazione.org/
- **OTHER ACTIVITIES** - The Foundation has a magazine called Dionysus, and an on-line magazine Prometheus.
- **IMMERSED IN CULTURAL POLICIES** - To be managed by the Foundation, the performances of the theatre are within a cultural program of the city and the environment, therefore participating in the cultural policies of the region.
- **TOURISM** - The theatre is integrated into the cultural offerings of the city including visits as a tourist heritage. In addition there are offers that involve other sectors such as catering or transport.

ROMAN THEATRE IN AMMAN (JORDAN)

Photograph of Jesus Santos. Published by DOMUS PUCELAE

The Amman Roman Theatre has a capacity of 7,000 spectators. Built in the year 190 it was the largest theatre in the east. The row of columns at the north, against the Roman Theatre, is all that remains of the Forum, which became one of the largest public squares of all Imperial Rome, flanked on three sides by columns and on the fourth by Seil Amman. Three distinct tiers can be seen: the lower section for the rulers who sat near the performance, the middle section for the military, and the common people at the top of the enclosure.

USES AND ACTIVITIES OF THE THEATRE

- **FESTIVALS** - Two festivals are held, one in autumn-winter and the other in the summer:
 - *International Festival of Amman Theatre.* In November 2011 the 18th Edition of the festival was held featuring works of theatre companies from all over the Arab world. The festival has been held annually since 1994 and tries to create a dynamic interaction between the Jordanian, Arab and international theatrical scenes. Last year, the festival was attended by 15 theatre groups from the Arab countries that include Jordan, Morocco, Oman, Saudi Arabia, Palestine, Kuwait, United Arab Emirates, Iraq, Algeria, Sudan and Egypt, as well as groups from Poland and Italy. Theatre works are carried out in a number of places in Amman, including Al - Hussein, the Cultural Centre and the Royal Cultural Centre.
 - Amman Summer Festival. Roman army and experience Chariot (RACE) organizes regular performances at night in the Roman Theatre in the Centre of Amman. These actions are part of the Summer Festival and include singers, groups of traditional dances and the band of the army of Jordan. The spectacle of the RACE is composed of 35 fully armed Roman legionaries showing battle formations and tactics, and 5 pairs of gladiators fighting "to the death". Composition of theatre - with its Roman architecture and acoustics, in combination with the effects of light and sound - makes the show really spectacular.

- **MANAGEMENT and DIRECTION** - The international festival is an initiative of the Jordanian Ministry of culture in cooperation with Amman Al-Fawanees, the Union of Jordan artists, and the summer festival is organized by the City Council in collaboration with the Ministry of Tourism and Antiquities and the Jordan Tourism Board.

- **OTHER ACTIVITIES** - Apart from theatrical performances, there is also a series of seminars included. In the year 2011, the subject "theatre of the future - changes and perception" was held, with the presence of specialists in theatre of renown in the Arab world, including Hanaa Abdel Fattah, Salam Abu Al - Hassan and Al - Hamdi - Gabri Egypt.

- **TOURISM**
 - The Roman Theatre is home to the museums of folklore and traditions. Both present embroidered clothing, utensils, etc.

from nomadic tribes, as well as customs and a bit history and photographs.
- Jordan's Tourism Department is found in the urban environment and includes uses for the local population and regional and international tourism.
- **DISSEMINATION, INFORMATION AND COMMUNICATION** – The theatre and the festivals do not have their own web page. Its distribution is done through official bodies of Jordan and through the official website: http://sp.visitjordan.com/

GREEK THEATRE OF KOURION (CYPRUS)

The Ancient Theatre of Kourion dates back to approximately the 2nd century AD and is located in Limassol, the second largest city in Cyprus. It has capacity for 3,000 spectators. It was originally built by the Greeks and later underwent some changes in Roman times. In the 4th century the theatre was destroyed and later rebuilt, offering majestic views of what it looks like nowadays.

USES AND ACTIVITIES OF THE THEATRE

- **FESTIVALS -** The International Festival of ancient Greek drama has been held for 17 years. Performed with subtitles in English and Greek.
- **OTHER ACTIVITIES:**
 - Conferences.
 - Week of Greek-Cypriot theatre by bilateral agreements signed with Greek centres.
 - Exchange of artists to become familiar with the global trends in theatre and share and transmit experiences with other colleagues.
 - Participation of Cyprus groups in international activities, such as the *Theatre of Nations*, the *Theatre of the suitcase*, the *Monodrama Festival*, the *United Nations Theatre University*, the *Quadrienale Prague*, the *Experimental Festival Theatre* in Cairo, and the *Bangladesh Festival Theatre*.
 - Symposium, hands-on sessions, publications.
- **MANAGEMENT** - Is managed by the Cyprus Centre of International Theatre Institute (ITI), which is a non-governmental association in formal relations with UNESCO. It was officially inaugurated during the meeting of its first World Congress of Prague in 1948, organized at the initiative of UNESCO and a group of international experts in the theatre. The objectives of the ITI are the following:
 - Promote the international exchange of knowledge and practice in the field of the arts.
 - Stimulate the creation and increase cooperation between the people's theatre.
 - Increase public awareness of the need to take into account artistic creation in the field of development.
 - Deepen the mutual understanding and contribute to the consolidation of peace and friendship among peoples.
 - Participate in the defense of the ideals and objectives of the UNESCO
 - Combat all forms of racism or discrimination, social and political.

 It also has partners and public and private sponsors.

- **MARKETING -** Pricing, renowned artists, advertising and communication.
- **DISSEMINATION, COMMUNICATION AND INFORMATION**
 - Webs of theatre as a heritage and events. http://www.cyprusevents.net, http://www.cyprus-theatre-iti.org www.ancientgreekdramainstitute-cyprus.org.
- **IMMERSION IN CULTURAL POLICIES:**
 - Involvement of all stakeholders, City Hall, Government, and foundations.
 - The creation in 1998 of the International Summer Institute for ancient Greek drama. It started as a summer school, running in parallel with the international meeting and theatre schools Festival, organized under the auspices of the cultural identity and Committee of development of the Institute International Theatre, as an annual event. In the year 2000 an ancient Greek Theatre professional summer session was added as an Institute. The International Summer Institute for classical Greek drama and the theatre gradually became a centre for the study of various methods to deal with and the realization of ancient Greek performances.
 - Involvement of the child audience.
- **TOURISM -** Integrated in the tourist circuits of the city, and in the tourist site of Limassol.

THEATRE OF HERODES ATICCUS (GREECE)

It is called Roman Herodus Atticus Odeon (Athens) and is located on the southwest slope of the Acropolis of Athens. Its construction dates back to the year 161 B.C. The state of the theatre was, as were the majority of the monuments in the entre of Athens, in ruins. In particular, what was left of the theatre was a huge wall of stone and part of the "iron curtain" of the theatre. The stage had to be renovated, as well as the stands. The renovations were made in marble, the original material. It has a capacity for 5,000 spectators.

USES AND ACTIVITIES OF THE THEATRE

- **FESTIVAL -** Every year since 1955, Athens has organized the Festival Hellenic, a cultural show that has been attended by people from all parts of the world. It is held in the summer between the months of June and September. The festival includes musical performances, dance, theatre, puppets, and other expressions of art and they are represented in spectacular places of Athens such as the Athens Concert Hall and the Odeon of the Acropolis. Over the years the festival has included artists of great talent, such as Pavarotti, Dimitris Sgouros, Leonidas Kavakos, Theodorakis, Savvopoulos, Elton John and Marinella.
- **OTHER ACTIVITIES:**
 - Live music, singing and dancing. A Greek band holds live performances with dancers over three days of the Hellenic Festival.
 - Church tours. The Hellenic Festival offers visitors the opportunity to learn more about the Greek Orthodox Church and the Orthodox faith, its history, the beautiful iconography, architecture and liturgical practices through visits to the Church.
 - Children's corner. Various activities for children, such as painting faces, games and balloon animals are carried out during weekends of the Hellenic Festival.
- **MANAGEMENT -** The Office of Tourism carries out the management of the theatre for visits and the *Hellenic Festival Company*.
- **MARKETING -** The theatre visit falls within the visit of the Acropolis and has various discounts. There are also all kinds of items for sale that have to do with the Greek culture and its theatres.
- **DISSEMINATION, COMMUNICATION AND INFORMATION -** In addition to the web site of the festival, the theatre is included in the official tourist site of Athens. It is immersed in the cultural policy of the whole city. There is a specific communication for the theatre. The pages are: www.greekfestival.gr and http://www.hellenicfest.org.
- **TOURISM -** Not only is it included in the circuit, in addition you can only visit inside the theatre if you buy an entrance ticket for the Acropolis.

THE THEATRE OF EPIDAURUS (GREECE)

The theatre of Epidaurus, located in the northeast corner of the Peloponnese, in Greece, was built in the fourth century. It remains one of the most beautiful Greek theatres in the world, famous for its exceptional acoustics. The actors on stage can be perfectly heard by 14,000 spectators, regardless of their seat.

USES AND ACTIVITIES OF THE THEATRE

- **FESTIVAL -** Despite not being in the Athens Hellenic Festival, it also incorporates these impressive theatre performances.
- **OTHER ACTIVITIES:**
 - Workshops that take place in the theatre. The workshop forms the backbone of their activities, allowing you to operate as an independent, self-sufficient organization open to all, without distinction of race, creed, or social status.
- **MANAGEMENT -** As well as in the theatre of Herod Aticcus, the Office of Tourism carries out theatre management for visits and the Hellenic Festival S.A. Company for events that take place in the theatre.
- **DISSEMINATION, COMMUNICATION AND INFORMATION -** There is a theatre website: http://www.epidaurustheater.org/. There

is also the web site of the festival and the official tourist site of Athens. It is immersed in the cultural policy of the whole city.

- **TOURISM** - Although it is not located in Athens, it attracts tourists due to the natural acoustics of the theatre that impresses the visitor.

forum. Today, due to the political and social situation in the country the webpage of the festival is not active or updated.

- **TOURISM** - People can visit the theatre as a cultural asset of the city of Bosra.

THE THEATRE OF BOSRA (SYRIA)

THEATRE OF ASPENDOS (TURKEY)

This theatre is located 140 km south of Damascus, in Syria. The city of Bosra already appeared on Egyptian hieroglyphs in the 14 century BC. The Romans conquered the city in the year 106 AD, and it became the capital of the province of Arabia. The theatre of Bosra was built in the 2nd century AD. A fortress around the theatre was built by the Ayyubids, and now it is one of the best-preserved Roman theatres in the world. At the beginning of the 20th century most of the interior had become filled with sand, which acted as a natural preservative. The theatre was restored to its former glory between 1947 and 1970. The main restoration works are directed to the area of the stage and the ranks of top seats. Part of this work was done in Egyptian pink granite. There is capacity for 15,000 spectators.

USES AND ACTIVITIES OF THE THEATRE

- **FESTIVAL** - The theatre serves as the headquarters of the Bosra Festival, a festival of national music that has been held since 1985 in the month of August or September. The music of *Bosra International Festival* is music of Syrian culture, although they invite artists from other countries. In 2009 the *Culemborg Netherlands folk group* attended, invited by the Ministry of Culture of Syria. The festival features singers, poets and other artists from the show in the Middle East and beyond. Visitors can also enjoy exhibitions of Visual Arts and crafts.
- **MANAGEMENT** - The government of Syria manages this theatre.
- **DISSEMINATION, COMMUNICATION AND INFORMATION** - There is a web page of the festival: www.bosrafestival.org/. It also has information on *Facebook* and provides contacts and the festival

Aspendos is known for having the best-preserved theatre of antiquity. With a diameter of 96 metres and a capacity of 7,000 people, it was built in the year 155 BC by the Greek architect Zenon, born in the city during the reign of Marcus Aurelius. Rebuilt periodically, it has been used as a caravanserai (accommodation for travellers), and during the twelfth century was used as a palace. From the time of its Greek beginnings, its construction took advantage of the hill on which the acropolis was found, but the top rests on vaulted arches. It once had a wooden roof that was lost over time.

The main entrance and facade remain intact. Until recently the theatre continued operating for concerts, festivals and events. However, due to damage caused by modern sound equipment, artistic activities in the theatre were suspended temporarily. A modern building known as Aspendos Arena has been built very close to this monument to continue the tradition of outdoor theatre in Aspendos.

USES AND ACTIVITIES OF THE THEATRE

- **FESTIVAL -** Every year the International Opera and Ballet Festival takes place. For a few years and due to the danger for the conservation of the theatre, the Festival has been carried out at the new Aspendos Arena with capacity of 4,500 spectators, which belongs to the company "Fire of Anatolia", thus helping maintain the cultural tradition of the theatre and at the same time eliminating criticism from archaeologists and the Committee for the Conservation of Cultural and Natural Assets. In 2012, the festival has again been held in the ancient theatre of Aspendos.

- **MANAGEMENT -** The management of the theatre is carried out by the Ministry of Culture and Tourism of Turkey and the stage direction by the General direction of the State Opera and Ballet. It has public aid and private sponsors.

- **DISSEMINATION, COMMUNICATION AND INFORMATION -** The official website of the festival: http://www.aspendosfestival.gov.tr/tiyatro_tarihce_e.html has information about the theatre and the festivals.

- **TOURISM -** Near the theatre are the remains of the acropolis, including its stadium, the agora, the remains of a basilica, and especially a 15 km long aqueduct.

4.4.9. GOOD PRACTICES TO GENERATE ECONOMIC DEVELOPMENT IN THE TERRITORIES THROUGH THE CULTURAL ACTIVITY IN ANCIENT THEATRES

In the following tables are reflected good practices carried out in the ancient theatres observed previously in relation to three aspects:

1. Cultural synergies with the environment.

2. Management and financing of the theatre and the cultural events carried out therein.

3. Dissemination and communication.

TABLE 1: CULTURAL SYNERGIES WITH THE ENVIRONMENT

THEATRE	COUNTRY	INTEGRATION IN THE LOCAL CULTURE	CONTRIBUTION TO CULTURAL TRAINING	ACTIVITIES FOR DIFFERENT AUDIENCES	INTERACTION WITH OTHER HERITAGE LOCAL OR FESTIVITIES	CULTURAL IMPACT
Orange	France	HALF	HIGH	YES	LITTLE	INTERNATIONAL
Mérida	Spain	HIGH	HIGH	YES	A LOT	NATIONAL
Sagunto	Spain	HALF	HIGH	YES	LITTLE	LOCAL
Tahormina	Sicily (Italy)	LOW	HALF	YES	NOTHING	INTERNATIONAL
Siracusa	Sicily (Italy)	LOW	LOW	NO	LITTLE	INTERNATIONAL
Amman	Jordan	HIGH	HALF	YES	LITTLE	NATIONAL
Kourion	Cyprus	HIGH	HIGH	YES	A LOT	NATIONAL
Herodes Atticus	Athens (Greece)	HIGH	HIGH	YES	A LOT	INERNATIONAL
Epidarius	Greece	LOW	LOW	NO	A LOT	NATIONAL
Bosra	Syria	HIGH	HALF	YES	NOTHING	NATIONAL
Aspendos	Turkey	LOW	LOW	NO	NOTHING	NATIONAL

TABLE 2: management and financing of the theatre and cultural events developed in them

THEATRE	COUNTRY	CAPACITY	MANAGEMENT (PRIVATE, INSTITUTIONAL OR SHARED)	PRIVATE SPONSORS OR PARTNERSHIP	SUBSIDIES, PARTNERSHIP AND PUBLIC SPONSORS	INSERTION IN CULTURAL POLICIES
Orange	France	8500	PRIVATE	YES	YES	YES
Mérida	Spain	6000	SHARED	YES	YES	YES
Sagunto	Spain	4000	SHARED	YES	YES	YES
Tahormina	Sicily (Italy)	19000	PRIVATE	YES	YES	NO
Siracusa	Sicily (Italy)	15000	SHARED	YES	YES	YES
Amman	Jordan	7000	INSTITUTIONAL	NO	YES	YES
Kourion	Cyprus	3000	INSTITUTIONAL	YES	YES	YES
Herodes Atticus	Athens (Greece)	5000	SHARED	YES	YES	YES
Epidarius	Greece	14000	SHARED	YES	YES	YES
Bosra	Syria	15000	INSTITUTIONAL	NO	YES	YES
Aspendos	Turkey	15000-20000	INSTITUTIONAL	NO	YES	YES

TABLE 3: DIFFUSION AND COMMUNICATION

THEATRE	COUNTRY	THEATRE WEBSITE	CULTURAL EVENT OR FESTIVAL WEBSITE	CONNECTION WITH LOCAL TOURISM WEBSITE	PROMOTION THE EVENTS BY MEDIA	PUBLICATION IN JOURNALS OF THE CULTURAL OFFERING	USE OF SOCIAL NETWORKS
Orange	France	YES	YES	YES	NATIONAL	YES	YES
Mérida	Spain	NO	YES	YES	NATIONAL	YES	YES
Sagunto	Spain	NO	NO	YES	LOCAL	NO	NO
Tahormina	Sicily (Italy)	NO	YES	YES	NACIONAL	NO	NO
Siracusa	Sicily (Italy)	NO	YES	YES	NATIONAL	NO	NO
Amman	Jordan	NO	NO	YES	NO	NO	NO
kourion	Cyprus	YES	YES	YES	NATIONAL	YES	YES
Herodes Atticus	Athens (Greece)	NO	YES	YES	NATIONAL	NO	YES
Epidarius	Greece	NO	YES	YES	NO	NO	YES
Bosra	Syria	NO	YES	YES	NO	NO	NO
Aspendos	Turkey	NO	YES	YES	NO	NO	YES

4.4.10. REFERENCE

- Amendola, G. (2001): Cultura, Desarrollo y territorio. En Cultura, Desarrollo y Territorio. Vitoria-Gasteisz: Xabide, Gestión Cultura y Comunicación.
- Andreasen, A. & Belk, R. (1980): *Predictors of Attendance at the Performing Arts*. Journal of Consumer Research, vol. 7, n.2, pp.112-120.
- Antuñano et al. (1993): *Experiencias de desarrollo local en la Comunidad Valenciana: un primer avance*. Comunicación presentada al 2º Congreso de Economía Valenciana. Instituto Valenciano de Investigaciones Económicas.
- Borgonovi, F. (2004): Performing Arts: An Economic Approach. Applied Economics 36, pp. 1871-1885.
- Champarnaud, L.; Ginsburgh, V. and Michel, P. (2008): *Can Public Arts Education Replace Arts Subsidization?* Journal of Cultural Economics vol.32, n.2, pp. 109-126.
- Cubeles, X. (2010): *Sostenibilidad y actividades culturales*. In *Cultura, Empleo y Desarrollo*. Alfons Martinell & Gemma Carbó (Coord). Girona, Ed.Documenta Universitaria.
- Dewenter, R. & Westermann, M. (2005): *Cinema Demand in Germany*. Journal of Cultural Economics, Vol 29, n. 3, pp.213-231.
- DiMaggio, P. & Useem, M. (1978): *Social Class and Art Consumption: The Origins and Consequences of Class Differences in Exposure to the Arts in America*. Theory and Society vol.5, n.2, pp.141-161.
- DiMaggio, P. & Useem, M. (1980): *The Arts in Education and Cultural Participation: The Social Role of Aesthetic Education and the Arts*. Journal of Aesthetic Education, vol. 14, n.4, pp.55-72.
- Frey, B. (2000): *Art and Economics*, Heidelberg, Springer-Verlag. Published in spanish as: *La economía del arte*, Barcelona, La Caixa, 2000.
- Geffre, X. (2001): *El papel de la cultura en el desarrollo territorial*. En Cultura, Desarrollo y Territorio.. Vitoria-Gasteiz, Ed. Xabide.
- Hawkes, J. (2001): The fourth pillar of sustentaibility: Culture's essential role in public planning Cultural Developement Network (Victoria-Australia).
- Jacobs, J. (1969): *The economy of cities*. Random House.
- Kea (2006): *The Economy of Culture in Europe*, Study prepared for the European Comission. Accessed in June 2012: [http://www.keatnet.eu/ecoculture/studynew.pdf].
- Landes, W. & Levine,D. (2006): *The Economic Analysis of Art Law*. V. Ginsburgh and D. Throsby, eds., Handbook of the Economics of Art and Culture, Amsterdam, North-Holland, pp.211-251.
- Marshall, A. (1890): *Principles of Economics*.
- Orero, J.I. (1993): Promoción económica local en la Comunidad Valenciana» Comunicación presentada al *2º Congreso de Economía Valenciana*. Instituto Valenciano de Investigaciones Económicas.
- Palma, L. & Aguado, L.F. (2010): *Economía de la Cultura. Una nueva área de especialización de la economía*. Revista de Economía Institucional, vol. 12, nº 22, pp. 129-165.
- Rausell, P. et al (2007): *Cultura, Estrategia para el desarrollo local*. Madrid, Agencia Española de Cooperación Internacional, Ministerio de Asuntos Exteriores y Cooperación, Dirección General de Relaciones Culturales y Científicas-AECI.
- Sanchís, J.R. *Las estrategias de desarrollo local: aproximación metodológica desde la perspectiva socio-económica e integral*. Accesed in June 2012: [http://revistadyo.com/index.php/dyo/article/viewFile/301/301.
- Santagata. W. (2002): Cultural Districts, Property Rights and Sustainable Economic Growth. International Journal of Urban and Regional Research vol. 26, n. 1, pp. 9-23.
- Seaman, B. A. (2005): *Attendance and Public Participation in the Peforming Arts: A review of the Empirical Literature*, Andrew Young School of Policy research Paper Series, Working Paper 06-25. This paper can be downloaded at: [http//aysps.gsu.edu/Publications/2006/index.htm].
- Throsby, D. (2001): *Economics and Culture*, Cambridge, Cambridge University Press. Published in spanish as: *Economía y Cultura*, Madrid, Cambridge University Press.

- Thorosby, D. *La sostenibilidad cultural*, A. Towse, R. (ed) *Manual de Economía de la Cultura*. Fundación Autor-Sgae, 2005.

- Throsby, D. (2006): *Introduction and Overview*, V. Ginsburgh & Throsby eds., *Handbook of the Economics of Arts and Culture*, Admsterdam North-Holland, pp.3-22.

- Throsby, D. (1994): *The Production and Consumption of the Arts: A View of Cultural Economics*, Journal of Economic Lterature vol. XXXII, n.1 pp.1-29.

- UNCTAD (2008): Creative Economy Report: The Challenge of Assesing the Creative Economy towards Informed Policy-Making, New York, Accesed in June 2012: [http://www.unctad.org/en/pages/PublicationArchive.aspx?publicationd=945].

- UNESCO (2005): *Convention on the Protection and Promotion of the Diversity of Cultural Expressions 2005*, Paris.

- World Commission on Environment and Development, WCED (1987): *Our Common Future. Brundtland Report*.

CULTURAL CLUSTERS AND LOCAL ECONOMIC DEVELOPMENT: THE CASE OF THE SIRACUSA AND MERIDA THEATRES

Alicia Llorca Ponce
Laura Fernández-Durán

Department of Business Organization
Universitat Politècnica de València
alllopon@omp.upv.es
lauferdu@omp.upv.es

ABSTRACT

This paper explores the role of culture, and more specifically, clusters and cultural districts in the local development of the region. The study performs a literature review identifying the activities that determine the cultural product of the clusters and districts. It identifies the existence of a variety of typologies of clusters, noting significant differences in the offered cultural products. It also addresses the role of brokers in the cluster and their involvement in governance. Finally, it analyses two specific cases of culture clusters based on historical heritage and in the offer of events - the theatres of Merida (Spain) and Syracuse (Italy)- that exceed the national demand level. In both cases, there is an identification of the agents involved, as well as the offer of cultural products based on the methodology developed by Luciana Lazzaretti that applies the CAEH methodology to identify the actors in the cluster and the various activities that make up its cultural offer.

1.- INTRODUCTION

In recent times, the link between cultural dynamic and economic system has evolved considerably. During the Fordist period, the economic and cultural developments were more frequently opposed than integrated. While cultural development was related to issues such as creation and liberation, economic development meant routine, replication of standardized processes and, in some ways, the slavery of man who was dedicated to the performance of repetitive and routine tasks. From the decade of the 70s and 80s and, also, nowadays, the technical and scientific knowledge is considered to be the key resource for development. In parallel, and in a growing way, the different forms or artistic and cultural expressions are perfectly integrated into the economic development, regarding not also the production of industrial goods (such as fashion, books, design, multimedia etc.) but also services (cinema, tourism, entertainment, and so on), (Kebir and Crevoisier 2008, p.55) and (Boltanski and Chiapello 1999).

This work begins by analysing the role of cultural resources in the generation of new products, and then focusing on the contribution of cultural clusters in local development. It performs a review of the literature regarding the different activities that determine the cluster and its possible existing typologies, as well as relevant aspects that may be useful to advance in the design of successful clustering strategies. Finally, the study uses a model that identifies two cultural clusters related to cultural heritage and more specifically with the ancient theatres in the cities of Merida in Spain and Syracuse in Italy.

2.- CULTURAL RESOURCES AND THE ROLE OF CULTURE IN LOCAL ECONOMIC DEVELOPMENT

In recent times, the local development models based on cultural resources have become a research area based on the contribution of different economic disciplines such as the regional and urban economy, the geographic economy and the cultural economy. Culture not only represents the anthropological image of the material, spiritual and social life of people, it is also a "resource for sustainable economic growth" (Santagata 2004, p.2). According to Cinti (2008, p.70) the key issue to deepen is "how culture can represent a mechanism for setting in motion the economic engine of cities and regions".

Based on Throsby (2000), we understand that the concept of culture is thus used in the sense of cultural capital. Culture is a resource, an accumulated capital that identifies the community. The cultural resources –tangible and intangible– can be used for the production of cultural goods where intellectual activity and human creativity play an important role.

Cultural activities have significant towing capacity and "there is also wide recognition that traditional cultural facilities and activities have a catalytic economic role in the urban economy" (ibid. p.26). The development and concentration of cultural activity attracts other related activities due to the generated demand of indirect goods and services such as, for example, accommodation, transport, retail trade, and restaurants. "…it is widely accepted that there is a cultural industries multiplier of around 2.0." (Myerscought 1988)[1]

It is important to carry out a brief review of the relationship among cultural resources, economic growth and development. The different schools of thought have divergent ways to conceptualize what resources

[1] Quoted in Cooke (2008, p.26)

are. Two main approaches can be underlined: the neoclassical approach and the constructivist approach (Kebir and Crevoisier 2008, p. 48).

According to the neoclassical approach, resources (land, work and capital) exist independently of production, they are limited and perceived as a stock that can be defined and controlled, they are homogeneous, mobile and they can be incorporated into different processes of production. Their incorporation in production will depend on the existent technology and the evolution of the relative prices of the factors. Resources, as well as technology, are considered exogenous to the productive process and they constitute a limit. Given limited resources and a predefined target, the key question from this perspective is how to assign (allocate) existing resources more effectively.

To Kebir and Crevoisier (2008, p.50) the constructivist approach best explains how resources are integrated in the territory and its effect on production and wealth generation. From the vision that resources are constructed and not directly imposed, a resource can be considered as a relationship among an actor, a practice (mediated through work) and a material. Without a practice, material remains purely inert and its properties dormant. Practice, as a reality evolving over time, provides expertise and knowledge accumulation. The role of productive action is very important, taking into account that resources are neither fixed nor finite due to their natural characteristics; in addition, many are products of human ingenuity from the setting of science and technology (De Gregori, 1987 p.1247). According to this approach, resources constituted a process that uses objects and production systems. A cultural resource is an object (e.g. a building or other heritage resource) linked to the production system. Because, "it is the economic and social activity that transforms this living environment into a resource, at a specific moment and for a given period, allocating it one or several specific types or use" (De Mongolfier and Natali (1987, p. 171)[2].

Cultural resources are submitted to a process of creation and destruction. Creating innovation through both production and use, and destruction for various reasons such as the disappearance of those who possess the knowledge, physical or chemical deterioration, or the pressure in the housing market, among others (Kebir and Crevoisier 2008). The objects (cultural in our case) and production systems have effects on each other and co-evolve.

The objects and the production system are associated with other systems. For example, an ancient theatre can be, at the same time, a space for the performing arts, a local community system, a tourism production system and a world cultural system. The diverse relations will affect the cultural object in different ways. On one hand, if the theatre isn't going to be restored and preserved, it could diminish in attractiveness to tourists. Conversely, if the flow of tourists were to increase, the theatre could lose its attraction (due to congestion and predation) (Kebir and Crevoisier 2008, p. 54).

3.- THE NOTION OF CLUSTER AND INDUSTRIAL DISTRICT

The literature on industrial clusters or districts is quite rich and involves different areas of research, such as social science, regional economics, economic geography, economic policy and industrial organization. This has provided a key knowledge and models to explain the reasons for the competitive success of clusters. The study of business clusters associated with a given activity began in sectors engaged in manufacturing or other industrial activities. Although its existence dates from long ago, it should be noted that since the second decade of the twentieth century this system has had a major organization resurgence. The recent Italian experience and other international experiences show that industrial districts have become a good example of endogenous growth (Santagata 2004).

Districts are formed by many small businesses that interact directly and indirectly with each other along the production chain. The most important feature of the district is the interdependence between businesses and the existence of an industrial atmosphere that encourages contacts between the agents (exchanges of inputs in the production process, participation in the production of goods, etc.).

The study of the concentration of firms in a space or territory begins in the late nineteenth century with the contributions of Marshall in his Principles of Economics, book IV, chapter X: The concentration of specialized industries in particular localities. Published in 1890, Marshall studied the concentration in England of small and medium-sized enterprises around others larger sized conforming spaces that he called industrial districts. Such districts emerge in geographical micro-regions that benefit from advantages that result from environmental elements. These advantages (of location) are related to cost reductions resulting from infrastructure, easier access to skilled labour and other inputs, technology dissemination, and use of local resources. Location economies allow cost reductions and increased competitiveness of enterprises that produce goods for the domestic and foreign markets. The set of these benefits is what Marshall called external economies.

In the 1980s and 1990s, the most influential model in the study of clusters of companies was the Italian industrial district model initiated by Becattini (1979), heir of the plans of Marshall. Becattini defines industrial districts as small concentrations of highly specialized companies belonging to traditional consumer industries, in an institutional environment characterized by historical social relations, common values, mutual understanding and cooperation among businesses and among businesses and local government. "The social

[2] Quoted in Kebir and Crevoisier (2008, p.52)

habitat of the industrial districts is made up of large families and of firms where the entire household, including the wife and children, are employed. Tacit knowledge, mutual trust and the accumulation of social capital are pervasive traits of local society and culture" (Santagata 2004).

From the Management approach, the Porter Diamond model (1990, 1998) puts its main emphasis on the importance of competition and productive links with suppliers of inputs and services as contributing to increasing competition. Porter argues that the benefits of agglomeration arise or result from: high levels of innovation as a result of the proximity of companies, improvements or advances in transportation, communications and other public infrastructure, abundant skilled labour in the sector, and reduced search costs for consumers.

While economies of localisation capture the benefits of spatial concentration of firms in the same sector or industry, urbanisation economies refer to the advantages of agglomerations related to: productive diversity, a varied labour market and special services – financial, education, communications, etc.– The urbanization economies are related to external economies similar to Jacobs types (1969).

In the same line, following Cinti we do not consider a clear terminological difference between using the terms cluster and district. The district is a term mainly used in the United States and Italy, while the rest of Europe tends to use the term cluster. "Americans name their cities, since the term "district" is adopted as a way of increasing recognition and identity of some urban areas, while Italians use the term "district" as derived from economic-industrial studies (that is, the concept of industrial district)" (Cinti 2008, p. 71).

4.- CULTURAL CLUSTER ACTIVITIES, SOME EVIDENCE

Frost-Kumpf (1998) define the cultural cluster as an area well distinguished, labelled and multipurpose in a city, in which a high concentration of cultural facilities serves as a teaser for the development of other activities.

Valentino (2001, p.2) defined cultural districts as "a system of relations set in a territorially-bounded area, with integrates the process of valorisation of material and immaterial cultural resources with infrastructure and different productive sector associated to the process itself". Carta (2004, p. 40) defined them as "a local system shaped by a combined system of values of a territory, whose heritage can then build up material for future projects, tangible resources and mechanisms of development for the community".

Frost-Kump (1998) identify a set of activities, including: education (artistic training), production and rehearsal of art performances; retail sale of artworks and handiworks; product and artistic street trading (arty products); exhibitions, fairs and festivals; film samples; readings; happenings of performing arts; public art; performance spaces; museums; galleries; shops; art, music, media and dance studios; collages and schools of art; libraries, and so on.

In the cultural activities of the districts, there are three types of programming aimed at different market segments. First, the "classic programming" includes the traditional fields of art (typical cases are Dallas and Boston). Second, the "popular programming" which focuses on the younger group, such as discos and nightclubs, and thirdly the "teaching program" aimed at the people who produce and offer culture. All three types can be combined, as in Philadelphia and Pittsburgh, (Brooks and Kushner 2001, p.10).

LOCALIZATION	ACTIVITIES	SOURCES
United States		
Indianapolis	City history, theatre and music scene (local and African-American Styles)	Brooks and Kusher (2001)
Newark (New Jersey) and Charlotte (North Carolina)	Performing arts	Strom (2003)
Fort Worth (Texas)	Performing arts, cultural events and shows	Brooks and Kusher (2001)
Netherlands		
Dordrech	Museums, galleries, historic buildings and architecture	Wynne (1992)
Westergasfabriek (Amsterdam)	Performing spaces for theatre companies, parties and festivals, conferences, fashion shows, etc.	Mommas (2004)

LOCALIZATION	ACTIVITIES	SOURCES
United Kingdom		
Cardiff (industrial cultural cluster)	Music production, visual arts, film and video, media and multi-media.	Cooke (2008)
Manchester (industrial cluster)	Handicraft, design, architecture, media and music	Van den Berg et al. (2001)
Bristol (industrial cultural cluster)	Production of natural history, industrial development of animation	Van den Berg et al. (2001)
Germany		
Postdam-Babelsberg (industrial cultural cluster)	Industrial film	Krätke (2002)
Karlsruke (industrial cultural cluster)	Electronic media for videos, industrial design and production software	Dziembowska-Kowalska and Funck (2000)
Monaco		
(Industrial cultural cluster)	Specialised in advertising, audio-visual, telecommunications and information technology	Van den Berg (2001)
Portugal		
Chiado (Lisbon)	Arts, operas, ballets, fashion and libraries	Costa (2002)
Barrio Alto (Lisbon)	Nightlife, restaurants, fado, etc.	

LOCALIZATION	ACTIVITIES	SOURCES
Italy		
Florence	Restoration of heritage, artistic and cultural heritage.	Lazzaretti & Cinti (2001), Lazzaretti (2007)
Langhe	Music	Lazzaretti et al. (2005)
Caltagirone	Wine and Food Production	Bravo (2002)
Vivo Valentia (Calabria)	Pottery	Santagata (2004)
Reggio Calabria	Crafts and Agriculture	Santagata (2004)
Val di Noto (Sicily)	Cultural heritage	Santagata (2004)
Frosinone (Sicily)	Agriculture typical, traditional handicrafts, trade and retail and tourist	Cinti (2008)
San Gregorio Armeno (Naples)	Production and sale of nativity Scene Figures	Cuccia et al. (2008)
Switzerland		
Swiss Jurassic Arc from Geneva to Basel	Watchmaking industry and tourism related to watchmaking	Kebir and Crevoisier (2008)
Spain		
Semana Santa and Feria de Abril (Seville)	Traditional festivities	Lazzaretti (2008)
Ireland		
Dublin Temple Bar	Restaurants, nightlife, galleries, etc.	Cooke (2008)

Source: prepared by author

Table 1. Some examples of cultural clusters and main activities

Overall, we can say that the USA's cultural production emphasizes the arts in general and, in particular, the performing arts. Europe tends to focus on cultural industries, while Italy pays special attention to local heritage and traditional goods production. In most cases, districts include activities related to leisure and entertainment such as restaurants, cafes, bazaars of typical products and other activities related to culture (Cinti 2008, p. 80).

Santagata et al. (2007) defined the following types or stylized models:

Industrial districts producing goods and services based on the material culture

- Networks or clusters of archaeological sites
- Tourist cultural districts
- Museum districts
- Districts of the performing arts and festivals
- Clusters of creative industries (film, TV, publishing)

Their study of a cluster of archaeological sites such as the North Saqqara Necropolis shows that "good internal management means to define the optimal size of the site (number of temples, tombs, and artefacts shown) compatible with the trade-off between maximizing the number of visitors and means to organize the site in order to offer business opportunities to the local population. Exploiting the presence of a great number of visitors and supplying them facilities and traditional handicrafts can be a way to the local development as well", (Santagata et al. 2007). In contrast with the preceding example, the touristic cultural district is based on the offer of a collection of activities: accommodation, travel and local tourist services, intangible and tangible heritage. The election of a place is a decision based on the valuation of the collection of the offered services and other variables such as the international reputation of the place, the costs of the trip, or the quality of the hotels among other aspects. An example of this type of cluster is the case of Fayoum Oasis, (ibid. p.14).

5.- CULTURAL CLUSTER, CULTURAL POLICY AND LOCAL DEVELOPMENT

Much of the rediscovery of the importance of cultural industries to the urban economy was due to shocks that many advanced economies suffered from the seventies. In the Fordist period, many of the cities that grew with industrialization declined gradually due to the changes in system. Citizens, organizations and institutions sought a reorientation of the economy based on the resources inherited from the past. The empty buildings were rehabilitated and renovated spaces reused in new wealth-generating activities, Cooke (2008, p. 27). The cities of Glasgow, Manchester, Rotterdam, Amsterdam or Bristol are some examples.

The Region of Abruzzo (a cultural institution district) "established that the goal of the district is on the one hand, to make the production of culture more effective and well organized, and on the other hand, have the greatest social and economic impact at the local level" (Cinti 2008, p.82). The author states that, in the case of Italy, the aim is to improve its historical and artistic heritage. The cultural district plays the role of organizing the way they intertwine and connect the preservation and enhancement of resources; this is the case of the cultural cluster of museums described by Santagata (2002).

Strom (2003) shows some examples of the strategies developed for the creation and development of three cultural districts in USA. In all cases the cultural policies are framed or related to urban regeneration policies, strategies and actions directed to the creation of cultural facility serving as the area's cultural engine. Some examples are Philadelphia, in South Broad Street in the Arts and downtown Charlotte. In all cases the funding is public and private, although, in some of them, donations are an important part of the financing.

Mommaas (2004) investigates the German clusters and finds that some (for example the museum district of Rotterdam and Utrecht) have no central administration. In contrast, Amsterdam has a centralized management negotiating rent and location of buildings. It organizes social campaigns and promotes mixed financial support mechanisms. In Tilburg mixed solutions are seen in which local government shares responsibility with other groups and actors of the cluster. In Germany, most of them have received funding from public sources, while, in a few cases, the private sector is involved in the way companies or private investors combine their contributions.

At this point it is interesting to ask what aspects influence the success of strategies based on "cultural clustering". Although from different points of view or approaches, diverse studies agree that the key elements determining the development and growth of clusters are cultural aspects related to the capability of interacting agents, networks, trust and the existence of a shared strategy. Among the specific conditions of the cluster, the aspects considered relevant are: the critical mass of actors and cultural services necessary for a cluster to work well and generate economic benefits; the quality of the actors who currently run the machine; and the level of interaction between the actors and the ability to build mutual trust which, among other things, allows production sharing and technology transfer (Van den Berg et al. 2001). Along with these, the success or extent of objectives depends on the existence of a shared vision and strategy, public-private networks, along with some degree of political and social support and an appropriate level of leadership (Cooke 2008, p.28).

In the case of the USA, diversified growth strategies and fundraising are elements or factors of success in the districts. Certain districts are identified as successful and observe some common characteristics

such as: a mixture of public and private management; diversified funding sources; defined goals (unambiguous); the existence of a management leader and the real intervention at all levels of the public government, the private sector and volunteer services (Brooks and Kushner 2001).

6. CLUSTER BASED CULTURAL HERITAGE: MERIDA THEATRES AND SYRACUSE

Cultural goods and, in particular, the historical heritage possess certain characteristics: they have the status of being public or semi-public; they are associated with an interest in their maintenance by citizens, since they presuppose a hallmark of the peoples and their history; they are unique, not replaceable; and they generate a series of revenue from the uses of their different services and values demanded. All these qualities create the breeding ground where cultural clusters form that favour the economic development of the region (Bedate, Sanz and Smith, 2001).

Ballart and Juan-Tresserras (2001) and Garcia Canclini (1999) speak of heritage as a distinctive and easy differentiator to transform into a focus of attraction and a meeting place where, according to them, the key point is to find the formula of balance between conservation and use.

Lazzaretti (2008) studies the clusters intensive in cultural resources, and the governance of high culture through a structured model of the cultural district. This model is focused towards sustainable economic development and is based on the trinomial culture-economy-society, and on the resources-actors-community axis. It tends to enhance the artistic differences, cultural, social and environmental impacts of the different towns and assumes that culture is a resource for economic growth of cities and regions. The perspective used responds to a duplication and implementation of Becattini and Marshall's own industrial district approach.

Based on this model, we have studied two clusters based on heritage, and more specifically in the ancient theatres of two European cities: Merida and Syracuse, which meet the conditions of being High Local culture places (HCLP) to which they can apply CAEH methodology (Cultural, Artistic and Environmental Heritage) developed by Cooke and Lazzaretti (2008).

Cultural Cluster of the Theatre of Mérida

This theatre is located in the Archaeological Ensemble of Mérida, which is one of the largest and most extensive archaeological sites in Spain. It was declared a World Heritage Site by UNESCO in 1993. It has been considered, since 2007, one of the 12 Treasures of Spain, being the most visited monument in the city.

In 1933, the first edition of the Festival of Classical Theatre was held. This festival had various interruptions, but from 1954 to date it has been held uninterruptedly welcoming in their representations of scenarios the greatest works of classical Greco-Roman theatre. It has capacity for 6,000 spectators.

This international festival is the engine of economic and cultural development of the city. As a public good, institutions and governments are responsible for its conservation. However, the festival is funded by a sponsor consortium composed of eight institutions, three sponsors and eight partners. The agents involved, among others, are the Government of Extremadura, the Municipality of Mérida, the Ministry of Education, Culture and Sports, the provincial Excellencies of Cáceres and Badajoz, the Savings Bank of Badajoz and the Savings Bank of Extremadura. The objectives of the institution of economic, technical and administrative cooperation among entities involved for the management, organization and delivery of cultural services are the promotion of the Classical Theatre Festival at the Teatro Romano de Mérida. The Festival features the following economic financial resources:

- The allocations come from the associated entities.
- Grants awarded.
- Voluntary or individual contributions or donations.
- The revenue from its services (ticket sales).

The private company "Pentación" leads and manages the Festival but also other uses of theatre as awards, conferences and mounting workshops.

The disclosure of the activities of the Theatre is run by the company "Publiescena" who is in charge of advertising and disclosing all its activities in the media. To publicize the activities and the theatre program, the Festival has a dedicated website and this information is also incorporated into the official website of tourism, the city hall and the community of Extremadura.

The theatre is integrated into the local culture and is part of the street passes "Festivitas" that were created to fill the streets of Merida with festivity, as happened centuries ago in Rome itself. Following the Roman calendar, it is a journey through all the months of the year, highlighting the festivities and rituals of every month, so not only artistic or touristic consumption is achieved but also cultural integration in the region.

Gradually they have been covering more market segments and what began with the use of the theatre for the performing arts and for the public lover of this classic theatre, has led to the search for other audiences and other uses. So, children's activities are done such as training workshops of the "Augustus" aimed at children.

Moreover, the theatre is integrated at the Touristic Heritage promotion. The International Festival of Classic Theatre of Mérida offers to the spectator of the performances tools to facilitate and complement a visit to the city.

As a consequence of the activities generated at the Theatre, other ones such as handcraft, commercial and touristic activities have been added –small souvenirs businesses, topographies, printers, bars, restaurants, hotels, hostels, etc. Therefore, there is a cultural cluster based around the theatre. We have represented this cluster based on the CAEH methodology used by Cooke and Lazzaretti (2008).

Cultural Cluster of the Theater of Merida

Institutional actors

- City Council of Merida
- Provincial Government of Extremadura and Ministry of Education Culture and dependence.

- Limpieza Bomberos Seguridad local Medios de Transportes locales
- Policía Nacional Protección Civil

Economic actors

- Subcluster of Tourism
- Subcluster of multimedia and services
- Artistic subcluster

- Bars
- Restaurants
- Hotels
- Travel agencies
- Transportation

- Local press
- Local TV and Radio
- Record Labels
- Printers
- Photographers
- Specific Shops

- Florists
- Printing
- Orchestra
- Decoration
- Lighting
- Sound

Non economic actors

- Primary
- Secundary

- Actors
- Local public, national and international

- Universities, Schools
- Performing Arts vocational Schools

Source: Own elaboration base on Lazzaretti (2008)

We are looking at a cluster very similar to Mérida's Cluster, based on the use of drama that generates agglomeration of firms and economic development of the city. The Theatre has been publicly owned and managed by the "Istituto Nazionale del Dramma Antico, Fondazioni" ONLUS since 1998, by legislative decree.

The tasks of the Foundation are:

- The production and representation of dramatic texts in the Greek theatre of Syracuse, in the cinemas and other special cultural environments.
- The promotion and coordination of efforts in Greco-Roman theatres.
- A series of initiatives to promote classical culture through the use and enjoyment of the cultural heritage and the Foundation.

Both the Foundation and the various events have public and private sponsors. The architectural adaptation of the stage and the artistic decoration are provided by two private companies, OMA and AMO, based in Rotterdam. OMA is a leading international partnership practicing architecture, urbanism, and cultural analysis.

AMO operates in areas beyond the traditional boundaries of architecture, including the media, politics, sociology, renewable energy, technology, fashion, curating, publishing and graphic design. These two companies adapt the Theatre of Syracuse according to the type of event to be performed in it.

Thanks to its large capacity, the Theatre of Syracuse can host art events and international musical performers, including concerts by Sting, etc.

For the dissemination and communication of the events of the theatre, the Foundation has a web page and also with the official tourism website of Sicily. It also publishes two magazines Dionisio and Prometheus, the latter being an on-line magazine.

Another feature that has allowed the formation of the cultural cluster based on the Theatre is the immersion in cultural policies establishing a cultural program of the city and its surroundings and participating in the cultural politics of the region.

As tourist use, the theatre is integrated into the cultural offering of the city including its visit as heritage attraction and making joint bids with other sectors such as catering or transport.

Around the theatre have been appearing, and are still being born, small shops related to giftware, craft and tourism: hotels, restaurants, bars, etc. These have made this cultural cluster based on the Greco-Roman theatre of Syracuse. This cluster can be seen graphically in the chart below, conducted based on the methodology of Lazzaretti CAEH (2008).

Cultural Cluster of the Theater of Syracuse			
Institutional actors	City Council of Syracuse	Cleaning, Fire, Local security, Local Transport Media	
	Ministero per I Beni e le Attività Cultural Direzione Generale per lo Spettacolo dal Vivo; Regione Siciliana Assessorato del Turismo; Istituto Nazionale del dramma antico	Sightseeing tours, shows, theater festivals	
Economic actors	Sub-cluster of tourism	Bar, Restaurants, Hotels; Travel agencias; Transportation	
	Sub-cluster of multimedia and services	Newspapers, Radio and local television, Labels, Photographers, Printers, Specific trades	
	Artistic sub-cluster	Florists, Printing, Atrezzo, Orhuestra, Decoration, Lighting, Sound	
Non economic actors	Primary	Actors; Local public, national and international	
	Secundary	ASAM Universities, Schools, Performing arts vocational shools	

Source: Own elaboration base on Lazzaretti (2008)

CONCLUSIONS

The implementation of successful strategies will require a major effort in less developed areas that, in many cases, requires the involvement and support of policies that go beyond the local and regional level.

It seems that financing or obtaining resources is a key element. In many cases, cultural activities require the new creation or regeneration of cultural facilities. This leads to the involvement of the public sector to a greater extent in developing environments that should also develop infrastructure related to accessibility and receiving visitors.

The CAEH methodology has been useful to identify and differentiate the activities and actors involved in the cultural cluster. It shows the relationships of the different agents in the chain of production of culture and identifies the governance considered as a key element in the development of the cluster. We believe that this methodology is useful in the design of strategies to develop the potential of existing clusters as well as the "ex novo" development.

The analysis of Mérida and Syracuse supports the constructivist theory of resources and endogenous growth. In the case of Mérida, it can be observed that cultural activity is sustained over time around the theatre, which has led to new insights into the field of possibilities in theatre involvement in cultural activity. The use of learning economies has led to an improvement in the quality of accessing more cultural product market segments, including international.

Merida's strategy is based on the theatre festival, which has been the driving engine of the generation of the local development of the cultural cluster.

There are differences regarding the role of the equipment in the cultural product. Mérida continues its strategy with a product of high cultural level, its international festival of classical theatre. In Syracuse, the theatre itself, along with the scenic product, constituted a specific product. The renovation of the stage encourages public attendance beyond the specific content of the show, stimulating a more continuous and intensive use by the population of the region.

Considering the classification of Brooks and Kushner (2001), the cluster of Merida would focus on classical programming expanding towards educational programming. Syracuse is more focused on popular programming, but also has a teaching schedule. We think that this behaviour is conditioned by differences in the capacity or higher capacity of the theatre.

REFERENCES

Ballart, J. & Juan-Tresserras J. (2001): Gestión del patrimonio histórico. Barcelona: Ariel.

Becattini, G. (1979): Del settore industriale al distretto industriale, Rivista di Economia e Politica Industriale, nº 1, pp. 1-8.

Bedate, A and Herrero, L.C (2001): Turismo cultural y patrimonio histórico: aplicación multivariante al estudio de la demanda. Estudios turísticos nº 150, pp. 113-132.

Boltansky, L. & Chiapello, E. (1999): Le nouvel esprit du capitalisme, ed. Gallimard.

Bravo, G. (2002): Individualismo-Cooperazione-Free Riding. Ascesa e maturazione di un distrettoculturale, WorkingPaper nº 2. Dipartimento di Economia "S. Cognetti de Martinis", Università di Torino.

Brooks, A.C. & Kushner, R.J. (2001): Cultural districts and urban development, International Journal of Arts Management, vol.3, nº 2, pp. 4-15.

Carta, M. (2004): Structture territoriali e strategie culturali per lo sviluppo locale. Economia Della Cultura, vol. 14, nº 1, pp. 39-56.

Cinti, T. (2008): Cultural cluster and districts: the state of the art. In P. Cooke & L. Lazzaretti. (eds), Creative Cities, Cultural Clusters and Local Economic Development. Northampton, MA, USA, Edward Elgar, pp. 70-92.

Cooke, P. (2008): Culture, clusters, districts and quarters: some reflections on the scale question. In P. Cooke & L. Lazzaretti. (eds), Creative Cities, Cultural Clusters and Local Economic Developement, Northampton, MA, USA, Edward Elgar, pp. 25-47.

Costa, P. (2002): Milieu effects and sustaianable development in a cultural-quarter. Barrio Alto-Chiado area in Lisbon, paper presented at GREMI 6, Ressources patrimoniales et milieux innovateurs, Séminaire de recherche du GREMI, Université de Neuchâtel, Switzerland.

Cuccia, T.; Marrelli, M. & Santagata, W. (2008): Collective trademarks and cultural districts: the case of San Gregorio Armena. In P. Cooke & L. Lazzaretti. (eds), Creative Cities, Cultural Clusters and Local Economic Development, Northampton, MA, USA, Edward Elgar, pp. 121-136.

De Gregori, T. (1987): Resources are not; they become: an institutional theory. Journal of Economic Issues, vol. 21, nº. 3, pp. 1241-63.

De Mongolfier, J. & Natali, J.M. (1987): Le patrimonie du futur, Paris, Economica

Dziembowska-Kowalska and Funck, R.H. (2000): Cultural activities as a location factor in European competittion between regions: Concepts and some evidence, The Annals of Regional Science, vol. 34, pp.1-12.

Frost-Kumpf, H.A. (1998): Cultural district Handbook:The Arts as a Strategy for Revitalizing our Cities., Annapolis Junction, MD, American for the Arts.

García Canclini, N. (1999): "Los usos sociales del Patrimonio Cultural", en Aguilar Criado, E. (Coord.) Patrimonio Etnológico. Nuevas perspectiva de estudio. Granada: Consejería de Cultura. Junta de Andalucía. pp. 16-33.

García Canclini, N. (2000): "Opciones de políticas culturales en el marco de la globalización", en Seminario Nuevos retos y estrategias de las políticas culturales frente a la globalización. Institut d´Estudis Catalans. Barcelona, 22-25 noviembre 2000. Universitat de Barcelona.

Jacobs, J. (1969): The economy of cities. Random House.

Krätke, S (2002): Network Analysis of Production Clusters: The Postdam-Babelsberg film industry as an example, European Planning Studies, vol.10, nº.1, pp. 27-54

Kebir, L. & Crevoisier, O. (2008): Cultural resources and regional development: the case of cultural legacy of watchmaking. In P. Cooke & L. Lazzaretti. (eds), Creative Cities, Cultural Clusters and Local Economic Developement, Northampton, MA, USA, Edward Elgar, pp. 48-69.

Lazzaretti, L & Cinti, T. (2001): La valorizzazione economica del patrimonio artistico delle città d'arte: il restauro artistico di Firenze, Firenze University Press, 2001.

Lazzaretti L. (2007): , Creative firms in creative regions: the case of Florence in P. Cooke and D. Schwarz (eds), Creative Regions; Technology, Culture and Knowledge Entrepreneurship, Cheltenham, Uk and Northampton MA, USA, Edward Elgar.

Lazzaretti, L. (2008): The cultural districturalization model. In P. Cooke & L. Lazzaretti. (eds), Creative Cities, Cultural Clusters and Local Economic Developement. Northampton, MA, USA, Edward Elgar, pp. 93-120.

Lazzaretti, L. (2008): El distrito industrial. Colección Mediterráneo económico nº 13, pp. 327-351.

Marshall, A. (1890): Principles of economics. London, Macmillan.

Mommaas, H. (2004): Cultural cluster and the post-industrial city: towards the remapping of cultural urban policy. Urban Studies vol. 41 nº 3, pp.507-532.

Myerscought, J. (1988): The Economic Importance of the Arts in Britain, London; Policy Study Institute.

Norgaard, R.B. (1994): Development Betrayed, New York, Routledge.

Porter, M. E. (1990, 1998) The Competitive Advantage of Nations. Free Press, New York.

Santagata, W. (2002): Cultural districts, property rights and sustainable economic growth. International Journal for Urban and Regional Research vol.26, nº1, pp. 9-23.

Santagata, W. (2004): Cultural districts and economic development. Working Paper nº1/2004. International Centre for Research on the Economics of Culture, Institutions, and Creativity, EBLA.Università di Torino.

Santagata, W.; Baig, S. and Bertacchini, E. (2007): Cultural Systems and Local Sustainable Development Fayoum Oasis and North Saqqara Necropolis Egypt. International Centre for Research on the Economics of Culture, Institutions, and Creativity, EBLA. Università di Torino.

Scott, A. J. (2004): Cultural-products industries and urban economic development. Prospects for Growth and Market Contestation in Global Context, Urban Affairs Review, Vol.39, Nº 4, pp. 461-490.

Strom, E. (2003): Cultural policy as development policy: evidence from the United States , International Journal of Cultural Policy, vol. 9, nº. 3, pp. 247-263.

Throsby, D. 2000: Economics and Culture, Cambridge University Press, Cambridge.

Valentino, P.A. (2001): I distretticulturali. Nouveoportunita di sviluppo del territorio, Rome, Associazione Civita.

Van den Berg, L.E. (2001); Braun and W. Van Winden (2001): Growth clusters in European Metropolitan Cities, Aldershot: Ashgate.

Wynne, D. (1992): The Culture Industry. The Arts in Urban Regeneration, Aldershot, Abevury.

REFERENCES WEB
http://oma.eu/
www.eventiturismo365.it/en/
www.festivaldemerida.es
www.indafondazione.org
www.lasicilia.es/siracusa
www.pentacion.com
www.publiescena.es

4.5. LEGAL FRAME

4.5.1. LEGAL OWNERSHIP: COPYRIGHT AND EASEMENTS

For the development of a conservation and uses plan for each one of the theatres involved in this project, at the legal level, one must take into account the regulation of rights *in rem* affecting each theatre, mainly property rights and possible easements that were levied against or benefited the same. To do so, one must go back to Roman law regulation where the theatre is seen as a "thing" (*res-rei*) likely to be the subject of legal relations. Firstly, we consider the theatre as inheritable asset, i.e. an element that belongs to the inheritance of someone and both are subject to the right of ownership.

The property term comes from the Latin word *propietas*, derived in turn from *propierum* i.e. "what belongs to a person or is his own". The property for the Romans showed the faculty that corresponds to a person, the owner of something obtained directly from one particular thing all the legal utility that this thing is capable of providing. In particular, the *propietas* was defined as a real right that conferred on its owner the power to use -*ius utendi*-, enjoy -*ius fruendi*- and have -*ius abutendi*- things with certain restrictions imposed by law. In any case, it's a real right defensible by vindicatory action.

Such restrictions or limitations to the full exercise of the right of ownership, right *in rem par excellence*, among others, are understood by the Roman law easements and *iura in re* today as an alien thing right -aligned-. Servitude or *servitus* is a charge, lien, easement or benefit imposed on one property for the benefit of another belonging to a different owner, which implies a limitation or restriction on the power of all of the property. As a sign of this regulation of the easements, one can cite in the rustic *sevidumbres* a step lien -*iura itinerum*-; a water easement -*iura aquarum*-; an urban easement of slope -*iura stillicidiorum*-; an easement for walls -*iura parietum*-; and an easement for light and views -*iura luminum*.

However, today, from the Supreme Law of each state, you must also take into account the consideration of public goods, the regulation of the heritage of the State, its administration as well as guarantees of defence and conservation. More specifically, in relation to the Goods of Cultural Interest, it is crucial to consider the regulations and criteria established for the purposes of conservation and intervention laid down for such immovable property and for the protection of the surrounding areas delimited by regulations for the purposes of their own Cultural Heritage.

The first thing is to start with a consideration of the different buildings and their legitimate ownership, i.e. agreeing about whom the goods belong to and whether they may be publicly or privately owned. The management, administration and operation of the property and rights of the patrimony of the State, which correspond to all those properties owned by public bodies according to their rules of organization and functioning or creation or their statutes, subject in any case to the laws providing for such assets.

More accurately, by reason of the legal regime to which they are subject, the property and rights that make up the heritage of public administration may be public domain and domain property, corresponding to goods and public property and public domain of public ownership rights affected with characteristics of general use or for public or private service, as well as those laid down expressly by the Act with that character. In relation to such property or ownership of them, we can find charges or conditions that limit the right of the property. We then go on to the subject of civil or administrative servitudes.

Among the Spanish best practice can be mentioned the "*Patronato de la Alhambra y el Generalife*" and the "*Real Patronato de la Ciudad de Toledo*" where in both cases it was decided to form special institutions aimed at the management of these two important sites. In the first case it was the "*Consejería de la Cultura*" of the Junta de Andalucia which is the Regional Ministry of Culture that promoted the creation of an autonomous institution aimed at the correct management and coordination of the various aspects concerning conservation, use, cultural and economic development. The document with which the "*Patronato de la Alhambra y el Generalife*" was created can be used as template for the development of other autonomous institutions provided with juristic personality, own capital, and administrative and financial autonomy. All these legal features are aimed at pursuing a series of aims described in the document such as, for instance:

"Prepares and develops conservation plans, consolidation, maintenance, restoration, excavation and research on the heritage within the monumental area, checks that such plans comply with the updated criteria for conservation and restoration of monuments, according to the criteria listed in international charts and, at the same time, conserves the environment and landscape of the zone."

Alhambra and Generalife (AG) Patronage

Direction:

-The general conditions of sale of publications, or any other class of objects in the exhibition facilities

-Provide for expenses and authorizes payments

-Proposes to adopt the necessary measures to ensure protection of the monumental area and approves proposals (charts, recommendations) for conservation and restoration works.

-Authorizes the urgent extraordinary measures for preservation of monumental ensemble, giving immediate notice to the Committee.

-Promotes cooperation agreements with other similar centers and institutions, and organization of educational, cultural and scientific.

-Execute the agreements of the Commission and Council of the Alhambra and Generalife.

-Assume any other duties not expressly assigned to other organs of the Council .

Reference regulations, laws

Alhambra and Generalife (AG) Patronage

- Institutional promoter
- Juridical definition of the patronage

Definition of functions and aims:
- Management and Conservation of AG
- Guarantee the protection of real property and chattels
- Development of conservation plans, restoration, research
- Guarantee of safety of the visit for the public
- Promotion of study and scientific collaboration with other institutions
- Training of specialized handicraft for the conservation of AG

Direction:
- Management in accord to the recommendations of the permanent commission and council
- Development of annual action plans
- The preliminary draft budget of the AG Patronage
- The general conditions of sale of publications, or any other class of objects in the exhibition facilities

Land registry (ownership of land and property)

Based on the land and property in question, it can be inventoried and registered in the General Inventory of Assets and Rights of the State, giving the property a reference code and also indicating the status of equity or private domain and the use for which the property is intended, and thus the user domain information are: the property register of the place where the property is located that provides information concerning the property's surface, boundaries and specific observations mainly relating to any charges and conditions registered against the property.

Descriptive and graphic information (cadastral information) is provided by the land registry or administrative office of the Ministry of Finance, as well as planimetric information that provides an up-to-date valuation of the property. In any case, if there is any inconsistency, log onto the land registry for the purposes of obtaining title that will always prevail without prejudice to current checks.

4.5.2 URBAN FRAMEWORK

The purpose of this paragraph is that participants in the project come to determine the existing and applicable legal framework in the urban area by reference to the planning instruments in order, where appropriate, to recover the primordial traces of theatres, improve the urban development of their environment and improve the visual beauty of the monument.

Therefore, the essential objective of urban and rural planning should be the protection of the architectural and archaeological heritage that makes up each theatre that is involved in the project. It must ensure protection and integrated conservation, understood as both the conservation and protection of the theatre itself as well as that of its atmosphere and environment. Therefore generic guidelines are necessary for the adequate protection of the participating theatres in terms of their historical, archaeological, architectural and urbanistic interest and are, consequently, set out in this document with the required coordination between the different administrations involved in the management of the territory.

BASIC GUIDELINES, from the urban point of view to be developed subsequently according to the particular conditions of each theatre:

1. Determination of the instrument of planning containing the control. It refers to both supra-municipal territorial action planning instruments, general municipal management planning and the possible special development planning instruments aimed at the protection, preservation and conservation of the theatre.

2. Location of the theatre. Usually legislation is applied differently depending on the location of the theatre, if it is located within the town or, on the other hand, is located in isolation out of the urban fabric of the population within the municipality.

3. Delimitation of zones and soil classification:

 3.1. Inserts theatres within the nucleus of population (urban): would normally be included within the archaeological zone by setting a few ordinances of the monument as the environment aimed at comprehensive protection for its great archaeological value.

 3.2. Theatres in rural area - archaeological zone (land not of special protection for its high historical and archaeological value): the plan specifies and defines the zone or the scope of protection by establishing a rule that regulates the conservation and protection of same, as well as the regulation of activities carried out in this area which, in any case, shall be compatible with the protected values and the maintenance and sustainability of the rural environment.

 3.3. Catalogue the archaeological monument. The corresponding instrument of planning may include the theatre as a unitary element (property, indoor or outdoor spaces or other significant structures) in a catalogue of goods and protected areas for the purpose of formalizing policies of conservation, rehabilitation or protection of same, and establishing its level of protection. It is advisable to obtain a comprehensive protection of the monument, which implies its full conservation for its singular or monumental character and historical or artistic reasons while preserving all of its architectural features.

 3.4. Demarcation and regulation of the environment. Inserts theatres within the urban area, probably available in a regulation applicable to the urban environment of the theatre which should take into account the following aspects:

 - Ordinance of specific building which ensures that new plant construction and the reform, rehabilitation and expansion of the existingbe in harmony with the cultural environment. At a minimum, the content of the ordinance should regulate the maximum height permitted, volumes, colours and the architectural composition of the harmonizing in any case with the protected right.

 - Protocol in the case of the appearance of archaeological remains.

 - Obligation of prior report of the competent administration of the service of heritage for the carrying out of actions involving new works plant, earth removals or excavations.

 - Order and preserve the historic structure of the division as well as the maintenance of the alignments and grades.

 - Identification of the discordant elements with good values, establishing appropriate corrective measures. In this sense, they should determine those constructions that are considered out of management by manifest incompatibility with the surroundings and regulate their transitional system.

 - Establishment of the regime of uses allowed, compatible and incompatible, advocating for the maintenance of the traditional uses and for the defence of economic activities involving revitalization that benefits the protected asset in any case.

 - Control of perceptive or visual pollution that may, for example, shine certain lights on the facades, certain elements and facilities in the field of energy and telecommunications, labels, signs and urban furniture, outdoor advertising etc.

Finally, for theatres located in rural areas, there may be a zone of protection perimeter or barrier of damping that contains specific and restrictive regulation, being understood as a transitional space between the theatre and the surroundings that attempts to minimize the impact of human activities that are carried out in the immediate theatre territories.

4.5.3. CULTURAL PROTECTION FRAMEWORK

Cultural Heritage

From the point of view of the cultural heritage, the study of the law of historic heritage as a standard sector on the subject which concerns us, allows us to determine the assets that make up the concept of broad and generic cultural heritage, grouped in accordance with the highest rules, from two aspects, from the time of the establishment of the area protected by that provision. To do this, a review must be done, as detailed as possible, of any values or scope of interest currently requiring application, as well as the classification of the assets under its protection; and, on the other hand, the authentic meaning of the concept of Cultural Heritage should be fixed in accordance with various established procedures of declaration.

Sectoral state law should also be taken into account and, where appropriate, of the various towns, where the categories of assets that can be declared Properties of Cultural Interest (PCIs) are located. In the same way, you must pay attention to the criteria of intervention in the PCIs, because it will determine the scope of protection, conservation and enhancement of these assets. Thus, in the line that is drawn, we will highlight the legislation containing the definition of the scope of PCI; ultimately, the criteria of delimitation of the PCI environment has been based on the existence of special links and of visual perception between the goods of Cultural Interest and the buildings and urban spaces that are in their surroundings.

4.5.4 ADDITIONAL RULES
(LEGAL FRAMEWORK FOR ACTIVITIES)

Public Shows

The governing rules are given under the aforementioned state law, and, where appropriate, the specific legislation of the town, by virtue of its authority concerning public performances, recreational activities and public institutions, which provide the observance of a system of administrative authorization of realization of this type of activity. The general procedure for opening of public establishments and starting-up operations of these types includes presentation of documentation and timelines; special procedures by reason of capacity or special conditions of risk (shows or extraordinary, unique or exceptional activities); requirements for not opening activity and operating licenses; regime of complementary activities, licensing for casual, portable or removable installations. There is a need for civil liability insurance. Finally, there are regulations relating to the reserve and right of admission, protection of minors, schedule of establishments, shows and activities, advertising, and regime of entries and their sale.

Rules on Safety and Health

There are general technical conditions which must be taken into account in the field of safety and health in relation to public shows, on the basis that public shows, recreational activities and public establishments must meet the conditions of safety, health and hygiene to avoid inconvenience to the audience and to third parties and, in particular, comply with those regulations applicable to activities that are annoying, unhealthy, harmful or dangerous.

This means:

· Safety for the public, workers, performers and assets.

· Terms of robustness of structures and installations.

· Conditions and warranties of electrical installations such as public premises.

· Prevention and fire protection and other risks inherent to the activity, facilitating the accessibility of means of external aid.

· Conditions of health, hygiene and acoustics, expressly determining conditions of soundproofing of the premises necessary to avoid discomfort to others.

· Protection of the natural and urban environment.

· Conditions of accessibility and enjoyment for people with disabilities, in accordance with the regulations on accessibility and removal of architectural barriers, and that enable the real enjoyment of the show by those. In this regard, specific adaptations in the premises and facilities must be carried out within the time limit established.

· Emergency plan according to the rules of self-protection in force

Accessibility / architectural barriers

Prior consideration of any physical barrier as any impediment, lock or obstacle that does not allow the free use and enjoyment in safe conditions of spaces, facilities, buildings, services and systems of communication, as well as accessibility as the basic nature of the environment, whether of the planning, building, transport or communication systems that allow people to access and use the spaces, facilities, buildings and services regardless of their physical or sensory conditions.

Efforts will be made to the contemplation of the guarantees of accessibility to the physical environment in conditions conducive to equality of all persons, whatever their limitations and the permanent or transitory character of these by State law or the locality that contains:

a. Regulation of requirements that permit the use of facilities, goods and services to all persons and, in particular, to those who are affected by a situation of reduced mobility or sensory limitation permanent or transient.

b. Promoting the elimination of existing barriers, through incentives and support for rehabilitation activities, and planning.

c. The establishment of appropriate means of control, management and monitoring that ensure the application of the legislation concerned.

d. Promotion of the values of integration and equality through a system of incentives and explicit recognition of the quality of actions in the field of accessibility, as well as the promotion of research and the implementation of economic and technical aid to facilitate the use of goods and services by people with physical and sensory limitations.

In all actions related to the planning, design, management and execution of actions in the field of buildings, urbanism, transport and communications, one should aim to revise the rules which regulate actions to the new installation, construction or use both of the rehabilitation or reform of existing structures in the targeted areas, either promoted or carried out by physical or legal persons, public or private in nature.

More specifically where actions in buildings and facilities are concerned, there should be legal regulation related to:

1. Existing buildings: the actions on these buildings that should be encouraged is to obtain a level of practical accessibility, adapted if necessary for the different types of buildings and with the order of priority to be established.

2. The urban environment: public roads, parks and other existing public spaces, as well as the respective services and urban furniture, which will be gradually adapted to the facilities.

4.6. EQUIPMENTS AND REQUIREMENTS

In the cultural cluster, and in particular for the theatre, it is important to provide facilities and supplies related to the following list of activities:

- TOURISM
- STAGING ACTIVITIES
- EDUCATIONAL ACTIVITIES
- FORMAL AND CEREMONIAL ACTIVITIES
- CULTURAL ACTIVITIES AND LOCAL TRADICIONS

In the following paragraphs we explain the needs of an archaeological site concerning the carrying out of ATHENA project activities: suggestions and recommendations inspired for best practices, etc.

In this document there is an explanation and a description of the kind of equipment, resources and services that makes the functioning of the theatre possible as a place for a visit and, at the same time, as a contemporary place for performances.

The following paragraphs refer to favourable situations, "Best Practices" that should be taken into consideration for managing the site. Then, a selection of concrete examples is furnished with photos and drawings concerning interventions inside archaeological sites in relation with the former list of activities. Suggestions and advice came from international reference literature.

4.6.1. EQUIPMENT

For the use of an ancient theatre, lots of technological equipment is needed that has to fit with the ancient masonry walls and with the aesthetic of an archaeological site with the aim of providing a high level of safety standards for tourists, workers and all the people that have something to do with the archaeological site. A second aspect that involves the necessity of special signals or other technological tools in the area has to do with the knowledge of a site through an easy learning system.

Lighting

The role of lighting is crucial from many points of view, in particular during the play:

- "The staging of live performances and hi-tech pageantry shows on the place's history will profit from the use of new technologies for lighting, images and sound with a view to improving the very quality of the performance through an enhancement of the site" (from Verona Charter).

1. Visit to the site:

 Lighting is needed for a safe path system during the night performances and visits, but also for the illumination of all the parts of the archaeological site where natural lighting cannot enter: criptoporticos, ambulacra, cryptas, etc.

 When artificial/natural light sources illuminate works of art, drawings, etc., exposure should be kept to the minimum level with the aim of providing adequate visibility and not causing damage. In general, the illumination level should comply with national regulation and standards.

2. Theatrical performance:

 From the point of view of the archaeological site as a place for performances, the theatre, and in particular its orchestra and stage, should be respected also from lighting design during the events:

 - "Structures should be erected only when it is necessary for the performance itself. The scenery equipment should be temporary and together with the other facilities and services should be in place only for the length of the event. It is recommendable the use of light modular easily-removable

LIGHTING

Theatrical performance

Excessively bulky sets can be avoided.

Provisional structures for staging activities. Removable structures are more advisable than permanent ones. Villa Adriana (Tivoli Italy).

In any case it is advisable to avoid bulky sets as in this case: the ancient ruins have been completely covered.

structures, the materials of which need to be compatible with the ruins of the theatre" (from Syracuse Charter).

- "The use of the lights and the sound will contribute to the comprehension and enhancement of the spatial and cultural properties of the area and will give a critical interpretation of the building even with virtual reconstruction of the non-preserved structures" (from Syracuse Charter).

Lighting design has to comply with a wide regulatory framework regarding site preservation, protection and investigation (intrinsic actions); at the same time lighting devices have to attempt to satisfy all users' requirements (artists, visitors, public, archaeologists, etc.) in an intelligent manner, i.e. to try improving the understanding of the site by means of such devices and measures:

- "Using light as part of the scenery, so that excessively bulky sets can be avoided" (from Verona Charter).
- "Using mini-equipment for the lighting, projectors, wiring, control unit, etc." (from Verona Charter).

LIGHTING

Theatrical performance

Mini-equipment for the lighting.

Provisional lights.
Permanent lights.

Great thermal baths of Villa Adriana: During night, staging activities

Permanent lighting devices are more suitable for interiors and staging

LIGHTING

Theatrical performance

Structures should be erected only when it is necessary.

LIGHTING

Theatrical performance

Structures should be erected only when it is necessary.

Permanent lighting devices are more suitable for interiors and in general covered places. Mérida theater.

In general, permanent structures aimed at lighting should be avoided in favour of removable devices

RUBBISH / LITTER

Rubbish during the spectacles.

Responsible for picking up the rubbish during the spectacles.

Need temporary placement to through the rubbish.

The bins should be in places where don't disturb the view of spectacle and near to the viewers.

RUBBISH / LITTER

Rubbish in a place to enjoy permanent.

Also the paths that lead to the arqueological area have to be supplied with bins to avoid uncontrolled production of waste from parking areas to the main of monuments.

It is important to take consideration the importance of the peak season in order to plan the proper garbage collection

Rubbish/Litter

The expected use of a theatre as place for contemporary performances produces an anthropic stress: the uncontrolled production of rubbish may create various problems for the theatre and cultural cluster.

The Syracuse Charter made clear the importance of providing appropriate facilities to the public, not just for enjoyment of the theatre itself as a place for performances (seats, speakers, lighting devices, etc.), but also as a place to enjoy during the stay. With this aim, it is fundamental to reduce every risk of pollution and decay in the site through the introduction of a proper waste management system (rubbish bins, toilets, planned garbage collection). The experience of a visit to an archaeological site should avoid every source of annoyance produced to the visitors by a lack of care in the management, but at the same time, taking care of the theatre's surrounding environment (public lawns, gardens, etc.) could even provide an important enhancement to the quality of the visit.

It is important to train the local population about the importance of waste management and disposal, not just of the archaeological site, but of the whole cultural cluster because in many cases the presence of uncontrolled waste accumulation creates a high level of annoyance in tourists.

At the same time tourists should be properly informed about the potential threats caused by their presence in order to avoid accumulation of rubbish, dirtiness, etc. in the archaeological site.

Access system and capacity

For sustainable archaeological fruition and theatrical activity, paths and facility services should comply with national standards and regulations and, furthermore, should take into consideration the intrinsic fragility of ancient floors, in particular mosaic or *opus sectile*.

The Verona Charter suggests building *"attractive paths that steer the public away from fragile areas. In some cases, access to sensitive or dangerous areas will have to be prohibited"*; focusing the attention of the site managers on the importance for the public of perceiving safety in the design quality of all the new structures (paths, access, etc.)

With the aim of evaluating and improving the enjoyment level of ancient theatres, we can take into consideration the general recommendation from the Spanish technical code concerning public buildings; these regulations comply with European standards and could be a useful base for computing some important features of ancient theatres, in particular the dimensioning of the escape routes in relation to the capacity of the *cavea*.

Following the next steps, it is possible to evaluate the capacity of the sectors of the *cavea*, the measurements of escape routes, paths, etc. Once the fulfilment of these simple rules has been evaluated, it is possible to establish a limit to the number of spectators in order to make the general conditions for carrying out stage activities safer, in particular in case of fire:

1. Identification of all the areas suitable for seated spectators (bleaches) and the number of exits that can be considered suitable as escape routes.

2. Identification of the sectors of the cavea whose spectators have to evacuate from a specific stair/passage.

3. Computation of the net area of the cavea dedicated to seats (without the stairs) in order to evaluate the number of spectators that may need to evacuate from the relative stair/passage.

Access system and capacity

Phase 0

Phase 1

- Not accessible areas used as lapidarium deposits, etc.
- Usable bleaches
- Praecintiones
- limit of the proscanium
- Escape, direction to follow

Access system and capacity

Phase 2

Stairs

Subdivision of the cavea in order to detect for every horizontal sectors the corresponding vomitorium

limit of the proscanium

Phase 3

153,1 m² = 306 sp

153,1 m² = 306 sp

147,8 m² = 295 sp

147,8 m² = 295 sp

156,2 m² = 312 sp

limit of the proscanium

158,45 m² = 316 sp

158,45 m² = 316 sp

sp = spectators

Access system and capacity

Phase 4 and 5

$A_4 \geq sp/480$

$A_4 \geq sp/480$

65,7 m

27,5 m

27 m

limit of the proscanium

○——▶ Maximum length of evacuation for every sector

sp = spectators

According to the Spanish national regulation, every person occupies an area of 0.5 m².

4. Checking the maximum length of evacuation à ≤ **75 m** (for open public places). Maximum evacuation height of à**28 m**
5. Dimensioning and/or testing the passages for evacuation.

 Steps between rows of fixed seats
 (A_n = width of the passage in metres)

 Space between rows of fixed seats
 (A_n = width of the passage in metres)
 - ≤ 14 seat / row à A_1 ≥ **0.30 m** + 1.25 m for every additional seat
 - ≥ seat / row à A_2 ≥ **0.50 m**

- Passageways intermediate
 - Every 25 rows **1.20 m** à Corridor
- Open space zones
 - Steps, walkways and ramps. A_3 ≥ P/600 In any case, the width of the paths (praecintiones, ambulacra, etc.) and doors (vomitoria) should never measure less than 0.8 m wide.
 - Stairs **A4 ≥ P/480**

Security systems

The safety of the archaeological area is a critical theme for the correct development of a site and related cultural clusters, for their physical integrity and for the health of tourists and spectators. With the aim of avoiding damage and potential threats both to ancient structures and to people that visit and work at the site, the institutions responsible for the management have to plan surveillance facilities such as remote cameras, agents and adequate enclosures.

The kind of threats affecting archaeological sites without proper surveillance systems include acts of vandalism and theft, in many occasions committed by the same local populations that should be taking care of their own heritage.

In many cases, just the unobtrusive presence of agents or a light fence can prevent these kinds of damage. A video surveillance system offers the opportunity of keeping vast areas under control, but needs a constant maintenance of ducts and systems of electricity supply. In addiction, trained staff and an effective storage system of video data is required.

As in other cases, the managerial structure of a site has to face those problems not just through surveillance facilities and adequate staff, but also by means of training policies that could

SECURITY SYSTEMS

The safety of the architectural area has to protect the security of the tourist, spectators and the ancient structure.

In order to avoid an excessive visual impact is advisable to located surveillance cameras in the surroundings of the main monuments but not directly on them. Because they could affect ancient structures.

In general it is better to put more small cameras, avoiding high stakes, in place of bigger structures that can affect the perception of the monument.

Security cameras should be integrated in the environment. In the case of Ostia museum the managers of the site opted for discreet and small surveillance cameras located in the surroundings of the area.

help the local population and tourists to understand the value of the cultural heritage.

These surveillance measures also deal with the detection of other hazards caused, for example, by fire or due to structural collapse; in those cases, skilled agents have to manage the panic that might ensue among the throngs of artists or spectators. In accordance with the Verona Charter, the following steps have to be taken into consideration for the correct management of safety:

- Define a safety zone around the monument or site that prevents random parking and allows the police and emergency services to circulate freely.

- Draw up specific safety standards for each site. Such standards must define:
 - Maximum capacity in terms of the number of visitors or spectators.
 - Public safety measures, including hazard prevention, medical treatment, and emergency facilities.

DEFENSIVE STRUCTURES: HANDRAILS

An effective handrail and system of safe paths is required for the use of the archaeological area and the theater, for tourists and for the audience.

The handrails have to be planned in order to protect and not damage the ancient monument: in the case of Italica anfiteather the defensive system is also aimed at respecting the visual perception of ruins.

In the case of permanent structures the manager of the site has to take in consideration their visual incidence in order to avoid incorrect perception of the site.

In Dougga theater it is still visible at the high of every praecintio the slots used for lodging the *baltei* , the ancient defensive

In Aphrodisias stadium, the researcher Katherine Welch proposed a possible solution for the ancient defensive

Defensive structures: handrails

An effective handrail and system of safe paths is required for the use of the archaeological area and the theatre, for tourists and for the audience.

These facilities have two main aims, the safety of the visit and the protection of the more fragile parts of the remains, but their presence can also provide the opportunity to guide the flows of visitors and be the support for signs and lighting supply inside an integrated system.

The presence of these structures has to be planned in order to protect and not damage the ancient accesses and floors and to prevent interference with archaeological excavations and other intrinsic actions such as maintenance practices.

Not all barriers and handrails have to be permanent; in fact some of them could be placed during the theatre season in order to avoid an altered perception of the ruins due to redundant or unnecessary structures during the greater part of the year. In this case, it is necessary to indicate the assembly procedures and a proper location for their storage.

The reason for adopting removable elements, as much as possible, has to do with many factors, not just concerning their aesthetic impact, but also the potential threat caused by the interaction between new metallic structures and masonry walls.

It is important to guarantee regular maintenance of these removable structures to avoid the risk of staining, damaging of the walls by anchorages, and the infiltration of oxidizing substances. In fact, iron oxides driven by water from rusting handrails induce the development of a brown staining on the underlying stones.

Some recommendations are presented as basic requirements to reduce the risk of damage to the users to acceptable limits during the intended use of the buildings as a result of the characteristics of the project, construction, use and maintenance.

PAVEMENTS / WALKWAYS
- Soils should be the most appropriate possible to discourage people from slipping, tripping or having obstructed mobility.
- With the aim of limiting the risk of slipping, it is recommended that soils have a certain roughness.
- Discontinuities in the pavement should be minimized by protecting the surface with some additional element, thereby guaranteeing continuity and avoiding potential tripping.

PROTECTION AGAINST FALLING
- The risk of falls because of gaps, changes in levels, and stairs or ramps should be minimised.
- The risk of users suffering impacts or entrapments with fixed or moveable parts of the building should be limited.
- Also, the risk caused by situations with high occupancy should be limited by facilitating the movement of persons and sectorization, with elements of protection and containment in anticipation of the risk of crushing.
- Barriers to delimit areas of circulation should have a height of at least 800 mm.
- In order to limit the risk of falling, there should be barriers of protection on the slopes, gaps and openings (both horizontal and vertical), balconies, windows, etc. with a difference of dimension greater than 550 mm, except when the constructive provision makes falling unlikely or when the barrier is incompatible with the intended use.
- Protection barriers should have, at a minimum, a height of 900 mm when the difference of the dimension that protects does not exceed 6 m and 1100 mm in the rest of the cases, except for holes of stairs of less than 400 mm in width, where the handrail shall have a height of not less than 900 mm.
- The height should be measured vertically from the floor level or, in the case of stairs, from the line of slope defined by the vertices of the treads to the upper limit of the barrier.
- Protection barriers, including those of stairs and ramps, situated in areas intended for the public, shall be designed in such a way that children cannot easily scale them.

Signage and signs

The main purpose for signs inside the archaeological area and related cultural cluster is to convey information about the main activities carried out: tourism, staging activities, education and maintenance. An effective signage system will help people make proper decisions based on the information provided. In general, signage can be classified into the following functions:

- **Information**
 To this category belong all the signs giving information about services and facilities: the map of the cultural cluster or the theatre, telephone numbers and location of a particular office/service, instructions for use of services, hours of operation, working and closing days, etc.

- **Identification**
 Signs indicating on a map the location of the signal/panel seen by the tourist, services and facilities, ID code of seats of the cavea (names, acronym, numbers), museums, exhibition halls, toilet signs, etc.

178 PROTOTYPE OF MANAGEMENT PLAN FOR ENHANCEMENT OF NEW ACTUALITIES

SIGNAGE AND SIGNALS

Panels for the situation and explication about different places that the visitor can visit.

In this panel there are different parts to explain the main construction and reconstruction.

- Responsible institution for management.
- Monumental explanation.
- Little explanatory map.
- Virtual reconstruction.
- English version.
- Audio guide.

This panel represents the different uses or activities in Ostia.

- Situation in the map.
- Legend about different places for the visitant.
- Some itineraries to visit different things.

SIGNAGE AND SIGNALS

Panels for people with low vision.

Text
Braille
Model 3D

Suggestion about blind people's panel.

Explanatory panel of the Ostia theater. For people with low vision creates a tactile playback in three dimensions.

The construction of the mosaic is presented in braille.

- Direction
 Signs leading to services (toilets, restaurants, coffee shop, bookshops, box offices, etc.), facilities (lighting supply, water supply, drainage system, etc.), functional spaces and key areas (meeting point for guided tours, emergency exits, sign posts, directional arrows, etc.).

- Safety and Regulatory
 Signs giving warnings or safety instructions, traffic signs, exit signs, rules, regulations, etc.

Due to the special characteristics of the Athena sites, the signage system has to produce a low impact on the overall image of the archaeological environment; a proper solution is the **development and implementation of the site's corporate identity** in order to promote the use of a common layout for the graphic production related to the cultural cluster.
From website to brochures, guidebooks and informative panels - everything has to comply with a shared graphic regulation.

The cultural cluster is the reference area for a proposed permanent system of signs. In addition, some of the signs should be provisional and consequently placed at specific times of the year, e.g. during festivals or exhibitions, cultural events, etc. with the aim of helping people to find ephemeral structures and supplies.

The selection of the places where to put signs is, of course, very important and has to do with the correct musealization design of the area. The whole site can be considered as an "open air" museum, and for the correct understanding of the exhibition, an effective communication strategy is essential.

In general, archaeological remains have lost a great part of their original qualities and, along with them, their functions. Moreover, there is the problem of understanding the historical stratification process that led to the current state of a site; this is the reason why it is very important to provide to tourists with an integrated strategy for an easier, but correct way to learn information.

At every archaeological site, urban or extra-urban, a series of different itineraries should be clearly specified, based on different durations and themes: from a short visit focused on the most important monuments to the possibility of a wider and deeper understanding of the many aspects that formed the life of a town in ancient times. With this aim, the signs should clearly identify the presence in the archaeological site of specific typologies of buildings or functions that characterized the town: thermal baths, places for performances (theatres, circuses, amphitheatres, stadiums, etc.), places for handcrafted production, shops, etc.

In general, it is important to opt for a sober signage system capable of "blending" properly with the character of the ruins, avoiding flashy colours or fonts and, of course, with modest panel size. The site's integrity could be badly affected by improper signage, and also by the point of view of the quantity of information provided by signs. In general, archaeologists responsible for site investigation and maintenance tend to provide an excessive quantity of data using a scientific approach.

It is important to provide high quality information but in a correct way; a possible approach, used in many sites, is to split the panel referring to a specific monument into three parts: each one corresponding to a different deepening degree. By means of this simple approach it is possible to allow people with different time availability and specific knowledge to learn the basic information with a simplified (but correct) lexicon or, in the case of a scholar, provide greater amounts of data expounded with a more rigorous approach.

In any case, two aspects have to be borne in mind: the appropriate location of the panels and their correct size. Too many and too large signs should be avoided in favour of a lighter system where the role of new technologies could help with the teaching of visitors and spectators.

In the Siracusa Chart the importance of technology in preventing problems concerning the excessive anthropic pressure is clearly expressed: *"Use of new information technology will facilitate the tasks of recording, analysing, scheduling and monitoring work carried out on the sites by professionals, and may also help to relieve the pressure of excessive numbers of visitors, in the case of fragile sites that are too popular, by offering people interested in the sites the possibility of remote access via virtual imagery and the multimedia"*.

The increasing number of people having smart phones and tablets can help achieve a lighter signage system by means of many possible solutions: for instance the use of QR codes and Podcasts.

These digital media have to comply with some others suggestions from the Siracusa Chart concerning the dissemination of information: *"[...] multimedia products should be able to minimise the risk of scientific data becoming irrelevant or distorted. In any event, the persons responsible for setting up a project will need to define the level of their particular objective (for example scientific research, evocation or popularisation). Professionals in the specific case of ancient places of performance will have to comply with any ethical and moral principles adopted in the future at international level concerning the use of new information technology in the cultural sphere."*

The signage system has to be maintained regularly and properly without causing damage to ancient structures.

Measures for fire prevention

In order to avoid potential fire hazard inside archaeological sites, it is important to improve policies aimed at preventing that risk by means educating the public about taking precautions to prevent potentially harmful fires, and being educated about surviving them. These proactive methods can be carried out by means of proper training to acting companies and to the workers involved in staging activities, because they have to manage electric equipment that could cause short-circuits.

Measures in keeping with the site layout or position of the monument will have to be adopted for dealing with not only the effects of a fire or any other hazard, but also, and above all, the panic that might ensue among the throngs of visitors or spectators (from Verona Charter).

In general, the materials used for the stage should be certified, conforming to existing national or international regulations aimed at promoting the use of constructive elements that, in case of fire, keep their mechanical strength, integrity and thermal insulation for the time necessary for people to leave the area.

The responsible institution for the site management has to provide plans describing the ways to escape from the scenic building both to workers and the public; in ancient theatres the educational problem about fire hazard has to be efficient and at the same time should respect the aesthetic of the building. From this point of view signs can be critical elements because of their impact on the historical walls (Siracusa Charter).

A proper solution could be an integrated policy of low impact signs, proper lighting devices, informative brochures, quick brief of the audience by attendants or doormen and, before the beginning of the play, some informative advice about the ways to escape in case of fire.

MEASURES FOR FIRE PREVENTION

Firefighting system.

The case study of Ostia arqueological site offers an interesting solution for fire prevention because it is possible for firemen to reach the teather throght a passage paralel to the Decumanus Maximus outside the arqueological area.

Decumanus Maximus
Service passage

Fire hidrants have been located beyond frons scaenae walls: they are hidden to the sight of the public but very closed to the stage where is more probable start a fire.

Escape, direction to follow

Fire hydrant

MEASURES FOR FIRE PREVENTION

Also exhibitions and museums (antiquarium, lapidarium, etc.) have to comply with existing rules and regulations for fire prevention.

In addition it is important to take in consideration the visual impact of devices aimed to burn out flames: in the case of Ostia museum the managers of the site located fire extinguishers at the sides of the main facades of the building.

Ostia's archaelogical museum : main façade.

Fire hydrant.

All equipment necessary for extinguish the fire.

All new structures relative to theatrical activities (visitor centres, museums, etc.) have to comply with national and international regulations and standards concerning fire hazard and, in particular, have to be supplied with smoke detectors, smoke alarms and proper signs (about behaviour in case of fire, escape routes, etc.).

The management institution of the archaeological site is responsible for complying with the correct maintenance of all the electronic devices for the detection of fire hazards: the most common cause of smoke detector failure is missing or disconnected batteries.

Police and emergency services, in particular firemen, should be allowed to circulate freely through the archaeological site, but this is a hypothetical condition, almost impossible to make true. In fact, the reduced size of ancient streets, the fragility of the floors and the presence of underground vaulted structures (*criptoportici*, etc.), make it quite difficult to allow the presence of firemen, carrying heavy equipment, without a proper plan of the paths for the displacement of vehicles and devices.

A fire hydrant system would be more desirable then the necessity of carrying fire engines or a conventional pumper of the Fire and Rescue Service into the site; in order to avoid a heavy aesthetic impact on the masonry walls and ruins it is preferable to hide hydrants under manholes.

For a correct carrying out of the rescue operations, it is also important to prevent random parking around the archaeological site because, in case of emergency, it could cause delays of the operations aimed at helping and treating wounded or burnt people.

APPROACH CONDITIONS FOR FIREFIGHTERS

1. **Approach to buildings**

 The access road next to the theatre should have the following conditions in order for firefighters to be able to perform their task in case of fire.

Minimum high or gauge	→**4.5 m**
Minimum width straight (A1)	→**3.5 m**
Minimum width curved	→**7.2 m**
Outer turning radius (Rext)	→**12.5 m**
Inner turning radius (Rint)	→**5.3 m**

2. **Environment of building.**

The theatres with a height more than **9 m** must have a space for the action of firefighters that meets the following conditions along the facades in which the access or the interior open space is located:

- Minimum unobstructed width (A2) →**5 m**

- Separation of the vehicle of firefighters from the facade of the theatre (A3):
≤ 15 m height	→**23 m**
15 m to 20 m height	→**18 m**
≥ 20 m height	→**10 m**

- Maximum distance from the entrances of the building necessary to be able to reach all its areas. →**30 m**

The area for manoeuvring should be kept free of trees, urban furniture, gardens, landmarks or other obstacles.

4.6.2 RESOURCES

Information point

In order to provide information to visitors and spectators it is important to have a widespread diffusion of info points related to the theme of tourism and theatrical activities; in particular it is important to provide certified, reliable information in all the places aimed at reception: airports, ports, highway/motorway stations, etc.; or in the public areas of the cultural cluster that can be considered as reference meeting points: main squares, main streets crossing, etc.

The design of the info point should be considered as part of the corporate identity of a site, using a common graphic layout that should make easy to recognize them as part of an integrated system for tourism development (using official brands and logos of local and national institutions, etc.). The opening hours of the info points should also be compatible with the arrivals of the main international flights in order to give tourists advice for a correct and comfortable stay in the country. The info point staff has to be professionally trained and know languages, in particular English, and should be in adequate number in order to prevent the formation of long queues and discomfort during the peak season.

The main objective of an info point is to be a reliable place where it is possible to pick up maps, get information from brochures about cultural activities, guided tours, schedules and opening hours of cultural sites, supplies, car rental, public transport, etc.

In accordance with the Athena objectives, it is very important to let tourists know, through these structures, information about all the places and local activities that should be promoted and developed. The aims of this policy are twofold: to relieve excessive anthropic pressure on the most visited sites and to offer people a wider range of destinations, in particular related to a powerful attractor: theatrical performance, etc.

Bookshop

Bookshops form part of both the economic and cultural aspects of a site: on one hand there is the quality of the dissemination, and on the other the possibility to promote local activities through the selling of traditional handicrafts.

A bookshop as an info point should be designed within the general framework of the corporate identity of the site and should be located close to the archaeological site or exhibition halls, museums, etc., and be properly indicated.

Its function should be easily recognized and be accessible independently from the archaeological site with the aim of attracting people before a tour inside the area, but at the same time it should be accessible before and after the visit.

The opening hours should be compatible with those of the archaeological sites and museums and the staff should be professionally trained on selling and should know foreign languages.

The bookshop can offer a wide range of items, not just books, but as a matter of fact the main objective is to spread knowledge about the archaeological site and in general about local culture/traditions, etc.

The store has to offer books and gadgets for different targets: from children to people fond of archaeology to specialists in the field. Interior design and visual merchandising of the shop can facilitate the identification of books and gadgets aimed at different targets, so that different products are not mixed together. The quality of the guidebooks as well as other publications has to comply with international standard avoiding the supply of incorrect and not updated historical-artistic data. From this point of view, the role of digital media (videos, virtual reconstructions, virtual tours, real-time explorations, etc.) must also comply with scientific standards as recommended by the Syracuse Charter.

The role of a bookshop is also concerned with keeping alive the memory of former exhibitions held at museums and exhibition centres of the whole region/country. With this aim in mind, it is important to keep inside the bookshop the constant presence of exhibition catalogues that can be considered an effective way to promote the cultural role of the area within the framework of the whole country.

The quality of merchandising (T-shirts, cups, bags, etc.) within bookshops is another fundamental point, not just for the economy, but also from the point of view of the general appearance and attraction of a site; in no case should products be dangerous or risky for the purchasers and should comply with national and local safety standards.

Handicraft products have to be present inside bookshops, but their role is not just to be souvenirs; in fact they also help in the dissemination of local culture and contribute to the "global image" of the region; for this reason these objects have to tell a story, a legacy, by means of brochures and displays designed with the aim of improving their power to communicate traditions.

Bars - Coffee shops

As with other services, bars and cafés should comply with the global image of a site through high-level standards. Their impact as new constructions obviously depends on their specific location inside the archaeological area and cultural cluster, but in general it is important to take into consideration the opportunity to design these annexes avoiding a strong impact with respect to the environment and site skylines.

Basically there are two approaches to the design of these buildings: to spread out or to concentrate their functional presence. In other words, coffee-shops, bookshops, info points and exhibition areas can be concentrated inside a big building or spread all over the area or cultural cluster as a set of little kiosks or vending stands. The two approaches have advantages and disadvantages that should be calibrated depending on the nature of the site. But in the case of services regarding the supply of food and drink, the responsible institutions of a site should take into proper consideration a theme that could generate problems. The visit to an archaeological site can be a wearying experience, in particular in the case of extra-urban sites, but also depending on the climatic conditions of the area (sunny, desert, etc.). In many cases, urban spread sites, as in the case of Merida's Cultural Cluster, don't present this kind of inconvenience, but when the area is far from towns problems arise regarding safety and comfort. An extended visit during the summer at midday can cause physical problems in particular to two age groups: advanced age tourists and children. For this reason bar and refreshment stands should be properly spread out on vast areas, also providing shelter from the sun, fresh water by means of free fountains, but without causing a high aesthetic impact on the archaeological surroundings. Throughout the year, and in particular during the peak seasons, those responsible for the site should plan the garbage collection with different frequencies in order to avoid an uncontrolled production of rubbish in those periods all around kiosks and bars.

Toilets

A critical aspect regarding the site management deals with the supply of a sanitation system for the archaeological area and theatre, but the hygienic and health standards must comply with more than just national and local regulations about sanitation, because the

ancient ruins present very fragile structures and environments compared to modern buildings for performances.

Depending on the type of site, the position and the typology of toilets can be very different: in particular, urban sites rather than isolated ones have different needs and problems concerning drainage system, furthermore the timing of different activities during the whole year plays an important role in the quantification of the adequate number of toilets in case of staging or cultural activities inside the site/theatre.

As general condition, it is advisable to divide the supply of sanitation depending on the kind of users: people who work in the archaeological site should have separate areas for resting that may include toilets. Kiosks, ticket offices, exhibition rooms, should be equipped with flush toilets connected to septic tanks or main sewage pipes provided by local governments or private corporations. Obviously the number of these stable toilets, included inside not ephemeral spaces, depends on the number of people working at the site: surveillance, assistants, technicians, responsible for maintenance, etc.

For visitors and spectators, in particular during the season of staging activities, site managers should be able to plan for an adequate integration of chemical toilets close to the more stressed areas, close to the theatre and relative main paths.

Some kinds of toilets use chemicals to deodorize the waste instead of simply storing them and need proper and constant maintenance. Also the position of these boxes has to comply with the global aesthetic of the surrounding environment, avoiding a negative impact for spectators and visitors, but at the same time their location has to be planned in accordance with functional aspects: easy and safe access, particularly for impaired people, should be guaranteed and clearly signalled.

Ticket office

The ticket office of the archaeological site has basically two main functions: to provide info and to sell tickets for the archaeological site, or in case of staging activities, to check pre-printed tickets, bought through a website, or bought at another box office.

As a building the box office has to be located at the boundary of the archaeological site, has to be placed close to parking areas and in the neighbourhood of bus stops or other public transportation stops. Info point and ticket office could be placed inside the same building and share the same opening hours.

The ticket office has to comply with the global corporate identity of the site with the aim of being clearly identified by tourists and spectators. At the ticket office should be available informative materials such as brochures, audio guides, PDA and UMPC, tablets that could facilitate the independent visit to the archaeological site, but also information about booking guided tours to the site, etc.

The advertising present at ticket office plays a fundamental role in the dissemination of different cultural activities and the ticket office staff has to be professionally trained and know languages, in particular English, and should be in adequate number in order to prevent the formation of queues and discomfort during the peak season.

Depending on the nature of the site (urban, dispersed, concentrated, etc.) the ticket office should include a wide range of proposals capable of promoting the visit of other monuments and heritage in the cultural cluster: a general policy of prices is advisable, so with this in mind special prices could be offered for multiple location visits including other sites, museums and exhibitions, especially when they have a deep relation with local culture and traditions.

During theatrical season the ticket office has to be tightly linked and coordinated with other ticket sellers, for example via the web or other box offices, etc.; the aim is to avoid overbooking or overlapping problems.

Web site effectiveness for booking theatre tickets deals with many aspects regarding web authoring, interface ergonomic, languages, etc. A professionally developed web site should provide lots of information and could help with the dissemination of the archaeological site and theatrical culture.

Infirmary

During the visit or a theatrical performance different kinds of unexpected problems can occur due to the nature of the site, the physical conditions of visitors, incidents that can affect people working for maintenance, and so on. The theme of the first aid to injured people is a crucial point for safety and quality of an archaeological site; for this reason a number of measures should be taken into consideration to minimize risks and to provide the necessary help in order to save lives.

- The area should be provided with an infirmary for first aid treatment placed close to one of the accesses to the archaeological site.

- People working in the archaeological site (technicians, guides, etc.) should be professionally trained at detecting the more common signs of danger to the health of visitors and workers and, in case, provide the initial care for an illness or injury.

- The first aid providers are also likely to be trained in dealing with injuries such as cuts, grazes or bone fracture, burns, etc. They may be able to deal with the situation in its entirety (a

small adhesive bandage on a paper cut), or may be required to maintain the condition of something like a broken bone, until the next stage of definitive care (usually an ambulance) arrives.

- Due to the high number of spectators of various ages and depending on the hour of the day chosen for staging activities the distribution of water and hats (as shelter from the sun) should be planned for, and the presence of trained personnel in order to provide help to old or impaired people.

Exhibition hall / Interpretation centre

The exhibition hall forms part of the fundamental spaces for a proper visit to the archaeological site because it deals with many goals of the Athena project. First of all education of the visitors about the archaeological site, the town during ancient times and its later development and, in particular, the theatre as a living monument: its role, its social and cultural purposes, etc.

Through a deeper knowledge, people when "using" the site and the theatre, may have greater respect for these delicate and fragile structures.

The interpretation centre has to be placed close to the entrance of the archaeological area and should be visited before entering the site in order to provide visitors and spectators with information for a correct interpretation of the ruins and theatres.

Among the many examples provided by new interventions, some of them represent a good balance between architectural design of the exhibition, quality of the information provided, and ease of understanding.

The visitors, before entering the theatre, have to understand the evolution process of this important typology, its design, the differences between Roman and Greek theatre, its parts and their functions, etc.

The theatre as a monument is just one part of the aspects that people should deepen during the visit, and for this reason it is advisable to reserve a part of the permanent exhibition to ancient literature (drama and comedy) in order to let people know about the main authors, literary genres and their evolution, etc.

The exhibition centre should include scale models of reconstructions/interpretations of the theatre and ancient town, and multimedia materials complying with the most updated scientific literature in order to provide reliable interpretations of the building. The quality of these multimedia reconstructions could benefit the suggestions from the *"London Charter for the computer based visualization of Cultural Heritage"* http://www.londoncharter.org/, the ICOMOS Charter for the Interpretation and Presentation of Cultural Heritage Sites and the "Seville principles – international principles of virtual archaeology".

As a building, the interpretation centre, has to comply with all the aspects already mentioned about kiosks, toilets, informative points, etc. Due to the dimensions of an interpretation centre, it is highly advisable to take care of the relation established with the surrounding landscape in order to avoid a heavy impact on the natural/original aspect of the site.

One of the best Spanish examples of an interpretation centre linked to an ancient theatre can be found in Cartagena (Murcia) where the architect Rafael Moneo designed, in collaboration with various experts (archaeologists, experts on restoration, etc.), a museum that can be described as a physical and cultural "access" to the theatre: a long corridor and a monumental stair let the visitor increase their level of knowledge through an immersive experience that ends with the sudden arrival inside the *cavea* of the theatre.

Exhibition /Interpretation center
Cartagena (Murcia, Spain)

4.6.3 INTERNAL SERVICES

Physical Resources

Official tourist guides (staff)

Trained touristic staff form one of the strong points of a correct, pleasant and interesting visit to an archaeological site because, in the majority of cases, ancient ruins do not provide enough data by themselves to let people understand their ancient functions, original appearance, etc.

For this reason the role of a tourist guide is crucial because without them a visit can become tiring and in many cases almost incomprehensible, but when the guides are specifically trained and managed with the psychological aspects related to the visitors' point of view and expectations, then one of the main Athena goals can be achieved: the improvement of the quality of the archaeological site and principally its reputation.

A pleasant and interesting visit that mentally involves tourists of different ages and education is not achieved empirically, but has to do with many different aspects. First is the correct knowledge of different languages, second is a deep knowledge of the matter (in this case ancient Greek and Roman culture, architecture, habits and customs, etc.), and finally there is the skill of public speaking.

Depending on the category of visitors, the guides of the archaeological area have to be able to provide different quantities of information, but without forgetting the accuracy of historical and technical data. In order to avoid an approach ranging from unspecific and much too general, or, on the other side, too complex and scientific, it is important to allow tourists to be able to choose guided tours characterized by different levels of depth.

To provide an adequate training to the staff, it is very important to keep control over the results of the questionnaires designed for visitors and audience members: the statistics about the site will supply information aimed at knowing the requested number of guides in relation with the site users (profile, education, age, etc.); once this information has been gathered, it will be possible to establish priorities in the visit's design, the daily schedule, the duration of the visit, etc.

The main typologies of guided visits are the following:
- Schools
- Generic visitor
- Specialized/informed tourist

For each one of these categories a different depth of information should be provided and depending on the age and specific characteristic of the site, a different duration of the visit. In the case of schools, the interaction plays a crucial role for a correct understanding and, depending on the age of the schoolchildren, the visit could be planned as a "play" where the main actor performs the role of a specific historical character who also interacts with other people in historical costume. This kind of technique permits them to be involved psychologically also when they are very young children, converting their visit into a vivid experience with the benefit of introducing them to ancient world culture by means of an entertaining play.

Visitors from high schools to middle aged people can be considered as forming part of the same set, and can be provided with technological equipment for a more engaging experience, such as headphones for clearer listening, particularly for groups up to 20 persons that in many cases cannot follow the speech from the guide because are too distant from him or her. The design of these guided tours should range from a basic introduction to the classical age, the historical- geographical context of a town during the classical age (role during Hellenic-Hellenistic and Roman age, etc.) to the description of functions of the features of the most common buildings and their social-political roles. The visit should begin with a preliminary visit to the interpretation centre where drawings and scale models could facilitate the global comprehension of the ancient town. The visit should also focus the attention of the tourists on the role and importance of the architectural typologies for spectacles and their implication for the ancient society, in particular theatres and their legacy from the Greek typology to the contemporary use. For a better comprehension of the site it is advisable to provide a proper number of brochures to the visitors, in particular a plan of the area with the identification of the main buildings and a summary of the main historical events in the area.

For the specialist visitors (archaeologists, architects, engineers, scholars and experts in general) guided visits could be planned independently from the more general ones and during these special occasions the guides could be replaced by the very experts that work and study the site, extending the conventional itineraries to include areas under excavation and places with more difficult access. In this case it is advisable to explain to the participants the importance of a safe visit and provide them with helmets, boots and every other kind of equipment needed to ensure their health and safety during the visit.

Official tourist guidebooks

The quality of the books provided inside the bookshop of the archaeological area is very important, but the concept of quality should not be confused or misunderstood with the quantity of data or with the scientific approach to the texts. The most important thing

is to supply various levels of depth as in the case of guided visits: a more general and recreational approach for pupils, an official guide of the site for generic visitors and books on more specific topics with the results of specific investigations.

The authors of the books should be helped in their work by the experts of conservation belonging to the institutions responsible for the management of the archaeological site because in many occasions it happens that new discoveries may create the need to revise these books: in some cases the global knowledge on a site may become partially obsolete after a few archaeological campaigns, also depending on the amount of excavated/studied areas of the site. In order to contain these problems, it is important for the site managers to constantly provide supervision of media aimed at diffusion for the purpose of detecting mistakes or out of date information.

There are basically three kinds of visitors interested in deepening their knowledge of an archaeological site that form part of a specific set concerning education and training: young children from primary schools, bachelor/college students, and university students. These typologies need different ways or strategies of communication in order to let them acquire the proper amount of information about a site.

There are also other two categories: the generic visitor that ranges from an age of 25-30 years to senior citizens that, depending on the case, may visit the site in larger or smaller groups or couples, etc. Another category is that of specialists or professionals that visit the site not just for the pleasure of the cultural experience, but also because they have specific purposes concerning the knowledge of specific features of an ancient city or architectural typology, etc.

Every category has specific distinctive aims and cognitive capabilities that lead them to visit a site and, consequently, a guidebook should reflect in its contents and communicational strategies the cognitive possibility to understand and appreciate the ancient ruins (material aspects) of a site and other immaterial aspects of the cultural cluster.

Different books should be provided inside the bookshop as well as in any other place aimed at receiving visitors before entering the site; the categories of guidebooks should not just reflect the age or the level of education of people belonging to one of the categories formerly listed. For example, a bachelor student could use the same guide as a retired person, but at the same time a child from primary school would not have the sufficient level to understand the complexity of those texts; on the contrary a Ph.D. holder may find the information provided in such a book too generic. In order to avoid such problems, the best solution is to plan two kinds of guidebooks: one aimed at young pupils characterized by a more "graphic" or "comic book" approach with simplified and basic information on a site or even on a whole category of archaeological sites: in our case Greek-Roman towns. On the other hand, there are official multipurpose guidebooks capable, by means of a proper strategy, to provide a general interpretation structure of the site for the majority of visitors, but at the same time to deepen the quantity-quality of information in special occasions during the general texts. For example, at the end of every chapter should be included more specific data on a distinctive feature of a site, with the possibility to increase one's knowledge thanks to a reference bibliography: in this way a guidebook could easily be used by the generic visitor, but could also be considered as a vector of more specific knowledge, for example for university students, without converting it in a heavy and too specific "scientific" book.

The guidebook should describe in a logic sequence the single buildings or a particular set of buildings (forum, theatre with *porticus post scaenam*, *insulae*, shrines, etc.) that characterized the site and that nowadays are still in good condition. The guide should include a map with the location of the main buildings or points of interest and two or more possible paths of the archaeological area. The aim of providing different paths is to let people visit the area depending on various factors: the available time, the difficulty in physical terms (focusing on the problems of impaired or elderly people), or a specific theme of cultural interest (places of performance, water supply, public places, etc.).

A guidebook forms part of the national cultural policy on dissemination, and in order to comply with the aims of the ATHENA Project it is fundamental to include inside these books the following chapters:

- The location of the site/theatre within the framework of the Mediterranean Basin in order to let the visitors understand its political, strategic and cultural relevance during the ancient age, including a map aimed at comparing the current names of the main countries and their former ones during the classical age.

- A timeline where the foundation of the ancient town is underlined, its time of prosperity and development, the decline and its modern discovery: the aim of such schemes is to locate the importance of the site within the main historical facts.

- The book should include a final chapter dedicated to a thesaurus of ancient terms related to architecture and ancient culture, with special regards to the theatre and dramatic activities.

- Depending on the site, it should include a chapter dedicated to other important aspects of the site, using for instance other locations outside the perimeter of the archaeological area. Those

monuments, ruins or natural sites can provide the opportunity to complete the knowledge of a site also from the point of view of material aspects such as local tradition, folklore, gastronomy, and typical products. The way to provide such suggestions is a delicate theme because a guidebook should never become touristic advertising! The goal is to supply cultural information and at the same time let tourists know about other relevant aspects that could produce a benefit also for local economy.

Bookshops should provide a variety of different guides, each one aimed at providing information to different typologies of visitors (age, education, specific interest, etc.).

Brochures

It is important to disseminate and allow all the tourists to know about the presence of special events, exhibitions and all other cultural activities that could produce an improvement in the local economy. Brochures are a simple and handy tool that get directly into the hands of tourists and should be spread in all the main attractors such as hotels, restaurants, bed and breakfasts, info points and sites of cultural interest.

Brochures should be designed for tourists, but for local populations as well and they have to be written in different languages and include practical information such as telephone numbers, public transportation, opening hours of the specific site and beginning of the event.

In general it is very useful to put a simplified map of the town where the location of the event is emphasised and the main access roads, bus and train stations, as well as some relevant buildings or places that can help a tourist to quickly realize how to get there.

Due to the diffusion of smart phones and tablets it is advisable to include on the brochures the QR code that directly link to the website of the event/exhibition in order to get more information.

The authority, institution or the artistic company that organized the event should be clearly indicated.

In the Fiesole's Brochure a series of useful recommendations is included.

The Fiesole's Brochure informs the visitors about the location of services and monuments also adding a brief description of cultural offerings.

Audio guides

Audio guides are special electronic tools that through basic programming can play pre-recorded descriptions of a specific monument, place, painting, statue, etc. They operate by means of a simple interface into which the visitor enters a special code that be can easily detected near a point of interest, and then the description plays.

The languages offered should be chosen on the basis of the statistics about the visitors, but in general English has to be included.

Most tourists can use audio guides without particular difficulties, but in the case of young children it is advisable to think about other mechanisms that can introduce the pupil, by means of a sort of game, to the discovery of a cultural site. In some cases the tools used for achieving this goal was a customized videogame that led a group of children through a site using the excuse of a "treasure hunt".

Telematic Resources

A web site inspired by the principles of Web 2.0 and aimed at promoting the activities and the contemporary uses of an archaeological area has to comply with many features that have to do with the active role of a web site user in creating content and writing his comments. One of the goals of the ATHENA Project is to disseminate this philosophy at the moment of designing the web site of an archaeological area, which should be focused on the following three aspects: dissemination, marketing and sharing of information between the users.

The first aspect can be considered as an intrinsic aim of a website: to let people know the existence of a cultural site, how one can visit it, how to get there.

The second aspect has to do with another of ATHENA's aims: the economic development by means of cultural activities; the web site is a powerful vector of information that can help the visitor to buy services (tickets, guided visits, podcasts, hotel reservations, car rental, etc.) and objects (books, souvenirs, gadgets, typical products).

One of the distinctive features of the Web 2.0 is the power of interaction between computer application and other users in order to create content: this last one is an essential factor for the achievement of a successful site.

Among the many concepts at the base of the design of a web site there is the overtaking of former "rigid" structures of the sites by adding some new features that can be summarized in the following table (comparison between Web 1.0 and Web 2.0):

WEB 1.0	WEB 2.0
Read	Write
Companies	Communities
HTML	XML
Web sites	Blogs
Property	Sharing

An effective overall strategy for the development of the web site of the theatre and respective archaeological area has to include blogs, wikis, social networks, interactive 3D applications (real-time) and podcasts.

A web site of an archaeological site area has many aims: from one point of view it can be considered a tool aimed at scientific dissemination, but in general it has to be designed also with a didactic approach aimed at providing general information about the history of an ancient ensemble, the main monuments, etc.

In the case of an ATHENA archaeological area, there is also a distinctive feature that has to do with the presence of used ancient theatres that, as a matter of fact, have to be promoted and managed also through the web site: in addition to the classic information on the history of the site, a link should also be provided that is dedicated to the promotion and purchase of normal and season tickets. A detailed list of performances has to be easily navigable for people from different countries.

Among the best websites of this type in Spain must be mentioned the case of Segobriga (Cuenca, Castilla-La Mancha) where the Consorcio del Parque Arqueológico de Segóbriga developed a very effective website, in particular from the scientific dissemination point of view. The site is formed by many different frames, though the three main ones are arranged vertically: the left one is dedicated to the links concerning the most common information that a visitor may need before and during the visit, the central frame is bigger and is dedicated to the content the user asked for. The right frame hosts the links that lead to other interesting and specific services dedicated to the different users, from the experts, as students or researchers, to the common visitors that want to download audio guides.

From the point of view of economic and cultural development, one of the more interesting experiments is the one carried out in Italy by

The central frame of the Segobriga website is aimed at displaying the different content, aimed at various users, from the researcher to the visitor.

Istituto Nazionale del Dramma Antico (also known by the acronym INDA) which is a cultural foundation operating since 1998, but its activities were brought to life in 1914. The institution is famous for organizing the cycle of classical performances at the Greek theatre of Syracuse. By means of their website http://www.indafondazione.org/en it is possible to get lots of information, not just related to theatrical activities, but also tourism, training, and the diffusion of ancient theatre between new generations (INDA youth).

The Segobriga web site offers the researchers a detailed series of links concerning bibliographic resources.

Home page of the INDA web site: it contains information, prices, special offers, accommodation and, at the same time, promotes cultural events keeping alive the memory of the previous staging activities held at the Roman-Greek theatre of Siracusa.

The page "Theatre Season" provides info about the tragedies and comedies held during the season that lasts two months and is focused on three different plays. For each one there is a special link to a page that describes the plot and the characters. In a discreet frame there is touristic info and advertising, but it is important to mention how the web design respected the general corporate identity of the whole site.

The page "Biglietteria" (ticket office) in a compact way provides different info useful for the public: how to buy tickets, offers, presale, seat location and relative prices, etc.

The page "Biglietteria" (ticket office) is characterized by a very effective structure because it provides to the site visitor a great quantity of info in a very small space by merging alphanumeric and graphic data (prices, dates, offers, part of the theatre, etc.)

4.6.4 EXTERNAL SERVICES

External Parking

For the correct operation of any theatre, it is necessary to have an area for the parking of vehicles. These can be divided into two zones, one for the parking of vehicles of internal staff and one for tourists. We consider internal staff to be the people who work and maintain the theatre, as well as actors, installers, technical sound experts, etc. In the car parking lot designed for tourists, there should be special places for disabled persons. In addition, it is necessary to add, apart from the parking spaces for visitors and spectators, special spaces for public transportation services that reach the vicinity of access, to ensure accessibility to all kinds of audiences.

The number of parking spaces will depend on different factors, the capacity of the theatre and the available space. It is recommended that there is one parking space for every fifteen users and, in the case where the number of people exceeds five hundred, one space for every ten users. In any case, there will be a certain number of accessible places. The Spanish legislation recommends one accessible space for every fifty car spaces.

Depending on the type of parking, the surface area that a parking lot will occupy in m² and the number of parking spaces will be:

It is also important to take into consideration that the presence of cars and buses can affect the correct and pleasant perception of the archaeological area and its surroundings; when possible the area chosen for the parking lot should be hidden by trees or bushes, which could also help in defining the external boundaries of the zone. In other cases, it is possible to lower the level of the parking area, hiding it by means of a small hill. In particular, it is the presence of buses and mini-buses that may affect the view of landscape or of the ruins due to their volume (depending on the type and models, they range from 6 to 12 meters).

KIND OF PARKING	SURFACE FOR ONE PARKING SPACE (M2)	PARKING SPACES IN 100 M²
PARALLEL It is difficult to get in and out. Suitable for narrow streets.	22.7	4.4
30° DIAGONAL It is relatively easy to enter and exit. Optimal use of the surface.	26.3	3.8
45° DIAGONAL It is easy to enter and exit. Relatively good use of the surface.	20.3	4.9
60° DIAGONAL It is easy to enter and exit. Good use of the surface.	19.2	5.2
90° PERPENDICULAR. Width of the squares 2.5 m.	19.4	5.1

In the event that parking spaces are allocated for buses, the minimum measure that the parking lot must comply with is 3.5 x 12 m. It is recommended to always leave a zone for these vehicles.

The parking areas of a site can be divided into different categories depending on their function and should be managed in order to avoid problems concerning interference:

- Generic visitors (cars, motorcycles, buses)
- Taxis
- Public transportation
- People working in the site
- Ambulances
- Emergency services (fire trucks)
- Heavy trucks aimed at maintenance, gardening
- Artists and workers for the theatrical activities

Consequently there is not just **one** parking area, but as many as there are intrinsic activities and contemporary uses developed inside the archaeological site.

In the case of Villa Adriana (Tivoli), there are two main parking areas, one aimed at tourists and the other for workers, special visitors and people with physical disabilities. The first is close to the fence of the archaeological site and is a secure parking lot that opens and closes at established times, the same as the archaeological site. The other parking area is close to the main monuments of the archaeological site that lie on flat ground, in contrast to other parts of the villa that lie on a hill.

The first parking area has in its surroundings a series of other useful services (toilets, bookshop/gift shop, and ticket office), while the other one is close to the very core of the villa's built heritage and is provided with a drinking fountain, an interpretation centre with a reconstructed model of the villa and rest rooms. On special occasions, it is possible to use this parking area when it is necessary to bring heavy equipment closer to the area, but there is also the possibility to use a series of "safe" paths that lead to the main monuments, such as the great thermal baths, during the theatrical season. It is important to note that the presence of a *criptoportico* or *via tecta* has to be taken into consideration in order to avoid the structural risk caused by heavy trucks (moving or parked) on underground fragile vaults. In particular, a net of tunnels surrounds the thermal baths, while in other situations these are vaults for at the drainage system; these hidden structures have to be reinforced during special events because of the prolonged presence of vehicles.

Public transportation

Tourist offices, bus and train stations in the surroundings of an archaeological site should be provided with brochures and informative materials aimed at helping visitors to get to the main touristic attractions, as well as hotels and main communication nodes (airports, ports, etc.). Informative materials have to be translated into the main languages (English, French, German, etc.) and at kiosks and ticket offices the presence of people able to speak one or more foreign languages is advisable.

Web sites can provide useful information by means of three kinds of sites:

- Town (city council) website
- National town WIKI website
- Transportation suppliers websites

It is also very important to highlight through signs the presence of official taxis in the main communication nodes (airports, ports, etc.) in order for tourists to avoid the bad experience of having to confront unprepared taxi drivers who swindle with excessive fees. On the contrary, it is very important to display in every means of transportation the prices of tickets, rentals, etc. in order to avoid misunderstandings and confusion. These kinds of problems create very bad impressions on tourists because, in many cases, these experiences happen at the beginning of the vacation and can compromise the good reputation of a country. This last consideration has nothing to do with direct management of contemporary activities of an archaeological site, but it is important to remind the importance of these aspects to the people in charge of local policies aimed at the improvement of tourism and economic activities.

During special events inside the archaeological site, coordination between service suppliers is fundamental, in particular among those responsible for public transportation. Sometimes the events, performances, etc. are held during the evening and may last until late; for those performances held at non-urban archaeological sites or in the case of a lack of hotels in the immediate surroundings of the ancient theatre, it is necessary to make provisions for special public transport, taxis, buses, etc. complying with a special schedule in order to ease the return of the attendees to their hotels and accommodations.

Accommodations and restaurants

In order to provide to tourists the most comfortable stay within the cultural cluster, it is fundamental to supply, before and during the visit, detailed information about accommodation, restaurants and the supply of general services. To do this, info points and web resources play a crucial role for the planning of a pleasant stay inside the Cultural Cluster, but the activities carried out by these offices should be the expression of an integrated policy aimed at sharing information and purposes between local managers of culture, politicians and stakeholders-investors that operate at the level of the cultural cluster. The general improvement of cultural

FUNDAMENTALS 195

RESOURCES
Public transportation

At the info points of Cartagena (Murcia, Spain) there are flyers and brochures that provide different kinds of information, among which can be found two maps, one at the provincial level and the other at the town level.

RESOURCES
Public transportation

RESOURCES
Flyers

Accommodations and restaurants

Sagunto's tourist flyer

Categories:
- rice (paella)
- meat/steakhouse
- Self-service
- Sandwich/hamburger
- Buffet
- Take away
- Fusion food
- Italian
- Mediterranean food
- Oriental
- Vegetarian
- Fast food
- Sea food

Accommodations:
- Hotels
- Camping
- Apartments
- Bungalows
- Main parking areas

Hotel info:
- Quality (stars)
- Name of the hotel
- Address
- Telephone
- Fax

Restaurants-local gastronomy names and locations:
- Playa
- Town
- Port

and economic conditions is strictly linked to the capability of a site to receive in standardized conditions visitors and tourists, in particular from foreign countries. The total capacity of the site has to be quantified in order to avoid overbooking and, at the same time, it is important to have at one's disposal statistics about the maximum number of visitors in relation to the months of the year, detect the peak season and consequently design a general policy aimed at managing and receiving the influx of tourists. Hotels, campgrounds, apartments, bungalows, etc., have to comply with national and international regulations and laws about hygienic standards in order to have their quality certified; moreover, at planned times they have to be checked for the certification renewal. It is a priority for the reputation of a high level archaeological area to guarantee the healthiness and safety of drink and food served in the surroundings of the site; this is not just a bureaucratic matter, but has to do with the improvement of marketing skills of the stakeholders and the institutions operating at the local level. In this sense, it is important to take into consideration the importance of the creation of certified brands/consortiums concerning the quality of food, in particular when they are the produced inside the Cultural Cluster. This strategy includes the catering, but also the accommodation industry, because in general tourists feel reassured and attracted by a certification of quality that guarantees the standard level of typical products as well as the way they are hosted inside hotels: they know that they can find trained staff able to speak their language and that know their different cultural features. This strategy does not just need an important design and coordination phase, but also the skill to promote and disseminate the work done to provide healthy and quality food to consumers under a common brand/certification.

ATTACHMENTS 4

A.4.1	SEGESTA DECLARATION (Digital version)	
A.4.2	SIRACUSA CHART (Digital version)	
A.4.3	VERONA CHART (Digital version)	
A.4.4	ICOMOS International (Digital version)	

ATHENA PROJECT
ANCIENT THEATRES ENHANCEMENT FOR NEW ACTUALITIES
DIAGNOSTIC

5. Ancient Theatre Usage Manual

The Ancient Theatre Usage Manual is a document aimed at carrying out the diagnostic phase and the subsequent Action Plans starting from the information provided on a particular theatre. This document will be completed for the Jarash theatre (Jordan), and is intended as a manual for managing current uses and possible future ones. The output document can then be used as a reference model for other manuals of theatres, concerning the sustainability and compatibility of activities of theatres and odeas inside archaeological sites.

The study and analysis of some of the parts of this manual is made using the results of questionnaires developed by IPELSHT / IRP. These should be filled out during the theatrical season in Jarash. Then the results will be processed by means of the following tables: 5.2 "User's Profile" and 5.3 "Time distribution", that later will be used in the section "Actions Plans". The outputs will be used to carry out an analysis that evaluates the level of compatibility of uses and activities performed that do not form part of the intrinsic activities of the specific theatre.

5.1. CULTURAL CLUSTER DEVELOPMENT

Carrasco (2006): *Medir la cultura. Una tarea inacabada*, Periférica nº 7

Myers, D. Smith, S.C. and Shaer, May (2010): *A Didactic Case Study of Jarash Archaeological Site, Jordan: Stakeholders and Heritage Values in Site Management.* The Getty Conservation Institute. Department of Antiquities Hashemite Kingdom of Jordan.

Rapetti (2006): El problema del financiamiento de la cultura.

Rapetti, Sandra, (2001). Pasión por la cultura. Una investigación sobre la gestión, el financiamiento y la problemática de las organizaciones culturales de Montevideo.

Rausell, P. (2007): *Cultura. Estrategia para el desarrollo local. Agencia Española de Cooperación Internacional.* Ministerio de Asuntos Exteriores y Cooperación.

Rausell, P. and Carrasco S (1999): El Patrimoni Industrial de Sagunt: Un Factor Possible de Desenvolupament Territorial, en Revert, X. *Industrialización y Patrimonio en Puerto de Sagunto.* Edit. Universitat de València, pp.83-90

Rausell, P. y Martínez, J: *Apuntes y herramientas para el análisis de la realidad cultural local.*

UNESCO (1986): *The UNESCO framework for cultural statistics. Third joint meeting for cultural statistics.*

5.1.1. SOCIO-ECONOMIC AND INTANGIBLE ASPECTS

Throughout this chapter, we will address those aspects relating to the cultural sector that will allow us to make a diagnosis on the cultural reality of a territory, and provide us with a starting point for the establishment of development strategies based on cultural activity.

The main objective of this chapter is the completion of a master plan whose purpose is to indicate the guidelines to be followed to achieve bottom-up development through the use of the historical and archaeological heritage of a region. Specifically, we study the potential of ancient theatres in order to promote development of a Cultural Cluster.

From the socio-economic point of view, we reflect on benefits that we could develop in the area. The population is the main recipient of these benefits and can improve their quality of life (environment, services, etc.). Ultimately, the benefits that development brings are based on conservation, tourism, artistic, educational, historic, commercial and cultural use of the historical and archaeological heritage that many of our cities have.

In order to generate sustainable economic development based on a Cultural Cluster, it is important to know the starting point. Once the resources, the stakeholders and other aspects of the region are known, the objectives for the design and implementation of the strategy to be developed can be defined. Finally, in the Action Plans, the results that are obtained will be planned and assessed in order to facilitate continuous improvement and success in the economic development based on the Cultural Cluster.

Thus, this work tries to design lines to follow in order to make the diagnosis of the socio-economic and intangible aspects of the region. This chapter will set out guidelines to follow in order to plan the diagnosis of the socio-economic and intangible aspects of the region. In some sections, when possible, we will try to illustrate the concepts with the data from the city of Jarash.

5.1.2. CULTURE-BASED DEVELOPMENT - CULTURAL CLUSTER

This part develops different aspects that characterize or define the Cultural Cluster, a cluster based on heritage and, in particular, the ancient theatres.

The Cultural Cluster is characterized by collecting in a territory a range of cultural activities, i.e. a cultural offering that can take very different forms, from the cluster focused on activities related to the performing arts, such as concerts and festivals of music and theatre, or others where the main sources of income are the production and marketing of local handicrafts and farm products. In our case, the objective will be to determine which set of activities could define a cultural offering to the zone, able to generate a level of employment that increases the standard of living of the population.

The cultural offering in the cluster must have its origin in products and activities that show the specificity and the idiosyncrasy of its people or society. This offering must be attractive for both local residents and tourism from other countries. A cultural offering needs facilities and cultural infrastructure for its development. Therefore, if the cluster has an orientation toward cultural tourism, it will be very important for the transport infrastructure as well as other tourism services like travel agencies and hotels.

Beyond the equipment and infrastructure issues, the success of a cultural cluster, its ability to create cultural products that generate income and development opportunities, is the degree of interrelation between the agents. Aspects such as trust improve the relationship among companies and thereby information is transmitted, generating new knowledge and innovation.

Another important feature of the cluster is governance. There are clusters in which there is no coordinating entity and decisions are decentralized, but there are others where there is a "central authority" that makes strategic decisions. Financing is also an important issue and there are several types, but in all cases it requires public participation for the financing of equipment, resources and infrastructure.

The main goal of this paper is to determine the lines of action to put in place a sustainable cultural cluster. Ultimately it will be determined, based on the resources of the area, how the culture cluster will be defined, which cultural products will be offered, and how cultural offerings will occur.

In addition, it is necessary to analyse various socio-economic aspects that will be relevant to future design strategies.

1. Analysis of the demand characteristics for cultural assets: It should look at the demand in order to identify which cultural products to develop. To do this, we will have to conduct a survey in which aspects related to the profile of the current users and possible future attendees are collected, as well as to detect their needs.

 - Size of the population, potential local demand, and characteristics of those who demand the culture: age, level of income, profession, level of studies, patterns of cultural consumption current needs, etc.
 - Tourism: profile of the tourist, current tourist products, potential of the sector.

2. The agents belonging to the cultural sector: public institutions, cultural enterprises, organizations and non-profit foundations. At this point it is important to determine the mechanisms of governance of the cluster, i.e., decision making, the choice of which agents are involved and how.

It is necessary to recall that we are looking for bottom-up development; actions should be implemented from the bottom. In this sense the participatory mechanisms are very important: the strategies and actions must be defined with the consensus of those involved and the action plan should be a plan in which all participants feel motivated and identified. Such strategies above and below require that they are defined by the very agents who must carry them out; these agents are those who best know the characteristics of the territory, the intervention of the public sector will be necessary to facilitate the mechanisms for cooperation and development of the cluster.

In terms of local development, our goals in the short term include implementing the definition of cultural activities base, the support for such activities, the construction of equipment and the improvement of infrastructure. It is hoped that the cultural activities undertaken are able to attract other types of activities (other cultural activities different from the initial, and other complementary activities like restaurants, hotels, excursions, sale of local handicrafts, among others). Once the cluster is set up, the learning experience will allow the undertaking of new cultural products, new uses or new markets.

5.1.3. IDENTIFICATION OF RESOURCES

The first stage in the analysis is to define the guidelines to be followed in order to identify existing resources in the region. We will look for resources needed to generate a cultural cluster based on the theatre. Later we will pay attention to associations and foundations due to the high involvement they have in the cluster based on the historical heritage, for the conservation of this heritage, as well as the management, financing and organization of various cultural products which may develop in the theatres. Finally, we will identify the stakeholders and investors.

TANGIBLE HERITAGE

RELIGIOUS CULTURAL RESOURCES
- CHURCHES
- CATHEDRALS
- CONVENTS
- TEMPLES
- SYNAGOGUES
- HERMITAGES
- CHAPELS
- MONASTERIES
- OTHER

MONUMENTAL CULTURAL RESOURCES
- ANCIENT THEATERS
- CASTLES
- PALACIOS
- UNIQUE HOMES
- LANDMARK BUILDINGS
- WATERWORKS
- MAIN SQUARES
- BRIDGES
- MILITARY CONSTRUCTION
- WALLED ENCLOUSERES

MATERIAL RESOURCES LINKED WITH HISTORY
- ARCHAEOLOGICAL SITES
- DOMESTIC ARCHITECTURE
- STREETS WITH HISTORY
- DISTRICTS
- ROMAN BATHS
- ARAB BATHS
- ARTISTICS ROUTES
- PARKS

RELIGIOUS CULTURAL RESOURCES
- CULTURAL LANDSCAPES
- INDUSTRIAL CENTERS
- ENGINEERING WORKS

TANGIBLE HERITAGE
- MANUSCRIPT
- DOCUMENTS
- WORKS OF ART AND CRAFTS
- HISTORICAL ARTIFACTS
- NATURAL SCIENCE COLLECTIONS
- RECORDINGS
- MOVIES
- PHOTOGRAPHS
- OTHER

INTANGIBLE HERITAGE
- CULTURAL EVENTS
- ORAL TRADITION
- GASTRONOMY
- CRAFTS
- LITERATURE
- MUSICAL EXPRESSIONS
- TRADITIONAL INSTRUMENTS
- THEATRICAL TRADITIONS
- FESTIVALS
- RITUALS AND CUSTOMS
- LIFESTYLES
- ETHNIC STORIES
- CULTURAL FESTIVALS
- POPULAR RELIGION
- WORKING TOOLS
- WAYS AND RESOURCES OF TRANSPORT

5.1.3.1. ORDINARY AND SPECIAL RESOURCES FOR THEATRE AND CC

To be able to make a cultural offering a "success" as a set of different cultural activities, we must first identify the tangible and intangible resources that we have, particularly those that would be involved in the cultural offerings of the cluster based on the theatre. This will require the following steps:

- Identify the tangible resources and potential intangible resources of the area.
- Classify and value resources to ascertain a possible relationship with the theatre as a cultural offering. Assess the resource to determine its historical, artistic value and its potential as a tourist resource, among others.
- Establish the activities or products that define the offering or cultural base of the area.

1. The identification of tangible resources is not one of the most difficult tasks as in many cases there is an inventory of existing resources, in others mere observation enables us to identify where the cultural heritage of the area is located. The identification of intangible resources is often more complicated. One participative way to plan this would have two phases: initially, from a sample of population of the universe, try to identify the main resources. This list should include and differentiate the various types of tangible and intangible resources.

In the case of Jarash, researchers Myers, Smith and Shaer identify the following tangible resources:

Aerial view overlooking the archaeological site of Jarash. In the foreground are the Cardo and the North Theatre. The Temple of Artemis is at the upper right.
Photo: Courtesy David Kennedy
Source: Myers, Smith and Shaer (2010)

Satellite image showing the path of the ancient city wall of Jarash (solid line) and the archaeological park owned by the DoA (area left (west) of the yellow dashed line). The area of the ancient city to the east (right) of the dashed line is obscured by modern development.
Photo: © 2008 DigitalGlobe, © Google.
Source: Myers, Smith and Shaer (2010)

The locations of all monuments are indicated on the map of Jarash:

TANGIBLE RESOURCE LIST OF JARASH			
1	Hadrian's Arch	27	Synagogue Church
2	Chapel of Bishop Mananus	28	North-West Gate
3	Hippodrome	29	Church of Bishop Isaias
4	South Gate	30	North Theatre
5-6	Temple of Zeus	31	Byzantine House
7	South Theatre	32	West Baths
8	The Oval Plaza	33	North Tertapylon
9	Macellum	34	North Gate
10	House of "The Blues"	35	Water Gate
11	South Tertapylon	36	South Bridge
12	Umayyad House	37	East Baths
13	Mortuary Chapel	38	Procopius Church
14	Church of Saint Peter and Paul	39	Church and Roman House
15	South-West Gate	40	Byzantine House
16	Church of Bishop Genesius	41	Small Byzantine Baths
17	Church of Saint Comas, Damian, Joan the Baptiste and George	42	Chapel and Elies, Marta and Soreg
18	Temple C	43	House of "The muses and the poets"
19	Church of Saint Theodore	44	Church of the Prophets, Apostles and Martyrs
20	Clergy House and Baths of Placeos		City Walls
21	Cathedral		Tombs
22	Nymphacum		The Cardo
23-24	Artemis Church and Propilaea	D	Museum
25	Mosque and roman villa		Agora
26	Temple of Artemis		Tombs

Source: designed by author from Myers, Smith and Shaer (2010)

2. Once identified, the tangible and intangible resources should be assessed to establish a hierarchy, depending on the characteristics that define the importance of the resource for encouraging socioeconomic aspects. To obtain this information we could perform surveys of certain users related to the culture sector, such as artists and professionals, public and private managers, critics, etc.

Based on the classification of Rausell and Carrasco (1999) we can assess the tangible resources from the following categories:

- Antiquity.
- Status of conservation.
- Historical relevance.
- Artistic and architectural value.
- Symbolic value.
- Ability to generate cultural activity.

This evaluation of tangible resources must be carried out with experts in heritage, culture and traditions of the area.

For intangible resources, it is possible that the process could be more extensive. First of all, we must make an initial study that allows us to create a list of possible intangible resources. This study should be done over the whole population. It should involve the local population, potential consumers of local products, as well as other agents involved in this sector, workers of cultural businesses, cultural institutions and experts in the field. The aim is the identification of intangible resources that are able to generate local development by increasing employment and the quality of life of the inhabitants of the region.

Once we have a list of intangible resources, we must evaluate and rank them because, as we know, resources are limited and future measures must be aimed at those actions that have real impact on the economic and social fabric of the area.

Following Rausell (2007, p. 125), the categories that we could establish for the valuation of intangible resources are as follows:

- Intrinsic importance: Refers to the subjective perception of the respondents with regard to their general relevance, independent of the possibilities of use.
- Usefulness as a tourist resource: In this category we must evaluate the potential of the resource to become an element that generates attraction to the area and a flow of visitors.
- Utility as an element of local identity: Here we measure the potential of the resource to generate or strengthen the feeling of belonging to a local identity.
- Utility as an economic resource: The resource is evaluated for its potential to create business and professional activities related to the symbolic element referred to.

Qualified partners are requested to prepare an exercise of simplification quantifying from 1 to 5 (1 = none, 2 = moderate or limited, 3 = significant, 4 = important, 5 = very important).

As we have seen, making cultural activity sustainable over time requires a diversified range of activities both cultural and complementary. Once existing cultural resources are known we will have to determine what assets or resources could have a relationship with the theatre, both from the perspective of cultural tourism as well as a space that can accommodate other cultural activities, particularly those related to the performing arts.

We must search for synergies between the theatre and other tangible and intangible resources. In this part we have to identify:

- Any tangible resources which can be related to theatre: Other upcoming monuments, for example closed spaces in which activities related to theatre could take place, other cultural activities such as museums, other nearby spaces of the same historical period, streets, walks, etc.

For example, in Jarash there are two ancient theatres located within the archaeological heritage of the same era.

- Other intangible resources that could have relation to the theatre.
 - Local and regional festivals.
 - Cultural events.
 - Local festivities.
 - Traditions and historical facts.
 - Local artistic activity: actors, musicians and singers.
 - Amateur theatre festivals.
 - Contests: prizes cultural activities, social policies.
- Tours, themed tours.

5.1.3.2. ASSOCIATIONS AND FOUNDATIONS

Associations and cultural foundations are important key agents in cultural activity. They develop different roles and can support culture in different ways. These institutions can be broadcasters of the culture, they can organize activities such as exhibitions, festivals, competitions, lectures, concerts, or they can put the cultural production of the artist in touch with the consumer of culture. Finally, these entities can provide funds for stimulating the culture.

A study on associations and foundations should contain the following points:

	ASSOCIATIONS	FOUNDATIONS
Name:		
Cultural sectors associated with them (music, literature, dance, folklore, theatre, cinema, painting...)		
Brief description of the activities carried out		
Ownership (public, private or mixed)		
Sources of funding		
Other information of interest		

A model of a checklist for the collection of relevant information from various foundations and associations are set out below.

Table 2. Collecting information from foundations and associations

Cultural environment in which it operates	(Music, theatre, dance, painting, literature, folklore and traditions, cinema...)		
Brief description of recent activities			
Sources of funding	Private	Public	Public-Private (indicate % public)
Degree of collaboration with public entities	(% of billing and brief description of planned collaboration)		
Organization data	Social Address	Nº of founding members	Nº of workers

5.1.3.3. STAKEHOLDERS AND INVESTORS

To perform a proper diagnosis, it is necessary to know the institutions and companies that have some degree of direct or indirect influence on the heritage and cultural activity. You must identify and assess the activity of the following agents:

- Public agents and institutions.
- Cultural agents:
 - Festive or cultural associations.
 - Private non-profit related cultural institutions.
 - Educational centres.
 - Sponsorship companies.
 - Individual personalities from the world of culture.
 - Cultural enterprises.
 - Companies and agencies specialized in the management and organization of events.
 - Companies' production mediators who develop the connection between the artists and the creation/production/distribution structures. An example is the literary agent, the gallery owner of the artistic representative, the manager, etc.
 - Distribution and consumption.
 - Artistic or technical training in professions related to culture.
 - Dissemination, communication, multimedia, marketing.
 - Conservation of heritage.
- Companies outside the scope of the culture but related to:
 - Craftsmen and shopkeepers.
 - Tourist activities: hotels, restaurants, transport, etc.

The diagnosis of the stakeholders can be carried out by observation of the official statistics, by surveys, or both of them. It is important for the study to collect different activities carried out in the area, the culture, as well as the scope and the quality of the services of each of them. In the same way, it is necessary to faithfully reflect the economic zone reality, because we are looking for bottom-up development resulting from uses that give to the historical heritage of the place.

As example for the collection of data on the identification of enterprises can serve as follows:

Table 3. Company data

Name of the company				
Property	Private	Public	Public-Private (indicate % public)	
Brief description of the main activity carried out by the company				
Field of action	Local	Regional	National	International
Brief description of other activities carried out by the company				

Myers, Smith and Shaer (2010) brought us some examples of stakeholders of the city of Jarash:

Two examples of Stakeholders of Jarash

STAKEHOLDER CATEGORY	STAKEHOLDER GROUP (*for primary stakeholders)	VALUES (*for highest priority)	INTERESTS (*for highest priority)
National Government	*Department of Antiquities	*Scientific, educational	*Protect and preserve the antiquities
Business	Handicraft seller	Economic	Contribute to archaeological knowledge, educate visitors and locals

Source: Myers, Smiths and Shaer (2010)

5.1.4. ECONOMY OF CULTURE

Culture as economic activity is a very appealing activity because of its ability to generate economic growth and employment in a sustainable way. Cultural production is produced and consumed, in many cases in the territory. On the one hand, the development of cultural production allows the generation of employment, an increase in income and the well-being of citizens. On the other hand, it allows access to cultural items whose consumption increases the satisfaction or well-being of the inhabitants. The development of cultural activity requires some equipment that is enjoyed by the inhabitants of the area. In addition, the production and consumption of such items develop creativity. It is, therefore, an activity on which are based many local development and urban regeneration projects.

To determine the relevance of the cultural sector in a region it will be necessary to make an analysis of its cultural offering and demand of the sector. On the supply side we will have to know the extent of the cultural activities, artistic performances, concerts, festivals and events, tourism, etc. On the demand side, we have to analyse the sector, i.e. who are the consumers of culture and what are their characteristics? Once their qualities are known, we can diagnose the situation of the cultural sector to subsequently establish aims.

5.1.4.1. NATIONAL AND LOCAL ECONOMIC ANALYSIS

Carrasco (1999) defines the Local Cultural System as a conceptual instrument, with practical configuration of a cultural reality. According to Rausell (2007), the Local Cultural System is structured in three dimensions:

- 1st level: relations between local and supralocal authorities are studied.

- 2nd level: elements and relations that determine the cultural supply and demand at the local level.

- 3rd level: relates the cultural systems of different nearby localities, relationships of competition, complementary or antagonistic, which may exist between cultural organizations of other nearby localities.

ANALYSIS OF THE CULTURAL SUPPLY

The result of our analysis is a description of the set of goods and services, as well as the planning that is available to citizens, for a certain period of time, in a given territory. The areas include culture derived from heritage, through music and arts, as well as via games and sports. The EU also performs a classification that maintains the same structure and adds priority areas that take into consideration the participation, employment and financing of culture.

1. The *material heritage*: This category includes those assets with a cultural value, in this case tangible or material (theatres, museums, monuments, etc.). In order to facilitate the collection of information, we will classify the cultural supply in the following categories:

 - Deposits and non-visitable archaeological parks. The visitable ones are not considered in this chapter as we consider them in the section on cultural equipment.

 - Real estate: this chapter incorporates the unique buildings of remarkable importance devoid of public visitors, sometimes offering special conditions of accessibility.

 - Museum Collections: in this chapter we differentiate between museums and collections. In museums are incorporated all those collections owned or exposed by the museum, but we will also have to identify those public and private collections with scientific or artistic importance that do not have conditions to be displayed to the public.

 - Libraries: Usually they are one of the facilities that often provide information about their contents, operations, etc. Libraries are containers of documents, files, books, etc. that are part of the cultural offering. It is recommended to include files (films, documentaries, and historical).

2. *Cultural programming*. The performing arts include cultural and artistic manifestations that are represented and performed uniquely on the stage including theatre scripts, theatrical pieces, choreography, etc. Also included in this category are theatre, dance and musical performances (classical, opera, modern, folklore and traditional). All the events, the administration and the private sector, will be considered. The data that we obtain, in

each of the cultural sectors, depend on the nature of the same. In the case of theatrical performances we are interested in aspects such as: number of theatrical performances, represented works, volume of attendance distributions of sessions between amateur and professional theatre, as well as the profile of consumers of different assets.

3. *Creation of original musical works*: modern, traditional music or opera, among others.

4. *Plastic arts include the artistic presentations* whose result or purpose is the creation of an original and unique work, in which the principal aim is the visual dimension (painting, sculpture, architecture, etc.).

5. *Intangible heritage:* In this category we include festivals, local traditions, local gastronomy and handicrafts, among others. These elements, in many cases difficult to measure, provide key potential benefits for many areas related to cultural tourism. It is important to identify them from the study of the potential supply and demand of consumers, and value their potential to the future policies of local development and cultural tourism-related instrumentation.

6. *Literature and publishing production.* In this section we consider literary production (novel, theatre, poetry, etc.). Regarding publishing production, it is easily to identify and measure through the database of the International Standard Book Number ISBN. The index is divided into four parts that indicate: 1) the code of country or language of origin, 2) the publisher, 3) the item number, and 4) the check digit. From this, we can identify the types of publishers: private publishers, author-publisher, private non-profit institutions, general, regional and local administrations, public and private educational institutions, and public and private cultural institutions.

7. *Cinema:* We measure the local activity from the exhibition halls. We are interested in aspects such as the number of halls, seats, spectators, or number of films screened. It is also interesting to note aspects such as the origin of films and fundraising films and rooms.

UNESCO (1986) - For the identification of the cultural supply, a model is proposed which establishes ten areas for cultural manifestations and five functions (within the process of cultural activity). Carrasco (2006) made a model that we consider useful for the realization of a diagnosis. In addition to the two previous categories, areas and processes, is added a third, resources which include human resources, the financial, equipment and infrastructure.

Table 4. Fields and functions in the cultural offering - General framework of UNESCO and EU

UNESCO		EU		
Fields	Functions	Fields	Functions	Priority issues
Heritage	Creation and Production	Heritage	Preservation	Participation
Printed materials and literature	Dissemination and Distribution	Archives	Creation	Employment and infrastructure
Music	Consumption	Libraries	Production	Financing
Performing Arts	Register	Books and newspaper	Dissemination	
Visual and Plastics Arts	Participation	Visual Arts	Business	
Cinema		Architecture	Training	
Radio y Television		Performing Arts		
Social and cultural activities		Audio-visual and multimedia		
Plays and sports				
Nature and Environment				

Source: Carrasco (2006): "Medir la cultura. Una tarea inacabada", *Periférica* nº 7

Once the different cultural goods and services within the marked areas are identified, we can combine the fields and functions and get an array that can be valued as manifesting different functions in each of the categories or areas. For example, in the field of the performing arts there are companies or organizations of production and creation, as well as distribution and diffusion, consumers, etc. Thus we can assess the situation of supply by identifying where there may be potential advantages or shortcomings.

The functions relating to the cultural offerings are classified into:

- *Creation.* Writing, composition, production of films, interpretation, performance, paintings, sculptures, etc.
- *Production.* It is the action that produces the cultural goods and services.
- *Registration.* It includes the conservation and preservation of heritage (restoration of documents, traditions, landscapes, etc.).
- *Dissemination.* Transmission, distribution and promotion of activities related to festivals, concerts, exhibitions, and in general the consumption of cultural assets.
- *Consumption.* Visits, attendance on site etc.

CULTURAL POLICY AND CULTURAL SUPPLY. ANALYSIS OF THE CULTURAL BUDGETS

The budgets in the cultural area can offer useful information relating to the cultural policy carried out by the different administrations involved in the cultural policy of a territory, especially local and regional administrations. Generally, the main source of information is the city councils.

Budgets will allow us to know, among other aspects:

- Expenditures relating to various activities (courses, workshops, exhibitions, performances, etc.).
- Aid or subsidies to associations, companies, groups, etc.
- Spending on investment in infrastructure of the administration in the cultural field (for example, maintenance of monuments, construction of auditoriums, etc.).

In addition to the above measures there are other measures of support to the cultural sector such as tax advantages applied to donations from individuals and corporations to the cultural sector. Corporate donations are usually sponsorship and donation. Government support options are oriented both to directly provide a good as well as to establish measures that will encourage the support of culture by the private sector, both individuals and corporations. Sponsorship and donations are found in this case.

ANALYSIS OF THE CULTURAL DEMAND

The analysis of cultural demand will attempt to determine the profile of the applicants for cultural goods and services, from the point of view of the characteristics of the population and its cultural consumption, what goods consumers demand and which elements bring satisfaction, as well as those that should be improved.

The sources of information used will be secondary sources such as censuses and official surveys; primary information will also be required, which is obtained from personal surveys and interviews. For the analysis of the cultural demand market (field studies and statistical analysis) research tools should be used.

Basically, the features that we want to know about the demand for culture are divided into two fields: socio-demographic data (age, level of studies, etc.) and those relating to the types of goods and services consumed. The socio-demographic characteristics of the localities are a source of relevant information as the cultural consumption is strongly related with both levels of income and the level of training of the population, among other aspects. We can get some of these features from the usual sources (censuses, registers, official surveys on the labour market, some of them accessible by electronic means).

The most relevant demographic variables are: the demographic structure of the population, level of studies, characteristics of the work market, and income levels, among others.

However, approximating models of cultural consumption of the population requires having one's own surveys. Before diving into the study of demand, we could conclude that the demand for culture decreases with age and increases with educational level and income level.

Then, we will focus on analysing the elements that are part of the process of primary information. The survey should be presented to all participants at different cultural events, performances, tours, etc. They will be structured into three sections:

- General data of the respondent.
- Data relating to cultural consumption.
- Other aspects: assessment of the visit, taxes to pay for care, cultural tourism financing, etc.

From the collection of the surveys we can determine the profile of consumers of current cultural goods and their preferences regarding certain issues. The following variables collect the general data of the survey respondent:

- Sex.
- Age.
- Level of studies.
- Occupation.
- Level of income.
- Place of origin.

Studies reveal that people who visit these places often have a high level of cultural behaviour. The surveys will be very useful to measure aspects such as the level of satisfaction by the visit. A scale from 1 (not satisfactory) to 5 (very satisfactory) can be used. Among other things that could be analysed:

1. Purchases
 - Typical products.
 - Typical crafts.
 - Guides and catalogues.
 - Others.
2. Types of attractive.
 - Visits to monuments and historical sites.
 - Visits to museums.
 - Visits to art galleries and exhibitions.
 - Concerts and music festivals attendance.
 - Theatrical and arts performances attendance.

3. Types of actions that are greater for cultural development.

In order to improve our knowledge and differentiation of the people who come to visit cultural attractions, it is useful to study the market sections that will allow us to describe the characteristics and behaviours of different consumer groups. Easily observable variables can be used to differentiate such as the age, sex, etc. As well, there are variables that reflect the travel motivation and attitude of tourists or local consumers, although these variables are subjective and more difficult to uncover.

We could try to determine market segments for the cultural demand of the area as a single unit, or focus on specific cultural properties, such as visits to museums and historical heritage or attending events. Market segments usually tend to be defined by more than one variable, as generally the profile of consumers from every segment is determined by several characteristic variables (sex, age, level of studies, types of goods consumed, provision for payment of taxes, etc.). To determine the market segments, we have to apply some statistical method that can measure the existence of relationship and dependence between the variables of segmentation (or variables such as sex, age, etc.).

As an example, we could use the method of Chi-square contingency tables. This method examines the relationship between two qualitative variables. The null hypothesis is that the variables are independent, against the alternative hypothesis that the variables are dependent. The statistical method employed is based on the differences between the values observed in the sample and the values expected under the null hypothesis. The critical region is composed of high values of statistics that show the greatest difference between observed values and expected values. In these cases we support the alternative hypothesis, which means a dependency between variables.

Content to take into account for the study of cultural demand[1]:

PART 1. CULTURE

On a scale of 1 to 5 (1 = none, 2 = low, 3 = moderate, 4 = quite a lot, 5 = high) what is your interest in...?
1. Theatre
2. Popular traditions
3. Popular music
4. Classical music
5. Modern music

6. Classical art
7. Photography
8. Cinema
9. Gastronomy
10. Others

Indicate:
11. Numbers of times (approximately) you attended a theatrical performance last year.
12. Numbers of times (approximately) you attended a concert of classic music last year.
13. Numbers of times (approximately) you attended a concert of modern music last year.
14. Number of times (approximately) you attended a performance related to classic art (dance, opera, etc.) last year.
15. Number of times (approximately) you visited a museum or theatre last year.
16. Numbers of times (approximately) you attended an art exhibition last year.
17. Numbers of times (approximately) you attended a folkloric festival last year.
18. Numbers of books (approximately) you bought last year.
19. Numbers of videos (approximately) you bought last year.
20. Numbers of music CDs (approximately) you bought last year.
21. Suppose that public administration granted about 100 € (translated into each country's currency) how would you like the money to be distributed among these types of cultural assets?
 a. Tickets for performances of theatre, music, opera and dance.
 b. Purchase of disks and books.
 c. Registrations for courses about theatre, music, dance etc.
22. Have you received some kind of artistic training in last 10 years? Yes/No
23. If yes for the above question, indicate in which category you received the training:
 1. Theatre
 2. Music
 3. Dance
 4. Design
 5. Paint
 6. Sculpture
 7. Photography
 8. Cinema
 9. Others
24. Do you belong to any theatre group?
25. Do you belong to any cultural association?
26. Do you belong to any festive or traditional association?

[1] Based on the work done by Rausell, P. y Martínez, J: *Apuntes y herramientas para el análisis de la realidad cultural local.*

PART 2. SOCIODEMOGRAPHIC ASPECTS

1. Age
2. Sex
 0. Man
 1. Woman
3. Nationality
4. Level of studies:
 1. None
 2. Primary school
 3. Medium
 4. High (University)
5. Employment status:
 1. Employed
 2. Unemployed
 3. Student
 4. Retired
 5. Housework
 6. Do not want to answer
6. Family status.
 1. Single without dependents.
 2. Single with dependents.
 3. Married (couple) without dependents.
 4. Married (couple) with dependents.
 5. Others.
7. Family Income (set intervals)

ANALYSIS OF TOURISM DEMAND

1. Evolution of national tourist entries.
2. Evolution of foreign tourist entries.
3. Evolution of overnight stays.
4. Evolution of entries by provenance.
5. Seasonality of overnight stays.

Tourist's profile
1. Last time you visited the zone.
2. Average stay.
3. Visits.
4. Transport used.
5. Average expenditure of tourist per day.
6. Travel (travel agency, by internet, etc.)

FINANCING

At this point we will examine the different mechanisms of financing of cultural activities. Generally, cultural activities are maintained by public funding, in addition to private. Over time, different mechanisms have appeared that lie somewhere between the private and public sectors. Financial support of the public sector comes from funds designated for the financing of cultural activities and the support of culture through the establishment of incentives and tax breaks to those who allocate portions of their funds to sponsors or patronage.

The various possible mechanisms for financing cultural activities are as follows. The study of the sources of funding is necessary in order to make a diagnosis of the situation of cultural activity. In addition, analysing new possible ways of financing is a fundamental aspect for the definition of successful performance strategies. We highlight the following funding mechanisms in the field of culture:

- Budgets, expenditure for the financing of cultural activity.
- Grants, aid to companies, foundations and organizations related to culture.
- Patronage. It is an activity related to the protection of the arts and culture. In various countries, the Patronage Act involves tax relief for funds invested in protecting the arts. Patronage implies private financing - by companies, individuals, business foundations, etc. of certain activities or cultural institutions. The activities of patronage, especially by companies, often have an interest related to the dissemination of their image.
- Sponsorship. It is an investment of an entity to protect or promote an event. This investment is part of the communication or the company's marketing budget. It involves the donation of aid from a company in return for some compensation, usually advertising. Patronage and sponsorship are the same in their process, however, they differ in their aims, while the goal of sponsorship is strictly commercial, patronage has apparently altruistic purposes.
- Fundraising. Generally, we can define it as attracting private funds for a philanthropic cause. It is the creation of a communication strategy to raise funds and other resources that do not have stable forms of funding. A fund-raiser is designed for the organization and implementation of non-profit organizations workers' on going fundraising plans.
- Direct payment (inputs). Certainly, the payment for tickets to shows, visits, concerts, etc., is a basic source of income. In the case of activities carried out by private companies, the price will respond to an analysis of costs and the amount willing to be paid by consumers, based on supply and demand. In many cases, this income is not enough is sustain an activity. We have to compare the prices of our cultural heritage with other territories.

- Merchandising. For this, we include all revenues associated with the sale of products in the cultural spaces themselves. In the case of museum merchandising, income derived from the sale of assets is included, including books of collections and related literature, stationery items and souvenirs, among others.
- Voluntary social activity. Realization of non-remunerated work, groups or individuals, in the production and dissemination of products and services. Financial partners and contributing institutions are also included in this category. These contributions are without anticipation of profit. It is the case of carnivals, religious activities or other theatrical groups.
- Among other sources of cultural activities income, there are:
 - Rights of retransmission of the product by electronic means.
 - Rights from licenses for the exploitation of the image or by-products.
 - Rights from granting of services (cafeteria, bookstore, etc.)
 - Rights granted from wealth management such as the renting of rooms.

The next table could be useful for diagnosing the structure of financing cultural activities. For its creation, we survey the different entities on their various sources of income and funds.

5.1.4.2. ACCESSIBILITY AND INFRASTRUCTURE

Cultural facilities are those buildings or spaces, which are commonly used for cultural activities, such as the representation of performing arts. In order to make a diagnosis of the cultural offerings, it is important to take into account the infrastructure status affecting the accessibility of the equipment.

In order to identify, measure and assess the level of the offering of cultural facilities, it is necessary to draw up an inventory of all the equipment currently existing in the area or region. This inventory list can be made up by sending out electronic forms aimed at those responsible for different equipment. To facilitate identification of the different facilities, we can build in the following classification:

a. Cultural infrastructure (cultural facilities) have been specifically designed and built for the development of cultural activities. We distinguish five categories:

1. *Performance spaces.*
 - Theatre
 - Performance spaces
 - Auditoriums and concert halls
 - Cinema spaces

Table 5. Financing of cultural activities

% SHARE OF TOTAL		THEATRE	OPERA	DANCE	MUSIC	ALL
Unearned income	Government					
	Sponsorship					
Earned income	Tickets					
	Sales (books, souvenirs,)					
	TV/Radio					
	Rent					
	Others					

Source: Rapetti (2006)

The table below offers some facts about the financing of non-profit cultural activities for different countries.

Table 6. Means of financing cultural activities.

COUNTRY	SERVICES AND FEES	STATE CONTRIBUTIONS	SPONSORSHIP/DONATIONS	SOURCE
Brazil	90	5	5	John Hopkins CNPS-2000
Argentina	97	2	1	John Hopkins CNPS-2000
Uruguay	92	4	4	Rapetti
Spain	41	24	35	John Hopkins CNPS-2000
United States	42	7	51	John Hopkins CNPS-2000
France	55	41	4	John Hopkins CNPS-2000

Source: Rapetti (2001)

2. *Exhibition spaces.*
 - Museums
 - Exhibitions spaces
 - Art galleries
3. *Documentation and training spaces.*
 - Academies
 - Conservatories, departments and higher schools
 - Libraries
 - Achieves
4. *Spaces of cultural exchange.*
 - Civic centres
 - Religious centres
5. *Real estate heritage resources of historical, artistic and landscape.*

b. Cultural infrastructure have been specifically designed and built for the development of cultural activities. We distinguish five categories:
 - Restaurants, café, pubs with cultural activities
 - Shopping and leisure centres
 - Hotels
 - Theme parks
 - Universities
 - Sports facilities

More than just a quantitative analysis of the cultural facilities, it would also be advisable to carry out a qualitative assessment of the enclosures, specifying the equipment for each kind of cultural event. Different items to be considered in the creation of a possible checklist for collecting information are listed below.

1. Identification data:
 1.1. Denomination
 1.2. Location
 1.3. Kind of resource/cultural equipment (theatre, concert spaces, exhibitions spaces, museums, etc.)
 1.4. Period/Style (building)
 1.5. Author/Architect
 1.6. Agency or people responsible for the conservation and promotion.
 1.7. Protection level
2. Conservation status
 2.1. Conservation status of the building or equipment.
 2.2. State of environment.
3. Accessibility and information
 3.1. Type of access (urban roads, pedestrian streets, outskirts, etc.)
 3.2. Direct transport
 3.3. Parking
 3.4. State of access
 3.5. Tourists signs
 3.6. Type of information provided (guides, brochures, and others)
 3.7. Promotion activities (information panels, media advertisements, and others)
4. Characteristics (related to performance equipment)
 4.1. Capacity
 4.2. Technical aspects (air conditioning, stage, stores, lighting, audiovisual, etc.)
 4.3. Services for actors and technicians (Dressing and rehearsal rooms)
 4.4. Human resources
 4.5. Technical equipment
 4.6. Shows programmed
 4.7. Services to the public (bar, lobby, cloakroom, accessibility, etc.).
 4.8. Covered enclosure
5. Assessment of the potential for tourism
 5.1. Visits
 5.2. Description of the current activity (representations, concerts)

Once the characteristics of the equipment have been analysed, we turn to analysing the transportation and communication infrastructure. In order to assess the potential of resources and the cultural offerings of a zone, we need to know the accessibility conditions from the point of view of transport. This issue is especially relevant in the case of cultural tourism since the possibility of receiving visits depends on the accessibility in terms of comfort, time and monetary cost. Thus, the potential of the sector will be higher when communications and accessibility (proximity to airports, ports, railways, expressways, etc.) are improved. To assess the situation, we also have to analyse the hotel capacity in the zone and, in the case of scarce accommodation resources, the possibilities for expansion.

When assessing the conditions of general accessibility we will consider:

- The distance and time to the airport from the nearest international connecting train stations.

- The distance and time to the nearest port (ports of travellers and cruise ships).

- Types of roads and transport networks with other populations in the region and the country.

- Existence of public transportation (typology, schedules, etc.).

- Conditions of accessibility from other locations and nearby destination regions.

5.1.4.3. TRADITIONAL LOCAL ACTIVITIES

Local economic development depends on the ability to mobilize the available and potential resources of the zone towards the satisfaction of needs and basic problems of the local population, and of the tourists who consume cultural products. This will require knowing, in addition to local culture and heritage:
- The local productive structure.
- Social work.
- Entrepreneurship.
- Technology.
- Natural resources.
- The local credit system.
- The social and political structure.

We must not forget that we are looking for development from bottom to top (bottom-up), so it will have to strengthen traditional local activities on the basis of a problem situation that we need to know.

How to know the local productive structure will depend on information that is available in each country. Thus, according to the study on the methodology for local development in Albuquerque, we could get information about:

State, regional and local statistical sources
Consultant reports
Databases
Local files
Press and local media
Business associations, chambers of agriculture, chambers of commerce and industry
Geographic and cartographic information services
Communication agencies and specific magazines
Financial institutions and fiscal system data
Registers of industrial property
Studies and university research
Studies of unions and workers associations

To make the diagnosis of the local economic structure and the traditional business we must analyse the following aspects:

A. Internal production structure.
 a. Main economic activities of the traditional activities at the local level.
 b. Dynamism of these activities.
 c. Most significant traditional local products.
 d. Productive relationships of local traditional activities.
 e. Technology trends in the main local activities.
 f. Possibilities for productive diversification in the traditional production.
 g. Developments of markets for major local products.
 h. Logistics, marketing and distribution of traditional products

B. Types of companies and business organization
 a. Companies of existing traditional activities, location, size and evolution -if it is possible it should put the business on a digital map with the help of a geographic information system.
 b. Inter-firm cooperation. Enterprise networks.
 c. Subcontracting.
 d. Existing business associations.

In addition, it is necessary to prepare a study on the population base and the local labour market. To do this, it would be interesting to know:

A. Demographic base:
 a. The local population pyramid.
 b. Main demographic trends.
 c. Geographical distribution of the population
 d. Migratory movements and determinants
 e. Active population by economic sectors and local traditional productive activities.

B. Local labour market:
 a. Characteristics and evolution of local employment in traditional and handicraft activities.
 b. Profiles of the supply and demand for traditional activities of local labour.
 c. Unemployed population according to age and gender.
 d. Business culture that exists in traditional activities. Innovation attitude and business risk.
 e. Existing labour and social relations.

It is interesting to have information on natural resources on the following aspects:
- Productive use of local natural resources used in traditional activities and current production processes.
- Use of potential resources and alternative uses for these types of activities.
- Abandoned traditional activities.
- Basic infrastructure necessary for the development of traditional activities.

In addition, it is recommended to collect information about the technological level of activities and businesses, access to new technologies by local companies engaged in traditional activities, the available supply of technical assistance instruments, and the degree of linkage of technical advice with the local productive system entities.

Once the information is collected and analysis and diagnosis has been made, a local development strategy can be designed establishing general and specific objectives for enhancing traditional local activities. Next, the design of the action plan will be carried out and, finally it will be checked and evaluated in order to correct errors.

5.2. USER'S PROFILE

This section is aimed at identifying the type of user that, with more or less regularity, visits the theatre and carries out various activities.

The best way to carry out this task is by conducting questionnaires that contemplate the basic data of the user and their comfort at the theatre. A model of questionnaires is *Attachment XI Questionnaire IPELSHT-IRP "Artists, visitors, spectators, and local residents"*. Results obtained have to be collected in a few tables in order to observe the results by percentages. All the results that had been sent are in *Attachment XII Questionnaires Results of the Jordanian Partner, Attachment XIII Questionnaires Results of the Tunisian Partner,* and *Attachment XIV Questionnaires Results of the Algerian Partner.*

In order to improve the visual understanding, it is recommendable to prepare different graphics using the tables above.

This task provides a generic view of a different kind of public than we contemplate in the Usage Manual. The diversity of age, level of studies, place of residence and type of visit will affect the decision-making process. Concretely, tables below are completed with the results obtained by the theatrical season in Jarash, as well as all documentation that they have provided us. This Jarash information could provide a clear example to follow in order to draw up a Usage Manual.

AGE

	0-10	11-18	19-30	31-50	51-65	↑65
VISITORS	2.78%	18.75%	47.22%	23.61%	1.39%	0.69%
SPECTATORS	0.40%	13.10%	53.17%	21.03%	1.98%	0.40%

As seen in the table and graphs, most visitors and spectators who attend the theater are between 19 and 30 years old.

STUDY

	ELEMENTARY SCHOOL	MIDDLE SCHOOL	HIGHT SCHOOL	UNIVERSITY
Visitors	6.29%	17.48%	24.48%	44.76%
Spectators	1.56%	5.47%	23.83%	60.16%

Generally the educational level obtained by visitors and spectators is university. With these results we can forecast the type of visit that will be demanded.

PLACE OF RESIDENCE

	LOCAL	REGIONAL	NATIONAL	OTHER COUNTRY
VISITORS	29.66%	20.69%	28.28%	13.79%
SPECTATORS	40.15%	9.65%	27.80%	12.36%

The place of residence is very diverse. Although most users are local residents, a huge proportion of them come from another part of the nation.

KIND OF VISIT

	INDIVIDUAL	COUPLE	SMALL GROUP	FAMILY	TOURIST GROUP	SCHOOL VISIT	ASSOCIATION
VISITORS	34.48%	14.48%	6.21%	22.76%	8.97%	0.69%	4.14%
SPECTATORS	16.34%	11.67%	28.79%	24.12%	4.28%	1.17%	2.33%

Visitors usually go to the theatre individually and spectators with their families, but there is a high percentage who go with tourist groups.

5.3. TIME DISTRIBUTION

The need to observe the periods with varying influx is essential to diagnose the compatibility between activities, as well as equipment and resources required at each time.

The need to observe the periods with varying influxes of visitors is essential to diagnose the compatibility between activities, as well as equipment and resources required at different times.

This section includes a series of visual tables containing data obtained with questionnaires. It contemplates everything related to the time of opening of the theatre. These tables are divided into different periods depending on the requirement. Periods could be annual, monthly or daily.

Results are completed with the case of Jarash in order to have a concrete example.

Recommended steps to follow:

Indicate the period of the year in which the theatre season occurs (specify days):

January	February	March	April	May	June Afternoon
July Afternoon	August Afternoon	September	October	November	December

Jarash data.

Indicate the days of the week and schedule in which the shows are performed:

MONDAY	TUESDAY	WEDNESDAY	THURSDAY	FRIDAY	SATURDAY	SUNDAY

Jarash data.

Indicate the days and opening hours of the theatre for visitors:

MONDAY - SUNDAY
7:30 a.m. to 7:00 p.m. (Summer)
8:00 am to 5:00 pm (Winter)

Jarash data.

Indicate the days and guided tours times of the theatre:

MONDAY - SUNDAY
7:30 a.m. to 7:00 p.m. (Summer)
8:00 am to 5:00 pm (Winter)

Jarash data.

Is there a diversification in the time of visits in the different sites of archaeological interest?

YES ☐ NO ☐

Indicate the days and the opening hours of the theatre / archaeological site for carrying out intrinsic activities (archaeological research, maintenance, etc.):

MONDAY	TUESDAY	WEDNESDAY	THURSDAY	FRIDAY	SATURDAY	SUNDAY

Jarash data.

	SEASON					
	January	February	March	April	May	June
THEATRICAL PERFORMANCE	-	-	-	-	-	-
ARCHAEOLOGICAL SITE	-	-	-	-	-	-
	July	August	September	October	November	December
THEATRICAL PERFORMANCE	-	-	-	-	-	-
ARCHAEOLOGICAL SITE	-	-	-	-	-	-

When is necessary. Do not have particular time.

HIGH	MEDIUM	LOW	CLOSED

	DAYS AND TIMES							
	Performances		General visits		Guided visits		Intrinsic activities	
	Summer	Winter	Summer	Winter	Summer	Winter	Summer	Winter
Monday	-	-	-	-	-	-	-	-
Tuesday	-	-	-	-	-	-	-	-
Wednesday	-	-	-	-	-	-	-	-
Thursday	-	-	-	-	-	-	-	-
Friday	-	-	-	-	-	-	-	-
Saturday	-	-	-	-	-	-	-	-
Sunday	-	-	-	-	-	-	-	-

Timetable of activities

		USAGE OF THEATRE											
		JAN	FEB	MAR	APR	MAY	JUN	JUL	AUG	SEP	OCT	NOV	DEC
VISITANTS	INDIVIDUAL	-	-	-	-	-	50 / 34.5	-	-	-	-	-	-
	COUPLE	-	-	-	-	-	21 / 14.5	-	-	-	-	-	-
	SMALL GROUP	-	-	-	-	-	9 / 6.2	-	-	-	-	-	-
	FAMILY	-	-	-	-	-	33 / 22.8	-	-	-	-	-	-
	TOURIST GROUP	-	-	-	-	-	13 / 9	-	-	-	-	-	-
	SCHOOL VISIT	-	-	-	-	-	1 / 0.7	-	-	-	-	-	-
	ASSOCIATION	-	-	-	-	-	6 / 4.2	-	-	-	-	-	-
SPECTATORS	INDIVIDUAL	-	-	-	-	-	42 / 16.4	-	-	-	-	-	-
	COUPLE	-	-	-	-	-	30 / 11.7	-	-	-	-	-	-
	SMALL GROUP	-	-	-	-	-	74 / 28.8	-	-	-	-	-	-
	FAMILY	-	-	-	-	-	62 / 24.1	-	-	-	-	-	-
	TOURIST GROUP	-	-	-	-	-	11 / 4.3	-	-	-	-	-	-
	SCHOOL VISIT	-	-	-	-	-	3 / 1.2	-	-	-	-	-	-
	ASSOCIATION	-	-	-	-	-	6 / 2.3	-	-	-	-	-	-

This table is only completed with the results of questionnaires of July. In this column it is indicated the number of answers and percentages. Jarash data.

5.4. CULTURAL CLUSTER INFORMATIVE SYSTEM

5.4.1. TECHNICAL ASPECTS

This section is dedicated to the study of the technical aspects of the theatre. First of all, it is essential to carry out a full study of the theatre. It is important to collect as much information as possible in order to develop an accurate diagnostic. This technical diagnostic should contemplate the different facilities, resources and existing services, as well as the functional, conceptual and contextual compatibilities with the ancient theatre.

5.4.1.1. STUDY OF THE THEATRE

The collection of documentation for the theatre to be treated is really important in order to prepare a diagnosis as similar to reality as possible.

In this chapter the following aspects must be considered:

At first, general graphical information must be considered that will allow us to recognize visually the dimensions and the volume. This documentation must have attached identification by title, scale, source, etc.

Also, a detailed description of the theatre is required together with a description of all the different parts of which is composed. It is always recommended to know the history of the theatre, as well as the history of interventions and restorations that have taken place over the years. The history study allows for participation with an appropriate point of view. Another paragraph should be devoted to the state of art or the technical studies carried out so far.

Finally, a section is reserved for physical compatibility in order to study the present state. It should be performed according to a prototype table that include all the features the theatre should have to ensure proper use.

Features should be analyzed for the study of theater.

5.4.1.1.1 General graphic information

Development of graphic documentation across files where it should indicate the origin of the drawing, the name, the scale and the date of completion.

Graphic documentation

Responsible partner: *Dipartimento di Storia, Disegno e Restauro dell'Architettura – Sapienza Università di Roma*

Drawing 01_2D geometric model: Theatre Plan
Scale 1:100. Date September 2012

Drawing 02_2D geometric model: Theatre Plan with snapshot of the point cloud
Scale 1:100. Date September 2012

Drawing 03_2D geometric model: Section A-A
Scale 1:100. Date September 2012

Drawing 04_2D geometric and architectural model: Theatre section A-A with snapshot of the point cloud
Scale 1:100
Date September 2012

Drawing 05_2D geometric and architectural model: Theatre section B-B
Scale 1:100
Date September 2012

Drawing 06_2D geometric and architectural model: Theatre section B-B with snapshot of the point cloud
Scale 1:100
Date September 2012

5.4.1.1.2 Description of the theatre

The South Theatre of Jarash (General Description):

The south theatre today is one of the most impressive of Jarash's public buildings, in part because of its extensive restoration and its good condition. The theatre was constructed and completed in the early 2nd century AD. It was started during the reign of Domitian, but there is evidence of an earlier theatre beneath the present structure. On its completion in the early second century, it was one of the most splendid civic monuments in the developing city and certainly the finest of its type in the whole province. Part of the cost was defrayed by generous donations from wealthy citizens such as Titrus Flavius, son of Dionysus, who is recorded as having given a block of seats. This was the period when Trajan created his new Province of Arabia (AD 106), bringing Jarash into the vortex of Provincial affairs so that the city's grandees willingly felt beholden to ensure that their city was as magnificent and celebrated as possible.

The south theatre is oriented in such a manner that the sun shines in the spectators' eyes for only a brief period in the late afternoon. The *cavea* of the auditorium was divided into two sections, with a wide terrace (diazoma) describing the full half circle between them, running the full length of the *cavea*. The lower half was built into the side of the hill while the top half was built up above it.

The theatre consists of four main parts: 1) the *cavea*, which is the seating area where the audience were seated; 2) the orchestra, which is the half circle platform which was usually used for the team of musicians; 3) the stage in front of the orchestra where the actors gave their performance; and 4) the *scaena*, which has the front *scaena* façade that makes the background to the stage and the back *scaena* part which is also called the back stage where the actors prepared themselves before entering onto the stage.

The outer diameter of the theatre is 70.5 m. and diameter of the orchestra is 20.4 m. The *cavea* consists of 30 rows of seats. The *scaena front* is divided into 4 parts, each with a niche surrounded by decorated columns and the triangle pediment with 3 doors in between leading to the back *scaena* which is called the *postcaenium*.

The lower half of the *cavea* is divided by stairs into four sections of fourteen rows each, with numbers inscribed underneath each seat in two outer sections. The number is most clearly visible in the lowest seats along the western side or the auditorium. The upper *cavea* was similarly divided into eight sections with fifteen rows.

Visitors today enter the theatre from the front through two arched passageways, or *parodoi*, that lead into the semicircular orchestra. Three sets of stairs lead from the orchestra to the lower seats. The upper seats of the theatre were reached through four-arched *vomitoria* which help support the upper half of the auditorium.

The lower section, which was built into the hillside, was divided by steep flights of steps (*scalarias*) into four *cunei*, or blocks, each of which had fourteen rows of seats. The upper section was similarly divided into eight *cunei* with approximately fifteen rows. Although the auditorium has survived remarkably well, the top rows of seats are missing, and one cannot be sure of the exact original number.

Even so, Kareling was able to estimate that the theatre could have seated well over three thousands spectators. Each seat was numbered, starting with the lowest rows working from right to left. This lettering is very interesting and can be seen in the western *cuneus*. The lowest row of seats was on the top of a podium, which had a wide, strongly moulded base and cornice with regularly spaced circular blind recesses in the wall. This podium was terminated at both ends by a pedestal on which a statue stood.

Inscriptions in the theatre enabled one to identify the statues and their donors, though the statues are now in the Palestine Archaeological Museum in Jerusalem. The podium stood on two wide steps, on the upper of which the chairs of important dignitaries would have been set, looking out across the beautifully paved orchestra.

Plan of The South Theatre of Jarash

1. Cavea

The *cavea* of the theatre includes two parts of seats, the lower part of which is called *imma cavea*, and the upper part of which is called *summa cavea*. The *imma cavea* consists of 14 rows of seats divided by five stairs; each stair is called *scalaria* or *kerkis*, while the summa *cavea* consists of 16 rows of seats divided by seven *scalarias*. The *imma cavea* is built on the rocky slope.

The seats were numbered, and each row has a height of 46-48 cm. while its depth is 72 cm. The *Diazoma*, which is a corridor between the two *caveas*, has a width of 1.75 cm surrounded by a wall called the *Praecinctio* with a height of 1.8 m. and consists of four doors leading through staggered barrel-vaulted structures under the *summa cavea* to outside the theatre.

As was usual with most Roman theatres, the means of access to the seats was highly organized. Spectators having seats in the lower section were admitted into the orchestra through the high arched *vomitoria* on either side of the front of the stage. Those with seats in the flanking *cuneus* then mounted steps behind the statues at the ends of the podium, whilst those with seats in the middle crossed the orchestra and went up a steep set of steps, which broke through the central point of the podium.

Those with seats in the upper section had to pass from the upper terrace of the Sanctuary of Zeus, round the back of the theatre, hard under the city wall, until they reached their appropriate *vomitoria* which admitted them onto the half-way terrace of the *cavea*. The upper section was also retained by a podium wall through which the *vomitoria* broke. On either side of these entrances, narrow flights divided up a break in the upper podium, giving access to the stairways, which divided the upper *cunei*. The upper *vomitoria* are well worth inspecting, not only for the engineering skill they display. The steep slope of the auditorium above is supported on a series of stepped arches of finely calculated masonry. This is the same arrangement as was used beneath the seats of the Hippodrome. They are massively strong and afford exciting views back through the low doorways onto the almost fantasy architecture of the *scaenae frons*.

2. Orchestra

The lowest row of seats was on the top of a podium, which had a wide, strongly moulded base and cornice with regularly spaced circular blind recesses in the wall. This podium was terminated at both ends by a pedestal on which a statue stood. Inscriptions in the theatre have enabled one to identify the statues and their donors, though the statues are now in the Palestine Archaeological Museum in Jerusalem. The podium stood on two wide steps, on the upper of which the chairs of important dignitaries would have been set, looking out across the beautifully paved orchestra with a diameter of 20.4 m.

3. Stage & Proscenium

The *scaenae frons* was divided into four sections with pedestals between them. Each section was decorated with a central pedimented niche flanked by arched niches. Steps at either end led up onto the stage, which was partly sub-vaulted and partly filled-in; it was here that remnants of an earlier structure are found, possibly the previous theatre.

Across the stage rose the stage wall, or *scaenae frons*. These elaborate architectural compositions are a common feature of Roman theatres, at times reaching magnificent proportions such as the one at Sabratha in Libya. They all have certain standard features, although the decorative design may vary from theatre to theatre. This *scaenae frons* has the obligatory three doors onto the stage from behind, with two large arched openings from the wings adjacent to, but slightly recessed behind, the orchestra *vomitoria*.

The central doorway, called the *porta regia*, was set like the two flanking it, in a half-oval recess formed by a projecting podium, on which stood a two-tier screen of columns. The front of each of these projections of the podium was recessed in the centre with a niche over them.

The niche was framed by smaller columns carrying their own independent entablatures with scroll pediments. The doorways themselves were strongly emphasized by impost pilasters with finely carved capitals and a fully articulated entablature consisting of a stepped architrave, fluted frieze, an elaborately carved cornice and a bold triangular pediment. It will be noted that the capitals of the impost pilasters are of the same type as those on the Hadrianic Arch and the South Gate, acanthus leaves rising in front of flutes. Above the main columns there was an entablature, which followed exactly the line of the podium below, breaking forward over the pairs of pillars and sweeping back into the oval recesses. This entablature helped to establish the basic rhythm of the façade, which at ground level was complicated by the deep recesses of the three doorways. It is probable that the whole arrangement was repeated on a second tier, giving the effect of a forest of pillars undulating across the curved and rectangular wall at two levels.

It is not known exactly how the façade was finished off at the top. Nonetheless, this was a striking design with a marked sense of `movement`. The constant breaking forward of the entablature, the change from rectangular to curved space, the strong vertical and horizontal emphases, all amount to a piece of great visual excitement. The effect of one scale within another was the main counterpoint whilst the bold, solid podium upon which the composition stood marked out the principal theme. The effect today is rather lost because none of the top storey exists and much else is incomplete, but one can still sense the contrasts.

The wall rising behind the stage, the *Scaenae Frons*, is pierced by three doors used by the performers to enter and exit the stage from the sides. The highly decorated *Scaenae Frons* includes some of the same finely carved acanthus leaves and flutes found on the South Gate and Hadrian's Arch. The *Scaenae Frons* would have had a second storey repeating most of the decorative and architectural elements of the lower level. Much of the outer (north) wall of the theatre is a modern reconstruction.

4. Accesses

Visitors today enter the theatre from the front through two arched passageways, or *parodos*, that lead into semicircular Orchestra. The entrances from the right and left side to the orchestra (as they were faced by the spectators) indicated the place from where the heroes were coming. The right entrance was a sign that they were coming from the palace or the town and the left from the fields, the port or another town.

Three sets of stairs lead from the orchestra to the lower seats. The upper seats of the theatre were reached through four-arched *vomitoria* that helps support the upper half of the auditorium.

The Romans built theatres anywhere, even on flat plains, by raising the whole structure off the ground. As a result, the whole structure was more integrated and entrances/exits could be built into the cave, as is done in large theatres and sports arenas today.

According to Vitruvius in his book V chapter 3, the entrances (*vomitoria*) should be numerous and spacious; those above ought to be unconnected with those below, in a continued line wherever they are, and without turnings; so that when the people are dismissed from the shows, they may not press on one another, but have separate outlets free from obstruction in all parts.

The parodos is an important element of the Greek theatre and serves a double purpose: first, it provides the audience with a way to access their seats. More importantly for the purpose of staging the play, though, it provides access to the chorus and allows some actors to reach the orchestra.

5. Sub Structures and façade

Since 1981, when the theatre was chosen to be reused for modern uses in the Jarash festival, new sub structures (removable structures) was added and attached to the back stage building of the theatre.

This structure is used as dressing rooms for the players and artists. Also it creates kind of security for them to isolate them from the people.

Later on in 1995, the Ministry of Tourism constructed toilets near the west side of the theatre, using stone techniques similar to the theatre's own in terms of colour and style. The problem of this structure is that it is irreversible and not well served to be clean and safe to be used by visitors. These structures were supplied with electricity and water. The quality of these structures is not that good with an absence of regular maintenance.

6. Theatre Drainage system:

The drainage system in the theatre was designed as in other Roman theatres. It mainly depends on the inner shape of the theatre through its rows of seats to collect rainwater and lead it to the orchestra platform, where a tunnel under the pavement of the orchestra is constructed with main holes to take the collected water outside the building. Usually, this tunnel is connected to the main sewage system of the city.

7. Materials and constructive techniques

The theatre was built out of hard limestone that has a creamy reddish colour. The construction methods adopted in this theatre mainly relied on the feature of the existing natural slope of the site in which the lower *cavea* of the seats was laid on natural slope, while the upper part of the seats (*summa cavea*) was constructed on free standing and massive walls using a staggered barrel vaulted system that was used to create access gates to the upper cavea.

BIBLIOGRAPHY ON THE SPECIFIC THEATRE

A l-Abadi, M (1974) Amman: Past and Present, Amman.

Adam J., (1990) Roman Building: Material & Techniques, trans. Mathews Anthony, B.T. Batsford Ltd. London.

Al-Dahash M. M. (1993) Methods of Construction of the Roman Theatres in Amman & Um Qeis: Comparative Study, Amman. (Master Theses in Arabic)

Arnott, P. (1959) An Introduction to the Theatre, London

Arthur Segal, (1995), Theatres in Roman Palestine and Provincia Arabia, Mnemosyne. Brill E.J, Leiden, New York.

Barghouti, A. (1982) "Urbanization of Palestine and Jordan in Hellenistic and Roman Times" Studies in the History& Archaeology of Jordan I, vol 1, ed. A. Haddadi, Department of Antiquities,

Bieber, M. (1961), A History of Greek and Roman Theatre, Oxford Univ. Press, London

Binda, L. and Barronio, G. 1985. Deterioration of porous materials due to salt crystallization under different thermo hygrometric conditions-I Brick, 5th International congress of deterioration and conservation of stone, Lausanne, pp: 279-288.

Brai, M.; Casaletto, M. P.; Gennaro, G.; Marrale, M.; Schillaci, T.; Tranchina, L. 2010, Degradation of stone materials in the archaeological context of the Greek-Roman Theatre in Taormina (Sicily, Italy), Applied Physics A, Volume 100, Issue 3, pp.945-951

Brockett, Oscar (1977), History of the Theatre, third edition, London.

Browning Iain (1982) Jarash & the Decapolis, Chatto & Windus. London.

Browning Iain, 1982, Jarash & the Decapolis/ Chatto & Windus. London/ /(Ds154.9 G47 B76 1982).

Carl H. Kraeling, 1938, Jarash City of the Decapolis/ Yale University / Published by the American Schools of Oriental Research/ New Haven, Connecticut// (Ds 154.9 G47 K56 1938).

Charola A. E. and Lazzarini, L, 1986. Deterioration of Brick Masonry Caused by Acid Rain, In Materials Degradation Caused by Acid Rain, Editor(s): Robert Baboian, Volume 318, September 25.

Charola, A.E., 1988. Chemical-Physical factors in stone deterioration, Air pollution and safeguarding our architectural heritage, Elsevier, Amsterdam.

Chase Raymond G., (2002) Ancient Hellenistic & Roman Amphitheatres, Stadiums, & Theatres. The Way They Look Now. Portsmouth, New Hampshire.

Diakumaku, E., Gorbushina, A.A., Krumbein, W.E., Panina, L. and Soukharjevski, S., 1995. 'Black fungi in marble and limestones — an aesthetical, chemical and physical problem for the conservation of monuments', Science of the Total Environment 167 , pp. 295–304.

Dinsmoor, W. B, (1974), The Architecture of Ancient Greece. London

Elgohary, M.A. 2008. Air Pollution and Aspects of Stone Degradation "Umayyed Liwân – Amman Citadel as a Case Study", Journal of Applied Sciences Research, 4(6): 669-682.

Fassina, V., 1988. Environmental pollution in relation to stone decay, Air pollution and conservation-safeguarding our architectural heritage, Elsevier, Amsterdam.

Fisher C.S/ Jarash City of the Decapolis/ 1938/ (Ds 154.9 G47 F5 1938).

Flatt, R., F. Giradet and J. Corvisier, 1995. Modeling of Sulphur dioxide deposition on the Bern Sandstone, Preservation and restoration of cultural heritage, Montreux, pp: 401-408.

Forman, R.J. (1989) Classical Greek and Roman Drama: An Annotated Bibliography. Salem Press,. Frank Sear/ Roman Architecture/ Cornel University Press/ Ithaca, New York / 1993 / (Na 310.S42 1993).

Frederiksen, R. (2000),"Typology of the Greek Theatre Building in Late Classical and Hellenistic Time", Proceeding of the Danish Institute at Athens, III, Edited by Isager, T. Nielsen, I.

Frederiksen, R. (2002), "The Greek Theatre: A Typical Building in the Urban Centre of the Polis", Historia: Einzelschriften, Franz Steiner Verlag Stuttgart.

Green, J.R. 'Excavations at the Theatre, Near Paphos, 1995-96, Mediterranean Archaeology 9-10, 1996-97, 239-242

Guidoboni, E., Comastri, A. and Traina, G., 1994. Catalogue of Ancient Earthquakes in the Mediterranean area up to the 10th century, vol.1, ING-SGA, Bologna.

Haddad M. K, (1995), Jarash: The Landscape, Urban Space, and Architecture, Florida International University, Florida, Miami. (Master Theses)

Haddad, H ., 2007, Criteria for the Assessment of Modern use of Ancient Theatres and Odea, International Journal of Heritage studies, Vol. 13.No. 3, pp.265-280.

Haddad, H. 2004, Assessment of the Relation between Ancient Theatres, Landscape and Society, Third International Conference on Science and Technology in Archaeology and Conservation 7-11 December 2004, Hashemite University, Jordan, actas, Fundación El Legado Andalusí, pp. 263-280.

Haddad, H. and Akasheh, T., 2005, Documentation of Archaeological Sites and Monuments: Ancient Theatres in Jarash, CIPA 2005, XX International Symposium, 26/9 -1/10/2005, Torino, Italy, pp. 350-355.

Haddad, H. and Fakhoury, L., 2010. Conservation and Preservation of the Cultural Heritage of Ancient Theatres and Odea in the Eastern Mediterranean, IIC Istanbul Congress, Conservation and the ATHENA – ENPI 2008/150- 86

Haddad, H., Jamhawi, M. and Akasheh, Akasheh , 2003, Relation between Ancient Theatres, Landscape and Society, Second International Conference on Science & Technology in Archaeology & Conservation, 7-12 December 2003, Jordan, actas, Fundación El legado andalusí, pp.243-256.

Haddad, H., Reviving the Architectural and Acoustical Theatre Heritage: the Role of ERATO Project, 2008, The Fifth International Conference of the Centre for the Study of Architecture in the Arab Region (CSAAR 2008 B) : Responsibilities and Opportunities in Architectural Conservation: Theory, Education, and Practice, pp.421-434.

Kimball, F. Harold, G. (1972) A History of Architecture, Westport: Green and Wood Press

Lampropoulos V., Karampotsos A., 2004, "Ancient Theatre of Megalopolis - Peloponnese. Corrosion Patterns and Propositions for Conservation – Restoration" 6th International Symposium on the Conservation of Monuments in the Mediterranean Basin, Lisbon, Portugal, 6 - 10 April. pp. 159-165

Lampropoulos, V.; Sotiropoulou, Ch.; Patrikiou, F.; Karampotsos, A. 2004. Ancient theatre of Sikyon: corrosion patterns and propositions for conservation-restoration", Proceedings of the 10th international congress on deterioration and conservation of stone, Stockholm, June 27 - July 2, 2004 , ICOMOS Sweden , Stockholm ,,pp. 915-922.

Lewin, S.Z., 1982. The mechanism of masonry decay through crystallization, Conservation of historic stone buildings and monuments, Washington DC, pp: 120-144.

Matova, M., 2008. Geoenvironmental problems for the world cultural heritage In north-east Bulgaria, Geoarchaeology and Archaeomineralogy (Eds. R. I. Kostov, B. Gaydarska, M. Gurova). Proceedings of the International Conference, 29-30 October 2008 Sofia, Publishing House "St. Ivan Rilski", Sofia, 362-366.

Penkett, S.A., B.M. Jones, K.A. Brice and A.E. a Eggleton, 1979. The importance of atmospheric ozone and hydrogen peroxide in oxidizing Sulphur dioxide in cloud and rainwater, Atmosphere environment, 13: 123-137.

Peter D (1989) Public Performance in the Greek Theatre, Routledge, London.

Rami G. Khouri, Al Kutba, 1988,Jarash A Brief Guide To The Antiquities, , Publishers, Amman , Jordan,

Rands, D.G., J.A. Rosenow and J.S. Laughlin, 1986. Effects of acid rain on deterioration of coquina at Castillo de San Marcos National Monument, Material degradation caused by acid rain, ACS Symposium, 318: 301-307.

Report L.J.J ,Guinee and Niede F. Mulder (1997)"Gadara. The Terrace, Theatre & Cardo Quarter in the Roman Period. Architectural Designed Integrated in the landscape: The designed of the West Theatre" in Annual of the Department of Antiquities of Jordan, 6th volume, pp317-322.

Ritchie, T., 1976, Moisture Degradation of Masonry Walls, DBR Paper No. 693. Division of Building Research Reprinted, with permission, from Proceedings, First Canadian Masonry Symposium held at the University of Calgary, Calgary, Alberta, p. 66 – 71

Robertson, D. S. (1974), Greek and Roman Architecture

Russell, D. (1980), Period Style for the Theatre, London

Sear Frank (1992) Roman Architecture, Cornell University Press, Ithaca, New York.

Simon, E. (1982), The Ancient Theatre, Translated by Vafopoulou- Richardson, London

Stovel, Herb, 1998, Risk Preparedness: A Management Manual for World Cultural Heritage, ICCROM, Rome,

The Classical World Bibliography of Greek Drama and Poetry. New York, 1978

The Classical World Bibliography of Roman Drama and Poetry and Ancient Fiction. New York, 1978.

Vitruvius (1960) , The Ten Books in Architecture, New York, Translated by Morris Morgan , Dover Publication

Walton, J. (1980), Greek Theatre Practice, London

Warscheid, T. and Braams, J., 2000 , 'Biodeterioration of stone: a review', International Biodeterioration and Biodegradation , pp. 343–368.

Wartelle, A. Bibliographie historique et critique d'Eschyle et de la tragedie grecque, 1518-1974. Paris, 1978.

Wei, H. and J.L. Wang, 2005. Characteristics of acid rain in JINYUN mountain, CHONGQING, CHINA, Applied ecology and environmental research, 3: 29-37.

5.4.1.1.3 Historical knowledge on the theatre

General and updated bibliography on theatres in the region

Treatise

Bieber, Margarete, The History of the Greek and Roman Theater, Princeton 1961.

Csapo, E. and Slater, William J., The Context of Ancient Drama, Ann Arbor 1995.

Dover, K.J., Aristophanic Comedy , Berkeley and Los Angeles 1972.

Duckworth, G., The Nature of Roman Comedy: A Study in Popular Entertainment , Princeton 1952.

Green, R. and Handley, E., Images of the Greek Theatre, Austin 1993.

Harsh, P.W., A Handbook of Classical Drama (Stanford 1963).

Pickard-Cambridge, Sir Arthur, The Dramatic Festivals of Athens, Oxford 1968.

Simon, E. , trans. by Vafopoulou-Richardson, C.E., The Ancient Theatre , London and New York 1982.

Archaeological/Architectural investigation on the theatre and reconstruction hypothesis

HISTORY OF THE EXCAVATIONS AND SCIENTIFIC RESULTS		
Brief description	Organizer authority/Author	Year
The site of Jarash was visited by Ulrich Seetzen and he mentioned "two superb amphitheatres".	Ulrich Seetzen	1806
John Burckhart made a brief visit, and in 1816 he visited the site and published the first rudimentary plan of the city, in J.S. Buckinham "Travels in Palestine through the countries of Bashan and Gilead".	John Burckhart	1812
Irby and Mangles visited the site and praised the scene of the south theatre as "singularly perfect".	Irby and Mangles	1818
An unpublished plan and section of the south theatre by O. Puchstein appeared in E.R. Fiecher "Die baugeschichtliche Entwicklung des antiken Theatres. Munich 1914: abb. 95.	E.R. Fiecher	1914
Some inscriptions found in the south theatre were published by A.H.M. Jones in JRA 18 (1928): 144-78, nos. 12-14, 16, 33	A.H.M. Jones	1928
Excavation works were carried out in the south theatre by the American School of Oriental Research, which the British team later took over.	The American School of Oriental	1930
C.H. Kraeling described both the south theatre and the north theatre in the book "Jarash-City of the Decapolis".	C.H. Kraeling	1938
This shift enabled the Emirate of Transjordan to gain independence from British rule, resulting in the establishment of the Hashemite Kingdom of Jordan. As archaeological investigation and excavations continued, the newfound national autonomy resulted in the expansion of work at the site to include more intensive development and the promotion of tourism.	The Hashemite Kingdom	1946
Work at the site began to focus on restoration and reconstruction to attract more visitors and on using the site for cultural activities.	The Hashemite Kingdom	1950

5.4.1.1.4. History of interventions and restorations on the theatre

Previous Restorations Works in chronological order

1925: Conservation works began in the south theatre under the direction of George Horsfield, who cleared the orchestra and revealed the whole stage area, and the architectural fragments from the upper part of the scaenae fronts were collected and placed in the orchestra to study.

1950's: In the early 1950s, restoration works began at the south theatre within the framework of a project to improve the site facilities in preparation for establishment of a festival for music and drama. This project was financed by the American Aid Commission through the medium of the Tourist Department of the Jordan Government under the supervision of Diana Kirkbride.

When the restoration of the south theatre started in 1953 most of the ima cavea was relatively intact including the vaults over aditus maximi, but little survived of the tribunalia or the rows of the seats behind them. The two central cunei of the summa cavea stood almost to their full height and only the top few rows of the seats were damaged in the lateral parts of the summa cavea. Most of the casings around the summa cavea were destroyed. Only the footings of the stage front survived in situ and the foundation of the stage, which was apparently a solid masonry structure. All the podia of the columnatio stood and some columns. A pair of columns at the west end and another on the east side survived complete with capitals along with the architrave they supported. The scaenae frons wall itself stood in parts to a height of 10 or 11 courses of masonry, almost to capital height, while little survived of the two side entrances onto the stage. The vault over the aditus maximi had survived.

Achievements from (1953-1956)

1. The postscaenium passage was excavated.
2. The scaenae frons was dismantled and rebuild.
3. The three doors of the scaenae frons were also rebuilt using new material in the pediments to substitute for parts which were missing and reinforced concrete beams were inserted inside the lintels.
4. The arched entrances at the sides of the stage (versurae) were rebuild as well as both arched entrances into the orchestra (aditus maximi) and the tribunalia above them.
5. The west end of the scaenae frons wall and the pairs of columns carrying a portion an architrave were found to be in such bad condition that a structural engineer was needed for advice and work stopped. Meanwhile some rebuilding took place but it was not bonded to the old work.
6. In 1956 funding ran out and it was some years before the stage and proscenium wall were finished.

1960's: In the early 1960s, larger-scale of restoration work began at the site. In 1962 and 1963, the Royal Engineering Forces assisted the DoA in re-erecting columns along the Cardo. In the late 1960s, work shifted from projects aimed at targeted restoration of specific monuments and development of specific infrastructural elements to site-wide planning. In 1968 a management plan was prepared for the archaeological site by a team consisting of specialists from the DoA, other Jordanian government institutions, and the United States National Park Service. The plan's main objective was to develop Jarash as a national park, focusing on improving both tourists' experience and the site's protection. It proposed development of a visitor centre complex and parking area outside the city walls and near the South Gate.

Between 1972 and 1975: Revealing and restoration of the vaulted passageways at the second storey of the cavea (media cavea) and restoration of the whole back semicircular wall of the south theatre, as well as the discovery of some Greek aspects.

1976 – 1981: The World Bank's Tourism Development Project for Jordan financed restoration and preservation of some major monuments in Jarash (and Petra) including the south theatre particularly the scaenae frons, and the southwest vaulted passageways (vomitoria).

5.4.1.1.5. Scientific and technical studies

SEISMIC / EARTHQUAKE HISTORY

1-Past Seismic Activity

Chronological Pattern

Overall, the recurrence data from the Dead Sea suggest that the rate of seismic activity along the Dead Sea Transform (DST) changed several times during the last 10,000 years. This is a very rough chronological outline.

1. Neolithic Period (c. 8000 – 5500 BC): seismically quiet, although a bias in the accuracy of the core's bottom levels might influence this picture. (Rollefson pers. comm.). However, no evidence for such settlements in the Jordan Valley has been found to confirm the earthquake hypothesis.
2. Later Prehistory (c. 5000 – 1 BC): moderately active, with a cluster of seismic activity between 1000 and 2100 BC.

The Chalcolithic period (c. 4500 – 3600 BC), during which pastoralism flourished and a number of current staples became domesticated (e.g. olives), ended with a notable "collapse" of the settlement system then predominant, and transformed into the proto-urban Early Bronze Age (Levy 1995). An earthquake of some magnitude is mentioned around 4000 BC in the upper Jordan Valley, although it's relation to the transition/collapse needs to be further examined. The more active part of this later prehistoric period falls into the end of the Early Bronze Age (c. 2000 – 1600 BC), which is characterised by large-scale destruction and abandonment of the fortified towns of the time in favour of nomadic, small-scale settlement. The ruins at Pella (modern Tabaqat Fahl in the northern Jordan Valley) bear evidence of such destruction in the massive walls of the Bronze Age structures. While the map produced by Midowski et al. 2004 (see below) does not identify any significant quakes in the immediate vicinity of the site, the geological sequence indicates a serious of major shake-ups that might have enveloped the entire area. A major earthquake is recorded in Israel in 31 BC, being the oldest historically documented disaster in the region.

3. Historical Period (0 – 1000 AD): low frequency of seismic activity. Nevertheless, quakes that did strike had devastating results in the entire Levant, as the earthquake of 749 AD can attest. That even quakes of 7.0 or higher on the Richter scale have left little evidence in the historical and archaeological records might be related to their epicentres being located at quite some distance from the DST or underneath the Mediterranean Sea, and/or originating so deep underground that not much of the tremor reached the surface. The geological sequence indicates mainly microscopically thin layers of disruption during that time period.

4. Modern Period (since 1000 AD): active. Especially the last 500 years have been recorded as particularly active, with major earthquakes striking at a high frequency all across the region, notably in 1837 just north of the Sea of Galilee and 1927 at the north-western end of the Dead Sea.

Although, and as mentioned above, there are many hypothesis and theories that mentioned many earthquakes during periods starting from the Neolithic period, there are only four large and notable quakes of the last two thousand years of high influence on the human settlements that made up a chronological pattern, which are:

- 31 BC: western Jordan Valley. Magnitude: 6.7. Massive geological impact. Occurred during a moderately active seismic period that was focused on the northern part of the DST.

- 363 AD: northwest of the Sea of Galilee. Magnitude: 6.7. Geological impact unknown (historical source only). Occurred during a period of low frequency activity that was focused on the northern part of the DST.

- 749 AD: northern Jordan Valley. Magnitude: 7.0 – 7.5. Low geological impact (thin disturbance layer). Occurred during a period of low frequency activity that was focused on the northern part of the DST.

- 1033 AD: southwest of the Sea of Galilee. Magnitude: 7.1. Massive geological impact. Occurred in the transition to the more active modern period during a time of even spread of the tremors along the DST.

A series of earthquakes in 749 AD did serious damage to the city and hastened its decline. By this date, the population was less than 4,000; and although the site was occupied in the Early Islamic period until around 800 AD, Jarash become nothing more than a small rural settlement. Its Roman name was transformed into a new Arabic one - Jarash - derived from the ancient Semitic name. And so - despite a brief occupation by a Crusader garrison in the 12th Century - the city became lost to Western history.

2- Acoustic Studies

In order to get an adequate diagnosis and adapt the ancient theatres to new uses from the acoustic point of view, it is necessary to follow the methodology represented in the tables below. The process of different fields of acoustic compatibility, diagnostic and intervention of each is defined.

Figure 2. The impact of the earthquake of 749 AD. The shaded area indicates the region of maximum destruction (Intensity X), and "severe loss of life" was recorded in many towns and cities of the region. From Marco et al. 2003

METHODOLOGICAL FRAMEWORK OF ACOUSTIC COMPATIBILITY

The acoustic compatibility must be evaluated in three different functions: the urban-environmental, architectural and functional. After analysing these aspects, we have to make a proposal for intervention.

From the point of view of urban-environmental aspects, a diagnosis by measuring the background noise needs to be prepared, together with a noise map of the urban environment, an urban study of the sources of noise, and an analysis of the uses of the area.

With this information, we shall proceed to the realization of an intervention project that will be defined in the following points:
- The placement of noise barriers.
- A detailed study of the times.
- Conducting a permanent architectural intervention in the immediate environment.
- Finally, defining a perimeter around the compound that needs protection.

In the architecture field the diagnosis that support the compatibility with the new activities is done by verifying the state of conservation. One needs to decide which architectural elements are preserved and which are damaged. Once the noise impact has been studied by standardized measurements, the proposed intervention will need solutions that optimize the acoustic models that are developed for its virtual acoustic enclosure.

At the functional level, the diagnosis for the acoustic requirements of the new uses are established by "reverberation time", which in ancient theatres is normally very low and compromises their fitness for such uses.

The proposed intervention will propose electronic acoustic enhancement systems that allow external input to combat artificial reverb sound leakage.

5.4.1.1.6. Physical compatibility

Defined as the capability to support the touristic and dramatic performances in terms of structural stability, superficial deterioration and maximum capacity.

This chapter aims to study the physical state of the theatre in order to determine the best compatibility with its use.

Evaluation of the general physical condition

		CRACKS & DEFORMATION	DETACHMENT	FEATURES INDUCED BY MATERIAL LOSS	DISCOLORATION & DEPOSIT	BIOLOGICAL COLONIZATION
CAVEA	Porticus	M-L	M-L	M-L	M-L	M-L
	Cavea/Cuneus/Seats	L	L	M-L	L	M-L
	Diazoma/Praecinctio	M-H	L	M-L	M-L	M-L
	Kerkis	L	L	L	L	L
	Parodos/Aditus Maximi	M-H	L	M-L	M-L	M-L
STAGE / PROSCENIUM	Proscaenium Wall/Front of Stage	L	L	L	L	L
	Pulpitum/Floor	L	L	L	L	L
	Scaena Frons	H-M	H-M	H	H-M	H-M
	Other	-	-	-	-	-
ORCHESTRA		L	L	L	L	L
POSTSCAENIUM/ EXTERNAL FAÇADE AND ACCESS		M-L	L	M-L	L	M-L
SUB-STRUCTURES		-	-	-	-	-

Each box must be completed with the typology of damage and an evaluation as in the table below:

HIGH	MEDIUM-HIGH	MEDIUM	LOW	VERY-LOW
H	M-H	M	M-L	L

Physical parts of the theatre

		CRACKS & DEFORMATION	MATERIAL DETERIORATION	STRUCTURAL STABILITY
CAVEA	Porticus	M-L	M-L	Needs to be reconstructed
	Cavea/Cuneus/Seats	L	M-L	End edges need to be reconstructed
	Diazoma/Praecinctio	M-H	M-L	It needs to be paved by stone
	Kerkis	L	L	Stable in good shape
	Parodos/Aditus maximi	M-H	M-L	Need more reconstruction
STAGE / PROSCENIUM	Proscenium Wall/Front of Stage	L	L	Stable in good shape
	Pulpitum/Floor	L	L	Stable in good shape
	Scaenae Frons	H-M	H	Need more reconstruction for the upper part
	Other			
ORCHESTRA		L	L	Stable in good shape
POSTSCAENIUM/ EXTERNAL FACADE AND ACCESS		M-L	M-L	Need more reconstruction
SUB-STRUCTURES				

Each box must be completed by estimating the level of compatibility, as indicated in the next table.

HIGH	MEDIUM-HIGH	MEDIUM	LOW	VERY-LOW
H	M-H	M	M-L	L

TYPOLOGY OF DAMAGE

Environmental factors of damage

	FACTORS	EVALUATION
CLIMATE	**1- Rain** *The amount of rainfall, which varies widely per year, presence of acid rains, force of the wind, salt damage in relation to wetting and drying cycles, growth of some salt crystals inside the pore structures, etc.*	M-L
	2- Sunlight (insolation) *The direct and indirect impact of the sun on ancient structures.*	L
	3- Wind direction (summer wind and winter wind etc.) *Information on the wind-driven rain, amount of rain and the wind speed (summer wind, winter wind), etc.*	L
	4-Temperature and Relative Humidity *Air and building material temperature, average temperature for each month, data of average temperatures in the period (from... to...) Month/Average, Maximum Temperature (oC)/ Average Minimum Temperature (oC)/ Average Thermal Amplitude (oC) and Relative Humidity should all be collected and tabulated.*	M-L
TOPOGRAPHY/SLOPE AND LANDSCAPE	**5- Natural Disasters** *Earthquakes, volcanoes, fires, flash floods, others.*	M-L
	6-New Forces *Topography & landscape, landslides, risks arising from structural problems and ageing of materials, others.*	M-L
BIOLOGIC	**7-Biodeterioration** *Vegetation: overhanging branches, climbing plants, overgrowth of surrounding vegetation, biotic coverage, fungi and lichens, algae, mosses, cyanobacteria, mould, moisture.* *Microorganisms, animals (goats, etc.), bird droppings.*	M-L

Level of risk for ancient structures

HIGH	MEDIUM-HIGH	MEDIUM	LOW	VERY-LOW
H	M-H	M	M-L	L

Anthropological factors of damage

	FACTORS	EVALUATION
INTRINSIC ACTIONS	1- Deterioration due to previous restorations	L
	2- Deterioration due to poor maintenance and related programmes of conservation	M-L
DECAY AND DETERIORATION DUE TO IMPROPER MODERN USES OF ANCIENT THEATRES AND ODEA	3- Tourism Growth *Studies, statistics about tourism of the area and CC.*	L
	4- Overloaded Capacity *Contemporary scientific studies about the capacity.*	M-L
	5-Risks of Authenticity *Constructing new structures such as partitions, additional seats in the orchestra for the audience, doors, shelters, footbridges etc.*	M-L
	6-Thermal risks of lighting systems *Information about the techniques adopted for fixing lighting equipment in the original material of the theatre (add photos if possible).*	M-L
	7-Noise pollution risk *Location of modern sound equipment, loudspeakers, amplifiers (add photos if possible).*	L
	8-Visual pollution risk *The location and conditions of technical devices, signage and panels, Graffiti, ticket office, on site signs, bookshop, etc.*	M-L
	9-Acoustics Qualities *Information and studies about theatre acoustics.*	L
POLLUTION	10- Air pollution *Sources of air and rain pollution in the Theatre Study Area (traffic, rubbish, toxic waste, etc.)*	M-L
LACK OF CULTURAL AWARENESS	11- Stealing of finds	M-L
	12- Conflict & Wars	M-L
	13- Graffiti	M-L

In relation to the study of the physical compatibility of the Jarash theatre, ancient structures are in need of a checking or inspection stage.

The passage of years has caused the structure to suffer cracks and deformations. Atmospheric agents are the main cause of damage to these structures. The rain and the continuous temperature changes cause material deterioration and biological colonisation.

On the other hand, anthropological factors of damage should also be considered. Many aspects, like regular maintenance, controls on tourism or carrying capacity, must be taken into consideration in order to preserve the physical condition. In this case, care must also be taken with respect to visual and physical compatibility of the ancient structure with the repair of different equipment.

In general terms, the physical condition of the Jarash theatre should be checked carefully, but mostly it is in acceptable condition, except for some parts of the *Scaenae Frons, Aditus Maximi* and the top of the *Summa Cavea* or *Porticus,* which are in critical condition.

5.4.1.2. DEVICES AND SERVICES.

This chapter contains every kind of service, supply, device, activity, action or need by the users of the theatre and archaeological site.

The diagnosis is applied to the equipment, resources, internal services and external services. To be able to carry out a detailed study, the IPELSHT prepared questionnaires that are enclosed in the *Attachment IX: Questionnaire IPELSHT / IRP "Artistic staff, visitors, spectators and local residents".*

The tables that are contemplated below should be filled out with an analysis and a reinterpretation of the results of questionnaires. In this case it has been done with the study of Jarash's theatre.

Features should be analysed for diagnostic of the theatre.

5.4.1.2.1. Equipment

The structure of this chapter is based on an ordered sequence of schematic technical sheets aimed at summarizing different aspects concerning the number, position and effectiveness of the equipment needed for the proper and safe use of the theatre.

The procedure anticipates the filling out of the technical sheets for the description and analysis of the equipment, which includes drawings and alphanumeric information gathered directly on the field during the general survey campaign. The document follows the same structure as the Guidelines for Compatible Utilization, but in place of general recommendations and diagnosis developed on the best practices, there is a deep recognition on the theatre of Jarash.

At the end of every aspect concerning the equipment, an analytic table is found where its features are explained and commented on in detail from the point of view of:

- State of conservation and relative maintenance.
- Visual appearance of the equipment in relation to the theatre perception.
- Conceptual compatibility of devices.
- Constructive and technical aspects of the equipment.

EQUIPMENT		
Maintenance		
POSITIVE	NEGATIVE	PURPOSES
Visual Appearance		
POSITIVE	NEGATIVE	PURPOSES
Conceptual Compatibility		
POSITIVE	NEGATIVE	PURPOSES
Constructive / Technical Aspects		
POSITIVE	NEGATIVE	PURPOSES

Prototype equipment table

Lighting – Permanent devices

Lighting devices typologies

Permanent lighting devices		
Symbol	n° of devices	Position
■ (green)	3	scaenae frons
✳ (cyan)	8	scaenae frons
▦	10	scaena, frons scaenae, orchestra, praecintio between media and summa cavea, right tribunal
▭	19	versurae, tribunalia, praecintio between media and summa cavea
●	23	post scanium, versurae, tribunalia, scaenae frons
◆	12	pulpitum
○	3	aditus maximi
◤	3	praecintio between media and summa cavea

Permanent lighting devices

Equipment 1	Equipment 2
Symbol: 🟩	Symbol: ✖

Equipment 3	Equipment 4
Symbol: ▦	Symbol: ▭

Equipment 5	Equipment 6
Symbol: ●	Symbol: ◆

Equipment 7	Equipment 8
Symbol: ○	Symbol: 🔊

LIGHTING – PERMANENT DEVICES MAINTENANCE

	positive	negative
Equipment 1	The presence of holes in the ancient structure dug in the masonry walls for the passage of cables, as well as of screw anchors, permits the easy replacement of damaged devices. The position and dimension of the boxes that house the lighting sources are close at hand and could be easily reached in case of revision.	In many cases, the presence of metallic parts in these permanent devices aimed at lighting produce a brown staining on the underlying stones of the masonry walls. Iron oxides are driven by water from the rusting railing. Screw anchors can change their size over the year; the expansion of an iron fixing in the stones for the lighting equipment on the frons scaenae, on the bleachers and tribunalia produce the classic "star crack" and other kind of fractures.
Equipment 2		
Equipment 3		
Equipment 4		
Equipment 5		
Equipment 6		
Equipment 7	Simple light bulbs are used in the accesses to the orchestra and pulpitum (aditus maximi, versurae) where more lighting devices are needed. The position is correct taking into consideration the usage of these parts of the theatre both from spectators and personnel working for staging activities. Due to their rough application (directly hanging on the masonry wall) their replacement is also quite easy for non-trained staff.	The lighting provided by this simple equipment is not enough during night spectacles and it is advisable to use more advanced and professional equipment. Heavier devices will cause the need for screw anchors that will obviously affect the masonry walls, adding new sources of deterioration.
Equipment 8	This equipment is not present during the greatest part of the year; they are positioned on the top of permanent stakes at the top of the theatre, behind the handrails of the media cavea's praecintio. The lighting supplied by these devices is quite useful both for the public and actors. Their negative impact on the ancient structures is limited because the strategy to keep a lightweight set of supports seems to be the better choice.	The presence of metallic parts on the surface in contact with the remaining masonry walls, if not controlled, can produce brown staining on the underlying stones (iron oxides).

LIGHTING – PERMANENT DEVICES PRESENTATION (VISUAL APPEARANCE)

	positive	negative
Equipment 1	During performances the scenographic lighting provided by this equipment fits very well with the ancient *columnatio* of the *frons scaenae*, emphasizing the architectural partition that create the frames of the *valva regia* and the two *hospitalia*. During the day, their "sandy" paint colour helps to hide their presence.	Despite the painting, during the day these devices appear not to be perceived as coherent additions and contribute to giving the *frons scaenae* a neglected aspect. Moreover, their position seems to be a bit too randomized (not homogeneous rotations and position, etc.) because they haven't been aligned to the architectural features of the niches and columns.
Equipment 2		
Equipment 3		
Equipment 4		
Equipment 5		
Equipment 6		

Equipment 7	During the day light bulbs do not create a heavy impact, in particular due to their position inside covered spaces such as the *aditus maximi*.	The not carefully planned position of the bulbs give the theatre entrances a neglected aspect that does not emphasize the monument features (vaults, mouldings, etc.) neither provide correct functional lighting.
Equipment 8	The presence of these lighting devices put on the top of stakes, approximately stuck in correspondence of the *scalae*, (stairs) at the height of the second praecintio is greatly useful and do not affect the global appearance of the *cavea*.	The negative aspect of these useful devices has to do with the way they have been connected to the remains of the *summa cavea* of the Jarash theatre. This part of the building was partially restored (the eastern part of the cavea) but still needs a consolidation of the fallen pieces of masonry walls of the southern and western sides. The lack of physical coherence of those parts and the lack of a stable plane, make the assembly and disassembly of the supports more difficult and unsafe.

LIGHTING – PERMANENT DEVICES, CONCEPTS (CONCEPTUAL COMPATIBILITY)

	positive	negative
Equipment 1 Equipment 2 Equipment 3 Equipment 4 Equipment 5 Equipment 6	The position of permanent lighting devices inside architectural elements of the facade (niches, between columns, etc.) can improve during night performances the reading of the *frons scaenae*. From this point of view it is important to underline the critical role of lighting design for a correct reading of the parts of the theatre: this activity can provide an interesting opportunity for educational activities.	In general during ancient times staging activities were carried out during daytime hours and thus, from a philological point of view, it is not correct to provide artificial lighting to the *frons scaenae* by adding equipment inside niches, basement of columns, *paraskenia*, etc. Some of the boxes that contain lighting devices are bigger than others and constitute a visual obstacle for a correct comprehension of some architectural features, but in general the main problem with them is their clumsy and neglected aspect due to a lack of attention in their design and maintenance practice.
Equipment 7	Lighting inside *cornificationes, basilicae, paraskenia, post scaenium, ambulacra* and *vomitoria* is useful because these spaces in general lack direct illumination. It is probable that they were provided with oil lamp or torches and so adding modern devices inside these places appears convenient and proper.	Current light bulbs inside *cornificationes* contribute to giving the site a neglected aspect, also considering the presence of visible wires on internal walls and barrel vaults.
Equipment 8	Lighting devices put on the top of removable stakes at the height of upper *praecintio* do not compromise the visual appearance of the theatre. In fact in Jarash just the trace remains of the *summa cavea*: a slope made of collapsed masonry walls. The benefit of to this equipment is to provide a general upper lighting to the cavea, permitting to spectators to see other architectural features during night performances.	In ancient times, theatres were illuminated by natural light because the staging activity was held during daytime. Starting from this statement, all kinds of equipment aimed at lighting may affect the perception of the ruins, in particular during the Jarash Festival. Removable stakes are stuck in the remains of the *summa cavea* that in great part still needs to be restored. From this point of view it would be advisable to arrange that part of the cavea in order to make it ready for a more coherent removable lighting system.

LIGHTING – PERMANENT DEVICES, CONSTRUCTIVE/TECHNICAL ASPECTS		
	positive	negative
Equipment 1	Technical data: Light beam halogen lamp and extensive power between 200 and 500 watts. Colour rendering of 98 CRI and colour temperature of around 1,800 ° Kelvin	It was necessary to pierce masonry walls in order to let wires get to the equipment, causing damage to the ancient structures. Due to the production of rust on the surface of protective metallic boxes it is frequent to see brown staining on the underlying stones. Iron oxides are driven by water from the rusting railing.
Equipment 2		
Equipment 3	Technical data: Projectors respond to gas discharge lamps, redder if we are talking about high-pressure sodium vapour, and if more bluish metal halide. Colour temperatures vary in both cases (2,200 ° Kelvin for the first case or 3400-5000 ° Kelvin for the second). Its CRI is also changed: in the first case 70 and 85 in the second.	
Equipment 4	Technical data: Projectors respond to gas discharge lamps, redder if we are talking about high-pressure sodium vapour, and if more bluish metal halide. Colour temperatures vary in both cases (2,200 ° Kelvin for the first case or 3400-5000 ° Kelvin for the second). Its CRI also be changed: in the first case 70 and 85 in the second.	Screw anchors and wires attached to the external walls of *aditus maximi* can produce "star crack" and other kinds of fractures. As before, these metallic anchorages cause brown staining on the underlying stones due to iron oxides.
Equipment 5		
Equipment 6	Same as Equipment 1	Same as Equipment 1
Equipment 7	Technical data: A 230-volt incandescent light bulb	Because of their inefficiency, incandescent light bulbs are gradually being replaced in many applications by other types of electric lights, such as fluorescent lamps, compact fluorescent lamps (CFL), cold cathode fluorescent lamps (CCFL), high-intensity discharge lamps, and light-emitting diodes (LEDs). Some jurisdictions, such as the European Union, are in the process of phasing out the use of incandescent light bulbs in favour of more energy-efficient lighting.
Equipment 8	Technical data: Equipment 4	It is very common to see provisional spotlight set at the height of the *praecintio* between the *ima* and *summa cavea*

DIAGNOSTICS 241

Lighting devices typologies

Seasonal 1: concerts and ballets		
Symbol	n° of devices	Position
⊙	between 30 and 40	scaenae, scaenae frons, tribunalia
◁	between 10 and 12	praecintio between ima and media cavea

Lighting devices typologies

Seasonal 2: concerts		
Symbol	n° of devices	Position
●	between 24 and 30	scaena
▦	between 6 and 8	scaena
◀	between 10 and 12	praecintio between ima and summa cavea

Phase 2

Stairs

Subdivision of the cavea in order to detect for every horizontal sectors the corresponding vomitorium

Phase 3

201,9 m² = 403 sp
195,9 m² = 392 sp
106,5 m² = 213 sp
106,1 m² = 212 sp
143,8 m² = 288 sp
158,6 m² = 317 sp
101,2 m² = 202 sp
102,0 m² = 204 sp

limit of the proscanium

Phase 4 and 5

$A_u \geq sp/480$

46,6 m
64,7 m
36,4 m
37,1 m
44,1 m
38,5 m

Maximum length of evacuation for every sector
sp = spectators

ACCESS SYSTEM IN ACCORDANCE WITH REGULATIONS

Maintenance

POSITIVE	NEGATIVE	PURPOSE
NA	The semicircular *prezintiones* present lots of holes and missing parts that in case of danger and consequent evacuation may increase the risk for spectators. In many cases the covered parts of the theatre (*vomitoria, aditus maximi and criptoporticus*) are used for the storage of technical equipment for staging activities that obstruct the access systems.	From this perspective, the constant surveying of the deterioration status of all the areas that lead to the main entrance and exits has to be considered fundamental.

Visual Appearance

POSITIVE	NEGATIVE	PURPOSE
NA	There is no signage to indicate the evacuation exits to the occupants of the theatre.	It should be necessary to provide some visual indications in order to indicate the traffic flow inside the theatre.

Conceptual Compatibility

POSITIVE	NEGATIVE	PURPOSE
NA	In ancient times theatre structures reflected the social order and for each sector of the *cavea* there was corresponding access. Nowadays, due to lack of maintenance, some of the entrances (*vomitoria*) are obstructed. The understanding of the ancient structures is compromised both in functional and conceptual terms.	

Constructive / Technical Aspects

POSITIVE	NEGATIVE	PURPOSE
After the analysis carried out on the dimensions and number of accesses/exits to the *cavea*, it was confirmed that they fit current regulations on evacuation plans.	NA	

Rubbish/Litter and Security system

RUBBISH/LITTER		
Maintenance		
POSITIVE	NEGATIVE	PURPOSES
A good practice that takes place in Jarash's theatre is the use of temporary items. This equipment is not attached to the structure of the theatre and does not produce any damage.	It is not enough to have only one person responsible for picking up the rubbish during the performances.	One feature that would be useful is the use of provisional litterbins according to the requirements of the moment. Provisional equipment that could increase or decrease according to the activity that is carried out in the theatre. In turn, the regular collection of waste is recommended at busiest times, such as during the theatrical performances. In addition, they may increase depending on the requirements of the moment.
Visual Appearance		
POSITIVE	NEGATIVE	PURPOSES
The bins are hidden in parts of the theatre that do not impair the viewing of the stage and do not affect the viewing of the performance.	This equipment does not follow a unitary design and it could have undesired visual impacts.	Location and size of the bins is essential not to distort the perspective of the spectator or visitor to the theatre. It is necessary to assign a few strategic points where there is an expected greater transit of people. In any case, they must not be placed in the *frons scaenae* not damage the view of the performance. In order to improve the visual appearance of the theatre, it is really important to assign a unitary design that includes all the equipment.
Conceptual Compatibility		
POSITIVE	NEGATIVE	PURPOSES
In the theatre of Jarash, the bins are in correct position, at the entrance and exit of the theatre but maybe there are not enough.	In many cases, the use given to the bins is incorrect. When the theatre is at full capacity a larger number of bins is required.	Conceptually, we should take into consideration the disposal of the bins according to their functionality. The number and position of bins should be considered according to their predicted usage. The location will be in areas close to the visitor such as the accesses and exits or passageways for seats, but it's important that they should never interrupt the passage. In order to prevent obstructions caused by any of them, we should study the areas with good flow and put many of them there. In any case, inside the theatre the bins must be placed close to the visitors to make them more convenient. Another very important factor is to educate the visitors about making use of the bins. Possibly this will require the placement of some information posters at the entrance.
Constructive / Technical Aspects		
POSITIVE	NEGATIVE	PURPOSES
NA	Insufficient capacity.	

SECURITY SYSTEM		
Maintenance		
POSITIVE	NEGATIVE	PURPOSE
Proper maintenance of security installations is essential for its operation.	Security system is stuck in the remains of the *summa cavea* that still mostly need to be restored. From this point of view it would be advisable to arrange that part of the *cavea* in order to make it ready for a more coherent removable security system.	It should be checked periodically.
Visual Appearance		
POSITIVE	NEGATIVE	PURPOSE
They are placed at points that encompass a complete view of the theatre or the greater part thereof.	Placement in clear places can compromise or distort the view of the surroundings. In the position that one of the security cameras holds, on the *summa cavea*, and it can have a visual impact for the surroundings. On the other hand, its location on the *frons scaenae* can disturb the view of the shows.	It is necessary to take into consideration the visual impact of these structures on the environment. This equipment should be slipped past the view.
Conceptual Compatibility		
POSITIVE	NEGATIVE	PURPOSE
The cameras must reach all public areas. Their mission will be to protect the ancient structures.	NA	
Constructive / Technical Aspects		
POSITIVE	NEGATIVE	PURPOSE
Coordination between all security equipment to have a generic view from a cabin where there is a security person ensuring the security of population and ruins.	NA	

DIAGNOSTICS 247

Defensive structures: handrails

movable handrails

Handrails typologies

Symbol		Position
	Provvisional handrails 1	orchestra aditus maximi
	Provvisional handrails 2	between ima cavea and praecintio
	Permanent	between media cavea and the remains of the summa cavea
	Permanent	tribunalia remains

DEFENSIVE STRUCTURES: HANDRAILS		
Maintenance		
POSITIVE	NEGATIVE	PURPOSE
NA	In many cases, defensive structures are quite deteriorated due to the permanent sun exposure. The presence of metallic parts of these permanent devices aimed at defensive structures produce on masonry pavements a brown staining on the underlying stones. Iron oxides are driven by water from the rusting railing.	Handrails need continuous maintenance to prevent their corrosion and degradation.
Visual Appearance		
POSITIVE	NEGATIVE	PURPOSE
A positive aspect to reduce the visual impact of these structures is the placement of provisional handrails depending on needs, as it is very well done in the theatre of Jarash.	Handrails do not follow a unitary design to have a favourable reading of the space.	These structures should follow a unitary design. This design should affect temporary and permanent handrails.
Conceptual Compatibility		
POSITIVE	NEGATIVE	PURPOSE
Handrails serve different functions. At the *summa cavea* they are for closing the edge area of the theatre. At the *praecintione* between the *summa cavea* and the *media cavea* railings are placed to prevent the risk of falls.	In Jarash's theatre we observed that a different placement of handrails is required depending on the performed act. Sometimes the orchestra is sectored in order to place lighting, direction and sound equipment. These cases should be studied carefully.	
Constructive / Technical Aspects		
POSITIVE	NEGATIVE	PURPOSE
NA	NA	

SIGNAGE AND SIGNS		
Maintenance		
POSITIVE	NEGATIVE	PURPOSE
NA	In some cases the maintenance is insufficient. The sun causes deterioration of signs making it difficult to read the panels.	
Visual Appearance		
POSITIVE	NEGATIVE	PURPOSE
NA	The visual appearance of the structure of these panels is inadequate. They do not follow a unitary design.	It is very important to follow a unitary design in order to improve the visual appearance of these panels. It would be interesting to include one part designated for the people with low vision and other part with a 3D reconstruction.
Conceptual Compatibility		
POSITIVE	NEGATIVE	PURPOSE
NA	These panels do not transmit a clear message for the tourist that does not know anything about the theatre. Lack of interaction with tourists: absence of audio guides, QR codes for downloading information (podcast, web pages), etc. Absence of elementary visual resources for comprehension such as virtual reconstructions, perspectives, augmented reality, etc. The information supplied by means of panels does not provide a diversification of possible routes based on the specific interests of the tourist or on the available time for their visit.	They should follow a sequence to guide the tourist throughout the theatre. The panels must be focused on different kinds of tourists, from children to tourists interested in a specific study of the theatre. This achieves a diversification of the public.
Constructive / Technical Aspects		
POSITIVE	NEGATIVE	PURPOSE
The structures are light and do not harm the ancient structures.	NA	

250 PROTOTYPE OF MANAGEMENT PLAN FOR ENHANCEMENT OF NEW ACTUALITIES

Detail 1

Detail 2

Detail 3

Detail 4

DIAGNOSTICS 251

5.4.1.2.2. Resources

This chapter attempts to collect all the documentation related with resources of the site and compare it with general recommendations developed in the Guidelines for Compatible Utilization.

In order to make an appropriate analysis, it is necessary to fill out some tables that indicate visually different aspects to take into consideration for the action plans. The following tables attempt to contrast basic information about the feelings of the users of the theatre. It is interesting to study this connection in order to make better use of the resources so that the needs of users are better met.

– Pictures: Attempt to reflect the visual appearance of each resource in order to reflect a first visual impact.

– Questionnaires: Contemplate answers of questionnaires filled out by different kind of users (Spectators, Artistic Staff, Visitors and Residents).

– Commentary: A brief description that reflects different kinds of compatibility according to the results of questionnaires and information collected in different ways.

Prototype resources table

Map to indicate the location of resources

The first stage in the analysis is to determine the location of different resources available at the theatre. The situation will be influential in considering the functional compatibility with its use.

R.1 Information point
R.2 Bookshop
R.3 Bar-coffee shops
R.4 Toilets
R.5 Ticket office
R.6 Interpretation center

INFORMATION POINT

Pictures

Questionnaires

Have you noticed deficiencies in this resource?

	Yes	No	Total	% (Yes)	% (No)
ARTISTIC STAFF	14	43	57	24.56	75.44
SPECTATORS	57	192	252	22.62	76.19
VISITORS	86	56	142	60.56	39.44

Did you access to the site information by the information point?

	Yes	No	Total	% (Yes)	% (No)
SPECTATORS	53	206	258	20.54	79.84
VISITORS	56	79	135	41.48	58.52

Commentary

There is an information point inside the visitor centre.

According to the answers of different categories of users, we can see that there is some discrepancy between artists, spectators and visitors. The last group have detected the most deficiencies in the information point.

In the way that they obtain their information, a low percentage of spectators get the information about performances from the information point while a higher percentage of visitors obtained all the information they needed at this site.

BOOKSHOP

Pictures | Questionnaires

Have you noticed deficiencies in this resource?

	Yes	No	Total	% (Yes)	% (No)
ARTISTIC STAFF	18	39	57	31.58	68.42
SPECTATORS	39	213	252	15.48	84.52
VISITORS	74	68	142	52,11	47,89

Did you use this resource? (Bookshop)

	Yes	No	Total	% (Yes)	% (No)
ARTISTIC STAFF	3	54	57	5.26	94.74
VISITORS	50	84	134	37.31	62.69

Did you use this resource? (Handcraft)

	Yes	No	Total	% (Yes)	% (No)
ARTISTIC STAFF	10	47	57	17.54	82.46
VISITORS	56	78	134	41.79	58.21

Commentary

There is a bookshop within the handicraft area near the main parking area. There is a café and ticket offices near the main entrance too. Thus, in general terms, the level of functional compatibility is acceptable.

In respect of deficiencies, most of the users do not find any in this resource. The bookshop has been used by a small number of people; however, typical products and handicrafts were more used by the visitors.

BAR-COFFEE SHOPS

Pictures

Questionnaires

Have you noticed deficiencies in this resource?

	Yes	No	Total	% (Yes)	% (No)
ARTISTIC STAFF	18	39	57	31.58	68.42
SPECTATORS	72	180	252	28.57	71.43
VISITORS	60	62	142	42.25	43.66

Did you use this service?

	Yes	No	Total	% (Yes)	% (No)
ARTISTIC STAFF	23	34	57	40.35	59.65
VISITORS	71	63	134	52.99	47.01

Commentary

There is a café and restaurant close to the Visitor Centre. At this location are found the main services that the archaeological site offers, therefore a good level of functional compatibility is obtained with respect to the location.

According to the results of questionnaires, it could be observed that for the most part the artistic staff, spectators and visitors do not detect any deficiencies with respect to bars and cafés, but it has to be considered that only half of the visitors and artistic staff used this service.

In the chapter on economic potential and action plans, the necessity of this service will be evaluated in order to improve the human comfort.

TOILETS

Pictures

Questionnaires

	Have you noticed deficiencies in this resource?				
	Yes	No	Total	% (Yes)	% (No)
ARTISTIC STAFF	8	49	57	14.04	85.96
SPECTATORS	70	182	252	27.78	72.22
VISITORS	81	61	142	57.04	42.96

Commentary

There are toilets in the visitor centre and the museum.

According to the answers given by the visitors that used the archaeological area, there aren't deficiencies with the toilets themselves. Instead, artistic staff and spectators felt the need to increase the number of toilets.

We interpret that a greater number of toilets are needed close to the theatre due to the capacity of spectators that it could serve.

TICKET OFFICE

Pictures

Questionnaires

	Have you noticed deficiencies in this resource?				
	1	2	Total	% (Yes)	% (No)
ARTISTIC STAFF	5	56	57	8.77	98.25
SPECTATORS	47	205	252	18.65	81.35
VISITORS	67	75	142	47.18	52.82

Commentary

There is a ticket office near the main entrance of the Cultural Cluster.

According to the answers, we can see that visitors have detected the most deficiencies in this resource. Performances are suggested at informative panels that indicate the place to buy tickets, but in a usual visit to the archaeological site, it is more difficult to find the place to buy the entrance ticket.

EXHIBITION HALL/INTERPRETATION CENTRE

Pictures | Questionnaires

	Have you noticed deficiencies in this resource?				
	1	2	Total	% (Yes)	% (No)
ARTISTIC STAFF	10	47	57	17.54	82.46
SPECTATORS	38	214	252	15.08	84.92
VISITORS	64	78	142	45.07	54.93

Commentary

There is an exhibition in the underground vault of the Zeus temple complex and there is a museum modern building inside the site of Jarash ancient city.

According to the answers of different categories of users, we can see that there is some discrepancy between artists, spectators and visitors. The last group have detected the most deficiencies at the interpretation centre.

INFIRMARY

Pictures | Questionnaires

	Have you noticed deficiencies in this resource?				
	Yes	No	Total	% (Yes)	% (No)
ARTISTIC STAFF	7	50	57	12.28	87.72
SPECTATORS	60	192	252	23.81	76.19
VISITORS	82	80	142	57.75	46.34

Commentary

There aren't any health care or first aid facilities at the site, but there is a hospital in Jarash modern city.

Artistic staff and spectators considered that an infirmary service is not necessary; perhaps they do not felt the need to go. However, visitors said that it could be necessary.

5.4.1.2.3. Internal services

This chapter contemplates internal services that offer archaeological site. The methodology to follow is the same as resources.

I.1 Official tourist guides (staff) I.3 Flyers
I.2 Official tourist guides (books) I.4 Audio guides

Map to indicate the localization of internal services

INTERNAL SERVICE	
Pictures	Questionnaires
Commentary	

Prototype internal service table

OFFICIAL TOURIST GUIDES (STAFF)	
Pictures	Questionnaires

	Have you noticed deficiencies in this service?				
	Yes	No	Total	% (Yes)	% (No)
ARTISTIC STAFF	20	37	57	35.09	64.91
SPECTATORS	98	160	258	37.98	62.02
VISITORS	78	61	139	56.12	43.88

Commentary

There are official tourist guides (personal) close by the visitor centre, so we could consider an adequate emplacement that fulfils the compatibility function. The results of the questionnaires do clarify the needs of this service. Approximately fifty percent think there are deficiencies.

OFFICIAL TOURIST GUIDEBOOKS

Pictures

Questionnaires

	Have you noticed deficiencies in this service?				
	Yes	No	Total	% (Yes)	% (No)
ARTISTIC STAFF	16	41	57	28.07	71.93
SPECTATORS	47	211	258	18.22	81.78
VISITORS	48	91	139	34.53	65.47

Commentary

There is an official tourist guidebook within the handicraft shops near the main parking area.
According to the answers of users to the questionnaires, most of them do not find deficiencies with the guidebook during their stay in archaeological area.
Visitors and spectators were provided with guidebooks.

BROCHURES/FLYERS

Pictures

Questionnaires

	Have you noticed deficiencies in this service?				
	Yes	No	Total	% (Yes)	% (No)
ARTISTIC STAFF	13	46	57	22.81	80.70
SPECTATORS	75	183	258	29.07	70.93
VISITORS	63	46	139	45.32	53.09

Commentary

There are brochures in the visitor centre.
The answers of the surveys reflect that the artist staff and spectators do not generally appreciate deficiencies. However, fifty percent of visitors disagree.

AUDIO GUIDES

Pictures

Questionnaires

Have you noticed deficiencies in this service?

	Yes	No	Total	% (Yes)	% (No)
ARTISTIC STAFF	12	45	57	21.05	78.95
SPECTATORS	56	202	258	21.71	78.29
VISITORS	76	63	139	54.68	45.32

Commentary

There isn't such service in the site.

According to the results of the survey, about fifty percent of visitors consider there to be a lack. We believe it would be appropriate to offer this service in order to facilitate the knowledge of the site.

WEBSITE

Pictures

Questionnaires

Have you noticed deficiencies in this service?

	Yes	No	Total	% (Yes)	% (No)
ARTISTIC STAFF	12	45	57	21.05	78.95
SPECTATORS	58	200	258	22.48	77.52
VISITORS	65	74	139	46.76	53.24

Did you access to the site information by the website?

	Yes	No	Total	% (Yes)	% (No)
SPECTATORS	41	217	258	15.89	84.11
VISITORS	33	101	134	24.63	75.37

Commentary

Some of them:

http://www.atlastours.net/jordan/Jarash_map.html
http://www.art-and-archaeology.com/jordan/Jarash/Jarash.html
http://www.sacred-destinations.com/jordan/Jarash
http://wikitravel.org/en/Jarash
http://www.jordanjubilee.com/visitjor/mapJarash.htm

One can observe a little discrepancy between the answer of artistic staff, spectators and visitors. The staff and spectators do not find anything lacking in this service while the visitors do.

Most spectators and visitors do not access information by these websites.

5.4.1.2.4. External services

This chapter contemplates external services that have some connection with the management of the theatre and Cultural Cluster. The methodology to follow is the same as for resources and internal services.

EXTERNAL SERVICE		
Pictures	Questionnaires	
	Commentary	

Prototype external service table

E.1 Parking areas
E.2 Public transport
E.3 Accommodation and restaurants
E.4 Shops and stores

Map to indicate the localization of external services.

PARKING AREAS

Pictures | Questionnaires

	Have you noticed deficiencies in this service?				
	Yes	No	Total	% (Yes)	% (No)
ARTISTIC STAFF	25	27	57	43.86	47.37
SPECTATORS	95	163	258	36.82	63.18
VISITORS	72	66	138	52.17	47.83

Commentary

There is a big parking area for buses and cars that satisfy all needs of the archaeological site. Also, there are some others parking areas distributed around the area.

There are important shortcomings with this service and approximately fifty percent of users are discomforted.

PUBLIC TRANSPORT

Pictures | Questionnaires

	Have you noticed deficiencies in this service?				
	Yes	No	Total	% (Yes)	% (No)
ARTISTIC STAFF	10	47	57	17.54	82.46
SPECTATORS	42	216	258	16.28	83.72
VISITORS	48	90	138	34.78	65.22

Commentary

There is public transportation to and from the modern city of Jarash.

Also, there is a normal public transportation runs on daily basis from bus station in Amman (North Bus Station) to Jarash Bus Station, only a few meters away from the main entrance of the Cultural Cluster. During the events, such Jarash Festival, the organizers runs specific buses from Amman to Jarash.

Most of respondents think that there are no shortcomings in this service. Public transport is located near the main entrance of the theatre.

RESTAURANT

Pictures	Questionnaires

Have you noticed deficiencies in this service?

	Yes	No	Total	% (Yes)	% (No)
ARTISTIC STAFF	11	46	57	19.30	80.70
SPECTATORS	47	211	258	18.22	81.78
VISITORS	63	75	138	45.65	54.35

Did you use this service?

	Yes	No	Total	% (Yes)	% (No)
ARTISTIC STAFF	26	31	57	45.61	54.39
VISITORS	63	73	136	46.32	53.68

Commentary

There is a restaurant inside the archaeological area.

Artists and spectators believe that there is no lack of service.

In order to promote the use of this service, it must be located in a strategic place with interesting views of the archaeological area, always taking into consideration the compatibility with the ruins.

SHOPS-STORES

Pictures	Questionnaires

Have you noticed deficiencies in this service?

	Yes	No	Total	% (Yes)	% (No)
ARTISTIC STAFF	10	47	57	17.54	82.46
SPECTATORS	35	223	258	13.57	86.43
VISITORS	38	100	138	27.54	72.46

Commentary

There are many shops-stores and restaurants around the site in the modern city of Jarash. They are located at the exit of the archaeological area.

Most respondents think that this service is not lacking.

This service would need to be more formally integrated with the surroundings.

CASH POINT / ATM

Questionnaires

Have you noticed deficiencies in this service?

	Yes	No	Total	% (Yes)	% (No)
ARTISTIC STAFF	20	37	57	35.09	64.91
SPECTATORS	70	188	258	27.13	72.87
VISITORS	66	72	138	47.83	52.17

Commentary

There is no cash point (ATM) or bank branch within the ancient site or nearby.

Most respondents think that there are no deficiencies in this service. However, a great number of visitors feel otherwise.

It is recommended that a cash point be provided near the ticket office and shops in order to improve their use.

ACCOMMODATION CAPACITY OF THE CULTURAL CLUSTER

Questionnaires

Have you noticed deficiencies in this service?

	Yes	No	Total	% (Yes)	% (No)
ARTISTIC STAFF	12	45	57	21.05	78.95
SPECTATORS	43	215	258	16.67	83.33
VISITORS	61	77	138	44.20	55.80

Commentary

There are perceived deficiencies in this service, especially for the visitors. As we can see in the results of the questionnaires and the table below, the artists, spectators and visitors have to move a large distance to be able to enjoy the theatre.

ARTIST				
DATE	TIME	HOTEL DISTANCE	HOTEL PERSONS	HOTEL NIGHTS
13/7/2012	8:45 pm	1.5 hours	1	3
13/7/2012	8:30 pm	45 minutes		
13/7/2012	8:30 pm	1 hour		
12/7/2012	9 pm	1 hour	2	1
13/7/2012		In Amman	2	4

SPECTATORS				
DATE	TIME	HOTEL DISTANCE	HOTEL PERSONS	HOTEL NIGHTS
		300 m	3	4
		500 m	2	10
		25 km	2	5
13/7/2012	8:15 pm	1 km	4	8
13/7/2012	8:45 pm	11 km	2	2
		3 km	2	7
13/7/2012	9:00 pm	5 km	7	21
12/7/2012	8:35 pm	80 km	1	5
12/7/2012	8:30 pm	80km	1	
12/7/2012	8:30 pm	From Amman	2	5
12/7/2012	8:00 pm	1 hour	5	14
		35 km	2	8
12/7/2012	8:00 pm	1 hour		
12/7/2012	9:00 pm	50 km	2	7
12/7/2012	5:45 pm	77 km	3	1
12/7/2012	9:15 pm	180 km	2	3
10/7/2012	8:30 pm	17 km	3	1
10/7/2012	7 pm	3 km	2	4
10/7/2012	9:00 pm	50 km	2	7
12/7/2012	8:30 pm	30 km	2	2

		VISITORS		
DATE	TIME	HOTEL DISTANCE	HOTEL PERSONS	HOTEL NIGHTS
14/7/2012	7 pm	20 km	4	8
14/7/2012	6 pm	n/a	n/a	n/a
14/7/2012	6 pm	18 km	4	3
14/7/2012	6:30 pm	5 km	5	20 days
14/7/2012	6 pm	5 km	2	2
14/7/2012	6 pm	5 km	7	3
		80 km	5	11 days
14/7/2012	5:46 pm	10 km	4	10 days
13/7/2012	7.30	2 hours	7	9
13/7/2012	6 pm	1 hour	2	3
13/7/2012	7 pm	1 hour	3	6
13/7/2012	4 pm	200 M	2	3
13/7/2012	4 pm	3 km	2	1
13/7/2012	4 pm			
13/7/2012	5:30 pm	less than 15 minutes	1	2
14/7/2012		14 km		
14/7/2012	10 pm	25 km		
13/7/2012		45 km		
14/7/2012	5:30 pm	4 km		
14/7/2012	4:40 pm	10 km		
14/7/2012	6 pm	2 km	2	2
14/7/2012		2 km	4	

5.4.2. THE TOURISM SECTOR

5.4.2.1. INTRODUCTION

The first information needed for managing an Ancient Theatre in an appropriate way is to know the inbound number of visitors. Next, the total amount of visitors per year must be registered, noting the peak season and the low season. Other useful data are the maximum number of visitors registered in one day; the daily and monthly average of visitors; and the type of visitors (nationals, internationals, individuals and scholar groups, tourist packaged groups, others).

In relation to the visitors' profile, it is important to know the dominant nationalities, percentage of the age range, gender percentage, level of education percentage, and occupation percentage.

Beyond the demographic data, it is necessary to know about the visitors' motivations that form the basis of the experience satisfaction level. Next, it is necessary to search for the visitors' cultural background (beliefs, rituals, values, ways of thinking, etc.) and social influences (references groups, lifestyle, etc.). Workshops with stakeholders, interviews with interested people, and direct observation of visitors' perceptions and behaviour patterns must be carried out in order to obtain an approximation to this information.

Other factors determining the satisfaction of the visit are, for instance, safety issues and the existing congestion or overcrowding conditions in some areas. Safety issues deal with the risks for users during the development of the activity (places with stairs or grades, irregular trail surface, topography, etc.).

Congestion or overcrowding of the main iconic attractions produces a psychological constraint for the visitors. Congestion can occurs periodically (indicate day, month, season), always, or seldom (only in special events).

Other elements related to an unsatisfactory experience are the presence of large queues in some areas. It must be highlighted that not only can the iconic attractions be affected by queues, but also toilettes, the entrances, and the ticket office for the theatre may also be affected.

Finally, it is necessary to note if there are any surveys regarding visitor satisfaction. Data from these questionnaires are very useful for addressing visitors' needs, and then improving the experience.

5.4.2.2. JARASH THEATRE CARRYING CAPACITY

The following analysis has been carried out with statistics based on data provided by the Ministry and not by the results of the questionnaires prepared by the Athena Group. The time period that our questionnaires reflect is insufficient due to the fact that it pertains only to the period of the summer festival and reflects only a short space of time. In short, the data provided by the Ministry are more complete and cover a larger time period, so the visitor's profile is more representative.

This work deals with the Recreational Carrying Capacity Assessment (RCCA) for the Southern Theatre of Jarash (Jordan). This Ancient Theatre represents one of the most significant monuments of the archaeological site of Jarash. The Recreational Carrying Capacity Assessment addresses the question of how many people can be permitted into an area without risk of degrading the site and the visitors' experience on it. It is not the same concept as Seating Capacity, which refers to the number of spectators that an Ancient Theatre can accommodate. It is not a Tourism Carrying Capacity Assessment either, because it does not focus attention on the accommodation facilities of the tourism destination.

This heritage site is located 48 km north of Amman, in the Jarash Governorate, and situated within the Mountain Heights Plateau, which separates the Jordan Valley from the flat eastern desert.

This Archaeological Park is the second most visited site in Jordan because, in addition to this theatre, one finds paved and colonnaded streets, temples, another theatre, public squares, baths, fountains and the city walls.

The Southern Theatre can seat more than 3,000 spectators and it is still being used as a cultural venue, especially for performances and staging activities such as the Jarash Festival of Culture and Arts, in July.

The Recreational Carrying Capacity Assessment of the Southern Ancient Theatre of Jarash has taken into consideration the following components: the space where the activity takes place, resources involved, tourism activities, and visitors' profiles, behaviour and expectations.

Also, standards for conservation and the physical and psychological comfort of visitors have been considered. Results from the different analysis have been integrated and relationships (performance criteria) among the components, standards and limiting factors have been underlined.

The process of setting up all the aforementioned components and data was drawn following the classical three consecutive level approaching: Physical Carrying Capacity (PCC), Real Carrying Capacity (RCC), and Effective Carrying Capacity (ECC).

Spatial characteristics of The Southern Ancient Theatre of Jarash

The Southern Theatre has an exterior diameter of 70.5 m. The *ima cavea* is a semi-circular sector of 18.8 m radius length divided by five stairs into four sections; the *summa cavea* was similarly divided

by seven stairs into eight sections with fifteen rows. The *Ima and summa cavea* are separated by a wide corridor (*diazoma*) 1.75 m in width describing the full half circle between them (fig. 1). The radius length from the *orchestra* to the *summa cavea* reaches 31 m; the semi-circular *orchestra* has a diameter of 20.4 m.

The *ima cavea* was built into the side of the hill, while the *summa cavea* was built above it. Although the auditorium has survived remarkably well, the top rows of seats are missing.

The front of the stage was divided into four sections with pedestals between them. The *scaenae frons* is a 5.5 x 19 m platform, pierced by three doors used by the performers to enter and exit the stage from the sides.

Two vaulted *aditus maximi* entrances with a passing width of 3 m lead visitors into the *orchestra*. Four passages at the back of the theatre give access to the upper rows of seats.

Resources involved

The resources involved in this assessment are the monuments themselves; in other words, the architectural structure is both the main attraction, and also the physical support of the activities. That means the Ancient Theatre is subject to the natural damage caused by weathering (rain, temperature changes, biological colonization, etc.) natural hazards, and also to those effects due to staging and visiting activities.

In general terms, the physical conditions of the Jarash Theatre structures are acceptable, except some parts of *scaenae frons*, *aditus maximi* and top of *summa cavea*, which are in critical condition.

Tourism activities

Tourism activities have been the focus of this RCCA study, basically those related to visiting actions. Regarding the different current

Figure 1. Characteristics and spatial dimensions of the Southern Theatre of Jarash (Jordan)

types of visits in Ancient Theatres, the domestic or international packaged guided tour groups and ordinary individual self-guided visits are the most usual.

The level of compatible utilization between these activities and the staging and performance uses is low because both take place at the same place and present their peak season at the same time.

Visitors' profile and expectations

According to the results of the survey campaigns conducted periodically by the Jordan Ministry of Tourism and Antiquities, over the last fifteen years, the number of visitors to Jarash has fluctuated between 100,000 to 300,000. This oscillation in the annual visitation to the archaeological site is attributable to the international visitor flows that change due to the on-going political conflicts in the surrounding countries, and recently because of the world economic crisis. Of this total number of visitors, a flow of nearly 50,000 are always Jordanian visitors and the rest are foreign visitors, especially Europeans and, secondly, Americans. This makes the archaeological site solely economically dependent on international tourism.

The peak period for visiting the site varies depending on Jordanian visitors that prefer to go in the month of July, while foreign visitors visit Jarash in the spring period (March, April) and also in October (Ministry of Tourism and Antiquities, 2012). International visitors come to Jarash as part of a day tour from Amman or while en route to Syria where many more days (and nights) are spent.

Different tour-operators such as Kuoni, Tul or Kirunna dedicate the second day in Jordan to go to Jarash. All the visitors reach Jarash in the morning and they stay there till the midday. The time they spend at the ancient city of Jarash is just three hours, and because many tour-operators follow the same trip schedule, a concentration of visitors and buses is observed. At the same time, it must be stated that not too much time can be devoted to the visit of the Southern Theatre.

Abu Ali & Howaidee (2012) described the demographic variables of the Jarash visitors noting that senior tourists (34.1%) were the most represented tourist group vacationing in Jarash during the spring season. The sample of respondents was very evenly divided in terms of gender, with 56.9% males and 43.1% females. Tourists who visited Jarash for the first time were the majority (78%). Visits in tour groups were more 54.5%, while free individual groups were 45.5%. Tourists who visited Jarash for leisure purposes came first on the list (65%). We can conclude after these results that basically International tourists are general or accidental cultural tourists, not particularly specialized and with limited expectations. Commonly, the greatly motivated or core cultural tourist prefers an individual visit and his/her expectations about the visit are higher.

Whereas the cultural attractions in Jarash are at the most outstanding level, commercial visitor services in and around the site are at a rudimentary level. As a result, time spent on site and in the town is kept to an absolute minimum and do not satisfy the expectations of the greatly motivated visitors, although they are enough for the accidental ones.

5.4.2.2.1. Physical carrying capacity

The first stage in the analysis is to determine the Physical Carrying Capacity (PCC), which is a rough estimate about the maximum number of visitors that the Theatre is actually able to support at any given time and still allow people to be able to move.

PCC deals basically with spatial considerations and only space limiting factors must be taken into account, considering the existence of restricted zones because of the presence of valuable archaeological resources and also for safety reasons, as in the case of the Jarash Theatre. Therefore, a zoning system has been established highlighting the Available Surface Area for Recreation, by leaving out a part of the *summa cavea* that cannot be included in the calculation because of its critical state of conservation and safety considerations.

Spatial limitations due to the incompatibility with other staging and performance activities and also with archaeological works in operation must also be considered because in the summertime the Festival of Arts takes place in the Theatre and the *cavea*, *orchestra* and *stage* are all occupied by staging equipment making access difficult and damaging the aesthetics of the theatre. Archaeological and maintenance work takes place at any time.

The PCC can be calculated by following Boullon's formula (1985): area used by visitors divided by the average individual standard. The standard of individual space requirements are directly linked with the Visitors' Psychological Comfort. Proxemic studies and the World Tourism Organization (2005) talks about 4 m2 when developing dynamic activities.

Therefore the peak capacity is obtained by calculating the surface of the *summa* and *ima cavea* (approximately 2,900 m2) and dividing this by 4 m^2 needed for each visitor, the result being 729 visitors at any one time. Obviously, this figure is unacceptable because of the physical, acoustical and visual impacts that such a large number of visitors would have.

5.4.2.2.2. Real carrying capacity

This stage of the process basically deals with the study of the limiting factors, reducing the amount of visitors obtained from

PCC calculation. This study includes the analysis of the physical and social limiting factors, and it is based in the application of the performance criteria or standards that define the desirable site conditions. This kind of research usually finds the need to apply some reductions in the number of visitors or planned activities according to the impact level caused.

Therefore, the identification of the potential physical, acoustical and visual impacts has been carried out, and the zoning system the redefined in order to know the most appropriate areas for visitation where the minimal risk of impacts exists. Moreover, the visitors' touring pattern inside the theatre has been set, and also areas that need particular physical protection via ropes, fences, handrails, etc., have been identified.

A first approach to the potential damage that the public access may provoke in the Jarash Theatre informs us that mechanical degradations must be taken into account. Human passage provokes abrasion due to the rubbing of shoes on the floors and a large number of visitors can contribute to this damage. Another impact is the destruction of the archaeological setting (fall of blocks and fabric degradation), and that is closely related with the action of stepping on the theatre. As aforementioned, the *scaenae frons*, *aditus maximi* and top of *summa cavea* of the Theatre of Jarash are in critical condition, and thus these areas must be excluded from the visit wherever possible, preserving them in order to ensure their integrity.

Other impacts are related to the visual and acoustical features of the theatre. Ancient theatres have a high visual vulnerability when visited, being the visitors themselves the cause of the impact. A large number of visitors randomly distributed in the *cavea* provoke visual impacts by intrusion or obstruction of the view planes (foreground, middle ground and background) and because of the existence of many viewing locations or points from which the theatre can be seen. Additionally, the panorama views are the most usual in this type of semi-open spaces.

Regarding the acoustical impacts, it must be stated that a large number of visitors can also be the cause of impact. The theatre acoustical features amplify sound as many authors devoted to this issue such as Hadad (2007) have already demonstrated. Several sources of sound at one time can cause aural chaos and spoil the opportunity of benefiting from the uniqueness of this special soundscape, damaging the quality of the tourist experience.

In relation to tourism activities in Jarash, it can be noted that self-guided visits and guided tours take place during the time of opening of the Theatre. The days and opening hours of the theatre for visitors is Monday to Sunday; summer hours are 7:30 a.m. to 7:00 p.m. and winter hours are 8:00 a.m. to 5:00 p.m. Thus the site offers a large availability during the year. Visits to the Southern Theatre don't last more than half an hour.

Constrains in relation to the limiting social factors are related with Visitors' Psychological Comfort, in this case especially linked to the features of the setting where the activity is developed, the existing facilities and safety conditions. The perception of crowding or congestion is negligible and has been recorded not in the theatre itself, but occasionally queues have been observed in the ticket office and in the toilets. The group size and the number of encounters with others groups in the theatre can create physical and psychological discomfort.

The configuration, shape and characteristics of the theatre are important for designing and implementing the best touring pattern in order to avoid impacts, congestion, and to provide a good interpretation program and a quality experience to the visitors. The Ancient Theatres configuration imposes a complicated touring pattern, because of their visual fragility as mentioned before. Thus, the proposed touring pattern for the Jarash Theatre is to access through the *aditus maximi* and then the visitors go directly to the orchestra that is the meeting point and first station of the tour. From this point, a pie-shaped pathway (fig. 2) starts. Then visitors take the stairs on the right side of the *ima cavea*, and they reach the *diazoma*. At this passage, they could walk through the semi-circular corridor or they could climb more steps by taking the first stair on the right side of the *summa cavea* and reach the top row of seats where a spectacular panoramic view of the Jarash site awaits the visitors. Afterwards, the pathway leads the visitors back down to the orchestra pit by descending the opposite side staircase. Other complementary pathways could be implemented from the orchestra to the stage out of the staging season. Some spontaneous diversions can be permitted from the pathway to the *summa* and *ima cavea*. The pathway has a length of 331 m and less than 97 m if visitors take the *diazema* shortcut.

After these considerations, it is suggested that the group size not exceed 15 visitors and the number of encounters must be low, around two or three. That will guarantee the minimum mechanical, visual and acoustical impact and the best physical and psychological comfort for visitors. Consequently, it means that the pathway is the real available area to visitation activities, and a maximum of 45 people could meet at the site at the same time, having a pathway level use rate around 10%, which is the usual in linear recreational facilities (Viñals et al., 2011).

In relation to the safety limiting factors, the Theatre of Jarash in addition to the two *aditus maximi*, has four more escape

gates located in the *diazema* and also an evacuation plan exists. Permanent handrails are placed in the remains of the *summa cavea*.

The facilities limiting factor is a key issue because only some basic facilities (information point, bookshop, bar-café, toilets, ticket office and interpretation centre) exist in the Theatre of Jarash. According to the answers of questionnaires, the interviewed visitors have observed some deficiencies or they consider that these facilities are clearly insufficient. Information and Interpretation facilities are important tools for managing visitors in heritage sites and they would be very useful in implementing recreational carrying capacity measures.

The suggested aforementioned figures about the suitable number of visitors can be applied only in the case that no performing or staging activities take place at the same time because the *cavea* and other parts of the theatre can be occupied by sound and light equipment or additional seats. Therefore visiting activities can be seriously affected, and beyond the intrusive presence of these elements, the aesthetics and image of the site may be dramatically affected.

As concluding remarks of this stage, it could be highlighted that after taking into consideration many spatial and physical limiting factors and also the social ones, the adequate number of visitors at the same time is about 45 people. Knowing that the maximum number of visitors per year has been around 300,000, it means that the theatre has an average of 821 visitors at day. If the site is available an average of ten hours at day, by applying a rotation coefficient (number of daily hours available for the visit divided by average time of the visit), it implies a regular distribution of 82 visitors per hour. Considering the large dimensions of the Jarash archaeological site, it seems highly unlikely that visitors devote more than 30 min. to the visit of the Southern Theatre. In the worst-case scenario of 82 visitors per hour, this figure fits in well with the suggested number of 45 at the same time, each doing a visit of 30 min.

Figure 2. Suggested Touring Pattern to visit the Southern Theatre of Jarash (Jordan)

5.4.2.2.3. Effective carrying capacity

Finally, the third analytical stage is the Effective Carrying Capacity (ECC) that deals with the available managing capacity of the corresponding site administration (managerial limiting factor). Measuring managing capacity is not an easy task, since many variables (several of which are quite subjective) are involved, such as policy measures, legislation, infrastructure, facilities and equipment, staff, funding, and motivation for heritage conservation.

The Ministry of Tourism and Antiquities (MoTA) and the Department of Antiquities (DoA) are the responsible administrations for overseeing the archaeological site and associated tourist facilities. According to Myers et al. (2010), MoTA oversees regulation of the tourism sector, encouraging tourism-related investment, preparing studies and research for tourism development and growth, and enhancing the country's tourism workforce. The department's office for the governorate of Jarash is located at the Jarash archaeological site, and approximately sixty-five DoA personnel are based at the site (one inspector, two archaeologists, one museum curator, seven ticket sellers, six personnel who check tickets at the entrance gate, fourteen guards, ten custodial staff, and a few administrative personnel). The DoA is charged with enforcing the Law of Antiquities at the site as well as in the rest of the governorate. It also enforces the DoA's Instructions for Holding Activities at Archaeological Sites.

On the other hand, the regional authorities (Jarash Governorate) are responsible for tourists' security.

It seems that more staff devoted to visitors' management is needed because neither guides nor interpreters are listed in the staff role list and they are the key workers in dealing with recreational carrying capacity management and also in providing quality experiences to visitors.

Apparently, an effective legal framework exists for protecting the heritage site but more developments are necessary in the field of tourism management. Therefore, planning tools, such as zoning, and management techniques or visitor flow management, as mentioned, can mitigate the recreation impacts.

Finally, it can be stated that managerial limiting factors at this moment constitute a constraint on the process of managing recreational carrying capacity. In other words, the theatre can accommodate a larger number of visitors than the administration is effectively able to manage.

On the other hand, it must be said that the Southern Theatre at the present time has not exceeded its recreational carrying capacity, but additional personnel and some technical tools must be applied in order to improve the quality of the experience.

REFERENCES

Abu Ali, J. & Howaidee, M. 2012. The impact of service quality on tourism satisfaction in Jarash. *Interdisciplinary Journal of Contemporary Research in Business*, 3 (12), pp. 164-187

Boullon, R. 1985. *Planificación del espacio turístico*. Ed.Trillas. México.

Hadad, N. 2007. Criteria for the Assessment of the Modern Use of Ancient Theatres and Odea. *International Journal of Heritage Studies*, 13 (3), pp. 265-280.

Ministry of Tourism and Antiquities of Jordan. 2011. Tourism Statistical data 2011. *Tourism Statistical Newsletter*, 7 (4).

Myers, D.; Smith, S.N. & Shaer, M. 2010. *A Didactic Case Study of Jarash Archaeological Site, Jordan: Stakeholders and Heritage Values in Site Management*. Ed. The Getti Conservation Institute / Department of Antiquities of the Hashemite Kingdom of Jordan, 77 pp.

Viñals, M.J.; Alonso-Monasterio, P.; Alonso-Monasterio, M. 2011. Recreational carrying Capacity of the Iberian Settlement Castellet de Bernabé and its environment (Llíria, Spain). *4th International Conference on Tourism & Environment*. Cáceres, 2011.

World Tourism Organization. 2005. *Indicators of sustainable development for tourism destinations. Guidebook*. WTO, Madrid.

5.4.3. JURIDICAL ASPECTS

In view of documentation provided for that purpose, a value judgment must be made on legal issues affecting the theatre of Jarash.

As regards the aspects of legal treaties in paragraph 4.3.4 indicate the following:

1. Property Regime of theatre and CC.
2. System of protections and urban planning inside the CC.
3. Safety standards for performance buildings at the local and national levels.

First, it must be noted that three legal points are dealt with in the questionnaire, information that we have seen is required this document, without which it would be impractical to continue.

Next, the legal information referred to is evaluated.

5.4.3.1 PROPERTY REGIME OF THEATRE AND CC

According to the report issued on the property of the archaeological site and its surroundings, it is noted that the authorities involved in the administration of the site of Jarash are as follows: Department of Antiquities (general manager), Ministry of Tourism and Antiquities (Minister), and the Jordan Tourism Board, as an independent public-private organization.

Therefore, the first aspect that should be noted is the lack of coordination between administrations and entities involved in the management and regulation of the site. Thus, the Department of Antiquities applies the Antiquities Act throughout the province as well as the instructions for the celebration of activities in the archaeological sites; the Ministry is responsible for the development and promotion of the tourist sites of ownership public and, equally, regulates the tourism sector. At the regional level, the Governor is responsible for the infrastructure, public health, economic development and security of the tourists. Finally, at the local level, there is a mayor of the municipality that has authority over the urban development planning.

In view of the above, from our point of view, it would be desirable to see the establishment of a public law entity with the possibility of private sector participation, a kind of Consortium or Foundation, which joins together into a single entity with the aim of regulating, managing, protecting, and preserving the site of Jarash.

REPORT ABOUT OWNERSHIP OF THE ARCHAEOLOGICAL SITE AND THE SURROUNDING AREA

In terms of the DoA's administrative structure, the department is managed by a director-general who is directly linked to the minister of tourism and antiquities. The minister also oversees the Ministry of Tourism and Antiquities (MOTA) and the Jordan Tourism Board, an independent public–private sector partnership charged with promoting tourism to Jordan. These three bodies operate separately from one another. For example, although the DoA is under the minister of tourism and antiquities, it is not under MOTA. The minister is a key figure in decision-making concerning tourism and archaeology on a national scale as well as specifically regarding the site of Jarash.

The DoA's headquarters are in Amman, and it has twelve major offices around the country—representing each of Jordan's twelve governorates—and eight subsidiary offices. The department's office for the governorate of Jarash is located at the Jarash archaeological site, and approximately sixty-five DoA personnel are based at the site. An inspector who is also an archaeologist supervises all DoA personnel in the governorate, including at the site of Jarash. Other DoA staff within the governorate are currently composed of two other archaeologists, one museum curator, seven ticket sellers, six personnel who check tickets at the entrance gate, fourteen guards, ten custodial staff, and a few administrative personnel. The Jarash Project for Excavation and Restoration, based at Jarash archaeological site, also has administrative staff, approximately fifty workers, and six vehicle drivers under the management of the project's supervisor.

The DoA owns the Jarash archaeological site. The DoA office at Jarash is charged with enforcing the Law of Antiquities at the site as well as in the rest of the governorate. It also enforces the DoA's "Instructions for Holding Activities at Archaeological Sites." Generally, any activities undertaken within the DoA-owned site should be carried out with permission of the DoA. DoA staff at Jarash are involved in raising public awareness through outreach to schools and through the site museum. The museum curator has developed a number of educational programs for local schoolchildren grades 1 through 10, with the goal of getting their parents interested in the site. During the months of April and May, the DoA hosts two school groups per week at the site. It is currently developing new programs for families and working with the Ministry of Education to enhance school curricula on antiquities and the archaeological site of Jarash.

MOTA is responsible for the development and promotion of publicly owned tourism sites. It also oversees regulation of the tourism sector, encouraging tourism-related investment, preparing studies and research for tourism development and growth, and enhancing the country's tourism workforce. MOTA is based in Amman and has offices at most major tourism sites. The director of tourism for Jarash governorate, a MOTA employee, has an office at the visitor centre on the site of Jarash. This individual coordinates MOTA's responsibilities with respect to tourism at the site, including concessions, tour guides, the visitor centre, parking, and health and safety issues. Moreover, MOTA has been instrumental in the development of the tourism services infrastructure at Jarash, such as parking for vehicles and the handicraft centre.

At the regional level, the archaeological site is located within Jarash governorate, one of twelve governorates of Jordan, and its capital is the modern city of Jarash. The governorate is under the direction of a governor who is appointed at the national level, and includes several directorates, or departments. The responsibilities of the government of the governorate include infrastructure, public health, economic development, and safety, including the security of tourists. The governor is therefore a key figure in the management of the Jarash archaeological site, as he oversees the site's security. This role includes involvement in determining visitor access to the site and coordination of all levels of site security, including personnel from the tourist police, the governorate's directorate of police, and other kinds of security personnel.

The governor is also concerned with many challenges regarding the infrastructure to accommodate tourists, including the improvement of roads, upgrading water and sewer systems, supplying electricity, and building new hotels. The governor is also concerned about the economic well-being of the modern city and the governorate as a whole, and is keenly aware of the as yet unfulfilled opportunity of the Jarash heritage site in benefiting the region.

Locally, the site is situated within the Jarash municipality, which is under the leadership of the head of the municipality and a city council, who are all locally elected and oversee various municipal departments. Like the physical separation of the archaeological site from the modern city, the two are also clearly separated in terms of administrative authority. The DoA and MOTA oversee the archaeological site and associated tourist facilities, respectively, while the municipality has authority over the modern city, which surrounds the site on all sides. The municipal government plays an important role in regulating and approving land use within the municipality.

Both the governor and municipal leaders have an interest in seeing increased tourism to the site and a better connection between the site and the city to produce more local economic benefits. They also believe that more effectively connecting the site with the city will bring cultural benefits that will allow international visitors to learn of the friendly and hospitable nature of Jordanians, and the local people to learn about and from the cultures of the visitors, including learning foreign languages. In addition, they believe that local interaction with foreign tourists can moderate tourist perspectives about Arabs as well as temper local views of foreigners.

5.4.3.2 SYSTEM OF PROTECTIONS AND URBAN PLANNING INSIDE THE CC

According to the Antiquities Act, the DoA is considered to be the owner of the Jarash site and it is forbidden to change the use of land or carry out activities except excavations or tourism.

It seems to be a poor and weak regulation in the field of urbanism that only limits the classification of land uses or activities covered by the Antiquities Act.

Thus we propose more regulation of the land that places limitations on its uses and activities but, in turn, equips it with special protection. Also, there is the necessity of drafting laws and regulations on the protection and conservation of the theatre and its surroundings and limits the ability to build in the areas close to the protected zone. It is recommended that a security perimeter be created in which new construction works are forbidden except those directly related to the theatre.

> **REPORT ABOUT URBAN PLANNING REGULATIONS INSIDE THE CC**
>
> By the law of antiquities, the department of antiquities is the owner of Jarash site, and it is not allowed by law to change the land use or use its land for any other purpose other than excavations and tourism.

5.4.3.3 SAFETY STANDARDS FOR PERFORMANCE BUILDING AT LOCAL AND NATIONAL LEVEL

In accordance with established rules, this paragraph notes that the legal framework about performances is found in the Jordan Antiquities Law, the main state law regarding the regulation of the archaeological heritage.

Due to the limited information that has been provided, and without detriment to the points governed by the aforementioned law, the following subjects are proposed to be taken into account in a possible modification or improvement of the standard:

- **Museum use.** The aspects that should be defined in this chapter are: inventory of collections, museum activities, spatial characteristics, the way of management and financing, spaces and complementary activities, facilities that must be provided as well as the characteristics of the touristic tours.

- **Educational activities.** These activities should deal with art, archaeology and history in order to promote awareness of the historical heritage. Currently there are informative and educational programs in summer time, but school programs and family activities should be emphasised, extended to other groups, and held throughout the year aimed at promoting cultural development.

- **Boosting tourism.** It has to be implanted as a hallmark of historical heritage in the tourist routes. Currently it is one of the most spectacular buildings in the archaeology site due to its dimensions.
- **Staging activities.** The theatre is the setting for important cultural events. This kind of activity should be contemplated and emphasized somehow. It will open a forum for local, national and international visitors, fostering the values of the performing arts and generating international prestige.
- **Formal and ceremonial activities.** Develop cultural activities and local traditions.

REPORT ABOUT LAWS AND REGULATIONS REGARDING SPECTACLES

Legal Framework and Governing Authorities : The Jordanian Law of Antiquities is the nation's primary law governing archaeological heritage. This statute identifies the Department of Antiquities (DoA) as the national authority responsible for the protection, excavation, restoration, conservation, presentation, and management of antiquities in Jordan. It also gives the DoA the responsibility to promote awareness of archaeology, including through educational activities. In addition, it provides for a national register of all archaeological sites, and that the ownership of immovable antiquities is solely vested in the national government.

The principal policy objective of the DoA is the protection of antiquities, preferring conservation measures that do not require physical intervention to the remains as the first choice where possible. The secondary policy objective is for the presentation of antiquities, including research, survey, excavation, and site management. The DoA's protection-related responsibilities include enforcing national laws prohibiting illicit excavations and the trading, exporting, and importing of antiquities. The department employs a large number of site guards across the country to protect sites, including at Jarash. In the area of presentation, the DoA is responsible for preparing and placing interpretive signs at sites for visitors, as well as curating and exhibiting antiquities objects through its museums. The DoA also oversees all archaeological research missions in Jordan.

CONCLUSIONS

There are certain shortcomings in relation to the suitability of the legal instruments. Those are:

- According to their organization and functioning laws, there are some deficiencies with respect to the management and administration of regulations as well as the exploitation of the assets and rights of the public heritage.
- Contemplation of any restrictions or limitations on the full exercise of the right of ownership (loads or easements).
- Deficiencies in coordination, interconnection and juxtaposition of sectorial normative and urban development, regarding the protection of property, sectorial normative concerning the conservation, protection and intervention in the real estate assets of cultural interest.
- It is necessary to consider an urban regime that covers planning instruments, an overall plan, development and planning of special protection, treatment and delimitation of environment and urban regulatory requirements.

More complete supplementary regulations are required concerning public performances in relation to conditions of safety, health and hygiene. They should guarantee accessibility for all kinds of people whatever their limitations (removing of architectural barriers) as well as other aspects arising from tourism and matching activities of interest.

ATTACHMENTS 5

A.5.1	Deliverables tool III: Model (Printed and Digital version).	
A.5.2	Evaluation Questionnaires Results of Cherchell Theatre (Digital version)	
A.5.3	Questionnaire tool: IPELSHT-IRP "Artists, visitants, spectator, local residents" (Digital version)	

Attachment 5.1.
DELIVERABLES TOOL III: MODEL
WORK PACKAGE 4

TASK 4.3 – SETTING UP THE MANAGEMENT PLAN (MP) – INFORMATION NEEDED FOR THE DEVELOPMENT OF CC

INFORMATIVE SYSTEM

Specification and Plan of Actions

WP Leader: *Instituto de Restauración del Patrimonio (IRP) - Universidad Politécnica de Valencia*

Plan of Action

TASK	ACTIVITY	PARTNER IN CHARGE	DEADLINE
4.3.0	GENERAL GRAPHIC INFORMATION	ALL	15th of March 2012
4.3.1	Technical Aspects	ALL	15th of March 2012
4.3.2	Economic/Cultural Aspects	ALL	4th of May 2012
4.3.3	Intangible Aspects	ALL	15th of March 2012
4.3.4	Juridical Aspects	ALL	4th of May 2012

General structure of the Management Plan

Task 4.1. Information for the development of MP PRELIMINARY ACTIVITIES
Task 4.2. Information needed for the development of MP AIMS
Task 4.3. Information needed for the development of CC INFORMATIVE SYSTEM
Task 4.4. ACTION PLANS

Content of this document

General Description
Tasks Description
Deliverables
Plan of Action

Note

The activity written in **blue** is the objective of this document; questionnaires to be filled out in the coming months will be delivered to the partners in the following weeks in accordance with the general structure of the Management Plan.

General Description

All the graphic and alpha-numeric information gathered by each partner has to be managed through a common "structure" called Cultural Cluster Informative System (CCIS). Inside the Athena project there are four "aspects" corresponding to different activities related to the management of the theatre and Cultural Cluster:

1. Technical Aspects.
2. Economic Aspects /Cultural Aspects
3. Intangible Aspects.
4. Juridical Aspects.

Tasks Description

Every partner has to fill out the tables of the attached document taking in consideration the following list of thematic areas of the *"Cultural cluster informative system"*

TASK 4.3.0 – GENERAL GRAPHIC INFORMATION

4.3.1. TECHNICAL ASPECTS

The technical aspects are related to the complete scientific description of the theatre and its environment: from the geometric survey of the monument at different scales to the description of each phase lived by the monument as demonstrated by archaeological investigations (construction, spoliations, restorations, etc.).

To this aspect also belongs the historical knowledge on the theatre intended as the history of all the scientific studies on the theatre and CC (included drawings, engravings, written descriptions, commentaries, etc.).

Important information to gather is about the recent and updated scientific and technical studies for detecting and evaluating risk and threats: seismic activity in the area, typology of damage for each part of the theatre, environmental factors of damage, etc.

Facilities and supplies for the activities

4.3.2. ECONOMIC/CULTURAL ASPECTS

This part of the questionnaire was developed for detecting all the ordinary and special resources for theatre and CC: associations and foundations, stakeholders, investors and sponsors of the CC, local economy of the CC, accessibility and infrastructure.

4.3.3. INTANGIBLE ASPECTS

Internal services
Traditional local activities

4.3.4. JURIDICAL ASPECTS

This part of the questionnaire was developed for detecting various aspects related to the property regime of the theatre and CC, as well as the system of protections and urban planning within the CC.

Safety standards for performance building at local and national level.

Deliverables

- *Every partner has to deliver to the IRP team the questionnaire attached to this document, called "deliverables".*

Index
General Description

TASKS 4.1. INFORMATION FOR THE DEVELOPMENT OF MP PRELIMINARY ACTIVITIES

 4.1.1. AGENCY RESPONSIBLE FOR DEVELOPMENT AND IMPLEMENTATION OF MP

 4.1.2. IDENTIFICATION OF THE SITE AND CC
 Graphic documentation needed for the definition of the site and CC

 4.1.3. IDENTIFICATION OF THE UNIVERSAL AND EURO-MEDITERRANEAN VALUE
 Report about the Universal Value
 Report about Euro-Mediterranean Value of the Theatre

 4.1.4. SITE CLASSIFICATION

TASKS 4.2. MANAGEMENT PLAN AIMS- INTRINSIC ACTIONS

 4.2.1. KNOWLEDGE.

 4.2.2. CONSERVATION.

 4.2.3. MAINTENANCE.

 4.2.4. CULTURAL HERITAGE'S INCREASE IN VALUE.

 4.2.5. DISSEMINATION.

 4.2.6. ECONOMIC DEVELOPMENT.

TASKS 4.3. INFORMATION NEEDED FOR THE DEVELOPMENT OF CC INFORMATIVE SYSTEM

 4.3.1. TECHNICAL ASPECTS
 General graphic information
 Description of the theatre
 Historical knowledge on the theatre
 History of interventions and restorations on the theatre
 Scientific and technical studies
 Equipment and resources

 4.3.2. SOCIO-ECONOMIC AND INTANGIBLE ASPECTS
 Ordinary and special resources for theatre and CC
 Associations and foundations
 Stakeholders and investors
 Analysis of national and local economy
 Accessibility and infrastructure
 Traditional local activities

 4.3.4. JURIDICAL ASPECTS
 Property Regime of theatre and CC
 System of protections and urban planning inside the CC
 Safety standards for performance building at local and national level

Note

The activity written in blue is the objective of this document; questionnaires to be filled out in the coming months will be delivered to the partners in the following weeks in accordance with the general structure of the Management Plan.

Information priority

The alphanumeric and graphic information needed for the development of the MP are of three types, depending on the importance of these documents for the oncoming Management Plan:

LOGOS	IMPORTANCE	MOTIVATION
N_{ec}	Necessary	Information considered of high significance for the development of the MP. Without this graphic and/or alphanumeric data, the MP will not be implemented in a proper way.
A_{dv}	Advisable	Information supposed to be provided during the implementation of the MP, but not necessary for its start up. In any case, if an institution or a research centre has already produced those documents they have to be delivered for the production of the MP.
A_{cc}	Accessory	To this category belongs data of marginal utility. In some special cases, due to a site-specific problem or distinctive feature, the MP may also need this information.

TASKS 4.3. INFORMATION NEEDED FOR THE DEVELOPMENT OF CC INFORMATIVE SYSTEM

4.3.1. TECHNICAL ASPECTS

GENERAL GRAPHIC INFORMATION N_{ec}

GRAPHIC DOCUMENTATION NEEDED

Upload files at "Documents" of the "project area" inside the web site:

http://www.euromedheritage.net

....

LIST OF THE SENT DRAWINGS

Title of the file	Content of the file	Format (tiff, dwg, etc.)
....		

DESCRIPTION OF THE THEATRE

Detailed description of the monument

N_{ec}

1) CAVEA

(Cavea/Cuneus/Seats, Diazoma/Praecinctio, Kerkis, Parodos/Aditus maximi, Porticus, etc.)

To be filled in with data: text (max 5000 words) and images (4 or 5 drawings, maps, etc.)

2) ORCHESTRA

To be filled in with data: text (max 5000 words) and images (4 or 5 drawings, maps, etc.)

3) STAGE AND PROSCENIUM

(Proscenium Wall/Front of Stage, Pulpitum/Floor, Scaenae Frons, etc.)

To be filled in with data: text (max 5000 words) and images (4 or 5 drawings, maps, etc.)

4) ACCESSES

To be filled in with data: text (max 5000 words) and images (4 or 5 drawings, maps, etc.)

5) SUB-STRUCTURES AND FAÇADE

(On a slope, on a flat site, on combined slope and substructures)

To be filled in with data: text (max 5000 words) and images (4 or 5 drawings, maps, etc.)

6) THEATRE DRAINAGE SYSTEM:

To be filled in with data: text (max 5000 words) and images (4 or 5 drawings, maps, etc.)

7) MATERIALS AND CONSTRUCTION TECHNIQUES

To be filled in with data: text (max 5000 words) and images (4 or 5 drawings, maps, etc.)

BIBLIOGRAPHY ON THE SPECIFIC THEATRE

To be filled in with data

HISTORICAL KNOWLEDGE ON THE THEATRE

General and updated BIBLIOGRAPHY on theatres in the region [Nec]

1) TREATISE

To be filled in with data

2) PROCEEDINGS, JOURNALS ON ARCHAEOLOGY AND ROMAN THEATRES

To be filled in with data

Iconographic study on the theatre

GRAPHIC HISTORICAL DOCUMENTATION ABOUT THE THEATRE
Upload files at "Documents" of the "project area" inside the web site: http://www.euromedheritage.net

LIST OF THE SENT DRAWINGS		
Title of the file	Content of the file	Format (tiff, dwg, etc.)
....		

Archaeological/Architectural studies on the theatre and reconstruction hypothesis

HISTORY OF THE EXCAVATIONS AND SCIENTIFIC RESULTS

To be filled in with data: text (max 5000 words) and images (10-20 photos, archaeological drawings, maps, etc.)

ARCHITECTURAL STUDIES ON THE ANCIENT DESIGN OF THE THEATRE (RECONSTRUCTION, CONSTRUCTION PHASES, ETC.)

To be filled in with data: text (max 5000 words) and images (10-20 architectural drawings, rendering images, maps, etc.)

HISTORY OF INTERVENTIONS AND RESTORATIONS ON THE THEATRE N_ec

PREVIOUS RESTORATIONS WORKS IN CHRONOLOGICAL ORDER	
1st Restoration (Duration: From... to...)	
Restoration Objective	
Description of the Intervention	
Used Materials	
Add photos, drawings, etc.	

To be filled in with data

Add a table for each relevant restoration

SCIENTIFIC AND TECHNICAL STUDIES for risk and threats evaluation

Static and structural risk for the theatre A_dv

SEISMIC / EARTHQUAKE HISTORY

1-Past Seismic Activity

-Add one or more reports about: Seismic history.
-Add photos, drawings, etc.

2-Geological & tectonic features

-Add one or more reports about: geography of the city and geological and tectonic features, impact of earthquakes on individual and cluster of theatres.
-Add photos, drawings, etc.

3-Vulnerability (if any)

-Add one or more reports about: the mapping of seismic risks in the different urban areas with theatres.
-Add photos, drawings, etc.

Evaluation of the general physical condition

		CRACKS AND DEFORMATION	DETACHMENT	FEATURES INDUCED BY MATERIAL LOSS	DISCOLORATION AND DEPOSITS	BIOLOGICAL COLONIZATION
CAVEA	Porticus					
	Cavea/Cuneus/Seats					
	Diazoma/Praecinctio					
	Kerkis					
	Parodos/Aditus maximi					
STAGE / PROSCENIUM	Proscenium Wall/Front of Stage					
	Pulpitum/Floor					
	Scaena Frons					
	Other					
ORCHESTRA						
POSTSCAENIUM/EXTERNAL FACADE AND ACCESS						
Sub-structures						

Each box must be completed with the typology of damage and an evaluation as in the table below:

HIGH	MEDIUM-HIGH	MEDIUM	LOW	VERY LOW
H	M-H	M	M-L	L

Environmental factors of damage

	FACTORS	EVALUATION
CLIMATE	**1-Rain** -Add one or more reports about: The amount of rainfall, which varies widely per year, presence of acid rains, force of the wind, salt damage in relation to wetting and drying cycles, growth of some salt crystals inside the pore structures, etc.	
	2-Sunlight (insolation) -Add one or more reports about: The direct and indirect impact of the sun on ancient structures	
	3-Wind direction (summer wind and winter wind etc.) -Add one or more reports about: information on the wind-driven rain, amount of rain and the wind speed (summer wind, winter wind), etc.	
	4-Temprature and Relative Humidity Add one or more reports about: Air and building material temperature, average temperature for each month, data of average temperatures in the period (from... to.....) Month/Average, Maximum Temperature (oC)/ Average Minimum Temperature (oC)/ Average Thermal Amplitude (oC) and Relative Humidity should all be collected and tabulated.	
TOPOGRAPHY/SLOPE AND LANDSCAPE	**5- Natural Disasters** Earthquakes, volcanoes, fires, flash floods, others.	
	6-New Forces Topography & landscape, landslide, risks arising from structural problems and ageing of materials, others.	
BIOLOGIC	**7-Bio-deterioration** Vegetation: overhanging branches, climbing plants, overgrowth of surrounding vegetation, biotic coverage, fungi and lichens, algae, mosses, cyanobacteria, mould, moisture. Microorganisms, animals (goats, etc.), bird droppings.	

Level of risk for ancient structures

HIGH	MEDIUM-HIGH	MEDIUM	LOW	VERY LOW
H	M-H	M	M-L	L

SUMMARY . SOMMAIRE

BACKGROUND GLOSSARIES . GLOSSAIRES DE REFERENCE — page 4
GLOSSARY OVERVIEW . APERÇU GÉNÉRAL DU GLOSSAIRE — page 6

GENERAL TERMS / TERMES GÉNÉRAUX
- **ALTERATION** . ALTÉRATION
- **DAMAGE** . DÉGRADATION
- **DECAY** . DÉGRADATION

CRACK & DEFORMATION / FISSURE & DÉFORMATION
- **CRACK** . FISSURE — page 10
 - **Fracture** . Fracture
 - **Star crack** . Fissuration en étoile
 - **Hair crack** . Microfissure
 - **Craquele** . Craquellement
 - **Splitting** . Clivage
- **DEFORMATION** . DÉFORMATION — page 12

DETACHMENT / DÉTACHEMENT
- **BLISTERING** . BOURSOUFLURE — page 14
- **BURSTING** . ECLATEMENT — page 16
- **DELAMINATION** . DÉLITAGE — page 18
 - **Exfoliation** . Exfoliation

FEATURES INDUCED BY MATERIAL LOSS / FIGURES INDUITES PAR UNE PERTE DE MATIÈRE
- **ALVEOLIZATION** . ALVÉOLISATION — page 28
 - **Coving** . Creusement
- **EROSION** . ÉROSION — page 30
 - **Differential erosion** . Erosion différentielle
 - **Loss** . Perte :
 - **of components** . de constituants
 - **of matrix** . de matrice
 - **Rounding** . Erosion en boule
 - **Roughening** . Augmentation de rugosité
- **MECHANICAL DAMAGE** . DÉGÂT MÉCANIQUE — page 32
 - **Impact damage** . Trace d'impact
 - **Cut** . Incision
 - **Scratch** . Rayure
 - **Abrasion** . Abrasion
 - **Keying** . Bûchage

DISCOLORATION & DEPOSIT / ALTÉRATION CHROMATIQUE ET DÉPÔT
- **CRUST** . CROÛTE — page 42
 - **Black crust** . Croûte noire
 - **Salt crust** . Croûte saline
- **DEPOSIT** . DÉPÔT — page 44
- **DISCOLOURATION** . ALTÉRATION CHROMATIQUE — page 46
 - **Colouration** . Coloration
 - **Bleaching** . Décoloration
 - **Moist area** . Assombrissement dû à l'humidité
 - **Staining** . Tache
- **EFFLORESCENCE** . EFFLORESCENCE — page 48
- **ENCRUSTATION** . ENCROÛTEMENT — page 50
 - **Concrétion** . Concrétion

BIOLOGICAL COLONIZATION / COLONISATION BIOLOGIQUE
- **BIOLOGICAL COLONIZATION** . COLONISATION BIOLOGIQUE — page 64
- **ALGA** . ALGUE — page 66

INDEX . INDEX — page 76
REFERENCES . RÉFÉRENCES — page 78

DIAGNOSTICS 287

| **DEGRADATION** . DÉGRADATION | **DETERIORATION** . DÉGRADATION | **WEATHERING** . ALTÉRATION MÉTÉORIQUE | page 8 |

DISINTEGRATION . DÉSAGRÉGATION	page 20	**FRAGMENTATION** . FRAGMENTATION	page 22	**PEELING** . PELAGE	page 24	**SCALING** . DESQUAMATION	page 26
Crumbling . Emiettement		**Splintering** . Fragmentation en esquilles				**Flaking** . Ecaillage	
Granular disintegration . Désagrégation granulaire		**Chipping** . Epaufrure				**Contour scaling** . Contour scaling	
▪ Powdering, Chalking . Pulvérulence, Farinage						▪ Spalling . Desquamation en plaque	
▪ Sanding . Désagrégation sableuse							
▪ Sugaring . Désagrégation saccharoïde							

MICROKARST . MICROKARST	page 34	**MISSING PART** . PARTIE MANQUANTE	page 36	**PERFORATION** . PERFORATION	page 38	**PITTING** . PITTING	page 40
		Gap . Trou					

FILM . FILM	page 52	**GLOSSY ASPECT** . ASPECT LUISANT	page 54	**GRAFFITI** . GRAFFITI	page 56	**PATINA** . PATINE	page 58	**SOILING** . ENCRASSEMENT	page 60	**SUBFLORESCENCE** . SUBFLORESCENCE	page 62
						Iron rich patina . Patine ferrugineuse					
						Oxalate patina . Patine d'oxalates					

| **LICHEN** . LICHEN | page 68 | **MOSS** . MOUSSE | page 70 | **MOULD** . MOISISSURE | page 72 | **PLANT** . PLANTE | page 74 |

Anthropological factors of damage

	FACTORS	EVALUATION
INTRINSIC ACTIONS	1- Deterioration due to previous restorations -Add one or more reports about:	
	2- Deterioration due to poor maintenance and related programmes of conservation -Add one or more reports about:	
DECAY AND DETERIORATION DUE TO IMPROPER MODERN USES OF ANCIENT THEATRES AND ODEA	3- Tourism Growth -Add one or more reports about: Studies, statistics about tourism of the area and CC	
	4- Overloaded Capacity -Add one or more reports about: Contemporary scientific studies about the capacity	
	5-Risks of Authenticity -Add one or more reports about: Constructing new structures such as partitions, additional seats in the orchestra for the audience, doors, shelters, footbridges, etc.	
	6-Thermal risks of lighting systems -Add one or more reports about: Information about the adopted ways used for fixing lighting equipment in the original material of the theatre (add photos if possible).	
	7-Noise pollution risk -Add one or more reports about: Location of modern sound equipment such as loudspeakers and amplifiers (add photos if possible).	
	8-Visual pollution risk -Add one or more reports about: Location and conditions of technical devices, signage and panels, graffiti, ticket office, on site signs, bookshop, etc.	
	9-Acoustics Qualities -Add one or more reports about: Information and studies about theatre acoustics	
POLLUTION	10- Air pollution -Add one or more reports about: Sources of air and rain pollution in the Theatre Study Area (traffic, rubbish, toxic waste, etc.)	
LACK OF CULTURAL AWARENESS	11- Stealing of finds -Add one or more reports about the theme	
	12- Conflict & Wars -Add one or more reports about the theme	
	13- Graffiti -Add one or more reports about the theme	

EQUIPMENT AND RESOURCES

Equipment $\boxed{N_{ec}}$

LIGHTING		
Pictures	Map location	Commentary

RUBBISH/LITTER		
Pictures	Map location	Commentary

ACCESS SYSTEM IN ACCORDANCE WITH THE REGULATIONS		
Pictures	Map location	Commentary

SECURITY SYSTEM		
Pictures	Map location	Commentary

DEFENSIVE STRUCTURES: HANDRAILS		
Pictures	Map location	Commentary

SIGNAGE AND SIGNS		
Pictures	Map location	Commentary

MEASURES FOR FIRE PREVENTION		
Pictures	Map location	Commentary

Resources

	PICTURES	MAP LOCATION	COMMENTARY
Information point			
Bookshop			
Bar-Coffee shops			
Toilets			
Ticket office			
Infirmary			
Exhibition hall/ Interpretation centre			

Internal services

	PICTURES	MAP LOCATION	COMMENTARY
Official tourist guides (staff)			

Official tourist guides (books)			

Brochures/flyers			

Audio guides			

Website			
Ticket office			

Infirmary			

External services

	PICTURES	MAP LOCATION	COMMENTARY
Parking areas			

Public transport			

Coffee shop/restaurant			

Shops-Stores			

Cash point / ATM			

	ACCOMMODATION CAPACITY OF THE CULTURAL CLUSTER
Total capacity (maximum number of visitors)	
Hotel quality	-Indicate the number of hotels included under the corresponding quality (stars or other local parameters)

4.3.2. SOCIO-ECONOMIC AND INTANGIBLE ASPECTS

ORDINARY AND SPECIAL RESOURCES FOR THEATRE AND CC (N ec)

	ANNUAL INCOME
Theatre tickets	
Entrance ticket	
Protocol ceremonial use	
Exploitation fee	
Institutions/foundations	
Sponsors	

	EXPENDITURE
Service Fees	
Staff/personal	
Consumptions	
Ordinary maintenance	
Intrinsic activities1	

ASSOCIATIONS AND FOUNDATIONS N_{ec}

NAME	RESPONSIBLE MANAGER	SCOPE	ACTIVITIES

STAKEHOLDERS INVESTORS (public and private) N_{ec}

NAME	RESPONSIBLE MANAGER	SCOPE	ACTIVITIES (FESTIVALS, CULTURAL FAIRS, FOLK FESTIVALS)	ANNUAL SPONSOR
	

NETWORKS OF COLLABORATION BETWEEN DIFFERENT THEATRES

-indicate, if present, existing collaborations (cultural, economic, etc.) between theatres in the country or at international level.

NATIONAL AND LOCAL ECONOMY ANALYSIS - Main indicators

Productive activity

Nec

NATIONAL LEVEL - MAIN PRODUCTIVE ACTIVITIES AND PERCENTAGE OF EACH ACTIVITY ON GDP (GROSS DOMESTIC PRODUCT):

LOCAL AND REGIONAL ECONOMY - DESCRIPTION OF THE MOST IMPORTANT ACTIVITIES OF THE LOCAL ECONOMY

INDICATE THE MOST DYNAMIC SECTORS OR ACTIVITIES AND ALSO DECLINING ACTIVITIES.

Well-being standards and quality of life

AVERAGE INCOME PER CAPITA (NATIONAL ECONOMY)

EDUCATION	NATIONAL ECONOMY (%)	REGIONAL ECONOMIES (%)
Literacy levels		
Primary education		
Junior high		
High school		

LANGUAGES	%
Population who speak another foreign language	
Population who speak English	
Population who speak two or more foreign languages	

HEALTH	%
Type of health insurance	
Number of doctors per capita	
Number of hospital beds per capita	
Further relevant information	

NOTE. Explain whether the type of health insurance must be public or private.

ENVIRONMENTAL QUALITY		
Green space		Per inhabitant m2
Environmental pollution	Atmospheric	Determine site indicators and their values
	Acoustics	DB maximum noise level
	Waste in the environment	Frequency of waste collection
	Maintenance and cleaning of public spaces	Frequency of cleaning and refurbishment of landscape, gardens, parks
	Water quality	Indicators of water quality
Further relevant information		

Job market

ACTIVE POPULATION (NUMBER IN THOUSANDS)		%
Activity rate (percentage of population over the total population)		
Unemployment rate (percentage of population over the total population)		
Level of education (educational attainment of the employed population)		
Worker productivity (output per worker)		
Brief description of the most common types of contracts in the labour market	Severance pay	
	Duration	
	Health care coverage	

ACTIVITIES IN THE WORKING POPULATION[2]	%
Farmers	
Traders	
Construction workers	
Skilled technicians	
Professional (lawyers, doctors, etc.)	
Crafters	
Others	

EDUCATIONAL LEVEL[3]	%
University	
Professional studies	
Intermediate studies	
Primary studies	
Without studies	

Professional training

Training centres in several areas. Fill out the table below:

INFORMATION OF TRAINING CENTRES			
Training areas	Yes	Not enough	No
Catering			
Hosting			
Languages			
Computing			
Business management			
Trade			
Communication skills			
Dramatic art			
Music			
Dancing			
Others (specified below):			

ACCESSIBILITY AND INFRASTRUCTURE

Nec

AIRPORTS[4]
Location:
Distance in km to the theatre:
Approximate travel time between the airport and theatre:
Annual passenger numbers:
Connection with roads, highways....
Comments:

Add a table for each important airport in the region

PORTS[5]
Location:
Distance in km to the theatre:
Approximate travel time between the port and theatre:
Annual passenger numbers:
Connection with roads, highways....
Comments

Add a table for each important port in the region

ROADS[6]	Kind of road[7]	Distance in km	Travel time required	Frequency of stationary traffic
Capital				
Other important cities				
1.				
2.				
3.				
Neighbouring cities				
1.				
2.				
3.				

OTHER TRANSPORT[a]
1.
2.
3.

Comments

TRADITIONAL LOCAL ACTIVITIES LOCAL ACTIVITIES

	PICTURES	MAP	COMMENTARY
Activities carried out in the area (performing arts, music, film, dance)			

Gastronomy			

Typical products			
Traditions (festivals, shows, etc.)			

4.3.3. JURIDICAL ASPECTS

PROPERTY REGIME OF THEATRE AND CC [Nec]

REPORT ABOUT OWNERSHIP OF THE ARCHAEOLOGICAL SITE AND THE SURROUNDING AREA

To be filled in with data: text (max 5000 words) and images (4 or 5 drawings, maps, etc.)

SYSTEM OF PROTECTIONS AND URBAN PLANNING INSIDE THE CC [Nec]

REPORT ABOUT URBAN PLANNING REGULATIONS INSIDE THE CC

To be filled in with data: text (max 5000 words) and images (4 or 5 drawings, maps, etc.)

SAFETY STANDARDS FOR PERFORMANCE BUILDING AT LOCAL AND NATIONAL LEVEL

REPORT ABOUT LAWS AND REGULATIONS REGARDING SPECTACLES
Public spectacle regulation Evacuation and accessibility regulation Fire fighting regulation

To be filled in with data: text (max 5000 words) and images (4 or 5 drawings, maps, etc.)

FOOTNOTES

1 Archaeological excavation, surveying, analytic studies, etc.

2 You should indicate the approximate percentage of total value.

3 Calculated population percentage

4 Data from airports around the area. You should include nearby airports in other countries

5 Data from ports around the area. You should include nearby ports in other countries.

6 Access by road to the theatre from nearby cities and other larger cities

7 Indicate highway, two-way roads, and other roads. As far as possible you should indicate the road code.

8 Identify other transport in the area, rail, bus li

ATHENA PROJECT
ANCIENT THEATRES ENHANCEMENT FOR NEW ACTUALITIES
PROPOSALS

6. Action Plans

6.1. DETECTING COMPATIBILITY/INTERFERENCE

It is necessary to examine the real compatibility between the GUIDELINES FOR COMPATIBLE UTILIZATION and the AIMS OF THE MANAGEMENT PLAN - Intrinsic Activities (knowledge, conservation, maintenance, increase in value of the cultural heritage, dissemination and economic development). This will establish specific rules or suggestions for the proper usage and permitted operations at ancient theatres.

This is the reason why we kept the same activities as specified in the previous section GUIDELINES FOR COMPATIBLE UTILIZATION:

- *Tourism*
- *Staging Activities*
- *Educational*
- *Formal / Ceremonial (private, companies, etc.)*
- *Cultural Activities and Local Traditions*
- *Others*

Each of these sections will be analysed from different points of view, looking for interference and synergies with intrinsic actions, defined at PRELIMINARY ACTIVITIES:

- *Knowledge*
- *Conservation*
- *Maintenance*
- *Increase of value of cultural heritage*
- *Dissemination*
- *Economic development*

In order to detect the intrinsic compatibility and interference of each activity, one has to take into account the main factors analysed by the questionnaires. They are:

- *User's profile*
- *Time distribution*
- *Requirements*
- *Physical compatibility*
- *Functional compatibility*
- *Conceptual compatibility*
- *Contextual compatibility*
- *Economic Potential*

The relationship between all of these parameters will be assigned a letter to describe each specific interference or synergy:

Interference with the intrinsic actions
- **S** Spatial
- **T** Temporary
- **S** Security
- **R** Resources
- **O** Other

Synergies with intrinsic actions
- **I** Independence
- **L** Linking
- **D** Dependence
- **C** Complementary
- **O** Other

Definition of concepts

INTERFERENCE		
PARAMETERS	**DESCRIPTION**	**FACTORS**
S Spatial	It is considered that there is a spatial interference when both activities cannot be carried out in the same physical space.	Area occupied by the activity
T Temporary	Temporary interference is considered to be those activities that overlap in the same space of time. An example is the interference between a tourist visit and the development of theatrical activities. The simultaneous development may disturb or cause interference for both activities.	Free and with fee activities
Se Security	When carrying out both activities may cause accidents, having different technical sets for protection for each activity. For instance: conservation works during sightseeing or the staging of activities.	Depending on the hazard of the activity
R Resources	Equipment and physical resources may be insufficient for the achievement of adequate levels needed for carrying out both activities simultaneously. This chapter refers to lighting equipment, wastebaskets, security devices, toilets, etc. At the same time, we refer to other resources such as tourist guides, informative panels and signals, enough parking spaces, etc. For instance, when a lack of human resources or trained staff to carry out guided sightseeing occurs, in accordance with "CH's increase in value", or educational activities.	Human resources: security staff, tourist guides Equipment: lighting, rubbish, security system, handrails, fire prevention, toilets
O Other	In some cases a misleading perception of the image of a site may occur depending on the devices needed for carrying out specific activities. For instance, conservation works in areas close to the scene during the time of the theatrical performance.	-

SYNERGIES		
PARAMETERS	**DESCRIPTION**	**FACTORS**
L Linking ++	Two activities are of the "linking" kind when the synergy between them is necessary for each other. These activities are always joined. For instance, the dissemination of heritage values is essential for the improvement of tourism.	-
D Dependence +	Two activities depend one each other when subordination (causal-temporal) is implied. For instance, the synergy between tourism and conservation levels is binding: more tourism implies more maintenance work.	Simultaneous development
C Complementary	Two activities are complementary when between them exists an additional but not binding relation. In other words, one activity may support another. An example is given by the synergy between tourist visits and the development of theatrical activities.	-
I Independence	It occurs when two activities do not produce any kind of synergy: for instance, the development of knowledge produced by researches on the ancient theatre and its contemporary use.	-
O Other		-

All these concepts are contemplated in the table below including their relations.

With this template, any relevant data could be detected visually, in order to determinate a suitable action plan.

	INTERFERENCE	USAGE					
		TOURISM	STAGING ACTIVITIES	EDUCATIONAL	FORMAL AND CEREMONIAL	CULTURAL AND LOCAL TRADITIONS	COMMENTS
ACTIVITIES	KNOWLEDGE						
	CONSERVATION						
	MAINTENANCE						
	CH'S INCREASE IN VALUE						
	DISSEMINATION						
	ECONOMIC DEVELOPMENT						
USAGE	TOURISM						
	STAGING ACTIVITIES						
	EDUCATIONAL						
	FORMAL AND CEREMONIAL						
	CULTURAL AND LOCAL TRADITIONS						

	SYNERGIES	USAGE					
		TOURISM	STAGING ACTIVITIES	EDUCATIONAL	FORMAL AND CEREMONIAL	CULTURAL AND LOCAL TRADITIONS	COMMENTS
ACTIVITIES	KNOWLEDGE						
	CONSERVATION						
	MAINTENANCE						
	CH'S INCREASE IN VALUE						
	DISSEMINATION						
	ECONOMIC DEVELOPMENT						
USAGE	TOURISM						
	STAGING ACTIVITIES						
	EDUCATIONAL						
	FORMAL AND CEREMONIAL						
	CULTURAL AND LOCAL TRADITIONS						

CASE OF THE JARASH THEATRE

The Jarash theatre has been studied through the preliminary analysis of the development of each activity and its assessment according to the guidelines. This study aims to visualize compatibility and interference of activities with the usage of the theatre.

	INTERFERENCE	USAGE				
		TOURISM	STAGING ACTIVITIES	EDUCATIONAL	FORMAL AND CEREMONIAL	COMMENTS
ACTIVITIES	KNOWLEDGE	S/T/Se	S/T/Se	T/Se/O	S/T/Se	
	CONSERVATION	S/T/Se/O	S/T/Se/O	S/T/Se	S/T/Se/O	
	MAINTENANCE	O	S/T/O	O	S/T/O	
	CH'S INCREASE IN VALUE	R	S/T/Se/R	R	S/T/Se/R	
	DISSEMINATION	-	S/T	-	S/T	
	ECONOMIC DEVELOPMENT	S/Se	S/Se	Se	S/Se	
USAGE	TOURISM					
	STAGING ACTIVITIES	S/T/Se/R				
	EDUCATIONAL	Se	S/T/Se			
	FORMAL AND CEREMONIAL	S/T/Se/R	S/T/R	S/T/Se/R		

PARAMETERS	CONCEPT
S Spatial	Are they developed at the same place?
T Temporary	Are they developed at the same time?
Se Security	Is it safe to develop both activities simultaneously?
R Resources	Are there enough resources to develop both activities?
O Other	Visual impact and others.

Interference Evaluation

	INTERFERENCE	USAGE
		TOURISM
ACTIVITIES	KNOWLEDGE	S Touristic activities may interfere during the survey of the theatre. T The simultaneous development of both activities may be convenient. Se When archaeological site staff should take care of tourist safety during cases that imply the opening of barriers, gates, etc.
	CONSERVATION	S Touristic activities may interfere with conservation works on the theatre. T The simultaneous carrying out of both activities may be improper. Se Safeguarding the site should be guaranteed by means of all the needed resources when two activities interfere heavily. O Tourist perception of the theatre may be compromised by the conservation work.
	MAINTENANCE	O During peak season an increase in maintenance practices may be needed.
	CH'S INCREASE IN VALUE	R When a sufficient number of properly trained tourist guides aimed at the different interpretation levels is not available.
	DISSEMINATION	
	ECONOMIC DEVELOPMENT	S Special care is needed when allowing the presence of commercial activities (shops, restaurants, coffee shops, etc.) in the vicinity of archaeological/cultural sites in order to avoid visual occlusion and interference with the perception of the ruins. Se it is advisable to provide the theatre with the necessary financial resources independently of commercial activities inside the cultural cluster.
USAGE	TOURISM	
	STAGING ACTIVITIES	S Touristic visits may produce special interference in particular during the staging of activities. T Impossible to carry it out simultaneously. Se Different security system/devices for each activity. Security staff and handrails. R Not enough internal staff and services for carrying out activities.
	EDUCATIONAL	Se Safety for children groups should be met.
	FORMAL AND CEREMONIAL	S Touristic visits may generate spatial interference during ceremonial-formal activities. T Not compatible if simultaneous. Se Depending on the kind of formal and ceremonial activity some security devices or staff may be foregone. Re Not enough resources for properly carrying out both activities.

	INTERFERENCE	USAGE
		STAGING ACTIVITIES
ACTIVITIES	KNOWLEDGE	**S** Staging activities may interfere during the survey of the theatre. **T** The simultaneous development of both activities may be possible. **Se** Site staff should take care of spectator safety during the staging of activities carried out during a survey.
	CONSERVATION	**S** Staging activities may interfere with conservation works on the theatre. **T** The simultaneous carrying out of both activities may be improper. **Se** Safeguarding the site should be guaranteed by mean of all the needed resources when two activities interfere heavily. **O** Spectators' perceptions of the theatre may be compromised by the conservation works
	MAINTENANCE	**S** The simultaneous carrying out of maintenance practices and other activities may disturb spectators. **T** It may be improper to carry out maintenance practices during theatrical activities. **O** During staging activities it is necessary to increase maintenance, as for instance rubbish removal.
	CH'S INCREASE IN VALUE	**S** Guided visits may interfere with theatrical activities. **T** It is important to avoid carrying out simultaneous activities. **Se** Safety measures for staging activities may be different to those needed for guided visits. **R** It may happen that spatial resources are not enough both for exhibitions, museographic paths, etc. and rooms for staging activity staff.
	DISSEMINATION	**S** It may interfere spatially. Conferences cannot be held inside theatres during the theatrical season. **Te** Temporal overlapping should not happen.
	ECONOMIC DEVELOPMENT	**S** Care should be taken when placing shops, restaurants and cafes, in order not to interfere with performances. **Se** It is advisable to provide to staging activities the necessary financial resources independently of commercial activities inside the cultural cluster.
USAGE	TOURISM	
	STAGING ACTIVITIES	
	EDUCATIONAL	**S** They can interfere spatially. **T** Their temporary interference may disturb viewers. **Se** Security will be different for performances and educational activities.
	FORMAL AND CEREMONIAL	**S** They interfere spatially, as both need the same space. **T** Impossibility of simultaneous development. **Re** Insufficient resources for concurrent development.

INTERFERENCE		USAGE
		EDUCATIONAL
ACTIVITIES	KNOWLEDGE	T In a few cases the survey of the theatre could interfere with educational activities. Se They should take precautions appropriate for the safety of children. O Educational efforts should be according to the study of the theatre. Actions related to their history.
	CONSERVATION	S Depends on the volume of the conservation work but it will have to be especially carefully. T In some cases, conservation work could interfere with educational activities. Se They should take the precautions appropriate for the safety of children.
	MAINTENANCE	O Educational efforts require major maintenance during and after completion.
	CH'S INCREASE IN VALUE	R Perhaps there are not enough specific guides for each activity.
	DISSEMINATION	
	ECONOMIC DEVELOPMENT	Se It is advisable to provide to educational activities with the necessary financial resources independently of commercial activities inside the cultural cluster
USAGE	TOURISM	
	STAGING ACTIVITIES	
	EDUCATIONAL	
	FORMAL AND CEREMONIAL	S Educational efforts can produce spatial interference during ceremonial activities. T Incompatible simultaneously. Se Security for educational groups will be different from the ceremonial activities. Re Insufficient resources to develop both activities normally. Services and staff.

	INTERFERENCE	USAGE
		FORMAL AND CEREMONIAL
ACTIVITIES	KNOWLEDGE	**S** The ceremonies could interfere with the survey work of theatre. **T** It might be difficult to develop both activities simultaneously. **Se** Priority should be given to the safety of the participants in the case of simultaneous surveys works.
ACTIVITIES	CONSERVATION	**S** The ceremonies could interfere with the conservation work of the theatre. **T** It might be inconvenient to develop both activities simultaneously. **Se** It would have to be careful and take the necessary security; these activities could interfere with the gravity. **O** The perception of the theatre by the audience could be affected by the work.
ACTIVITIES	MAINTENANCE	**S** Its spatial interference may disturb the visitor. **T** It could be a problem if maintenance actions are carried out at the same time as a performance. Maintenance activities should be conducted before and after performances. **O** It will be necessary to increase the maintenance when there is any ceremonial or formal activity.
ACTIVITIES	CH'S INCREASE IN VALUE	**S** Spatial incompatibility. **T** Provided not conducted simultaneously. **Se** Security measures are different for an event and for a guided tour. **R** There may not be enough material resources, such as spaces that are part of the museum display and could be needed by the ceremonies.
ACTIVITIES	DISSEMINATION	**S** They can interfere spatially. Conferences should not be developed in the theatre during ceremonial performances. **T** Do not match.
ACTIVITIES	ECONOMIC DEVELOPMENT	**S** Caution should be taken with the location of shops, restaurants and cafes, so as not to interfere with the perception of the theatre. **Se** It is advisable to provide formal and ceremonial activities with the necessary financial resources independently of commercial activities inside the cultural cluster.
USAGE	TOURISM	
USAGE	STAGING ACTIVITIES	
USAGE	EDUCATIONAL	
USAGE	FORMAL AND CEREMONIAL	

| | SYNERGIES | USAGE ||||
		TOURISM	STAGING ACTIVITIES	EDUCATIONAL	FORMAL AND CEREMONIAL	COMENTS
ACTIVITIES	KNOWLEDGE	D	I	D	I	
	CONSERVATION	D	D	D	D	
	MAINTENANCE	D	D	D	D	
	CH'S INCREASE IN VALUE	L	C	L	C	
	DISSEMINATION	L	D	L	C	
	ECONOMIC DEVELOPMENT	L	L	I	L	
USAGE	TOURISM					
	STAGING ACTIVITIES	C				
	EDUCATIONAL	I	C			
	FORMAL AND CEREMONIAL	I	I	I		

PARAMETERS	CONCEPT
L Linking ++	Connected activities (indispensable for one another)
D Dependence +	Dependant activities (the growth of one increases the other)
C Complementary -	Reciprocal activities (if they are done together, it could improve the value)
I Independence - -	Activities are self-sufficient and there is no alignment
O Other	-

6.2. SWOT ANALYSIS

SWOT analysis is a strategic analysis that aims to establish strong points or strengths, weaknesses, opportunities and threats to an organization. Therefore it consists of a double analysis: internal (threats and opportunities) and external (weaknesses and strengths). This method could be an effective operational support tool for analysing the condition of the site and implement any strategies to improve its development.

SWOT analysis is the first stage of planning and helps to focus on key issues. We should aim to turn our weaknesses into strengths, and our threats into opportunities. Then finally, SWOT will give managers options to match internal strengths with external opportunities. The outcome should be an increase in 'value' for customers, which hopefully will improve their competitive advantage.

The main purpose of a SWOT analysis has to be to add value to ones products and services in order to recruit new customers and extend products and services to other cultures and countries.

In order to carry out a detailed analysis, we should start by assigning positive and negative aspects to the assets.

POSITIVE	NEGATIVE
Strengths	Weaknesses
Assets	Limitations
Resources	Challenges
Opportunities	Restrictions
Prospects	Threats

6.2.1. Strengths/weaknesses (internal)

DEFINITIONS:

Strengths

Strength is a core capability of any asset or project where this one has an advantage over others. Strengths are all those internal and positive elements that differentiate the project of others of equal class.

There are two kinds of strengths: tangible and intangible. The first one can be precisely identified and measured. Intangible strengths cannot be physically touched but we will try to measure them.

Strength is a positive internal factor. Different aspects to take into consideration:

What advantages does your organization have?

What do you do better than anyone else?

What unique or lowest-cost resources can you draw upon that others cannot?

What do people in your market see as your strengths?

What factors mean that you "get the sale"?

Weaknesses

Describe the factors on which you have a disadvantage compared to the competence. To perform the internal analysis one should considered the analysis of resources, activities and risks.

There are two kinds of weakness: tangible and intangible. The first one can be precisely identified and measured. Intangible weaknesses cannot be physically touched but we will try to measure them.

A weakness is a negative internal factor. Different aspects to take into consideration:

What could you improve?

What should you avoid?

6.2.2. Opportunities/threats (external)

Opportunities

Opportunities are those positive factors that are generated in the environment and that, once identified, can be exploited. They are potential events that facilitate the institution determining and achieving strategic objectives.

An opportunity is a positive external factor. Different aspects to take into consideration:

What good opportunities can you spot?

What interesting trends are you aware of?

Threats

Describe the factors that may jeopardize the survival of the heritage property, whether those threats are recognized in time and can be avoided or be turned into opportunities. Threats are negative situations, external to the asset, which may damage it, and when they arise it may be necessary to design an appropriate strategy to deal with them.

To perform the analysis one should consider an internal environment analysis, interest groups, legislative, demographic and political.

A threat is a negative external factor. Different aspects to take into consideration:

What obstacles do you face?

What are your competitors doing?

	HELPFUL	HARMFUL
INTERNAL ORIGIN	**STRENGTHS** Strong cultural significance. Outstanding historic and artistic heritage. Exceptional landscape value. Most extraordinary heritage of Mediterranean civilizations. Important tourist flows. Cultural events (conferences, festivals, exhibitions etc.)	**WEAKNESSES** Poor cooperation between institutions. Poor coordination work in publicizing the heritage site. Lack of synergy between development and leisure amenities. Weak tourist information. Incomplete documentation of the site. Low awareness among citizens and local communities. Insufficient funding for the maintenance of the historic and artistic heritage. Degraded urban furniture in all its forms (rubbish, lighting, information panels, etc.). Unregulated mobility. Lack of a coordinating entity. Lack of urban regulations.
EXTERNAL ORIGIN	**OPPORTUNITIES** Organization of trade activities in the theatre. Enhance handicrafts and long-established shops Coordination of interventions for the Cultural Cluster. Usage Manual for correct utilization. Implementation of solutions for equipment, car parks and bus roads. Coordination among institutions for the planning of cultural activities. Rationalization of financial resources for conservation (national, regional, local funds, etc.). Improve promotion of the theatre and Cultural Cluster in schools. Train available human resources and coordinate cultural volunteers for conservation initiatives.	**THREATS** Unregulated tourist flows. Degradation of the artistic heritage due to lack of conservation. Inadequate development and exploiting of sites as economic resources. Lack of monitoring of the deterioration due to use. Depopulation and lack of cultural identity. Landscape deterioration. International political instability.

6.3. DEFINITION OF AIMS

Athena project aims

The main objective of the Athena project of ancient theatres is to guarantee the theatre and the cluster as a living entity able to tell to present generations its story though the centuries.

This project is trying to set up a more effective instrument for preservation and enhancement of Ancient Theatres and Cultural Clusters.

On the other hand, we should try to merge tangible with intangible features. Cultural and traditional local activities should be promoted with tangible heritage. The management of the promotion of cultural heritage has to be integrated with the encouragement of social and economical affects.

A network of Euro-Mediterranean Ancient Theatres should be created in order to become a model of coexistence for the different cultures. The Athena project would become a real element for the promotion and enhancement of social awareness.

6.4. PROPOSAL

Once the information has been collected and its analysis and diagnosis carried out, a local development strategy can be applied that establishes general and specific objectives for enhancing traditional local activities. In order to illustrate this task, we will discuss different aspirations, strategies and actions proposed for the Jarash theatre.

6.4.1. Aspiration

A1 Diversify the User's profile.

Related to: User's profile

Description:

According to the results of the diagnosis, relating to the polls during the month of July, most visitors to the theatre are university students aged 19 to 30. Most of them are local residents, and a few come from other countries. Visitors often attend the theatre individually and spectators tend to be in family groups.

To increase the use and dissemination of the theatre it will be necessary to diversify the user's profile.

A2 Extend the theatre season and the time distribution of the archaeological site.

Related to: Time distribution

Description:

In relation to tourism activities in Jarash, it can be noted that self-guided visits and guided tours take place during the time of opening of the Theatre. The days and opening hours of the theatre for visitors is Monday to Sunday; summer hours are 7:30 a.m. to 7:00 p.m. and winter hours are 8:00 a.m. to 5:00 p.m. The visits to the Southern Theatre don't last more than half an hour. The period of the year in which the theatre season takes place is June, July and August. Nevertheless, the theatre is open for visitors and guided tours during all the year. The main Summer Jarash Festival of Culture & Arts takes place on July.

Therefore, it is recommended to extend the theatre season (Segesta, Syracuse) in order to enhance the local economy and avoid the massive concentration of people in the summer season that could cause excessive erosion of the ancient structures.

A3 Enhance local economy.

Related to: Socio-economic and intangible aspects.

Description:

The local economy is detached from the heritage resources of the Cultural Cluster. Local economic development depends on the ability to mobilize the available and potential resources of the zone towards the satisfaction of needs and basic problems of the local population and tourists that consume cultural products.

A4 Improve user's comfort.

Related to: Tourism sector; Physical compatibility; Equipment and resources; Legal framework

Description:

More complete supplementary regulations are required concerning public performances in relation to conditions of safety, health and hygiene. They should guarantee accessibility for all kinds of people whatever their limitations (removing of architectural barriers) as well as other aspects arising from tourism and matching activities of interest.

The equipment and resources of the Cultural Cluster such as ticket offices, coffee shops, information points, toilets, parking, etc. are located in appropriate places in general, but they have some deficiencies that do not satisfy user's need. Most of them could be improved thereby enhancing the theatre as a local economic resource and safeguarding the user´s comfort.

A5 Protect the heritage of ancient structures.

Related to: Physical compatibility; Legal framework

Description:

In general terms, the physical condition of the Jarash theatre should be checked carefully, but mostly it is in acceptable condition, except some parts of *Scaenae Frons, Aditus Maximi* and top of *Summa Cavea* or *Porticus* that are in critical condition and some of them need to be reconstructed.

Environmental factors (climate, topography and biologic actions) slightly damage the surface of the theatre.

A6 Development based on cultural activity that improves the well-being of citizens.

Related to: Socio-economic and intangible aspects; User's profile; Equipment and resources

Description:

The development of cultural production allows for the generation of employment, an increase in income and greater well-being of citizens. On the other hand, it allows access to cultural goods whose consumption increases the satisfaction or well-being of the inhabitants. The development of cultural activity requires some equipment that can be enjoyed by the inhabitants of the area.

The aim is the identification of intangible resources that are able to generate local development by increasing employment and the quality of life of the inhabitants of the region.

Once the existing cultural resources are known we will have to determine which assets or resources could have a relationship with the theatre from the perspective of cultural tourism as a space that can accommodate other cultural activities, particularly those related to the performing arts.

A7 Search for synergies between theatre and other tangible and intangible resources.

Related to: Socio-economic and intangible aspects; Equipment and resources; Tourism sector

Description:

We have to identify any tangible resources which can be related to theatre. Other near monuments, for example closed spaces in which activities related to theatre can be held, and other cultural activities such as museums, other nearby spaces of the same historical period, streets, walks, etc. In Jarash there are two ancient theatres located within the archaeological heritage of the same era.

6.4.2. Strategy

S1 Bottom-up development.

Related to: A3; A7

Description:

For bottom-up development, actions should be implemented from the bottom. The strategies and actions must be defined with the consensus of those involved. Such bottom-up strategies require that they be defined by the very agents that must carry them out. These agents are those who know best the characteristics of the territory, and the intervention of the public sector will be necessary in order to facilitate the mechanisms for cooperation and development of the cluster.

In terms of local development, our short-term goals are to implement the definition of the cultural activities base, provide support for such activities and the construction of equipment and improvement in infrastructure. It is hoped that the cultural activities undertaken will be able to attract other types of activities (like restaurants, hotels, excursions, sales of local handicrafts, among others). Once the cluster is set up, the learning experience will permit the development of new cultural products, new uses or new markets.

S2 Children's educational component in situ.

Related to: A1; A2

Description:

It aims to implement a strategy to involve children with the culture of the theatre. It is intended to spark their interest with a small theatrical performance with characters set in the era of theatre to tell the story of it. This could be done once a day. If children learn to value the heritage, future generations will know how to enhance it.

S3 Utilize the theatre as a space for the interpretation of the site.

Related to: A2; A3; A7

Description:

It will be necessary to determine a space inside the theatre where an interpretation centre of the theatre and Cultural Cluster can be located. It will be useful to emphasize the importance of the historical and monumental heritage in this space.

S4 Enhancing traditional products.

Related to: A3

Description:

The cultural offering in the cluster must have its origin in products and activities that show the specificity and the idiosyncrasy of its people or society. This offering must be attractive for both local residents and tourism from other countries. Cultural offerings need facilities and cultural infrastructure for their development.

S5 Enhance funding.

Related to: A3

Description:

Financial support of the public sector comes from funds designated for the financing of cultural activities and the support of culture through the establishment of incentives and tax breaks to those who allocate portions of their funds to sponsorship or patronage. We highlight the following funding mechanisms in the field of culture: budgets, grants, patronage, sponsorship, fundraising, direct payment (inputs), merchandising and voluntary social activity, among others.

S6 All activity must have a marketing component.

Related to: A3

Description:

All activities must be planned a way that an advertising component exists for self-financing and self-benefit.

The main goal of this paper is to implement a strategy of promoting a product or service to the customer. Marketing is the link between a society's material requirements and its economic patterns. It could be looked at as an organizational function and a set of processes for creating, delivering and communicating value to customers, and managing customer relationships in ways that benefit the organization and stakeholders.

S7 Recovery and use of natural resources of the area.

Related to: A3

Description:

It is important to enhance the productive use of local natural resources used in traditional activities and current production processes, as well as recovering the abandoned traditional activities. Local products could be very attractive to tourists.

6.4.3. Actions

After completing and analysing the results, strategic aims (provide, guarantee, promote, reduce, prevent, regulate, preserve etc.) will be defined in order to help specific actions (concrete actions to achieve the strategic objectives, prioritized by: importance, number of goals, time, cost, etc.) from the field of promotion, preservation, regulation, economic, or otherwise.

It is necessary to note that development consists in a bottom up strategy, implementing all activities directly to the user, so the actions will be prioritized according to the following rating:

- Provision of material, human and financial resources.
- Urgency of action.
- Impact offered to benefit the theatre.

This will be evaluated with a number depending on the level of importance (low=1, medium=2, high=3).

Based on the study and proposal of actions, a specific project should be developed for each of them to get into the details. Thus for the projects, we mark actions which should be developed with higher or lower priority, always taking into account the resources, the urgency and its subsequent impact.

T1 Website.

Priority: HIGH

Related to: S1; S6

Description:

The dissemination of the theatre through a website is a great resource for encouraging bottom-up development. Users of the theatre can easily get information related to visits, shows, etc., as well as generic information about the theatre (history, evolution, interventions, etc.).

Qualification:

Resources = 3
Urgency = 3
Repercussion = 2

T2 Control access to the theatre.

Priority: HIGH

Related to: S5

Description:

It is important to limit and control access to the theatre. The group size and the number of encounters with others groups in the theatre can create physical and psychological discomfort.

The Recreational Carrying Capacity Assessment of the Southern Ancient Theatre of Jarash has taken in consideration the following components: the space where the activity takes place, resources involved, tourism activities, and visitors' profile, behaviour and expectations. Also, standards for conservation and physical and psychological comfort of visitors have been considered.

As concluding remarks of this stage, it could be highlighted that after taking into consideration many spatial and physical limiting factors and also the social ones, the adequate number of visitors at the same time is about 45 people. Knowing that the maximum number of visitors per year has been around 300,000, it means that the theatre has an average of 821 visitors per day. If the site is available an average of ten hours at day, by applying a rotation coefficient (number of daily hours available for the visit divided by average time of the visit), it implies a regular distribution of 82 visitors per hour. Considering the large dimensions of the Jarash archaeological site, it seems highly unlikely that visitors devote more than 30 min. to the visit of the Southern Theatre. In the worst-case scenario of 82 visitors per hour, this figure fits in well with the suggested number of 45 at the same time doing a visit of 30 minutes.

A control of theatre access should be carried out in order to limit the number of users. This could be performed by different mechanisms and depends on the existing resources. Using human resources, like security personnel, to control access could be a very useful mechanism.

Qualification:

Resources = 3
Urgency = 3
Repercussion = 2

T3 Travel agencies and accommodation.

Priority: HIGH

Related to: S1; S6

Description:

There is a huge need for the development of number of hotels and travel agencies in the country. There is no hotel near the archaeological site.

Qualification:

Resources = 2
Urgency = 3
Repercussion = 3

T4 Improve equipment, resources, infrastructure and tourism services.

Priority: HIGH

Related to: S1; S7

Description:

In order to maintain the comfort of users, it is necessary to improve existing equipment, resources, infrastructure and all tourist services.

A cultural offering needs facilities and cultural infrastructure for its development. Therefore, if the cluster has an orientation toward cultural tourism, the transportation infrastructure will be very important, as well as other tourism services like travel agencies and hotels. Our goal in the short term is to improve the equipment and infrastructure in order to support cultural activities.

Qualification:

Resources= 2
Urgency= 2
Repercussion= 3

T5 Fundraising by collecting royalties.

Priority: HIGH

Related to: S1; S5; S6

Description:

Among other sources of income from cultural activities, funds can also be raised by licencing certain rights: retransmission of the product by media; exploitation of images or by-products; granting of services (cafeteria, bookstore, etc.); and rights granted from wealth management, such as the rent of rooms.

Qualification:

Resources= 3
Urgency= 3
Repercussion= 2

T4 Restoring the Summa Cavea, Aditus Maximi and Vomitoria.

Priority: MEDIUM

Related to: S3; S7

Description:

In order to improve certain functional aspects of the Jarash theatre, it is very important to focus attention on the following parts of the building: *summa cavea, aditus maximi and vomitoria*. The *summa cavea* of the theatre has almost disappeared, but its trails are visible beyond the handrails of the current upper *praecintio*. The ancient access system to the bleachers of Jarash theatre was formed by two kinds of accesses: from the *aditus maximi* and from the outer semicircular path that led to the four *vomitoria*. The whole set of accesses has to be re-established with two aims: the first is obviously functional while the second has to do with a clear reading of the monument. In fact, nowadays the theatre seems to be formed just of two *maeniani* (*ima* and *summa cavea*) in contrast to the majority of ancient buildings for performances in which the *cavea* was horizontally split into three levels.

Qualification:

Resources = 1
Urgency = 2
Repercussion = 3

T5 Books, videos and stories for children.

Priority: MEDIUM

Related to: S1; S2; S7

Description:

In order to diversify the user profile and disseminate information about the theatre, always from the point of view of cultural education, we propose the creation of books and videos designed for children. This aims to capture their attention and arouse interest in heritage.

Qualification:

Resources= 3
Urgency= 1
Repercussion= 2

T6 Monitoring the deterioration of the theatre.

Priority: MEDIUM

Related to: S3; S7

Description:

Deterioration suffered by the theatre should be periodically diagnosed to assist on-going maintenance. There is a need to study the climatic and environmental conditions of the area using the checklists in the section of physical compatibility.

Qualification:

Resources = 1
Urgency = 2
Repercussion = 3

T7 Improving public transportation.

Priority: MEDIUM

Related to: S1; S5

Description:

The improvement of public transportation and the associated infrastructure will provide accessibility advantages to the theatre. The quality of infrastructure and public transport will encourage the use of the facilities and increase the comfort of users.

To encourage the use of public transport people should know its benefits. Public transport should be prioritised over private in order to increase social equity, efficiency and quality of life.

Qualification:

Resources = 2
Urgency = 2
Repercussion = 2

T8 Enhance intangible resources.

Priority: MEDIUM

Related to: S1; S4; S5; S6; S7

Description:

It is really important to enhance intangible resources that could have relation to the theatre. We suggest some activities that could be developed at the theatre: local and regional festivals, cultural events, local festivities, traditions and historical facts, artistic activities, amateur theatre festivals, contests with cultural activities prizes, and social policies. Also, it might be interesting to develop themed tours that suit the needs and preferences of consumers.

Qualification:

Resources = 2
Urgency = 1
Repercussion = 3

T9 Set a calendar of activities and uses of the theatre.

Priority: MEDIUM

Related to: S1; S3

Description:

It is necessary to establish a clear timetable for the use of the theatre and nearby areas that can be used in order to avoid conflicts of temporary compatibility between these environments and other categories of use (maintenance, exhibitions, etc.).

Qualification:

Resources= 3
Urgency= 2
Repercussion= 1

T10 Specific regulations regarding the protection of the theatre and its environment.

Priority: LOW

Related to: S3

Description:

There is a need to draft laws and regulations for the protection and conservation of the theatre and its environment and limit the ability to build in areas close to the protected environment. It is recommended that a security perimeter be created in which new construction works are not allowed except those directly related to the theatre.

Qualification:

Resources = 1
Urgency = 2
Repercussion = 2

T11 Upgrade or modification of legal framework about performances.

Priority: LOW

Related to: S2; S7

Description:

Many subjects are proposed to be taken into account in a possible modification or improvement of the legislation. They are:

Museum use. The aspects that are defined in this chapter are: inventory of collections, museum activities, spatial characteristics, the method of management and financing, spaces and complementary activities, facilities that must be provided, as well as the characteristics of touristic tours.

Educational activities. These activities should deal with art, archaeology and history in order to promote awareness of the historical heritage. Currently there are informative and educational programs in summer time, but it should emphasize school programs and family activities, extended to other groups, and having them throughout the year aimed at promoting cultural development.

Boost of tourism. The theatre has to be implanted as a hallmark of historical heritage in the tourist routes. Currently it is one of the most spectacular buildings on the archaeological site due to its dimensions.

Staging activities. The theatre is the setting for important cultural events. These kinds of activities should be contemplated and emphasized somehow. It will open a forum for local, national and international visitors where the values of the performing arts are fostered and international prestige is generated.

Formal and ceremonial activities. Develop cultural activities and local traditions.

Qualification:
Resources= 2
Urgency= 1
Repercussion= 2

T12 Establishment of a public law entity.

Priority: LOW

Related to: S3

Description:

It would be desirable to establish a public law entity with the possibility of private sector participation, a foundation which joins both sectors into a single entity with the aim of regulating, managing, protecting, and preserving the site of Jarash.

An important feature of the cluster is the governance. It is proposed to create a single entity responsible for the management of the archaeological site. There should be a coordinating central entity that makes strategic decisions about the archaeological area. This authority should follow guidelines related to thorough management.

Qualification:
Resources= 1
Urgency= 2
Repercussion= 2

6.5. PLANNING

Once the main aspirations and strategies are determined, specific actions should be outlined granting to each a certain priority.

The plan is divided into different phases, each one lasting four years in which a specific number of tasks will have to be carried out; the quantity of actions depends on many factors: physical, economic, human resources, etc. Every action of the following scheme is marked with the letter T (T_a, T_b, T_c, T..., T_n); these different tasks last three years and are followed by an evaluation process of one year, aimed at understanding their impact on the site. In the case that the action achieves the expected result, it will be followed in the next phase by a new and different action (T_{n+1}, T_{n+2}, T_{n+3}, T...); if the result is weak the process restarts that specific action until the goal is achieved.

6.6. EVALUATION

Once the plan of action is developed, it will be controlled and evaluated in order to correct errors. With the evaluation, one will be able to see the errors of the first plan and the objectives or aspirations that have not been satisfied.

As we saw in the planning section above, an assessment report should be carried out every three or four years. This report has to be prepared based on different mechanisms that evaluate each goal. The tools for this purpose could be, for example, the number of website visits, questionnaires, or any statistic control implemented on the everyday use of the theatre. With this information, the management responsible for the site shall deliver an EVALUATION REPORT that evaluates the extent to which the objectives have been achieved.

Below, we can see some examples of questionnaires for visitors, spectators and local residents.

ATTACHMENTS 6

A.6.1	Questionnaire IRP "evaluation": Artists, visitants, spectator, local residents. (Printed and Digital version).	

EUROMED HERITAGE IV
Ancient Theatres Enhancement for New Actualities (Athena) Project

WORK PACKAGE 1
SETTING UP THE COMMON SCIENTIFIC AND CULTURAL FRAMEWORK

QUESTIONNAIRE TO VISITORS TO THE ARCHAEOLOGICAL SITE

INFORMATION

Place of the survey:
Date:
Time:
E-mail address:

EVALUATION

TIME DISTRIBUTION

What do you think of your visit to the archaeological area in relation to the following items?

	Excellent	Good	Satisfactory	Unsatisfactory	Poor
Visiting hours of theatre					
Schedule of performances					
Opening days of the site					
Schedule of guided visits					
Schedule of the interpretation centre					
Schedule of public transportation					
Schedule of catering services					

MANAGEMENT

Requirements

How would you rate the following services provided during your visit?

	Excellent	Good	Satisfactory	Unsatisfactory	Poor
Services (cafés, restaurants)					
Parking areas					
Toilets					
Security systems					
Information point					
Cash point / ATM					
Entrances					
Tours					
Signage					
Illumination					
Tourist guides					
Public transport					

Physical compatibility

What do you think of your visit to the archaeological area in relation to the following items?

	Excellent	Good	Satisfactory	Unsatisfactory	Poor
State of conservation of the site in general					
State of conservation of the theatre					
Maintaining the environment of the archaeological site					
Safety					
Accessibility					

Functional compatibility

How do you value the presence of the following activities in relation to the archaeological ensemble?

	Excellent	Good	Satisfactory	Unsatisfactory	Poor
Performances					
Tourist visits					
Protocol activities					
Cultural activities					
Traditional activities					
Archaeological Excavations					
Maintenance					
Shops					

Conceptual compatibility

How do you evaluate the quality of the following categories?

	Excellent	Good	Satisfactory	Unsatisfactory	Poor
Information at the site					
Cultural function					
Entertainment function					

Contextual

How has your degree of satisfaction been with the following categories during your visit to the archaeological site?

	Excellent	Good	Satisfactory	Unsatisfactory	Poor
Security					
Archaeological guide					
Local residents					
Technical					
Workers					
Other visitors					
Management					
Environmental quality					

ECONOMIC POTENTIAL

What do you think of the quality of your visit to the Archaeological Park in terms of the following items?

	Excellent	Good	Satisfactory	Unsatisfactory	Poor
Tourist promotion					
Accommodation					
Restaurants					
Cafés					
Typical products shops					
Bookshop					
Taxi					
Transport					
Activities conducted on the site					

What do you think of the prices for the following aspects of your visit?

	Very Expensive	Expensive	Acceptable	Quite Reasonable	Cheap
Tickets					
Accommodation					
Transport					
Bookshop					
Restaurants					
Cafés					
Typical products shops					
Taxi					
Activities conducted on the site					

CONCLUSIONS

What is your overall assessment about your visit to the archaeological site and the theatre?

Excellent ☐ Good ☐ Satisfactory ☐ Unsatisfactory ☐ Poor ☐

Comments

Sugerencias

Thank you for your cooperation.

STRATEGIES TO PROMOTE THE ANCIENT THEATRE AS A CATALYST FOR THE CULTURAL RESOURCES AND POTENTIALS

Dr. Mohamed El-Khalili*
Dr. Monther Jamhawi
Research team

Dr. Marwan Asmar
Supporting team

Department of Antiquities of Jordan
mohd_elkhalili@yahoo.com
mjamhawi@just.edu.jo
marwan.asmar59@gmail.com

*Research team leader

1. INTRODUCTION

Work Package 3 involves the drawing up of possible sustainable strategies for ancient theaters that involve risk perception and mitigation and knowledge gathering to allow the creation of tools to enable sites to have greater long-term potentials.

At this stage of work and based on previous studies and activities, a design for a sustainable strategies to promote the ancient theatres / cultural clusters raising its historical vocation of catalyst for cultural resources and presenting the possible interventions to enhance its potentials; public authorities and institutions as well as different stakeholders at general and local levels, is carried out.

With reference to Verona Charter (1997), strategies for promoting ancient places of performance must be built up on a comprehensive development scheme that is based on combining interregional and international initiatives and co-operation arrangements. These strategies must take into consideration the monuments saturation threshold and seek to redirect tourist flows to other alternative sites in need of further development to attain balanced cultural tourism.

In the last ten years a number of efforts have been made in order to set up a strategy able in preserving (and enhancing) the role of ancient theatres that have been playing in Mediterranean societies for more than two millennia, minimizing at the same time the risks of decay: in all of them a real "cultural" involvement of local populations has always been pointed out as a key factor for success.

It is clear now how ancient theatres can play again a crucial role for Mediterranean culture and cultural heritage: horizontally, they represent a kind of privileged "free zone" for non-tangible exchanges both in the south-north and east-west directions of the Mediterranean basin; vertically, they witness the continuity, though through diversity, of Mediterranean culture since its very beginning.

This work package 1) provides an up-to-date overview of the relationship between protection of cultural heritage and tourism, 2) describes strategies that can lead to sustainable tourism where cultural heritage is a key factor, and 3) points out how development cooperation can play a role in this process.

2. HERITAGE AND TOURISM

2.1. Introduction

The Convention of ICOMOS in its assembly meeting in 1976 agreed that "Tourism needs Heritage as a key to draw the crowds, while Heritage needs the support of Tourism to finance its maintenance". The mutual dependence that exists between tourism and cultural heritage is becoming more evident. While culture heritage creates a foundation for tourism's growth, tourism has the power to generate funds that make conservation possible. Cultural heritage loses much of its meaning without an audience, and a society participating in and benefiting from it. Without sustainable management, tourism loses its potential for growth.

Tourism is considered one of a developing country's main serious economic resources. It is described by Prentice (1993) as the export that doesn't go anywhere. According to Nart, the stable economic resource of a developing tourist industry could contribute to a high quality of development in other sectors. He wrote: "Tourism, as an economic activity in the developed tertiary sector, has great potential as a stable resource, qualifying economic development" (Nart, 1992).

Gearing and others stated that some of the indirect economic effects of a developing tourist industry include: 1) development of infrastructure in tourist areas or sites 2) job opportunities for unskilled workers will be found 3) a balance between the major industrial areas and other non-industrial areas will be created 4) the tourist industry may contribute to development of other sectors 5) development of the tourist industry may promote a better image of the country in the eyes of the world; this will affect other disciplines (Gearing et al.,1976).

According to Orbasli (2000a), the motive for conservation of heritage has changed from its being seen as valuable evidence for history, and understanding the aesthetic of the physical fabric of old architecture and the identity of communities, to its being viewed as a cultural product. Consequently, the approach to conservation treatment of heritage sites and historic areas is changing. This is because the visitor's perception, which focuses on external facades, has become more important, creating a loss in authenticity. In this respect, Nezar AlSayyad (2001) claimed that cultural heritage has become an object of world tourism; it is not related only to the people who built and generated it, but also to all visitors from all over the world. These consumers take an active role, transforming cultures in these cultural sites to fit their needs.

Therefore, history provides resources for cultural tourism, which is a very major industry arising from the heritage product. All its components-architectural buildings, landscape, handcrafts and the natural environment - have become commercial products for tourism to utilize for all customers seeking for leisure and a tourism

experience (Prentice, 1993). This is how tourists can discover other civilizations and appreciate them. Cultural tourism can be the key to a more humanistic and integrated form of touristic development at all levels (Moulin, 1990).

The idea of using the cultural heritage as a tourism attraction has been considered by Hall and Zeppel a marketing policy, leading to further development. They said: "'Culture' has been rediscovered as a major marketing tool to attract those travellers seeking a personally rewarding and enriching tourist experience. Therefore, the diversity of cultural attractions and their popular appeal has made cultural and heritage tourism a major area of growth in the special interest tourism market." (Hall and Zeppel, 1990).

Madran (1992) stated that some positive aspects of cultural tourism include:

- Providing financial support for preservation of the cultural heritage.
- Developing awareness among local people of the value of preservation of their cultural heritage as an income-generating activity; this leads to an effective participation of the local inhabitants in the protection of their heritage.

In addition, Nart argued that cultural tourism is a dynamic action; it should integrate with other factors, economic, social and cultural. He said: "Tourism can become a highly positive economic, social and cultural factor contributing to modernization and dynamism." (Nart, 1992).

Moulin (1990) likewise claimed that the reuse of the cultural heritage for tourism would save and keep the identity of this product as a tourist attraction; local people would feel the importance of their heritage as an economic resource that would encourage them to preserve it as product for attraction. Inskeep added that preserving local character and maintaining a high level of environmental quality in tourist areas is an important factor in attracting tourists as well as showing concern for the community (Inskeep, 1991).

Pizam and Milman (1984) considered tourism as diverse group of industries that have direct and indirect impacts on the environment. They divided these impacts into two categories: social and physical. The latter consists of all visible changes to natural features caused by tourism development to the environment, while the former is divided into four kinds of impact: 1) demographic impact, reflected in the new creation and density distribution of settlements, 2) occupational impact, reflected in the creation of new occupations or jobs, 3) cultural impact, reflected in attitudes, dressing, and changes in daily life, coming from the influence of dealing with tourists, and 4) economic impact, noticed through the creation of more jobs, increase of income, and therefore through some social changes. The social impacts are the result of the development of the tourism industry and the differences in cultures, traditions, attitudes, perceptions, and values between the tourists and the local population (Pizam and Milman, 1984; Vaughan, 1991; UNEP, 1992).

Cultural resources for tourism could be educative, producing knowledge, or entertaining, leading to enjoyment, producing confidence, or a mixture of both. Machin (1991) claimed that the mixture of both knowledge and confidence is evidence of an appropriate co-ordination of conservation and change. He asserted that management and interpretative strategies and publicity are tools for conservationists to measure the appropriateness of the balance between their conservation policy for their cultural sites and development, created as means of the changes needed to create tourism attractions.

On the other hand, tourism has now become a considerable force which, in return for some economic gain, has in many instances become a serious factor in the destruction, in a relatively short time, of the very valuable cultural heritage. The question raised now is do we need our cultural sites for all or for ever? Borg and Costa considered that mass tourism, even if it has positive economic impacts on local people, is a cause of damage to the heritage and therefore to the quality of the visitor's experience. They wrote: "Growing visitor numbers are supposed to have positive effects for the local society, especially in terms of income and employment...Tourism then causes damage to local environment, the monuments, the local population and even the quality of the visitor's experience." (Borg and Costa, 1995).

In this respect, Madran (1992) considered that the conflict between tourism and the architectural heritage begins when the number of tourists exceeds the limit of the site capacity. This so-called mass tourism will cause a gradual damage to the cultural sites and then to tourism itself. Additionally, Orbasli (1993) warned that tourism development, which has become an income-generating activity, should not lead to destruction of the heritage.

Therefore, the need for planning for the built environment and tourism, to control its relationship with the heritage and the social environment, has became widely recognized; there is a need for what is called sustainable tourism, the development of tourism through principles of sustainability that are compatible with the protection of cultural heritage. Sustainable development in tourism shouldn't only be to make money while consuming heritage, but also to keep and protect the physical fabrics and values of the existing built environment. The protection and conservation of cultural and heritage assets must be balanced with suitable levels of tourist use, along with sensible and appropriate development projects.

Moulin (1990) claimed that, for successful sustainable tourism, there is a need for cooperative management of appropriate changes at their optimal level, as heritage and nature are sensitive. He added

that tourism and heritage authorities need to join forces and talents to develop and save the environment. This leads to the importance of a partnership in heritage management as a necessary ingredient in cultural tourism development.

2.2. Sustainable Tourism and Urban Conservation

The concept of sustainable tourism has grown out of the concept of sustainable development (SD), sustainability, as a model for development, establishes the need to satisfy the requirements of today's society without making it impossible for future generations to satisfy their own. Kocabas (1994) claimed that this term gained its first popular definition in 1987, when mentioned in the report of the World Commission on Environment and Development WCED. This report defined the term as "Sustainable Development is development that meets the needs of the present without compromising the ability of future generations to meet their own needs." (WCED, 1987). Basically, this means that the development of a country cannot be achieved by the unrestrained exploitation of its resources (natural, cultural, social, etc.) to the point of extinguishing or destroying them, seeking to fulfill the needs of the present population (food, housing, health, work, etc.), without recognizing that these resources are the only platform, or potential asset, that the future generations of this country will have to meet their own needs.

This means that development goals, through use of the concept of sustainability, could be achieved by use of existing physical resources and taking into account development's impact on the built environment. Madran (1990) defined sustainable development as use of resources at a rate which fits their capacity for renewal. It is an approach to improving the capacity of existing resources by converting their physical use to fulfil present human needs.

Zancheti and Jokilheto (1997) saw heritage as a product of humanity. The cultural heritage is a non-renewable resource, and carries some most important cultural values. Such a resource is capable of maintaining these values in a new process of change based on established values. This sustainable approach deals with historic areas as part of a dynamic process of continuous change in town structures. They claimed that sustainable development is a powerful motivation for urban conservation planning. They wrote: "It would consist of a process of urban development based on the constant reuse of existing built and natural resources, associated with a low input of energy for adaptation to new requirements conceived in society." (Zancheti and Jokilheto, 1997).

In other words, sustainable development is the use of the valuable built environment with the necessary minimal intervention to achieve development. The issue is how we can balance the architecture of the built environment with development: the utility of the intervention in the architecture and the ability of its environment to service that utility to facilitate a new way of life. For sustainability in architecture to be durable, intervention's benefits should exceed the benefits it pre-empts in that location (Clark, 1992).

Although the idea is simple, the task is substantial. It means meeting four objectives at the same time:

- Social progress which recognizes the needs of everyone;
- Effective protection of the environment;
- Prudent use of natural and cultural resources; and
- Maintenance of high and stable levels of economic growth and employment.

An indicator of sustainable development is something that helps you understand where we are, which way we are going and how far we are from where we want to be. A good indicator alerts us to a problem before it gets too bad and helps us recognize what needs to be done to fix the problem. Indicators of a sustainable community point to areas where the links between the economy, environment and society are weak. They allow seeing where the problem areas are and helping show the way to fix those problems.

Indicators of sustainability are different from traditional indicators of economic, social, and environmental progress. Traditional indicators - such as stockholder profits, asthma rates, and water quality - measure changes in one part of a community as if they were entirely independent of the other parts. Sustainability indicators reflect the reality that the three different segments are very tightly interconnected, as shown in the figure below:

In 2007, Clark Miller from the International Institute for Sustainable Development IISD, the one of the world's leading NGOs supporting the development of indicators of sustainable development offered in his report the following guide to useful criteria for judging the value of a given indicator (see figure 1):

Figure 1. Criteria for judging the value of a sustainable development indicators

- **Policy relevance:** *which means can the indicator be associated with one or several issues around which key policies are formulated? Sustainability indicators are intended for audiences to improve the outcome of decision-making on levels ranging from individuals to the entire biosphere.*

- **Simplicity:** *the information should be presented in an easily understandable, appealing way to the target audience? Even complex issues and calculations should eventually yield clearly presentable information that the public understands.*

- **Validity:** *Is the indicator a true reflection of the facts? Was the data collected using scientifically defensible measurement techniques? Is the indicator verifiable and reproducible?*

- **Time-series data:** *Is time-series data available, reflecting the trend of the indicator over time?*

- **Availability of affordable data:** *Is good quality data available at a reasonable cost or is it feasible to initiate a monitoring process that will make it available in the future? Information tends to cost money, or at least time and effort from many volunteers.*

- **Ability to aggregate information:** *Is the indicator about a very narrow or broader sustainability issue? The list of potential sustainability indicators is endless. For practical reasons, indicators that aggregate information on broader issues should be preferred.*

- **Sensitivity:** *Can the indicator detect a small change in the system? We need to determine beforehand if small or large changes are relevant for monitoring.*

- **Reliability:** *Will you arrive at the same result if you make two or more measurements of the same indicator? Would two different researchers arrive at the same conclusions?" (IISD 2000).*

In the past, economic activity tended to mean more pollution and wasteful use of resources. We have had to spend to clean up the mess. A damaged environment impairs quality of life and, at worst, may threaten long term economic growth - for example, as a result of climate change. And too many people have been left behind, excluded from the benefits of development but often suffering from the side-effects.

We have to find a new way forward. We need greater prosperity with less environmental damage. We need to improve the efficiency with which we use resources. We need thriving cities, towns and villages based on strong economies, good access to services and attractive and safe surroundings. And we need international co-operation to overcome environmental problems, to allow trade to flourish and to help the world's poorest people as we move towards a more global society.

In a summary, we can define sustainable tourism as the balanced interaction of three basic factors within the tourism industry: 1) Proper stewardship of our natural and cultural resources; 2) Improvement of the quality of life of the local communities; and 3) Economic success that can contribute to other programs of national development (see figure 2).

The need for change is the challenge of sustainable development. It is substantial, but we are making progress. The Government's economic policies are increasing competitiveness and preventing a return to boom and bust. It is tackling social exclusion and improving the quality of housing, health and education services. Strong environment policies are improving our air and rivers.

Figure 2 The three basic factors within the tourism industry

For the future, we need ways to achieve economic, social and environmental objectives at the same time, and consider the longer term implications of decisions. We have to spread best practice, and build on what has already been achieved. Sometimes solutions will be obvious, such as not allowing land to be contaminated so that it has to be cleaned up. In other cases, new approaches will be needed if we are to achieve economic growth in a way which minimizes its impact on the environment: for example, by making more efficient use of energy and of our transport infrastructure.

Funding is a major issue for conservation. That is why conservation projects related to tourist sites are almost always successful, while urban areas and historic quarters hardly receive any attention (Hanafi, 1993). Therefore planners should accept the necessity for intervention to fulfill the demands of the consumers in terms of tourism needs, and for marketing their product (Ashworth, 1994). This is why regular tourism impact studies are so important to obtain information about the real needs of tourists as a demand input (Seward-Hannam, 1993).

2.3 Social Sustainability

As a society, we make social investments and we have a "stock" of social and human resources. Economic development can either contribute to

or deplete those social resources. The concept of socially sustainable development including socially sustainable urban development has received less attention than the concept of environmentally sustainable development. What would constitute socially sustainable development is that development which:

- meets basic needs for food, shelter, education, work, income and safe living and working conditions;
- is equitable, ensuring that the benefits of development are distributed fairly across society;
- enhances, or at least does not impair, the physical, mental and social well-being of the population;
- promotes education, creativity and the development of human potential for the whole population;
- preserves our cultural and biological heritage, thus strengthening our sense of connectedness to our history and environment;
- promotes friendliness, with people living together harmoniously and in mutual support of each other;
- is democratic, promoting citizen participation and involvement, and
- is livable, linking "the form of the city's public places and city dwellers' social, emotional and physical well-being".

Social sustainability is focused on the development of programs and processes that promote social interaction and cultural enrichment. It emphasizes protecting the vulnerable, respecting social diversity and ensuring that we all put priority on social capital. Athena Project creates an environment of connections within and between social networks (individuals, experts, organizations, cultural operators, artists, etc). Social sustainability is also related to how we make choices that affect other humans in our "global community". The succeeding in previous actions would produce a consistent social sustainability and finally a cultural one that is a real consolidation of mutual understanding and dialogue between Euro Mediterranean different cultures.

2.4 Planning for Sustainable Tourism

The concept of conservation is now an accepted part of urban planning in most developed countries. It is one reaction to the problem of an ageing urban landscape (Larkham, 1995). In the planning stage of considering urban areas for tourism development, three points should be taken into consideration: 1) the optimum number of tourists in urban areas should be determined, and an analysis made of the existing resources in these urban areas that could be reused and converted into new functions to meet tourist needs. 2) the demand for urban tourism should be taken into account in planning decisions. 3) planners should not forget the importance of the private sector having a good share in the outcome. Coordination of public and private sectors is essential to create a balance of interests. Tourism planning should be strategic, with desired objectives; it should be integrative, dealing with the whole country (Page, 1995).

The ICOMOS charter of 1976 recommends that the bodies representing tourism and the protection of the natural and monumental heritage should integrate cultural assets into the social and economic objectives and planning of resources of states; special training should be set up by tour operators for personnel working in, and travelling to promote, cultural tourism; education in the understanding and respect for monuments and sites should be promoted in schools and universities (Fawcett, 1993).

According to Page (1995), the public sector becomes involved in tourism for different reasons. These include:

a) Economic reasons that:
- Improve the balance of payments of a country
- Create regional or local economic development
- Increase income levels
- Create new employment opportunities

b) Social reasons that:
- Promote a greater cultural awareness of and in an area and its people
- Facilitate the integration between different cultures through tourism

c) Environmental reasons that conserve and keep the existing environment as a basis for sustainable tourism development.

d) Political reasons that predict the effect of government on different issues among from the tourism sector.

Even though cultural tourism could generate income for local communities, this does not mean letting it destroy the heritage. The absence of proper planning polices by official planners, with the communities' needs not considered, will probably result in some areas becoming deserted. This will lead to some social problems and of course will cost the government more in the long run (Orbasli, 1993). Brooks claimed that interaction between conservation and tourism needs the kind of planning that undertakes a careful analysis of the site. (Brooks, 1990)

In planning for cultural tourism, marketing the use of heritage as a cultural product for economic and political purposes has become an important aspect. It defines the opportunities of each cultural product or destination in the country. According to Orbasli (2000b), marketing has become the central force in the growth of the tourism industry.

It seeks to create balance between consumer satisfaction and profit, and between demand and supply.

According to Jamhawi (2002), the relation between conservation and tourism could be controlled and determined by six key variables or key factors. These key factors are of most critical to the success of conservation project for tourist purposes. They are:

a) A legislative and planning framework for conservation and protection of this heritage.

b) Training programmes in conservation techniques for local people.

c) Participation of local people in the decision-making of project.

d) Public awareness sessions to raise consciousness of the richness and importance of this heritage.

e) Regular re-assessment of the effectiveness of projects in achieving their objects.

f) Marketing of the new adaptive re-use projects.

(Figure 3) shows how these six key factors integrate into the relation between conservation and tourism. Participation of local communities and their public awareness is at the heart of this relationship; its absence means death to this relationship or its very limited life.

Figure 3 The six key factors in the planning and management module of conservation and tourism

The development of sustainable tourism can be consistent with the aim of development cooperation in general. Moreover, sustainable tourism represents a hitherto largely neglected opportunity for a developing country to generate employment opportunities (including for poor people), growth, and a more viable economy on terms that do not run counter to its long-term interests.

Sustainable tourism could be defined as the balanced interaction of three basic factors within the tourism industry: 1- Proper stewardship of our natural and cultural resources; 2- Improvement of the quality of life of the local communities; and 3- Economic success that can contribute to other programs of national development. Such balance must be found between limits and usage so that continuous changing, monitoring and planning ensure that tourism can be managed. This requires thinking long-term (10, 20+ years) strategies and realizing that change is often cumulative, gradual and irreversible. Economic, social and environmental aspects of sustainable development must include the interests of all stakeholders including indigenous people, local communities, visitors, industry and government.

2.5 Urban Tourism Planning and Management

Due to the complexity of cultural tourism, it's almost possible to comply all the principles of sustainable management approach (EUA, 2009), so the solution will be in the balance between the components of tourism which include meeting the needs of visitors, respecting the community, conserving the environment and the tourism as an industry; figure (4).

Figure 4 Integrated approach to sustainable tourism management; based on the EUA model for, 2009.

IMPACTS OF CULTURAL TOURISM

1. Economic impacts of tourism:

Tourism is considered a valuable economic activity for many historic towns, a field for investment, a job creator, and an important supporter for conservation activities through providing continuous financial source to its budget (Orbasli, 2000b). The economic benefits for local people could be direct, indirect and induced:

- Direct through people involvement in works related directly to tourism industry or could be government revenues derived from taxes and fees;

- Indirect as a result of the needs of those working in the tourism sector to maintain them;
- Induced effects as a result of increased income levels and re-spent those money again on services

Pearce (1989) argues that "The objective and detailed evaluation of the economic impact of tourism can be a long and complicated task" (Page, 1995). The economic impacts of tourism could be positive or negative (benefits/Costs); according to Page (1995) the economic benefits of tourism for urban areas could be:

- Generation of income for local economy "taxes revenue"
- Creation of new jobs
- Improvements in urban structures
- Encouraging entrepreneurial activity (inward an industrial investment)

Also, through enhancing the economic and social conditions in historic cores, we can provide a financial and sustainable source for urban fabric maintenance, and provide a continuous income for municipalities to make development projects (Al-Hagla, 2010). While the economic costs of tourism for urban areas could be (Page, 1995):

- The potential for economic overdependence on some activities
- The potential costs in local economy due to entrance of new consumers to the market
- Increasing in land prices
- Growing dependence on imported rather than locally produced goods
- Seasonality in consumption and production
- Leakages of tourism expenditure from the local economy

Also we have to point out that the nature of tourism as an economic term is usually elastic; easily influenced by small changes such as political unrest, unusual climatic and environmental conditions (Page, 1995).

2. Socio-Cultural Impacts of Tourism:

When we are taking about the social impact we mainly describe the effect of tourism activity on the social fabric of the community, and this refers to the interaction between tourists and host communities (Swarbrooke, 1999). These impacts could be negative or positive; the sustainable management should minimize these negative effects as possible.

Positive impacts and benefits of tourism on the social dimension:

- Cultural exchange between the host and guest; learning about other cultures, beliefs and values 'International understanding'.
- Positive changes in the life style as a result for the interaction of (host-guest); new values and new ideas.
- Developing community sense of pride in their culture and heritage.
- Enhancing community sense of identity.
- Developing new friendships
- Tourism as a tool for rising awareness and appreciation of the importance of cultural heritage
- Conserving of cultural and historical traditions (especially the intangible heritage)

While the negative impacts are:

- Intruding on local community daily life, and loss of privacy
- Losing of authenticity and cultural identity
- Developing negative attitudes and perceptions between host community and the visitors
- Negative changes in the life style as a result for the interaction of (host-guest)
- Cheapening of culture and traditions
- Cultural shock
- Congestion
- Increased crime
- Segregation, tension, hostility and misunderstanding

One of the most challenging and social concerns is damaging both the sense of place and the cultural identity of the destination.

3. Environmental Impacts of Tourism:

Tourism could have negative and positive impacts on the destination area, and one of the concerns is to preserve those environments both the natural and man-made from any possible damage. Those impacts should be studied before applying any tourism program in order to prevent them before they occur. On the other hand, we can't ignore the benefits of tourism on the hosting environments. The Positive impacts and benefits of tourism on the environmental dimension:

- Preservation and conservation of environment through the money earned from tourism sector.
- The physical enhancement in the environment that came with the rehabilitation and improvement on the destination as a tourist attraction.
- Increasing the local awareness about the importance of conservation of natural environment.

According to Mbaiwa (2009), tourism can destroy the environment that attracts tourists in the first place. Those negative impacts include the following:

- Pressures on the environmental resources because of the growing number of users "tourist"
- Damage the historical and cultural sites due to the overuse 'Wear and Tear'
- Noise, Air, water and visual Pollution
- Changings in the biodiversity caused by tourist activities
- Degradation of vegetation systems and wildlife "flora and fauna".

3. STRATEGIES AND SUSTAINABILITY OF HERITAGE

3.1 Introduction

In 2007 the European Commission, prepared an "Agenda for a sustainable and competitive European tourism", in order to develop economic, social and environmental policies. And came out with three key mechanisms that have to be encouraged, which include: sustainable destinations, sustainable businesses and responsible tourists. This agenda also focused on the involvement of all stakeholders both who have the power in decision making and the voluntarily ones.

In 2009 the European Association of Historic Towns and Regions EUA prepared guidelines on "Sustainable Cultural Tourism in Historic Towns and Cities" to regulate the management of Cultural tourism as a tool for economic and social development in a sustainable way. The EUA guidelines were built on the fact that 'places and cultural tourism are not static, but exist in relationships that affect each other (EUA, 2009); figure (5).

The framework was set as a reference for Municipalities "check list" for actions plans they will produce, seven main steps were produced as an action plan, which include:

- Prepare a policy that endorse the principles of sustainable management
- Establish a community stakeholder groups for all interests.
- Prepare position statement
- Assess the current position against the Guidelines
- Agree actions, resources and timetable
- Implement proposals
- Monitor and review

"Promoting Cultural and Creative Sectors for Growth and Jobs in the EU" is another report prepared in 2012 by the European Commission, proposes strategies to invest the potentials of cultural heritage in the economic development and the creation of jobs in Europe (EU, 2012). The report tried to present integrated strategies, built on the following:

- Partnerships between various departments: Blend of skills through the partnership with different sectors such as culture, industry, education and vocational training sector, tourism sector and others.
- Involving all public and private stakeholders with different values and interests.
- The strategies should be manage by continuous research to ensure effectiveness and sustainability
- Increase the awareness of financial institutions in the economic potential of cultural heritage in order to attract investment in these sectors.

Figure 5 EUA Dynamic process of sustainable Cultural Tourism in Historic Towns and Cities, 2009.

- *Exploiting the potential of ICT (information and communication technologies) in addressing the consumers demands and expectations*

Based on the above, the report proposes the following strategies (EU, 2012):

- *Export promotion policies in order to operate in a global environment "competitiveness".*

- *Reinforcing Cross-Sectoral Fertilization Strategy (Multi-Layered Strategy), through:*

 1. *Setting up networks and platforms between all relevant stakeholders using ICT technologies*
 2. *Launching initiatives to reinforce the cross understanding between different sectors involved.*
 3. *Recognition of the qualified persons/organizations in the field (formal and non-formal sectors).*
 4. *Improve investor-readiness of financial institutions through funds policies.*
 5. *Digitization of cultural content and develop online platforms "preservation of digital cultural heritage"*
 6. *The Development of international partnerships.*

- *Valorization strategy: by adding value to product in order to generate economic benefits "valuation of intangible assets", which is especially useful to access to the private financing. Reducing the fake cultural goods is a crucial point in this strategy and this can be solved through facilitating the cooperation between "intellectual property right-holders" and internet platforms, in the context of "The Memorandum of Understanding on the sale of counterfeit goods via the Internet".*

- *Policy Learning Platform Strategy: Exchange good policies and practices 'Export strategies' through setting up policy platforms and networks in order to promote cooperation between different policymakers and to improve the business models.*

- *Setting up Financial Facility that have access to bank loans in order to improve the capacity of financial institutions to support investments in the cultural sectors.*

- *Developing skills strategy through partnership with the education and training sectors to support the innovation policy and the creation of the mix of skills that is needed.*

- *Reinforce competitiveness through supporting technological developments that relate to those sectors in order to create innovative and competitive industries to meet the high standard demands.*

3.2 Strategy Parameters

Likewise, strategies on Sustainable Tourism were prepared by the Norwegian Multi- and Bilateral Development Co-operation (NWHO) in the report "Sustainable Tourism and Cultural Heritage: A Review of Development Assistance and Its Potential to Promote Sustainability". The report describe strategies to sustainable cultural heritage tourism and how to balance between conservation management and tourism; cultural heritage as a foundation for tourism growth which well have the power to generate funds to make conservation works possible (NWHO, 1999). Some of the strategies discussed in this report include:

- **Feasibility Studies, Project Formulation, and EIAs Strategies**

 The Feasibility Studies focuses on how a site can be developed in order to attract visitors through the well understanding of the tourism market. While the EIAs means identifying the environmental impact of tourism on the destination site in the early stages in order to avoid them "Environmental Impact Assessment".

- **Policy and planning strategy**

 A very wide strategy and extremely important, focus on the importance of planning to tourism with the partnership of all relative parties "Government led, private sector driven, and community based", it's mainly about the balance corporation. The main challenge is who take the leadership role in cooperation and the solution proposed was to develop cooperation agencies that can support ministries and tourism sector authorities and the coordination across them, for example the Jordan's Petra Regional Planning Council (PRPC) have representative from all the relative sectors in order to organize the planning policies in an effective way.

- **Partnerships strategy**

 The partnership between different actors (public and private sectors) which can help in the utilization of varied needed skills. For example formation of board that have representations from both public and private sector. In the same time this corporation can support the community empowerment through:

 - Employment of residents in the tourism businesses

 - share benefits between residents and outside operators

 - ownership of tourism businesses by local residents

 as an example to involve local community in this partnership, forming a community Based Associations that can grantee applying the previous goals and help communities to understand tourism as an industry and its impacts in order to become a cooperation part of it rather than a dependence one.

Figure 6 The role of community, heritage managers and tourism business in successful heritage places, by Australian heritage commission (AHC), 2005

- **Marketing and Infrastructure Development strategies**
 By providing high quality attractions and services the destination can attract the "big spenders" and the desired tourists, which means increase the revenue without increasing the numbers. This strategy called "up-market strategy". This strategy can be applied under main condition to serve the needs of residents and not effect on them negatively (NWHO, 1999).

- **Financing strategies**
 Due to the difficulties in getting public funding for cultural heritage sites, another alternate approach which called "User Pays" can be adapted to generate the needed fund through entrance and other fees. An example of this strategy the case of Fes Medina in Morocco which forms a special fee upon hotel reservation to support the preservation works in the city, those fees reach approximately 70$. The timing of fee is important as the fee size (NWHO, 1999). Another source for funding through donation programs; accepting donation in return for recognizing the donations name on important sites and places "Mass media". Tax breaks could also encourage the private sector in providing funds for conservation (NWHO, 1999).

- **Training in tourism management** *in order to illustrate an implement the recommended policies and strategies in the right way (NWHO, 1999).*

- **Hospitality training programs** *to ensure the community participation in the tourism industry through facilitate integration between local residents and local firms and provide them with the required knowledge they need to enter the market and generate economic benefits (NWHO, 1999).*

- **Information and communication strategy** *by promoting a series of books, journals, brochures to create a border understanding toward the destinations and its local populations (NWHO, 1999).*

3.3 Key Policy drivers

To respond to the major challenges identified above, concerned action is needed in particular in the following key areas:

- **Addressing changing skills needs:**
 There is a need for stronger partnerships between the cultural and creative sectors, social partners and education and training providers, both through initial training and continuing professional development. This should provide sectors with the mix of skills needed for creative entrepreneurship in a rapidly changing environment. Furthermore, some sectors are confronted with a shortage of employees with technical and traditional skills and crafts, because young people in particular are less attracted to take up such skills.
 Creative skills need to be learnt from an early age, in order to lay the foundations for a constant replenishment of creative talents and stimulate demand for more diverse and sophisticated creative contents and products. In a lifelong learning perspective, creative skills and competences can help to respond to changes in requirements of the labor market.
 Partnerships with education can also contribute to a stimulating learning environment, helping learners, notably those in difficulty, acquire basic skills and develop competences required for their future professional life, thus improving their employability. Creative and cultural initiatives at the local level can contribute to the integration of marginalized communities and offer opportunities for people in deprived neighborhoods.

- **Improving access to finance**
 The small size of cultural and creative businesses, the uncertainty about the demand for their products, the complexity of their business plans and their lack of tangible assets are obstacles for obtaining external financing. While equity finance, angel investment, venture capital and guarantees are alternative financing possibilities, they remain widely under-used. There is also anecdotal evidence of a market gap for export operations financing.
 Therefore, financial institutions need to increase their awareness of the economic potential of these sectors and develop their capacity to assess businesses relying on intangible assets. In parallel, entrepreneurs in these sectors should be helped in better understanding the requirements of business planning and allocation of funds to finance their activities and growth.

- **Enlarging the marketplace**
 Cultural and arts institutions and services need to strengthen their audience development capacity, seize new opportunities (in particular across borders) and respond to changes in audience behaviour and expectations. New services exploiting the possibilities

offered by ICT and online service delivery are emerging, offering ways to better address consumers' demand for access to a wide variety of contents and products and for greater participation in the creative process. These new approaches and services should also translate into new revenue streams.

To push ahead with the creation, production and distribution on all platforms of digital content, the cultural and creative sectors must enter strategic and fair partnerships with other sectors which can lead to innovative business models, through which content is accessed in different ways, achieving a balance between right-holders' revenues and the general public's access to content and knowledge, thus promoting cultural and media literacy. In that context, the full potential of Europeana14, the single access platform linking the digital collections of Europe's libraries, museums and archives, should be increasingly exploited as a basis for a new eco-system of applications and digital products targeting tourism, education, creation and culture.

- **Expanding international reach**
 Smart internationalization and export promotion policies are needed to allow a wide majority of small organizations and companies to operate in a global environment and reach new audiences and markets worldwide. It is necessary to identify the most effective support services, facilitate access to foreign markets, reinforce regulatory dialogues and assess possible risk sharing facilities. Pooling of resources and increased cooperation between various actors in the EU could be further explored to promote a stronger cultural and creative presence of Europe on the world scene and an attractive European image bridging our excellence in the field of heritage to vibrant cutting edge creativity.

- **Reinforcing cross-sectoral fertilization**
 The cultural and creative sectors need multi-disciplinary environments where they can meet with businesses from other industries. Any public intervention aiming to further develop them calls for cross-sectoral fertilization. This requires the development and testing of better business support instruments and policies that aim to facilitate cross-sectoral linkages and spill-overs. It implies fostering change amongst the sectors themselves while adding new skills and competencies into other industries and vice versa. It also requires further cooperation between different policies, embracing in particular economic affairs, industry, education, tourism, innovation, urban and regional development and territorial planning.

- **Turning Challenges into New Growth and Jobs Opportunities**
 The cultural and creative sectors are faced with a rapidly changing environment driven by the digital shift and globalization, leading to the emergence of new players, the coexistence of very big structures with micro-entities, a progressive transformation of value chains and evolving consumer behavior and expectations. While these changes offer great opportunities in terms of lower production costs or new distribution channels, they call for action at different levels. In this changing context, access to finance remains a major difficulty: the banking sector does not have the necessary expertise to analyze business models in these sectors and does not adequately value their intangible assets. The financial and economic crisis only makes this situation more critical at the very time when investments are needed to adapt.

3.4 Building up a Strategy for Jarash Site

Several strategies and policies were release in respond to the growing role of Cultural heritage in the Socio-economic development of societies (EU, 2012). Moreover the continuous tension between tourism and cultural heritage management. Many charters and guidelines where set to maintain the sustainable management of cultural tourism such as reports and agendas by European Commission, international charters and declarations.

Regarding Jarash theatres, a common strategy for addressing the problem that imply the design, implementation and testing of a management plan is needed. This instrument would not deal with theatre's problems only, but on the contrary would extend its influence to the environment of which the theatre is part.

☐ *Historical Area owned and managed by the department of Antiquities (The Archaeological Site).*
☐ *Historical Area owned by the department of Antiquities and managed by the Ministry of Tourism and Antiquities.*
☐ *Historical Area owned by the Public and managed by the Municipality of Jarash city.*

In Verona Charter 1997, It is mentioned that under the field of managing places of ancient performance, a contribution of the development of the following is important:

- *Places of performance are both a resource and a focus of local development, so they act as major tourist attractions, generating economic spin-off for the towns and regions concerned. They may fulfill this function more fully than other monuments when they continue to attract both visitors and large audiences for the performances held there. The use of the heritage of performance sites should be viewed as part of a process of sustainable development.*

- *The sustainable management of performance sites will only be possible if there is sufficient consensus among the various partners with regard to the conservation and use of the sites. This will entail drawing up a management plan defining the aims pursued and the partner's responsibilities, as well as identifying a coordinator to reconcile the different interests in the site.*

- *Strategies for promoting ancient places of performance must be incorporated into a comprehensive intersectional development scheme based on combining interregional and international initiatives and co-operation arrangements. With a view to attaining balanced cultural tourism, these strategies must bear in mind the monuments saturation threshold and seek to redirect tourist flows to alternative sites in need of further development.*

- *The development of ancient places of performance should centre on a range of cultural projects that create jobs for local residents without subjecting the latter or their environment to excessive disturbances.*

1. Challenges

However, drawing up strategies for ancient theatres or clusters is usually facing these major challenges:

1. *The interest and the "success" that ancient theatres widely arise among the public, certainly has represented (and still represents) a significant key factor for their "survival"; on the other hand, though, it conceives the most relevant cause for their decay: the audience, the technological services and equipment, even the set design and the staging, create in fact a continuous "pressure" on these structures originally designed for needs very different from those of contemporary representations.*

2. *Ancient theatres' life actually swings between these two extremes: on one side a contemporary reuse that revives the functions and the cultural, social and economic role of the structure but that in the long run would lead to a progressive general decay; on the other a strict protection with total exclusion of human "pressure" that would preserve effectively the site but lead to its inevitable cultural, social and economic death.*

3. *A third element, the lack of diffuse awareness among the population, still seems to play a major role in many situations: too often in fact, the site hosting the theatre (as well as the theatre itself) is regarded by the inhabitants either like a worthless "ensemble of stones" or simply as a "workplace". In both cases little or no intrinsic "cultural" value is attached to the asset, producing as a result an indifference attitude to its fate. (Importance to the significance of the theatre through public awareness)*

4. *Incomplete or obsolete documentation of sites – This can be listed among the preliminary problems to be solved just to get started. All the scientific community would consider it a major issue, while we could imagine that sites administrators or stakeholders would demonstrate (at least at the beginning) different attitudes.*

5. *Lack in studies concerning preservation and compatible usage of sites – Again this task would be crucial for the scientific community but this time also for sites administrators and stakeholders as well as for local communities. Eventually, though, these different groups would set out conflictual constraints which shall have to be composed through the management plan.*

6. *Partial documentation of cluster's vertical and horizontal intangible heritage – The UNESCO Convention for the Safeguarding of the Intangible Cultural Heritage 2003 established the pressing need to preserve, conserve and protect "living culture" passed on from generation to generation and considered by a given group of people as part of their cultural heritage. The Convention placed intangible cultural heritage at an equal degree of significance to tangible heritage in cultural heritage preservation programs throughout the world. Nevertheless this problem appears to be still open first of all on the theoretical side: there is in fact a great debate about the ways for documenting and cataloguing such information for which there is a wide perceived need for safeguarding crossing all communities. Also on the operational side many of previous documentation experiences appears to have been often offhand.*

7. *Lack in consciousness by local communities – Often local communities seem to partially or fully neglect even relevant ancient sites (ancient theatres too) as they were not part of their cultural heritage: this kind of attitude would somehow represent a sentence for the site. On the other extreme, the raw economic exploitation of sites, being considered not more than a workplace, would again determine an overall quick waste. Both these attitudes conflict with a strong perceived need for preservation coming from the general society, public authorities, international organizations and many other subjects.*

8. Inadequate development and exploiting of sites as economic resources – In both cases listed in previous paragraph (either sites neglected or exploited without control) we still register an inadequate development also from an economic point of view. Even if this question, directly connected with wealth and social well-being of local populations, mirrors a very well perceived need at all levels, nevertheless it still awaits to find more systematic answers especially in terms of sustainability in the medium and long period.

9. Underutilization or non compatible usage of sites - again this problem presents great connections with the others already listed. Anyway this specific issue pertains also to the core vocation of ancient theatres that is the hosting of performances: no compatible development and utilization of these sites can be set up without enhancing in a controlled way this main feature.

2. The Process

Therefore, and to start building up a successful strategy for Jarash site, series of subtasks could be proposed to have a comprehensive strategy. These subtasks include the following:

2.1. Stage I:

At this stage of work the different target groups and beneficiaries at different levels who will be involved should be identified. According to an order not completely consequent, we can list the following:

a) Public administrations and site stakeholders – As stated before, a successful strategy cannot be designed without involving these subjects both in the development of the action as well as in the dissemination of results. This approach would then determine an effective improvement of general experience and specific skills in all personnel involved throughout project's life. Targeted actions concerning training and capacity building would maximize the overall impact providing a consistent spreading of competences towards a vast ensemble of beneficiaries. (Police, civil defense, security measures, political stability).

b) Scientific scholars – the problems connected with ancient theatre/cultural clusters documentation, preservation and compatible utilization actually represent a major cross-cutting investigation subject for many researchers.

c) Local communities – Clearly this target group is composed by several "sub-groups" for which we have singularly tried to highlight each possible involvement. Nevertheless we cannot avoid mentioning this social level of beneficiaries as one of the most relevant target groups for Athena project. This would include a number of social and cultural parameters as cultural awareness, social consciousness, etc.

d) Groups involved in the educational system – In this frame the educational systems will profit of these actions also for specific teaching material produced in local languages.

e) Private individuals - The planned increase of sites' actual relevance would promote their potential attraction as tourist spots and consequently determine a higher chance of entering tourists' circuits. In this case an evident economic advantage for a number of private investors and individuals would be determined. We can expect, as final beneficiaries of this process, a relevant part of the local community.

f) The media campaign will give a potential number of contacts.

g) Young generations – This represents one of the most important target groups for a real long term sustainability of Athena Project. In this process we shall make any effort to involve the local educational structures at all levels.

h) Directors, performers, event organizers – The results coming from the study concerning the compatible usage of Ancient Theatres would obviously concern also this group.

i) The societies as a whole - A considerable effect is expected on the general consciousness the "virtuous circle" described could feed.

2.2. Stage II :

At this stage, a preparation of a Tourism Development Plan for Jarash within Jarash Governate until the year 2030 should be done. This usually goes in the following subtasks:

a) An implementation of a full built GIS system based on existing data collected from all relevant aerial, topographic, plant cover, and land use maps and plans, as well as the results of actual surveys of the zone of Jarash area where the study is focused on. This GIS system should be as a visualization tool to produce a base-map and all other maps needed for the Master Plan. The GIS system should also be developed to include the following features that perform specific functions as described below:

1. Roads existing and proposed infrastructures.

2. Population centers (densities) existing and projected urban growth with various services, water and services (waste water, solid waste dump sits, etc.).

3. Tourism development projects existing and proposed.

4. Ecological features: fauna and flora analysis based on satellite imagery. Forest areas. Agricultural areas. Natural reserves.

5. Cultural heritage sites with 3D views. Protected zones.

6. Environmental impacts of various development projects. Present and projected.

7. Land use plan existing and proposed. Wherever possible and needed 3D views will be created to better visualize any of the above features.

The GIS system can analyze the Land use and ownership plan, existing and proposed. Wherever possible and needed 3D views will be created to better visualize any of the above features. Also the system can analyze the infrastructure, existing and proposed. This will help also in drawing up the most effective regulations and infrastructure development for potential land use to enhance and facilitate tourism development.

b) Perform a background review of the relevant literature and data, including the historical condition of the environmental and resources of significant values, natural and cultural, and the nature of the risks facing them, especially those exacerbated by tourism numbers.

c) Examine the basic elements for creating tourist attractions within the Governate of Jarash. These elements are:

1. Easy transportation and accessibility to/from the Governate of Jarash.
2. Security, stability, and safety for tourists.
3. Tourist, archeological, religious, cultural and historic sites within Jarash.
4. Infrastructure of tourism sector which includes means of transportation, hotels, banks, guides, etc.
5. The linkage with other surrounding tourist attractions such as Ajloun and Irbid.
6. The particularity of Jarash area in relation to other neighboring competitors.
7. Advertisement and promotion.
8. Hospitality to tourists in the sites they visit.

d) Provide an assessment of infrastructure needs and appropriate policy responses to increased pressure from visitors and residents on infrastructure, such as roads; water treatment and sewage; waste management, recycling; fire prevention; park expansion; and maintenance, and public utilities management, utilizing information.

e) Identify and develop measurements for key economic, demographic and environmental factors reflecting the quality of life of residents and the quality of the visitor experience, and analyze the impact of changes in the level and composition of tourism on Jarash economy, quality of life, infrastructure and environment. Factors should include labor supply and demand; demand for the services of natural and cultural resources, income distribution, transportation congestion and information obtained from existing visitor and resident satisfaction surveys.

f) Provide simulations of the probable impact on the above factors resulting from changes in the level and composition of tourism and residents. The simulations shall address 15 to 20 year planning horizons.

g) Estimate the economic and social costs and benefits of tourism, and associated environmental and infrastructure polices using a dynamic approach that will incorporate population trends and demographic characteristics of Jarash residents to capture the potential impacts on the standard of living for a given change in tourism.

h) Provide linkages from the simulation results to the GIS System. This will permit estimations of the potential for tourism development subject to various constraints including available land, land suitability, zoning, infrastructure requirements, and other factors.

2.3. Stage III:

Based on the above findings and analysis, proposed scenario for tourism development of Jarash could be included. This scenario should:

a) Identify the potential tourism markets as an existing supply that include Jarash ancient city, Berktain site, Debbin reserve, Jarash city wall, handcraft souq, Souf area, the old downtown of Jarash, and Ajloun mountains.

b) Identify the priority areas or regions for tourism development in Jarash, and for those areas or regions, determine the socio-economic impact of tourism.

c) Provide a well presentation, interpretation and promotion for the site of Jarash.

d) Improve of the general knowledge concerning the relationship between the theatres of Jarash and its environment.

e) Modify the tourist activities that ensure the sustainability of the site and create integration with the people of Jarash.

f) Identify the finance and investment needs, and activate the fundraising resources for the different proposed activities.

g) Activate the promotion and marketing of the site and its seasonal activities, ie, Jarash festival.

h) Provide the incentive framework that will attract private investment.

i) Facilitates the sustainable development of tourism industry.

3.5 Conclusion

As a conclusion, comprehensive strategies for the promotion and tourism development of Jarash site and its theatres can be classified as follows:

1. Strategies related to maintaining and enhancing the tangible and intangible heritage of Jarash

- *Propose a short and long-term conservation and management projects that ensure a proper protection of the natural and cultural resources, particularly, for the two main archaeological sites, Jarash ancient city and the Berkatain, and the natural reserve of Debbein.*

- *Determine the optimum type and level of tourism in Jarash that will not result in environmental degradation.*

- *Establish tourism safety units to provide safety and enhance the protection of the cultural sites and visitors.*

- *Educate and train professionals in the management and conservation of cultural heritage.*

- *Provide the sector with the tools appropriate for management and conservation of cultural heritage including new information and communication technologies;*

- *Encourage creation of associations for management and conservation of cultural heritage.*

- *Put in place rules and regulations governing the use of Jarash site.*

2. Strategies related to promoting tourism to Jarash site and its tourist activities

- *Ensure that linkage sectors such as tourism, antiquities, agriculture and manufacturing, recreational facilities, community facilities and services, transportation and infrastructure; are all developed in an integrated manner to serve tourism as well as the needs of local community of Jarash.*

- *Improve accessibility and upgrade transportation facilities from and to the site of Jarash.*

- *Ensure that the development of Jarash tourist markets and products do not compromise environmental and socio-cultural objectives.*

- *Ensure to offer reasonable prices for visitors.*

- *Create reliability for the customers on the products by paying close attention to physical attributes of the products.*

- *Establish tourism safety units to provide safety and enhance the protection of the cultural sites and visitors.*

- *Impose measures on cleanliness and sanitation so as to improve the hygiene standards, service quality and environmental quality.*

- *Promote the country in collaboration with regional destination countries through different media in order to improve the country's image.*

- *Propose programmes for the development of tourism industry workers. These should include plans for social amenities, training, education and housing, to improve required language, competency skills and problem solving ability to improve the service quality and standards.*

- *Involve the media in raising awareness on preservation and protection of cultural heritage.*

3. Strategies related to activating the cooperation with Jarash local public and private authorities

- *Provide a rational basis for development staging and project programming, which are important for both the public and private sectors of Jarash to utilize in their investment planning.*

- *Recognize the important role of the private sector in the development and promotion of tourism of Jarash and the corresponding need to strengthen and promote collaborative activities and the community and national levels.*

4. Strategies on developing connections and integration with local communities of Jarash

- *Recognize the important contribution made by local communities in the development of sustainable tourism in Jarash, and resolve to encourage their full participation in the formulation of tourism strategies and policies.*

- *Create reliability for the customers on the products by paying close attention to physical attributes of the products.*

References

Al-HAGLA, Khalid (2010). The Role of the livable Promenade in Revitalizing an Entertainment Tourism City: The Case of Sharm El-Shaikh. Egypt.

ALSAYYAD, Nezar (2001). Global norms and urban forms in the age of tourism: manufacturing heritage, consuming tradition. in: Consuming Tradition, Manufacturing Heritage, Global Norms and Urban Forms in the Age of Tourism. Edited by Nezar AlSayyad. New York, Routledge, Taylor & Francis Group. Pp. 1-33.

ASHWORTH, G.J. (1994). Building a New Heritage, Tourism, Culture and Identity in the New Europe. Edited by G.J. Ashworth and P.J. Larkham. London, Routledge. Pp. 13-29.

BORG, J. and COSTA, P. (1995). Tourism and cities of art: Venice. in: Planning for Our Heritage. Edited by Harry Coccossis and Peter Nijkamp. Brookfield, USA. Avebury. Pp. 191-202.

BROOKS, Graham (1990). The European experience. in: Historic Environment. Volume 7, No. 3,4. Pp. 99-101.

CARR, E.A.J. (1994). Tourism and heritage, the pressure and challenges of the 1990's. in: Building a New Heritage, Tourism, Culture and Identity in the New Europe. Edited by G.J. Ashworth and P.J. Larkham. London, Routledge. Pp. 50-52.

CLARK, Tim (1992). Sustainable architecture. in: Building for Sustainability. University of York, Institute of Advanced Studies. Pp. 1-7.

European Association of Historic Towns and Regions, EUA (2009). Sustainable Cultural Tourism in Historic Towns and Cities. Norwich, United Kingdom .

EU (2012). Communication from the Commissio to the European Parlimant, the Council, the European Economic and Social Committee and the Regions. Promoting Cultural and Creative Sectors for Growth and Jobs in the EU. Brussels.

FAWCETT, Jane (1993). The impact of tourism on the environment. in: Companion to Contemporary Architectural Thoughts. Farmer, Ben Louw, and Hente (eds), London, Routledge.

GEARING, E. Charles; SWART, William W. and VAR, Turgut (1976). The economic and sociological impacts of international tourism. in: Planning for Tourism Development, Quantitive Approach. Edited by Charles Gearing; William Swart and Turgut Var. New York. Praeger. Pp. 27-39.

HALL, Michael and ZEPPEL, Heather (1990). Cultural and heritage tourism: the new grand tour? in: Historic Environment. Volume 7, No. 3,4. Pp. 86-98.

HANAFI, Mohamed (1993). Conservation and development in Alexandria, Egypt. in: Architecture and Development in the Islamic World . Institute of Advanced Architectural Studies, University of York, edited by Sultan Baraket. York. Pp. 206-222.

INSKEEP, Edward (1991). Tourism Planning, an Integrated and Sustainable Development Approach. New York, Van Nostrand Reirhold.

JAMHAWI, M.; BOSE, S.; DEL-BUE, L. and HEARTH, J. (1994). Conservation and Development. A group seminar report. Rome, ICCROM, presented on 26 May 1994 .

JAMHAWI, Monther D. (2002). Conservation and Tourism: the post 18th century Arcitectural Heritage of Jordan. Unpublished PhD thesis. Oxford Brookes University. Oxford. England.

LARKHAM, Peter J.(1995). Heritage as planned and conserved. in: Heritage, Tourism and Society. Edited by David I. Herbert. London. Mansell, Series Editors, Gareth Show and Allan Williams. Pp. 85-116.

MACHIN, Alan (1991). Background report. in: Historic Towns and Tourism. 6th European Symposium of Historic Towns. Cambridge, United Kingdom, 20-22 September 1989. Council of Europe Press. Pp. 129-132.

MADRAN, Emre (1992). Local government policies to be perused in order to maintain a balance between mass tourism and the preservation of cultural heritage. in: The Challenges Facing European Society with the Approach of the Year 2000: Strategies for Sustainable Quality Tourism. Palmero, European Regional Planning, No. 53. Council of Europe Press. Pp. 19-25.

MBAIWA, J. and SAKUZE, L. (2009). Cultural tourism and livelihood diversification: The case of Gcwihaba Caves and XaiXai village in the Okavango Delta, Botswana. In: Journal of Tourism and Cultural Change. vol. 7, no. 1, pp. 61-75.

MILLER, Clark (2007). Creating Indicators of Sustainability, A social approach. International Institute for Sustainable Development IISD.

NART, Garcia (1992). A balance between the development of tourism in vulnerable towns and natural areas and requirements to safeguard the architectural or natural heritage. in: The Challenges Facing European Society with the Approach of the Year 2000: Strategies for Sustainable Quality Tourism. Palmero, European Regional Planning, No. 53. Council of Europe Press. Pp. 43-49.

NWHO (1999). Sustainable Tourism and Cultural Heritage. A Review of Development Assistance and Its Potential to Promote Sustainability. A report submitted to UNESCO.

ORBASLI, Aylin (1993). Tourism and conservation of the historic towns, with special reference to Turkey. in: Architecture and Development in the Islamic World . Institute of Advanced Architectural Studies, University of York, edited by Sultan Barakat. York. Pp. 195-205.

ORBASLI, Aylin (2000a). Is tourism governing conservation in historic towns? in: Journal of Architectural Conservation. Vol. 6, no. 3 November Pp. 7-19.

ORBASLI, Aylin (2000b). Tourists in Historic Towns, Urban Conservation and Heritage Management. London and New York, E & FN Spon.

PAGE, Stephen (1995). Urban Tourism. London, Routledge.

PEARCE, David (1989). Conservation Today. London, Routledge.

PIZAM, Abraham and MILMAN, Adly (1984). The social impacts of tourism. in: Industry and Environment. Vol. 7, No. 1, Pp. 11-14.

PRENTICE, Richard (1993). Tourism and Heritage Attractions. London, Routledge.

SEWARD-HANNAM, Kim (1993). A Historic site preservative on tourism and sustainable development. in: Tourism and Sustainable Development: Monitoring, Planning, Managing. Edited by J. G. Nelson;

VERONA CHARTER (1997). Verona Charter on the Use of Ancient Places of Performance. Verona.

ZANCHETI, S. and JOKILEHTO, J. (1997). Values and urban conservation planning; some reflection on principles and definitions. in: Journal of Architectural Conservation. No.1.